John Crome

by Derek Clifford

*

A HISTORY OF GARDEN DESIGN

WATERCOLOURS OF THE NORWICH SCHOOL
(Cory, Adams & Mackay)

TASTE IN ART
(Evelyn, Adams & Mackay)

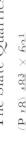

I. The Slate Quarries

c. 1804

(P. 18) 483 × 621

Tate Gallery

JOHN CROME

by

DEREK CLIFFORD

and

TIMOTHY CLIFFORD

FABER AND FABER
24 Russell Square
London

First published in mcmlxviii
by Faber and Faber Limited
24 Russell Square London WC1
Printed in Great Britain by
W. & J. Mackay & Co Ltd, Chatham

TO

EACH OF US

IN RECOGNITION OF

HIS

PATIENCE

IN FACE OF THE OTHER'S

CONTUMACIOUS

OBSTINACY.

Contents

Illustrations

COLOUR PLATES

MONOCHROME PLATES
after page 256

GENERAL

DRAWINGS

9

ILLUSTRATIONS

Acknowledgements

We thank Mr Geoffrey P. Barker for permission to quote from the Cotman letters in his possession; Mr T. R. C. Blofeld for information concerning the Skelton drawings; Mr Warren R. Dawson for much information about Dawson Turner upon whose life and publications he is an unequalled authority; Dr Norman Goldberg for helpful communications about certain Cromes in America; Mr E. P. Hansell for information about Crome's contacts with his family; Mr A. A. Hedges, the Borough Librarian of Great Yarmouth, for answering our enquiries about Yarmouth residents of the period; Mr Philip Heyworth, the City Librarian of Norwich, for dealing with our enquiries on many matters; Mr Michael Kitson for some helpful suggestions on the text; Dr M. Rajnai and the staff of the Art Department of Norwich Castle for answering enquiries and giving us ready access to the extensive material there; to Mr C. E. R. Sherrington for permitting us to use papers relating to the Sherrington Collection; and to Messrs Agnew, Christie, Colnaghi, Leggatt, Marshall Spink, and Sotheby for their assistance. We also particularly wish to acknowledge the great advantage we have derived from the use of the Witt Photographic Library and the ready help we have been given from all who are connected with it.

We are also grateful to the following owners who have generously given us permission to illustrate pictures and drawings in their collections: H.R.H. The Duke of Kent; Mrs I. Ashcroft; Mr Norman Baker; Sir Edmund Bacon Bt, K.B.E., T.D.; Sir Martyn Becket Bt; Mr John Clarke; Mr Timothy Colman; the late Sir Stephen Courtauld; Lady Crathorne; Mr L. G. Duke; Dr and Mrs N. Goldberg; Mr J. M. G. Firth; Mr John Gurney; Mr Quintin Gurney; Mr E. P. Hansell; the Hon. Doris Harbord; the Hon. Sir Arthur Howard, K.B.E., C.V.O.; the Rt. Hon. Malcolm Macdonald; Constance, Lady Mackintosh; the Hon. Keith Mason; Mr and Mrs Paul Mellon; Dr A. Renshaw; Mr Hereward Watlington. There are also a few works illustrated for which, as

ACKNOWLEDGEMENTS

we do not know where they now are, we have been unable to obtain permission. To the owners of these we offer our apologies.

We are also grateful for permission to illustrate pictures from the following public collections: the Williamson Art Gallery and Museum, Birkenhead; the Birmingham City Art Gallery; the Museum of Fine Arts, Boston, U.S.A.; the British Museum; the National Gallery of Canada, Ottawa; the Royal Museum, Canterbury; the Museum and Art Gallery of Doncaster; the Art Institute, Detroit; the Fitzwilliam Museum, Cambridge; the Ipswich Museums and Art Gallery; the Iveagh Bequest, Kenwood; the City of Manchester Art Galleries; the City of Nottingham Museum and Art Gallery; the Philadelphia Museum of Art; the National Gallery of Scotland, Edinburgh; the Tate Gallery; the Victoria and Albert Museum; the Whitworth Art Gallery, University of Manchester.

To all these and to many whom we have not named but whose help has in innumerable ways eased our work we are very grateful; and not least are we grateful to those who have written on Crome before us, for despite our frequent disagreement with them we gladly acknowledge that without their aid this study of Crome's work would have been much less complete.

Introduction

This book sets out to gather together all that is known about John
Crome, to use it in a coherent account of his life, and to identify
enough of his pictures and drawings to form a basis for recognizing
others. With some artists this would be comparatively easy: signed and dated,
or commissioned and documented works abound, and all that is needed is to
build on these fixed points; elucidation and comment follow, and the result
is a more or less satisfactory tool for the inquirer according to how well it is
done. But to uncover Crome's stylistic development is difficult. We know a
good deal about his life, although what we know seems oddly unimportant, yet
in his works there are few points which are fixed beyond doubt. Even we, the
authors, working closely together, with access to the same material, have not
always been able to agree, and what has seemed probable to one has been
sceptically regarded by the other. With an artist so ill defined as Crome it is
particularly important to establish a criterion of authentic work and to draw
attention to doubt where there is any. Collaboration has the advantage of
widening the area of doubt and of increasing the value of what, for lack of a
better word, we must call certainty.

A host of doubtful Cromes has accumulated because too few people have
known when Cromish characteristics cease to be adequate evidence of his
hand. In these circumstances the classic, but defeatist, method is to accept a few
undoubted masterpieces and to reject anything that does not measure up to
them; but this only leads to impoverishment in the opposite direction. No man
has produced only masterpieces, nor is all a man's work polarized upon them.
The way to great pictures is strewn with the inevitable debris of struggle,
imitation, experiment, and downright failure, by the light of which, the private
secrets which underpin his public fame, we are able to understand more clearly
what has been achieved. If any expert, ignorant of its provenance, were to go
through the Constable material at the Victoria and Albert Museum, or the
Turner Bequest drawings at the British Museum, the pile of rejects might well

exceed the pile of the unreservedly accepted. And yet the very idea of both artists has already been perceptibly enlarged by the existence of these reservoirs. When there is no authenticated store an artist is necessarily diminished and our idea of him is falsified. In our anxiety to have only pure gold we refine away until there is nothing left. At least one Crome expert has been so anxious to move safely that he rarely moves at all, for at every step he finds, not the true Crome but the disconcerting fact that Crome as a painter scarcely seems to have existed, that like Shakespeare, he was a fiction whose work was done by somebody else.

A jury of twelve sceptical connoisseurs who based their verdict chiefly on provenance would be bound to approve as by Crome, thirty-two etchings, perhaps as many paintings, and a mere handful of drawings. What then has happened to the work of so popular, so industrious and so well known an artist in the 147 years since he died? Does it no longer exist?

For about thirty years Crome was a drawing-master and his work was legitimately copied over and over again by his pupils. He was the founder of a School and his style was honestly emulated by his followers.[1] He had a number of apprentices who helped him to meet orders by working on his canvases.[2] His eldest son, who succeeded to his teaching practice, worked in a similar manner and had the same Christian name.[3] At his death there were unfinished works in his studio.[4] As his fame grew the demand for his work grew and was met by those whose business it was to meet it. Unfinished works were finished; original works were signed; large works were cut into two; pupils' work was upgraded; early works were repainted in the popular late manner; genuine works were cleaned to the board and elaborately restored; the forgers moved in. There is in the Colman Library in Norwich a disconcerting bill which reads as follows:

'*Mousehold Heath,*
Norwich, 1873.

MRS. WILLIAMS

To J. B. Ladbrooke	£	s.	d.
One year's Tuition and Material	7.	9.	6.
Improving Landscape and inserting Cattle	3.	0.	0.
Putting in sky and improving 'Old Crome'	1.	0.	0.
2 Circular Landscapes painted by myself	20.	0.	0.
	31.	9.	6.

J.B.L. 1874 Recd. Feb. 14th 1874
J. B. LADBROOKE'

16

What does the present owner of Mrs Williams's picture call it? And how many other 'Old Cromes' did J. B. Ladbrooke adjust to accord with the taste of the 1870s? Within forty years of his death there was scarcely anyone who knew what a genuine Crome looked like. As Reginald Gurney wrote in a letter in 1921 'I heard Laddie say "Crome is enormously copied: if anybody were to take one of his pictures out of the room and bring it back again in five minutes I would not guarantee it being the same".'[5] 'Laddie' was Robert Ladbrooke's son Henry who was so superficial a painter that one is not surprised to find him a superficial connoisseur, but his exaggeration fairly expresses the chaos into which by the latter half of the nineteenth century Crome's work had fallen.

From this slough the way out was arduous. No man did more towards re-establishing Crome than James Reeve, the curator of the Norwich Museums at the end of the nineteenth century. Reeve knew many people who had known Crome, he collected Cromes on his own account and on behalf of Jeremiah Colman. His own collection of Crome's drawings was bought by the British Museum in 1902. Depending largely on Reeve's knowledge W. H. Dickes published in 1905 *The Norwich School of Painting*. A year later, drawing on the same source, Sir Henry Theobald wrote on Crome's etchings. In 1921 Collins Baker, Keeper of the National Gallery, in his *John Crome* corrected some of the mistakes of his predecessors and reduced error still further; he also leaned heavily on Reeve.

It is no disrespect to Reeve's memory to say that his great reputation as a Crome scholar has proved at times a disadvantage. It was too readily accepted by others that Reeve was always right, and it has been too often assumed that the appearance of Cromes on the walls of Norwich Castle Museum, or in the Colman Collection, implied a Reeve acceptance of them. We have come across no case of Reeve rejecting a Crome which we accept, but several instances of him accepting work which we regard as being on the further edge of the 'possible' group . . . if not beyond it.

Reeve's comments on Cromes which he saw on public exhibition are unsettling reading. According to Baker, in the Norwich Loan Exhibition of 1860 a 'Crome' was exhibited by J. B. Ladbrooke which, when Reeve was Ladbrooke's pupil, he had actually watched Ladbrooke painting.[6] If Crome's nephew was not above this sort of thing how much worse must we expect from A. G. Stannard who, it is said, claimed to have painted 300 'Cromes'?[7] Or from Joseph Paul, of whom a friend of his reported 'He was a great actor, a great singer, a great gambler, a great rogue and a great fool', and who was also a capable and prolific painter who is reported to have run a Crome factory?[8] Or from 'Old Wigger' of Bethel Street, Norwich who bought Crome's pictures

and cut them up into two or three pieces in order to make them go further?[9]

In 1891 *The Times* in its 'Art Exhibitions' column referred to an exhibition by Messrs Dowdeswell in New Bond Street . . . 'By John Crome there are 15 pictures, all of unquestionable genuineness and many of high quality.' To which is appended a dry note by Reeve—'I called to see the Dowdeswell Collection and failed to see a Crome'. Reeve's copy of the Fine Arts Society's Catalogue of Norwich pictures in 1903 is scattered with notes like these: *Probably by J. B. Crome*; *Possibly a copy of a Cotman*; *Early Stark*; *? by J. Ladbrooke*; *? by Stark*; *Spurious*; *By a Constable forger*; *Perhaps an early Paul*; *J. B. Crome*; *Doubtful*; *By Paul*. Yet these were, presumably honestly, believed to be by Crome in the Bond Street of that day and it may well be that the descendants of the unfortunate purchasers cherish them as such still.[10]

By 1921 when the Centenary Exhibition was held at Norwich there had been a great improvement in standards. Of the fifty-seven principal exhibits in oil only ten were, in our opinion, wrong or doubtful. The authenticity of four was argued at the time.[11] The drawings and water-colours were in a much less creditable state. Nobody seems to have questioned them, presumably because nobody looked at them. Of the thirty-four shown only fifteen are admissible. Since 1921 the critical standard has in some respects fallen and many pictures have passed into public and private collections under Crome's name which he certainly did not paint. If half the pictures in a well-reputed collection turn out to be by Crome we regard the score as good. In many cases the owners and custodians of these pictures are well aware that there is, to say the least, an element of doubt. The Victoria and Albert Museum with nine oils, hang in fact only three—of which two are right. Of the drawings at South Kensington only three are certainly by Crome, four others remain in various degrees of doubt in the obscurity of a solander box, although one water-colour which is by George Frost tours the country in Loan Exhibitions and spreads a false image of Crome in the provinces. Of the drawings in the British Museum Print Room most are certainly by Crome; but there are a few which are very wrong indeed. The Norwich Castle Collections, which have naturally been regarded as the standard by which Cromes should be judged, have been the source of immeasurable confusion. Of the many oils which have at one time or another been hung or listed as by John Crome in the Castle a great many are misattributed or fakes; and of the collection of drawings there, few are from Crome's hand, although to balance the score one 'Stark' and five 'David Hodgsons' are by him.

These three fairly large collections, at the Victoria and Albert Museum, the British Museum, and Norwich Castle, have been largely built up over the last

seventy years or so and naturally contain works which pre-date the critical atmosphere of 1921, but a more recent great private collection, in America, although it scores two out of three with its drawings, which is good, has only four certainly right oils in eleven. A commercial gallery's exhibition in the West End in 1965 out of thirteen Cromes, drawings and paintings, several of them famous examples on loan, scored three only, with two possible.

The various books, pamphlets, and ephemeral catalogues concerned with Crome have all perpetuated error. Dickes listed a great number of impossible Cromes; Cundal who did well with only seven wrong and several doubtful out of a total of twenty-three, scored only two good drawings out of eight; and Collins Baker, who with a few exceptions was sound on the oils was hopelessly astray on the drawings. The drawings particularly have been a stumbling block chiefly because the material available for study has been so limited and what there was, particularly that in Norwich Castle, so extremely uneven in quality that a coherent idea of it seemed impossible to achieve. Of the seventeen drawings illustrated in *Watercolours of the Norwich School* three, we now believe, are by Crome's eldest son, John Berney Crome, and five others we have felt unable to include in the canon.

The uncertainty which this state of affairs breeds has two results, both unfortunate. The first is the disastrous effect all these doubtful pictures in public places have upon the reputation of a great painter. Inevitably his image is edged further and further into the realms of the superficial and the meretricious; an accelerating effect, for as the wrong Cromes are admitted to the disreputable canon, the right Cromes are rejected because they do not fit. Even more serious is that genuine Cromes are ignored or misattributed by those who have learned to tread warily. The Tate Gallery, whose standard of rectitude in the matter of Cromes is very high, hangs only one picture which is not by him; but they hang a Crome over the name of Cotman and keep yet another in the cellar as a John Berney Crome. We have several times come across authentic Cromes in places where the owners had been persuaded that their traditional attribution was wrong and had therefore meekly abandoned it. Although in the last few years some quite impossible 'Cromes' have been accepted and changed hands for large sums, several admirable pictures and drawings of the best period have been dismissed by the same connoisseurs as spurious. The danger in this case is that these abandoned but legitimate children will be allowed to drift back again into that dim world where their very existence is forgotten. Not many pictures pass through such an experience unscarred, some disappear for ever.

It might seem that the task of sorting out the genuine Cromes from this pile

of debris is impossible. It is not, of course. A reasonable familiarity with the work of the period and ninety Cromes out of every hundred scurry off to their appropriate holes. The ten which remain are the difficult ones.

We have tried by keeping our eyes on Crome as a figure in a mixed tradition, and by frequent reference to other contemporary figures faced with similar problems, to keep the historically probable before our minds. There is no lack of pictures, or of drawings, with speciously impressive provenances. 'Such and such a picture has always been in the family where Crome was visiting drawing-master.' True, perhaps, though sometimes not; yet were no other drawing-masters employed in the house? Not one of Crome's sons? There were many competent drawing-masters in Norwich, most more or less imbued with the spirit of Crome. Or why was not one of the pupils of the house the artist? Many were competent and many of the 'Cromes' thus authenticated would have been within their capacity. A good provenance does not turn into a Crome a picture that was painted by somebody else. Indeed a good provenance like a good alibi is a matter for suspicion: it is much more easily faked than the picture itself. Nor is a Crome any less of a Crome because it has no known history behind it.

When forming an idea of an artist so mistreated as Crome has been one must, of course, make every use of such documentary evidence as there is, but ultimately one is left with the necessity of making a subjective judgement. Stage by stage grows up a coherent image of the sort of thing Crome might have done, an image which is based on one's knowledge of the man and of the influences to which he was subjected; on the way in which he constructed his pictures; on the personal touches of his hand; on the quality of his pigment; on the range of his palette; and so on.

If we believe in causation we must accept that a pattern of some consistency will appear in a man's work, although if the pattern is wholly consistent one can be reasonably sure that it is false. For, when all has been plotted, one is still faced with the unpredictable in human nature. The path of a man is not like a railway track in which the sequence of stations between departure and terminus is constant. There are days of inspiration and days of dullness; works produced with the fire of enthusiasm and others done to order; there is the extreme vulnerability to suggestion that will alter an emphasis on the advice of an onlooker; there is the influence of a competitor; the effect of a chance word overheard in an exhibition gallery; the demand of a patron to repeat an earlier and forsaken mode; an idea enthusiastically entered upon and suddenly abandoned; or even muscular rheumatism in the painter's hand. Ideally, if one seeks to understand an artist one must try to understand as much of this as it is

open to us to know. In practice we can understand so little, even about our-
selves of whom we are in the position to know most, that the best we can hope
for is that, while reaching for the truth, we never lose sight of the fact that we
can touch only a small part of it. History is a science, and the writing of it an
art, and humility is a proper ingredient of either.

The book is arranged in two parts. Part One includes the Text. At the end
of this are printed the Appendices which include certain lists and digressions
which could not be accommodated in the text itself. Part Two consists partly
of Lists of Works and partly of Plates. The List of Etchings is based broadly
upon J. H. Theobold's *Crome Etchings*, omitting those by John Berney Crome
which Theobold mistakenly included and correcting certain other errors; the
result is a complete list of Crome's etched work. Because the study of Crome's
drawings has hitherto been almost neglected we have felt obliged to deal with
these in considerable detail and the result is as nearly complete a list of the
drawings and water-colours at present known or known of as we are able to
make at the date of printing. Of these there are about seventy-nine. There is
little doubt that more genuine drawings will come to light. At the end of this
List there is a section listing briefly drawings not by, or very doubtfully by,
Crome which have either been published or are in the principal public
collections. There are about 140 of these. Paintings, which numerically form
the greater part of Crome's extant work, presented a different problem. In this
case the listing of 'Cromes' in public collections throughout the world would
have been of little help as by far the greater number cannot seriously be held to
be by him, and, had we attempted to include 'Cromes' in private collections
with appropriate comments the book would have been unacceptably extended.
We have, therefore, kept in mind the promise in our opening sentence 'to
identify enough of his pictures to form a basis for recognizing others'. There
are 100 authentic pictures in this list. These naturally include nearly all the
well known pictures which we have felt able to accept and also a large number
that have never before been published. But they do not include every picture
which we know or suspect to be by Crome. The question is: what has been
excluded and why? In the first place we have been reluctant to include pictures
which we have not had an opportunity of studying at first-hand, photographic
evidence is by itself rarely sufficient.* Not only have we seen, and in many
cases repeatedly seen, by far the greater part of the paintings and drawings
referred to in this book, but we have carefully considered very many others.

* We have, for example, seen only seventeen drawings and paintings attributed to Crome
in North America. Many of these are wrong, but several which we have not seen we believe
may well be right.

On the few occasions when we list a picture we have not seen we say so. Secondly, many 'Cromes' are now John Crome's work only in part and the difficulty of deciding and explaining in many cases where the Master's hand is overlaid by others would have confused the presentation of the authentic Crome which is our chief purpose. Lastly, there have been a few cases where we have been unable to agree whether a certain picture was 'in' or 'out', a condition, which has several times resulted in it being left in limbo. After the genuine pictures we have added eighteen missing paintings rather as a sample of what remains to be found than as an attempted full list of missing 'Cromes'. Such a list, if complete, would be a great deal longer. Allowing for a rate of destruction which has probably been high we think it not unlikely that more than 100 genuine paintings still exist which are not listed here. Finally we have listed seventeen pictures which are either not by Crome, are doubtfully by Crome, or only in part by Crome. These are included as a warning. This portion of the book might have been greatly extended.

Not all the works listed have been illustrated. Here we have in part been governed by the economics of book production and partly by our inability to obtain satisfactory photographs. In only one case have we been refused permission to reproduce a picture in private ownership. As always the question of authenticity has led to difficulties. Permission to reproduce a 'Crome' in private hands often implies that it shall be reproduced as a Crome and permission would not be forthcoming if it were known that doubt was to be cast upon it. In these cases we have normally avoided mentioning the picture concerned. If, however, the work has *already* been published or publicly shown as a Crome we have felt no such inhibitions and have, if a useful purpose was served, drawn attention to it.

The Plates have been arranged in three groups: the Drawings, the Etchings and lastly the Paintings. Within their groups they are arranged very approximately, in what we conceive may be their chronological order; the chief exception to this is when we have grouped together treatments of the same subject which, though clearly of widely different dates, gain more from juxtaposition that they would from a strict adherence to chronology. After the three main groups there is a third small section of 'Cromes', for the most part well-known pictures and drawings, which are, whatever their merits, in our opinion not by him. These have been selected from many hundreds of candidates for this unenviable situation because we believe that they are particularly illuminating.

[1] There are many examples. In 1808 J. Kittle exhibited *View from Carrow Abbey, after Crome*; in 1810 G. F. Adams exhibited two *Water-colour drawings after Crome*; in 1813 there was a *Broken Ground, after Crome* by B. Gooch; and in the following year *Landscape—Back of the New Mills* by J. Gooch which could hardly but have been a reminiscence of one of Crome's treatments of the same subject. There are other instances of such pictures being exhibited, and, no doubt, there were many more copies that never reached the Exhibitions.

[2] George Vincent and James Stark certainly; the position of Crome's nephew, John Berney Ladbrooke, is not clear. He is said to have been a pupil but was probably not a formal apprentice.

[3] His son Joseph also exhibited at Norwich and inconveniently supplies another legitimate *J. Crome*. The other sons, Frederick Crome and William Henry Crome, particularly the latter, were more prolific and no doubt are also sometimes the source of confusion. William Henry's son Vivian was also an artist, but his signed works bear no resemblance to his grandfather's.

[4] None were in the sale of 1821 but a number appeared in his son's bankruptcy sale of 1834. In the meantime it is probable that others had been finished by, or over-painted by, J. B. Crome.

[5] Reeve.

[6] Baker p. 119; Reeve Cat. p. 25.

[7] Mottram p. 9.

[8] The Eastern Daily Press 31 January 1885 clearly refers to the work of Paul: 'Who has not seen the yellow cottage with masses of brown trees and indistinct dark foreground?'

[9] Mottram p. 8, quotes a letter from Arthur Michael Samuel: 'Also there is old Wigger of Bethel Street. I remember him well. He lived to be about 150, and died just about the time you were born . . . He also had the pleasant habit of buying Crome's pictures and cutting them up into two or three pieces in order to make them go further as instruments of sale.'

[10] Baker p. 100. He does not mention Reeve's name but there is no doubt to whom he refers. W. H. Hunt of Yarmouth in a letter to Reeve (1873) in the Reeve Album p. 71 wrote that there was no one in London at that time who had any notion of what a real Crome looked like.

[11] The discussion as carried on in the Press can be read in cuttings included in the grangerized Catalogue in the Colman Library at Norwich. No. 36 *View near Woodbridge* was suspect; Collins Baker said 'below par but certainly right'. No. 39, the Wantage *Sea Piece* which was proposed as a J. B. Crome was 'certainly by John Crome' according to Collins Baker. Nos. 53 and 54, Lord Mancroft's two pictures, were doubted by P. M. Turner who suggested Ninham because of 'meaningless touches of impasto in the sky and shaky drawing of detail'. Doubt by P. M. Turner is almost in itself cause for approving a Crome, just as his guarantee instinctively alerts suspicion. Yet in this case P. M. Turner was probably right in his doubts, although the suggestion that they were by Ninham is barely tenable; J. M. W. Turner or A. W. Calcott might be nearer the mark.

CHAPTER ONE

Norwich and Catton
1768–1798

In 1768 John Crome was born in Norwich.[1] In 1821, when he died, 'an immense concourse of people' attended his funeral to do him honour.[2] Yet in those fifty-three years he did little more than practise as a drawing-master and picture-restorer in a provincial city. He exhibited three hundred and seven pictures, of which only sixteen were shown in London; he etched thirty-three plates, but failed to publish them; he helped to found Britain's first provincial Art Society; he wrote with difficulty, and on the subject of art 'lacked words to express himself'.[3] That Kaines Smith in 1920 should compare this man to Velasquez is comprehensible;[4] that Laurence Binyon in 1897 should have written of him as greater than Hobbema, Claude, Ruysdael, and Constable may have come as no shock at that time;[5] but that the citizens of Norwich in 1821, those who had been brought up with the man and watched him painting, and had drunk ale at the bar with him, should have an inkling of his calibre is extraordinary.

Attempts to explain how it came about that a school of painters was established at Norwich have often underlined the city's isolation from the rest of England. By comparison with our present means of communication the roads of the early nineteenth century were certainly hazardous and slow; but they were so everywhere, not simply between London and Norfolk. The countryside of East Anglia was wild and picturesque; 'lanes were once wide as half-a-meadow, with broad strips of verdure on either hand, deep ruts in the road, curving and meandering here and there in many involutions'.[6] But every county of England in those days had its appropriate beauty, and men and women gloried in it and made pictures of it; but they did not all coalesce into local schools of painters. That the painters of Norwich did so was partly a

24

matter of tradition, and partly a matter of economics which dictated that Crome, their first leader, remained throughout his life in his native city.

In R. Muther's *History of Art* Crome is described as a provincial genius, a 'natural', who had no lessons and saw no pictures but Hobbema's. Today no one believes this, but the possessive pride of some Norwich writers has tended to overemphasize the extent to which he was a man of that city and a product of the Norfolk countryside. They have lost sight of the fact that Norwich, despite its marked individuality, is and was a European city, a representative of European culture; and that Crome was a flower of that culture.

In the biographies of many British painters the city in which they were born is of importance only as a jumping-off ground. It breeds their ambition, but the nurturing of it is the task of London. Their childhood friends welcome them briefly when they return with laurels, but that is all. Crome was exceptional in that the neighbourhood of Norwich was not only his birthplace but also the place where his work was done, the subject of many of his pictures, and the market in which he sold his talents. The men who influenced him by their advice and their example, who encouraged him with praise and patronage, necessarily either lived in Norwich or were frequent visitors to it. Despite occasional trips to London, two journeys to the Lake District, one to Hampshire, one to Wales, and one to Paris, Crome remained a provincial. He lived and died amongst people whom he had known, or known of, all his life.

But being a citizen of Norwich in the latter part of the eighteenth century was not to be a provincial in the narrow modern sense. Norwich was a provincial centre, conscious of its position as the heart of a great and wealthy province. It had been throughout the Middle Ages one of the largest and most influential cities in Britain and, although its relative importance was then declining, it still largely retained the spirit and the habits of independence which its remoteness from the main national routes had bred in it. One went from Norwich to London, or from London to Norwich, but one did not go by way of Norwich to any place of which it was not the acknowledged local capital. Yet, despite its independence, it was saved from becoming insular by the close direct relationship of the city with London and its contact with the continent by way of Great Yarmouth. Norwich was a great European city, and its leading men took a full part in the affairs of the world.

It is a temptation to write that Crome's life was uneventful. He would not have thought it so. The critical events of most lives, marriage, the birth and death of children, fluctuations of fortune, events which mark the lives of most of us, marked his also. The other critical moments, those that were the turning points of his growth as an artist are, by their nature, less easily distinguished.

Even to himself it might not have been apparent when or how he had learned some new secret of vision or of execution, nor perhaps would he have known precisely what had influenced him most to become the sort of painter he became. Yet these are the events with which the biography of an artist is concerned. He plucks so much from the thought and activity around him. How much? From whom? And why this and not that? The sources of his art do not lie in the man alone. His character, his hand, are the unique catalyst; but what his character is, what his eye can see, and what his hand can do, are the creation of time and place. Crome did what no other man but Crome could do; but what Crome was, Europe and the preceding centuries made him.

Crome was a Norfolk name which dated from the earliest Anglo-Saxon occupation of the area, for the word *croom* (which was evidently the way the painter himself pronounced it and the way men of Norfolk still do) means, in the local dialect, a crooked stick. On the whole the Cromes were people of little distinction although there was one Crome who became Sheriff, and an Edward Crome, a fellow of Gonville Hall in Cambridge in the sixteenth century, who became involved in religious controversy and narrowly avoided the stake in Mary's reign.[7]

Crome's father was a journeyman weaver who also kept an alehouse, a duality of jobs which was not difficult when weaving was largely a home industry. The alehouse was called 'The Griffen' and stood in what was then Conisford Street but is now King Street in Norwich. Although his patron, Dawson Turner, later described Crome's birthplace as 'a public house of far from the highest description',[8] elevation depends upon our viewpoint, and there is no reason to suppose that The Griffen was particularly disreputable. It was one of many such houses in the vicinity of the market and, whereas Dawson Turner was a respectable banker from Yarmouth, rather over-anxious about his social status, the customers of The Griffen were probably drovers and graziers from the surrounding countryside.

John Crome was born on 22 December 1768 and was baptized in the church of St George, Tombland, on Christmas Day. Tombland is the picturesque name of a piece of open ground immediately outside Norwich cathedral close.

It is not known where Crome went to school. Three holograph letters have survived which show that, although he found literary expression difficult, he could read and write, which was not a universal accomplishment even by the end of the eighteenth century.[9] In the Sale after his death 188 books were included and many more had been in a Sale of his property in 1812.[10]

In 1781 Crome made his first recorded personal contact with a man who was not only prominent in the affairs of Norwich but whose horizons extended

beyond the walls of the city. Dr Edward Rigby was in the tradition of one of Norwich's most distinguished citizens, Sir Thomas Browne, author of *Religio Medici* and the unforgettable *Urne Buriale*. Rigby, an active-minded medical practitioner, was born in Lancashire in 1747 and educated at Dr Priestley's school at Warrington. In 1762 he was apprenticed to the Norwich surgeon David Martineau whose son became John Crome's doctor and who, it is said, was once wise enough to accept a picture from Crome in payment for his services. Rigby married and settled in Norwich and in 1776 became well known in his profession through *An Essay on the Uterine Haemorrhage* which was translated into French and German and went into six editions within fifty years. There were many other publications throughout his life, not all of which were medical ones.[11] He made a second marriage, in 1803 to a daughter of William Palgrave of Yarmouth, which connected him with Dawson Turner who had earlier married Palgrave's daughter Mary. To this man in 1781 John Crome at the age of thirteen became errand boy.

Some anecdotes of this period of his life were probably given circulation by Crome himself. It is said that he sometimes changed the labels on medicines which he was charged to deliver, and that on one occasion in his master's absence he took it upon himself to bleed a patient and did so nearly to death.[12] There is also a story that some students placed a skeleton, normally used for anatomical instruction, in his bed, and that he promptly threw it out of the window.[13] It is not necessary to connect his change of employment in 1783 with these activities for one cannot be an errand boy for ever.

At the age of fifteen Crome was bound Apprentice to Francis Whisler, a coach and signpainter whose place of business was some sixty yards from Dr Rigby's house.[14] Through his apprenticeship to Whisler Crome was brought directly into the tradition of local craftsmanship. He learned such things as the grinding and mixing of paints, their technical handling, their durability, and how to lay them on; from the signpainting side of the trade he learned the need for broad effects that tell at a distance; and from the lettering, coachpainting, and heraldic drawing, he disciplined his hands to the carrying out of fine detailed work. Here he might have stopped and remained a coachpainter. In fact by 1790, when his apprenticeship ended, Crome had already begun the slow transference from the trade of decorating to the art of painting.

The distinction between trade and art was not so clear in 1790 as it has since become. Not only was it common for artists to enter on their profession by one of the trade openings but it was also not unusual for an artist to regard his work chiefly, if not solely, as a means of making a livelihood and of advancing himself in society.[15] Whether Crome was apprenticed to Whisler because

he wished to become an artist or whether he became an artist as a consequence of his apprenticeship is not known. The evidence of his son that he made his first sketch in oils in 1790 when he was twenty-two, does not suggest any early sense of dedication.[16] In comparison with such brilliant early starters as Thomas Lawrence, whose sketches at the age of six were remarkable, and who became an R.A. at the age of twenty-two; or of J. M. W. Turner, whose work was attracting widespread attention when he was seventeen, and who became an R.A. at the, then, earliest permissible age of twenty-four; or of his fellow-townsman, John Sell Cotman, who at the age of eighteen gained the Great Silver Palette of the Society of Arts; Crome was certainly a late starter. But late starting was neither exceptional nor disadvantageous. Reynolds became pupil to Hudson at the age of eighteen, and Northcote did not become Reynold's pupil until he was twenty-five.

There are several documented facts about Crome's life in the dark years between 1790 and 1798 but they help us very little in tracing the course of his early development as an artist.

On 2 October 1792, Crome was married to Phoebe Berney in St Mary's, Coslany, by the Rev. S. Forster. Among the witnesses were his friend, Robert Ladbrooke, and the bride's sister, Mary Berney.[17] On the 30th of the same month a daughter, Abigail, was born.[18]

On 30 March 1793, Crome was admitted to Norwich Hospital suffering from hydrocele. Although he was discharged on 1 June the cure was incomplete for he was in again on 14 September and remained there until 16 November.[19] On 3 October while Crome was still in hospital, Robert Ladbrooke married Crome's sister-in-law, Mary Berney.

In the following year on 31 August Crome's daughter Abigail died, on 8 December his first son, John Berney, was born. Frederick James was born on 30 September 1796; Emily on 8 April 1801; Hannah on 30 September 1804; William Henry on 22 October 1806; Joseph on 21 April 1810; and Michael Sharp on 27 October 1813. Other children did not survive infancy.

It is not until 1798 that we find the first evidence that John Crome was anything but a coach-and-signpainter. Then, in the journal of a fifteen year old girl, in the entry for 17 January there is written: 'I had a good drawing morning, but in the course of it gave way to passion with both Crome and Betsy—Crome because he would attend to Betsy and not to me and Betsy because she was so provoking'.[20] Richenda Gurney, in whose journal this appears, was one of seven daughters of the Quaker, John Gurney, a member of a well-known Norfolk family, who was at this time in business in Norwich as a woolstapler. The 'Betsy' referred to as being 'so provoking' became the formidable prison

reformer, Mrs Elizabeth Fry. John Gurney's affairs had so far prospered that in 1786 he rented a considerable house, Earlham Hall, in the countryside near the city. This junior branch of the Gurney family, although not so distinguished as it later became, was of local importance and once Crome was established as visiting drawing-master at Earlham he would have had little difficulty in gaining acceptance elsewhere. As the entry in Richenda's journal was made early in 1798 Crome was probably teaching the Gurney girls at least by 1797 and possibly much earlier.

The gap of seven years during which Crome made the step from coach-painter to drawing-master at Earlham Hall can only be filled from the accounts of Dawson Turner and Sir William Beechey, R.A. Both wrote long after the event.

Dawson Turner, remembering in 1838[21] what he had been told by others, amongst them, no doubt, Crome himself, firmly placed the beginnings of Crome's career as an artist at the time of his apprenticeship and attributed it in part to his friendship with Robert Ladbrooke. The two young men conducted a sort of commercial-art establishment, painting inn signs, copying prints, decorating cakes and, by agreement, dividing the fine art work in such a way that Ladbrooke produced portrait-heads at five shillings a time and Crome concentrated on landscapes for which he sometimes got as much as thirty shillings. Turner was emphatic that the joint-hiring of the garret where they lived together 'for some years' took place after the apprenticeship and that for some time Crome not only painted signs and shopboards on his own account but also worked as journeyman to his late master, Whisler. 'Some years' can only mean the period between 1790 (when the apprenticeship ended, for an apprentice lived with his master) and October 1792 when Crome married. It was evidently a time of financial hardship during which sacrifices were made, not only to live, but to buy prints.

The improvement in Crome's situation, according to Turner, dated from his marriage. 'From this time fortune favoured him. He united to his former employment the more safe and lucrative profession of a teacher, and in proportion as his sphere of operations enlarged, his talents as an artist were acknowledged, and his manners, as a man, universally gained him friends. He was equally at home, and equally welcome at the tables of the rich and high-born, as at those of a station similar to his own. He felt . . . that "genius is a dignity": but he never, therefore, offensively presumed. Frank, honourable, and disinterested in disposition, lively and instructive in conversation, and possessing a cheerful and social temper, united to a most winning naivete of manners—excellent also in his moral character, as a husband, a father, and a

friend—it is no wonder that everyone who knew him esteemed him and prized his society. There was at once about him a good temper that was proof against any trial, and an originality that was sure to captivate.'[22]

The relationship between an artist's work and his ostensible personality is rarely as close as is sometimes supposed but in Crome's case it was this good temper and originality, this natural dignity of character, which he was to make visible in his pictures.

The second witness to Crome's early years was Sir William Beechey, R.A. Beechey's way to success had not been easy. Apprenticed against his will to a lawyer he ran away and became assistant to a signpainter in Norwich before he was allowed to pursue his bent in a regular fashion by attending the Royal Academy Schools. Here, although no doubt he absorbed much from the general teaching of Reynolds, it is believed that his principal teacher was Zoffany. In later life he was several times singled out in the newspapers as the only portrait-painter who was in any way original, the rest being pale shadows of the great Sir Joshua.[23] There is no way of knowing whether this was an opinion genuinely held; few of the appreciations and criticisms published at that time were free from puff on the one hand or malignancy on the other. Beechey's originality as far as it went, and it is not easy to see him as anything but a follower of Reynolds, consisted in a sort of deflationary approach to Sir Joshua's grand manner. The sublimity which Reynolds sought was reduced by him to plain clothes and became subtly bourgeois. If it is usual now to concur in Opie's opinion that Beechey's pictures were of 'mediocre quality as to taste and fashion, that they seemed only fit for sea-captains and merchants',[24] it was nevertheless for a short time a matter of doubt to his contemporaries whether he would not prove to be the superior of Hoppner and Lawrence, the other leading contenders for the inheritance of Reynolds.[25] Beechey began to exhibit at the Academy in 1776 from various London addresses, but in 1785 and the following year his address is given as Norwich. In common with many other portrait-painters Beechey retained a provincial connection as a standby for lean periods and during the off-season in London.

Writing to Dawson Turner towards the end of his own long life and referring to events which had taken place about fifty years before, Beechey said; 'Crome, when first I knew him, must have been about twenty years old, and was a very awkward, uninformed country lad, but extremely shrewd in all his remarks upon art, though he wanted words to express his meaning. As often as he came to town he never failed to call upon me and to get what information I was able to give him upon the subject of that particular branch of art which he had made his study. His visits were very frequent, and all his time was spent in my paint-

ing room when I was not particularly engaged. He improved so rapidly that he delighted and astonished me. He always dined and spent his evenings with me.'[26]

If we are to interpret this letter literally William Beechey and Crome met about 1788 when Crome 'must have been about twenty years old'. According to Dawson Turner the meeting was in Harvey's house at Catton. The phrase 'about twenty' could be applied loosely to many a man between eighteen and twenty-six. Judging from his portraits, Crome had a youthful look and, given a free interpretation, the meeting with Beechey may have been as late as 1794 but can hardly have been earlier than 1788.

Another difficulty arises from Beechey's phrase 'as often as he came to town'. This has been interpreted as meaning that Crome frequently visited London, or implying that for some time he actually lived there, seeking employment. It is not easy to see how at this time either could be true. 'Frequent visits' imply an expenditure of time and money not likely to have been possible; and permanent residence could only have been practicable (unless we accept the expense of a divided home) after his apprenticeship ended and before his marriage. Neither interpretation is necessary if we remember that the two men met at Catton, which lies two miles outside Norwich, and that Beechey might quite reasonably have concluded that 'the awkward, uninformed country lad' lived in the village itself (in which, in fact, people of the name of Crome did live)[27] and that when the youth appeared in his studio in the city he might be supposed to have 'come to town'. It is also possible that Beechey was referring to a later period when Crome, himself now an exhibitor at the Academy, was an annual visitor to London.

In 1793 Beechey married as his second wife a Norwich miniaturist, Phyllis Anne Jessup, and in the same year, after seventeen years of exhibiting at the Academy, he was elected A.R.A. Five years later he achieved a notable success with his portrait of the King, was knighted, became an R.A., and was appointed Portrait Painter to the Queen.[28] Throughout his life, even when he had ample work in London, he maintained his contacts with Norwich.

Beechey was a portrait-painter, one who was paid according to his ability to catch likenesses. He painted a number of subject pictures and a few pure landscapes. In the sale of Crome's possession after his death there were four of Beechey's paintings, *Recumbent Venus*, *The Cottage Door*, a sketch for *The Cottage Door*, and a *Landscape*.[29] What his landscape paintings were like it is not possible to say but his landscape drawings, of which there are a number in the British Museum Print Room, are bold, rather coarse, wash drawings, sometimes heavily outlined in pen, rather in the general manner of Paul Sandby

and Robert Adam. In so far as he had exemplars in landscape they are likely to have been his friends, Sandby and Richard Wilson. As a teacher he would have echoed their doctrines and tempered it with greater realism. In the sense that Crome had no regular academic training he was self-taught, but we will probably not be far wrong in concluding that in many essentials he was the pupil of Beechey and that it was his association with Beechey which gave early direction to his ideas.

Portrait and landscape painting are closely allied activities. In the theocentric society of the Middle Ages the natural subject for painting was God; in the humanistic society of the eighteenth century it was man, and the portrait, which had first squeezed into the altar-piece in the shape of the donor, ultimately ousted everything else. The function of the portrait is to stabilize the personality. By its nature it confirms man's importance, serves to keep his spirits up, and helps in the hopeless task of giving permanent form to himself; a task which, after the Renaissance, had suddenly become uniquely significant. Landscape painting is an extension of portraiture and serves much the same purpose; it identifies and explains the world in which the personality moves. A portrait proclaims to man what he is; a landscape tells him where he is. Together they are a reflection of man's attitude to his surroundings and to himself and are both made from the same standpoint.

Beechey's standpoint was not an exalted one. His portraits lacked something in sensibility and imagination but they had a sober, manly, straightforward look which appealed to the sort of clientele which Opie had seemed to sneer at. A writer in the *Monthly Mirror* of 1796 commented: 'Beechey has fewer eccentricities than his competitors—for he never distorts his figures for the sake of extravagant attitude—he is less fantastic in his design and less exhuberant in manner, in short, he has more nature than the other two . . . Beechey, who is more fixed and determinate, both in his colouring and outline, studies only to be chaste.'[30] The 'other two' in this case were Hoppner and Lawrence. Twenty years later a critic writing of Crome might have said something very similar . . . with Turner and Constable as the 'other two'.

Crome's meeting with Beechey, and possibly all his most fruitful contacts and his ultimate success, arose from his association with Thomas Harvey of Catton. Harvey, a master weaver and a man of large property, lived at Catton Hall, two miles from the city. He had married the daughter of a Rotterdam merchant called Twiss and was thus connected with Mrs Siddons, herself a Norwich woman, whose sister was married to Mrs Harvey's brother.

There are many ways in which the young journeyman coachpainter might have become known to Harvey. He may have been employed in the

normal course of his painting work at Catton and have attracted Harvey's attention there. Or Dr Rigby, having kept in touch with his ex-errand boy, may have recommended him. Or Crome's father, a weaver as well as a publican, and probably known to Harvey, the master weaver, may have engaged his interest on behalf of a son who thought to become an artist. Or it may simply have been, as Dawson Turner wrote, that Harvey saw Crome's drawings in the window of the Norwich print-sellers, Smith and Jaggers, where they were displayed for sale.

Crome's association with Harvey brought him close to pictures of high quality. As there were then no permanent public exhibitions those who had no access to private collections could see Old Masters briefly in the sale-room; otherwise they knew them through copies only or in prints. To a far greater extent than today artists relied on learning from the work of their contemporaries for this was often the only work they were able to see. Harvey's collection provided Crome with an invaluable touchstone of past as well as present excellence, and a variety of examples far greater than he could have seen in the studios of the minor painters of Norwich. Harvey was both an amateur artist and a collector of pictures and it is important to an understanding of Crome to know something of what sort of an artist he was and what pictures he owned. Despite his intimate contacts with the Netherlands Harvey's interests were not limited to the Dutch and Flemish Schools. Jacob More, the painter-dealer in Rome, painted a picture expressly for him which was probably a classical landscape with figures in the Claudian mode. More also tried, perhaps with success, to obtain for him examples of certain Masters whom Harvey had listed.[31]

The pictures at Catton Hall were varied. Among them were Jan Steen's *The Christening Feast*, now in the Wallace Collection; Tintoretto's *Embarkation of St. Ursula*; a Hobbema which Harvey sold to Dawson Turner in 1815 and which he illustrated in his *Outlines in Lithography*; unidentified landscapes by Claude, Salvator Rosa, Gaspard Poussin, Cuyp, and Jacob More; an early work by Richard Wilson; possibly Wilson's *The Temple of Venus* which Dawson Turner owned by 1810 (see p 20); and the famous *Cottage Door* by Thomas Gainsborough which had been exhibited at the Royal Academy in 1780 while Crome was still running errands for Dr Rigby. In addition there were many prints and drawings, including some by Rembrandt.[32]

By the end of the eighteenth century a number of distinct traditions of landscape painting had met in England. Fundamental was the topographical tradition in which the landscape picture grew up as an extension of the map or plan; from it was logically derived the realistic landscape in which the visual appearance of a place was actually represented and not schematized. This view

of landscape ultimately depended upon recognition for its value. It was opposed by the classical-romantic landscape which constructed a world of blue skies, golden lights and distant prospects, a world accented with pillared porticoes, columns, and memorial urns, which no one supposed ever really existed in nature, any more than they supposed that classical mythology was historical fact. Such an ideal world was common to nearly all men of culture who knew that the best of themselves was the inheritance of Greece and Rome, and it served to position them, not in space only or even particularly, but in time and in the great meadows of thought. This essentially ritualistic landscape contained within itself the seeds of developments as opposed as rococo-teatray painting and the Picturesque, a self-conscious cult in which the emphasis was upon the rough, angular, and masculine qualities as opposed to the sleek, round, and feminine. The Picturesque was a way of looking at the world derived from the Italian landscapes of Gaspard Dughet, Salvator Rosa, and the Everdingen phase of Jacob Ruysdael but it was really no less idealistic in conception than the classical-romantic—it merely set up an antithetic ideal.* These were the broad traditions with which Crome would have been acquainted at Catton, but his attention would inevitably have been directed there upon two men in particular, the memory and example of whom dominated the last decade of the eighteenth century, Richard Wilson and Thomas Gainsborough.

Artistically Crome must have grown up to the sound of Wilson's praises. The popular preference once given to Zuccarelli, to de Loutherbourg, and to George Barret, had begun in 1790 to give way to a very different estimate. Frequently comparison was made between Wilson and Claude to Claude's disadvantage. 'Claude was the plain and minute *historian* of *landscape*; Wilson was the poet'[33] . . . 'Wilson's compositions are not encumbered with a multitude of parts, a fault frequently observed in Claude, whose subjects often appear studied, or in other words, over-laboured, from the introduction of too many beautiful parts.'[34] . . . 'Wilson's pictures appear as if they had been produced without effort. In this he is superior to Claude whose toil is visible amidst all the beauty and sublimity of his effort; but the power which gives birth to the grandeur and sublimity of Wilson is unseen.'[35]. . . And of Wilson's *View of Rome* 'It is as simple as possible and as grand as it can be; it is as if Michael Angelo had taken it up. Compared with Claude the largeness and dignity of Wilson's mind is most striking.'[36] By 1805 Wilson's reputation was so well re-established that Dayes could call him . . . 'the giant of the English School. . .

* Its herald in England was Captain Bernard Gilpin of Carlisle; its high priests were his son, the Reverend William Gilpin (son, brother, and uncle of painters) and two squires of the Welsh marshes, Sir Uvedale Price and William Payne Knight.

34

In the chiaroscuro and colour, he was all that Sir Joshua was; in both he was consummately skilled; and in the former he surpassed every other landscape painter.'[37]

Praise of this sort, if listened to, could not fail to create a certain climate in the mind even if the pictures to which they referred were absent. *Plainness, simplicity, grandeur, sublimity, largeness, dignity*, were words which if Crome heard them spoken when he was learning to be a painter and if they found an answering sympathy in his own nature, would have established for him a criterion of excellence more firmly than the sight of the pictures themselves.

Which actual pictures by Wilson were owned by Harvey we cannot be sure; there was one in his sale of 1819 and he may previously have sold others. Beechy tells of recognizing one of the pictures at Catton as a Wilson. He said of it that it was 'full of fire and painted off at once . . . painted at the height of his admiration for Mompers.'[38] Yet another is said to have passed from Harvey to Dawson Turner in whose possession it probably was when Crome, much later, painted a version of it (Plate 19). And in the sale of Crome's own collection after his death there was a Wilson which has not been identified.

We can only guess what sort of work Crome was doing between 1790 and 1803 when the influence of the Catton circle was greatest. Dawson Turner wrote that Crome painted in his early days the same kind of subject which he later made famous, little local landscapes, old cottages, mills, grove scenes and the like.[39] This may be so, but Turner is not the most reliable of witnesses. Slight, but more dependable evidence is in the Memorial Exhibition Catalogue of 1821. In this exhibition one hundred and eleven items were listed with the names of their owners and the dates on which it is believed they were done (Appendix D). There is clearly room for error here and in some cases the dates are more likely to be those on which the picture was exhibited or acquired. The earliest of all is called *Sketch in Oils (first work)* and is dated 1790. The only known painting by Crome which is likely to date from before his connection with Thomas Harvey or, at the latest before the connection bore fruit, is that one we know as *The Cow Tower, Norwich* (P 1, Plate 57). This strange picture is bold and broad in its main lines but quite unsophisticated in its handling. It is painted thinly in what is almost a brown-red monochrome on an amateurishly stretched canvas. The technique suggests the work of a man who has drawn much in monochrome wash, but who has never previously handled colour at all. It is the sort of picture which would hardly have survived until 1821 anywhere else but in the possession of the artist's own family, and is perhaps the actual 'first work' of 1790.

The Cow Tower owes little to Wilson but the next earliest picture in the

Memorial Exhibition avowedly did, this was *Composition: style of Wilson*, ascribed to 1796, and it was followed by yet another *Composition after Wilson* in 1798.

One or other of these may be the *Distant View of Norwich* (P 19, Plate 63a). It is a rather uncomfortable picture with two strange Wilsonian figures looking out between some shapeless and weightless rocks. There is rather more colour here than in *The Cow Tower* and there is a great deal more feeling for the quality of pigment. If it is the picture ascribed to 1796 it must be confessed that it shows a disappointingly slow rate of progress during the six years which lie between the two pictures. In any case as a very early work in oils it was a remarkable attempt which clearly foreshadowed the type of artist he was to become. The simple grandeur of the design and directness of the vision has nothing in common with such obviously accessible models as Barret and Zuccarelli but reaches back to greater masters, to Reynolds and to Velasquez.

Thomas Harvey's influence was, however, strong in another direction besides that of Wilson. Although his taste was catholic he was, if we may judge from a volume of pencil sketches and etchings by him in the British Museum, most in sympathy with Gainsborough and artists who derive from him such as Morland, Dr Thomas Monro, George Frost, and the Barkers of Bath.[40]

It is difficult to assess the influence of Gainsborough on Crome's earliest attempts to become a painter. We can point to no paintings made by him before 1806 which conspicuously relate to Gainsborough, nor even show any good grounds for supposing that such paintings existed. It is, however, different with drawings. Crome seems to have been earning his living as a drawing-master by 1797. This implies a reasonable degree of professional competence. If we may take the watermark of *Landscape at Hethersett* (D 1, Plate 4) as an indication of the approximate date at which the drawing was made we find that he was modelling himself on Gainsborough as early as 1794 for this draw-ing, if not very Gainsborough-like itself, is technically close to *Wooded Landscape* (D 2, Plate 5) which is a direct copy of a Gainsborough drawing now in the British Museum. These two drawings might be loosely described as of Gains-borough subjects drawn by a developed Wilsonian hand. A few years later, in such pencil and wash drawings as *Palings and Trees by a Pond* (D 13, Plate 12a) and *Trees on a Bank* (D 19, Plate 17), both in the British Museum, the traces of Wilson are almost gone but the conspicuous Gainsborough device of establishing his tonal range by placing areas of untouched paper in conjunction with a dark accent, a device constantly used by his followers, Frost, Monro, and James Robertson, is now very evident.

Wilson, Gainsborough, and Beechey are, then, the three men whom we

may be reasonably sure contributed most to Crome's early development. And to these we may perhaps add, on the basis of later evidence and of historic probability rather than of any undoubted examples from these early years, Morland, Ward, Ibbetson, de Loutherbourg and, perhaps rather surprisingly, John Taverner. To anyone who has looked with attention at the drawings by Crome in the British Museum (Plates 14, 17) the link with the water-colours of John Taverner will have been apparent. The improbability of Crome having had direct contact with the work of that shy amateur need present no stumbling block because in Crome's Yarmouth Sale of 1812 there were not only *two sketches by Gainsborough in black and white*,* but also a *landscape in bistre, fine by Tavernier* which was almost too much to hope for; and on the second day of the same sale there was yet another drawing by him.

By a strange accident it is probable that Crome was also familiar with the greater part of the work of yet another very rare English artist, Jonathan Skelton, whose water-colours have strong affinities with Taverner's own. It appears that Skelton's work, done while he was in Italy where he died at the age of 25, was acquired by Thomas Blofeld of Hoveton House near Norwich and remained in the library at Hoveton throughout Crome's life. Crome was not himself drawing-master to the Blofelds but John Thirtle was and it is more than likely that through Thirtle's agency Crome saw Skelton's drawings there.[41]

It is this great central landscape tradition, as humbly represented by Taverner and Skelton, neither idealistic nor topographical but in part each, a tradition of landscape seen as the subject of art but remaining essentially the passionately apprehended portrait of a place, which led directly to Crome, as it led also, and at the same time, to Girtin and to Constable.

* Was one, perhaps, the original of D 2?

[1] Register of the Church of St George Tombland, Norwich.
[2] R. M. Bacon in the *Norwich Mercury*, 28 April 1821. Reeve, p. 3.
[3] Turner, *Memoir*. Letter from Sir William Beechey, R.A., to Dawson Turner.
[4] Kaines Smith, *John Crome*, Chapter Three.
[5] Binyon, p. 45.
[6] John Wodderspoon, *John Crome and His Works*.
[7] *Dictionary of National Biography*.
[8] Turner, *Memoir*, and Turner, *Lithog*.
[9] Plate 3. A fourth, largely undecipherable, letter has since appeared.
[10] A copy of the 1812 Sale Catalogue (Lugt 8238) is in the British Museum Print Room. The 1821 Catalogue (Lugt 10113) is to be found in the Norwich City Library and in the British Museum Print Room; there is a typed copy in the Victoria and Albert Library and, according to Lugt, another copy was in the possession of W. Roberts, art critic. Among the books Crome

owned were—*Cox on Landscape Painting*; *Du Bos on Poetry and Music*; *Reynold's Works*; *Meng's Works*; *Richardson on Painting*; *De Vinci on Painting*; *Burnet's Theory of the Earth* (one wonders very much what he made of that); *Walpole's Anecdotes of Painters*; and *Du Fresnoy on Painting*.

[11] In 1783 Rigby became involved in local government, and in 1786 founded a Benevolent Society for the relief of 'the widows and orphans of medical men.' In 1789, during the Revolution, he visited France; his letters from there, addressed to his first wife, were published by his daughter, Lady Eastlake, in 1886. He became Alderman in 1802, Sheriff in 1803, and Mayor in 1805. He was a practical agriculturalist, a friend of Coke of Holkham, and experimented on his farm at Framlingham, five miles from Norwich. Apart from his obstetrical expertise and his experiments in agriculture, he is said to have introduced vaccination to the city and to have made known the use of the flying shuttle to Norwich Manufacturers. He died in 1821, six months after Crome (*D.N.B.*). He is also said to have been a teetotaller which would not have commended him to Crome.

[12] Turner *Memoir*.

[13] Reeve, p. 11.

[14] The indentures are in Norwich Castle. They operate as from 1 August 1783 and are dated the 15 October of that year.

[15] Charles Catton (1728–98), the Norwich man who was nominated by King George III in the year of Crome's birth as a Founder Royal Academician, had been apprenticed to a coachpainter and had risen to distinction by designing the supporters to coats of arms naturalistically. This man, although he exhibited landscapes and subject pictures regularly at the Royal Academy, was until the end of his days the Academy's housepainter. Of those who later became associated with Crome as fellow-artists, John Ninham (1754–1817) and James Sillett (1764–1840) were both brought up to the trade of heraldic painting. This in Ninham's case led to his commercial practice as an engraver, and in Sillett's to a lifetime of still-life painting and the teaching of drawing. Robert Dixon (1780–1815) began his career as a painter of stage scenery, and John Thirtle (1777–1839), although he became one of the most admired of water-colourists, learned the trade of picture-framer and practised it all his life. Joshua Kirby, in the year of Crome's birth President of the Incorporated Society of Artists, that early rival of the Royal Academy, had carried on a coach and house painting business in Ipswich. Movement in a reverse direction was also not unusual. Sir Godfrey Kneller's astounding success as a portrait-painter led him to the establishment of what was, in effect, a portrait factory, which after his death was frankly adapted to any sort of pictorial work going. And, in more recent times, William Capon, a Norwich man born to what we have come to think of as legitimate art as the son of a portrait-painter, went up to London where he retrogressed and became a topographer, an architectural draughtsman, and the painter of stage scenery at the pleasure-grounds of Ranelagh, and by so doing greatly exceeded his father in fame.

[16] No. 1 in the Crome Memorial Exhibition 1821.

[17] Reeve, p. 6.

[18] Reeve, p. 6.

[19] Reeve, 6. The implication in the footnote on p. 42 of *The Water-Colours of the Norwich School* that hydrocele was positively linked with syphilis was based upon an entry in the *Encyclopaedia Britannica* and is quite without foundation.

[20] Augustus Hare, *The Gurneys of Earlham*.

[21] Turner *Memoir*.

[22] Turner *Lithog*.

[23] William Roberts, *Life of Sir William Beechey*.

[24] Roberts, op. cit.

[25] Roberts, op. cit.

[26] Turner, *Memoir*.

[27] Reeve p. 9; from the Norwich Poll Books.

[28] An account of how Beechey came by his knighthood is quoted in Whitley Vol. 11, p. 217.

[29] Crome's Sale 1821 (Lugt *Repertoire des Catalogues* 9940).

[30] *The Monthly Mirror* quoted by Roberts.

31 From the letter which More wrote in August 1785 it seems that Harvey's need for these pictures was rather as an amateur virtuoso in search of examplars than as a collector: 'As you intend them for your own use in your amusement of painting I would propose to you to have some good groups copied from the pictures of the best masters whose most capital works we have here in Rome. Particularly the Caracci, Domenichino, Poussin, Salvator Rosa, etc. and as there are artists here who are very excellent at copying I think it would answer your purpose . . .' Whitley, II, 201.

32 F. W. Hawcroft, *Crome and His Patron: Thomas Harvey of Catton* in *Connoisseur* December 1959. There were two Harvey Sales: January 1821 (Lugt 9940); and in June 1819 when his pictures were sold. Dickes quotes from a catalogue in the possession of Colonel Harvey of Thorpe. It is not given in Lugt.

33 Wolcot in the supplement to the 1798 edition of Pilkington's *Dictionary* quoted in Constable's *Richard Wilson*.

34 Edward Dayes, *Professional Sketches of Modern Artists*, quoted by Constable.

35 Carey, *Letter to IA* 1808, quoted by Constable.

36 Ozias Humphrey in unpublished portion of Farington's Diary 10 June 1806, quoted by Constable.

37 Dayes, op. cit. quoted by Constable.

38 Whitley, I, 380.

39 Turner *Lithog.*

40 One of Gainsborough's last letters, when he was already a dying man, was addressed to Harvey: 'Dear Sir, Your very obliging letter inclosing a Norwich Bank Bill value sixty three pounds on Messrs Vere and Williams, I acknowledge (when paid) to be in full for the Landscapes with Cows and all Demands etc. . . . My swelled neck is got very painful indeed, but I hope is near coming to a cure. How happy should I be to set out for Yarmouth and after recruiting my quite crazy form, enjoy the coasting along till I reached Norwich and gave you a call. God only knows what is in store for me, but hope is the palette of colours we all paint with in sickness. I feel such a fondness for my first imitations of little Dutch landscapes that I can't keep from working an hour or two a day, though with a great mixture of bodily pain. I am so childish I could make a kite catch gold-finches or build little ships. . . .'

41 That Thirtle, John Sell Cotman's brother-in-law and a leading member of the Norwich School, was drawing-master at Hoveton was kindly communicated by Mr T. C. Blofeld.

CHAPTER TWO

Wales and the Lake District

1798–1806

I n 1798 Beechey had a great success with his equestrian portrait of the King and for some time Norwich saw little of him; in the same year another powerful personality arrived in the city and moved into Crome's circle.

John Opie (1761–1807) was a Cornishman whose father and grandfather were village carpenters.[1] He early showed signs of intellectual precocity and was taken up by Dr Wolcot (Peter Pindar), the satirist and art critic. At the age of nineteen Wolcot brought him to London where he at once became famous. Northcote, who had been in Italy, returned in May 1780 to be greeted by Reynolds with 'Ah, my dear sir, you may go back; there is a wondrous Cornish-man who is carrying all before him.'

'What is he like?' asked Northcote.

'Like?' replied Reynolds, 'Why like Caravaggio and Velasquez in one'.[2]

Opie exhibited first at the Royal Academy in 1782 and was elected both A.R.A. and R.A. in 1787 when Crome was still a coachpainter's apprentice. He married and his marriage ended in divorce. In 1797 he visited Norwich where he met Amelia Alderson, the beautiful daughter of a local physician. In 1798 he married her and from that year regularly spent some time in Norwich.[3]

Opie was very unlike Beechey. Beechey was a hard-drinking, hard-swearing, good-natured man; Opie was intellectual, saturnine, difficult, and utterly dedicated to his painting. He wrote a *Life of Reynolds*, published *A Lecture on the Cultivation of the Fine Arts in England* which recommended the formation of a National Gallery; lectured on art at the Royal Institution, and, as Professor of Painting at the Royal Academy in 1805, gave four lectures which were published after his death.

Reynold's remark 'Caravaggio and Velasquez in one' gives a fair idea of the

sort of painter Opie was, and is a pointer to his influence on Crome. The brothers Redgrave, writing in 1866, said of him: 'It is true that his methods are rude, and his execution the most common and unsatisfactory possible; but the feeling of vigour and power they display makes us overlook many of their defects, and we tolerate his works when not brought under too close inspection; but when weighed as to their real merits and defects, they are at times sadly wanting in many qualities'; and they went on to refer to his 'want of knowledge . . . his carelessness and indifference to means and method.'[4] If Crome, despite the examples of Beechey, Wilson, and Gainsborough, had ever shown any tendency towards admiring high finish and the littleness of art, there would have been no better corrective than the friendship and help of Opie.

Amelia Opie, writing to Dawson Turner many years after her husband's death, said: 'My husband was not acquainted with our friend John Crome before the year 1798, when we visited Norwich after our marriage. Crome used frequently to come to my husband in Norwich; and I have frequently seen *him* and Crome, and our dear friend Thomas Harvey, in the painting room of the latter. I have also seen my husband painting for Crome, that is the latter looking on while the former painted a landscape or figures. And occasionally I have seen him at work on Crome's own canvas, while the latter amused us with droll stories, and humorous conversation and observations. But this is to the best of my belief the extent of the *assistance* he derived from my husband;— this, however, Henry Briggs says, *was assistance*; and as he highly admired Crome's talents, I am very sure he would be glad to do him all the good in his power.'[5] The place of their first meeting was probably not Catton but Earlham, for in 1798 Opie was there painting a portrait of John Gurney, which the formidable Quakeress, Elizabeth, deeply hurt her father by refusing to look at.[6]

The economic condition of England in 1798 was bad. The difficulties caused by the war with France and the rebellion in Ireland, had their effect on the earnings of artists. 'So universally known was the condition of the artists in general that the Government expressly excepted Academicians and Associates from the operation of certain War Taxes'.[7] Opie, despite the approval which his pictures at the Royal Academy received from the critics, was caught up in the depression. By the end of 1801 'he saw himself . . . almost wholly without employment . . . Gloomy and painful', Amelia Opie records, 'were those three alarming months'.[8] It may have been at about this time, when profitable commissions were scarce, that he painted the splendid portrait of Crome in which a bullet-headed young man looks directly out at one with a sort of ruminating frankness (Plate 1).

Opie's only teacher, Dr Wolcot, had himself been a pupil of Wilson, so

that once more Crome had at his elbow a portrait-painter whose attitude to landscape was opposed to the triviality of Zuccarelli and the daintiness of George Barret. Opie's landscapes are scarce. One, which was among the lots in the Crome sale of 1821, was said by Dickes to represent a simple white cottage with a pentroof and a woman standing in the doorway. In Dickes's opinion (which is worth very little) it might have been taken for an early Crome but for its reddish tone.[9] Two others, *A Limekiln by Opie* and *A Sketch by Opie*, were sold in J. B. Crome's bankruptcy sale of 1834,[10] and ten landscapes by Opie were listed by Mrs Earland writing in 1911. Yet another (thinly painted and presumably unfinished) is on the back of an Opie Self-Portrait.* It is slightly reminiscent of *The Cow Tower*, and in its subdued, predominantly grey, colour is not unlike the *View of Norwich* which hangs in Norwich Castle, a picture which is not by Crome and is open to an attribution to Opie.

Opie, although not by choice, earned his living as a portrait-painter and his example reinforced the directness, the relationship of the thing seen with the picture painted, which was inherent in what Crome had learned from Beechey. To a disgruntled sitter Opie once protested 'Shall I not paint ye as ye are?' He had, however, another side to him for he was also and by choice a painter of dramatic historical scenes, featuring conspirators and murderers revealed in strong chiaroscuro, and even his simplest portraits are inclined to draw a dramatic quality from their lighting.

The years between 1795 and 1805 when not Crome only, but Girtin, Turner, Constable, and Cotman, came to maturity, were the great water-shed in English landscape-painting and in the fever of fresh discovery and achievement which made each year's Exhibitions memorable it would be reasonable to expect an enthusiastic, and essentially modest man to seize now upon this man's illumination and now upon that.[11] It is not surprising that the two sides of Opie's nature—'Shall I not paint ye as ye are?' and the dramatic creation of atmosphere, appear in Crome's work at this time. But Crome, although strongly susceptible to influences, never followed one example exclusively, nor abandoned it totally once the first enthusiasm was past. For example although we know that there were pictures relating to Wilson prior to 1798 there are certainly some which are much later; the influence of Opie on Crome, equally, is not limited to the dates when there was actual contact between the two men, 1798–1807; but appears intermittently throughout his life.

In 1802 we enter one of the brief periods when it is possible to date Crome's work with reasonable accuracy on the basis of his known movements. In that year Crome travelled with the Gurney family to the Lake District. James

* In my own collection. D.C.

Reeve, the curator of the Norwich Castle Museum, asked Richard M. Gurney in 1892 what records his branch of the family had of their association with Crome. He replied: 'In my great grandfather's account book (John Gurney of Earlham) is the following note: "Our 1802 journey via Matlock, Liverpool, Chester, Birmingham, Oxford and London, with son Samuel, six daughters and attendants about ten weeks". . . . I know from the many journals that John Crome was of the party but left there 28th Aug., when in the Lake District and appears not to have returned.'[12] This is confirmed by an entry in Rachel Gurney's diary: 'Patterdale, August 28th. This morning S. left us, and our heart felt regret, for he had been a companion to us thro' all the journey. We were also very sorry to part with John Crome.'[13] Another of the girls, Hannah, writing to his married sister Elizabeth, Mrs Fry, gave a description of the way the time passed on this tour: 'Ambleside, 1802. Today we could not get out until rather late on account of the weather, which none of us minded, as we were all busily employed in drawing, Kitty reading to us. Chenda (Richenda), Cilla, and Mr Crome were comfortably seated in a ro-mantic summer-house painting a beautiful waterfall. . . We generally get up early and draw for the first two or three hours in the morning before we set out on our excursions, which are mostly walking ones, as we like it far better than riding in this delightful country. Nothing, I think, have we been so delighted with as Grasmere'.[14]

Sketching tours such as this, whether to the Lakes, the Peak District, or to Wales, were a summer routine for landscape artists by the end of the eighteenth century. Girtin, Turner, Varley, Cotman, scarcely a landscapist of distinction failed to visit one or other of Britain's mountain areas between 1798 and 1804. In the year before that in which the Gurney family party passed through Matlock, John Constable sketching there had come upon Joseph Farington, the diarist and pupil of Wilson, doing the same thing at the entrance to Dove-dale; and in 1806 as Crome journeyed back from a second visit to the Lakes at the end of August he must have passed Constable on the road up.[15] But Lake-land, by the year of the Gurney's visit, was already more than an artists' sketching ground,[16] it had become identified with the essence of Romanticism as the home of the Nature Poets. At Grasmere, which so delighted Hannah Gurney, the Wordsworths had settled three years before.

In the year after the Lakeland trip of 1802 the Gurneys visited South Wales.[17] There is no record that Crome was of the party but he had certainly been to Wales before 1805. Henry Ladbrooke, writing much later, says that his father, Robert Ladbrooke, went there with Crome in 1804.[18] This does not preclude an earlier trip with the Gurneys which, in fact, we regard as probable.

It is usual to disregard the influence of Ladbrooke upon Crome, but a lesser man is often influential on the thought and practice of a greater and as the two men were closely associated for twenty five years it is not probable that the debt was all one way. Robert Ladbrooke has generally received bad publicity. He seems to have been gloomy and unsocial, although not without friends and loyal patrons. His pictures have largely disappeared, which is a pity because those that are known have considerable merits. Far more harmful to his reputation has been the custom of using him as a dumping ground for unidentifiable early paintings of a Norwich School type. As he was both a copyist and a dealer he may, as an artist, have been more eclectic than we yet realize but the impression the identified paintings give is that Ladbrooke was the most Dutch of the Norwich men and that his palette was distinctively low in tone. Something of the long persistence of low-keyed paintings in Crome's work may have been due to the example of his closest friend.

The four years from 1802 to 1805 (years of difficulty to the artists of London) were critical in Crome's life. By the time of his trip to Cumberland he had, by a variety of activities, maintained himself and a growing family for twelve years. A good deal of his earlier work was probably of the house-and-coach-painting kind, but he did not altogether abandon it as his practice grew for there is a receipted bill in his hand for *Painting Lame Dog writing and Gilding Board for ye Lamb and gilding name of ye Maids Head* which is dated as late as 22 May 1803.[19] Three inn signs said to be by him survive: *The Sawyers*, *The Two Brewers*, and *The Norfolk Wherryman*.[20] Other signs he is reputed to have painted were *The Black Boys* at Aylsham, *The Labour in Vain* and *The Original Angel*. Although, according to Dawson Turner, Crome in his earliest years had not disdained to design the decorations for iced cakes, it must have been clear to him by 1803 when he painted *The Lame Dog* that he was a legitimate artist and not a sign painter.

In this situation, with the example of Beechey and of Opie before him, it would have been natural for Crome to attempt to establish himself in London. Possibly a certain native caution, reinforced by warnings from Opie whose experience had made him a pessimist, determined him not to lose hold on the steady income of a drawing-master. Thirty years later Cotman, advising his son John Joseph, said 'London is the only air for an artist to breathe', and recommended him to give up Norwich 'with its little associations'.[21] By forgoing a move to London Crome was losing more than an opportunity for national fame, he was losing the invigorating company of fellow-artists, the corrective effects of public exhibition, and the stimulus of contact with a discerning metropolitan patronage. In 1803 Crome and his friend Robert Ladbrooke made the critical

decision to re-create in Norwich itself all the advantages of collective artistic activity.

The inaugural meeting of The Norwich Society was held on 19 February 1803. Its purpose was to make an 'Enquiry into the Rise, Progress and present state of Painting, Architecture and Sculpture, with a view to point out the Best Methods of study to attain to Greater Perfection in these Arts'.[22] Membership was open to artists, amateurs, scholars, and journalists. The entrance fee was the considerable one of three guineas, with an annual subscription of one guinea. All members had to submit an example of their work and were to be elected by ballot. The Society was to meet fortnightly, papers were to be read, casts, drawings, and prints studied, and a reference library was to be formed. The president, who appointed his own vice-president and secretary, was elected for six months.

It is not clear precisely what part Crome played in the foundation of the Society. Neither he nor Robert Ladbrooke were amongst its first officers, but Dawson Turner wrote that it was as a result of their 'common labour' that the Society came into being and tradition has given Crome the credit of being its founder.[23]

The Society's Minute Book has not reappeared and there are no records of its activities until, on 6 August 1805 in a room in Sir Benjamin Wrench's Court, off Little London Street in Norwich, it held the first of its Annual Exhibitions. The proclaimed intention was to act 'as an encouragement and stimulus to Art and an educator of the public'.

The catalogues of these Norwich Society Exhibitions are the source of a great deal of our knowledge of Crome's development. It is, however, necessary to be particularly careful when trying to identify extant with exhibited works. Not only are measurements rarely given in catalogues at this period (no exhibits in Crome's lifetime have measurements save four shown at the British Institution where the measurement includes the frames) but Crome's titles are stubbornly unrevealing. It is as though he had by painting the picture expressed himself in the only way he knew how and that the extra effort of giving verbal definition to it was beyond him. Often *Landscape* or *Moonlight Scene* are the only names, and when there is something more specific his *Such-and-such Lanes* and *So-and-so Groves* are so impermanent and of such purely local fame and so often repeated that we are not much nearer identifying them.

In the first exhibition there were 223 objects shown, mostly pictures and drawings, but some pieces of sculpture, some engravings, and some architectural plans. Crome contributed twenty-four items, seven of them the product of the Wye Valley trip of the year before, four deriving from his visit to the Lakes in

1802, and the remainder of East Anglian subjects which may have been of any date.

Crome's Wye Valley exhibits included pictures of Chepstow, Goodrich and Tintern, all of them in South Wales; Robert Ladbrooke on the other hand showed subjects as far north as the Conway Valley and it would therefore not be unreasonable to guess that Crome and Ladbrooke parted company. That they did not do so is suggested by three drawings and two paintings which show that Crome went as far north as Dolgelley and Blaenau Ffestiniog. The best known drawing is the pencil and wash sketch called *Dolgelley North Wales*, (Plate 9a). Two other pencil and monochrome wash drawings, both in the collection of Mr Norman Baker, help to plot Crome's journey, one is inscribed *Valle Crucis Priory* (D 6, Plate 8b) and the other *Llanrug* (D 7, Plate 8a). Llanrug is near Caernarvon in the Llanberis Pass, and Valle Crucis is near Llangollen. Further evidence of Crome's visit to North Wales, may be contained in the *Slate Quarries* itself (Col. Plate I). The mountain in the top left hand corner of this picture is recognizably the horseshoe ridge of Snowdon as seen from a point rather east of south. A similar aspect of Snowdon is shown in Wilson's *Snowdon from Llyn Nantlle*[24] but in Crome's picture it is seen from much further away. The summit on the right appears to be of the western slope of Moel Siabod, and the irregular landscape, with its glints of adventitious water, is typical of the heavily quarried vicinity of Blaenau Ffestiniog from the high ground above which Snowdon is visible. Finally, in a sale of pictures in the possession of a 'Mr Crome' in 1849, perhaps a son of W. H. Crome, appeared amongst other '*Pendaggon, North Wales* by Crome Senior'.[25]

The production of these years, from 1802 to 1806, includes some of the finest, most distinctive, and most truly original of Crome's works. These were, in fact, among the most remarkable years in the history of British landscape painting. Girtin had died in 1802, but Turner was going from strength to strength and had not yet abandoned the world of things for the dubious advantages of a world of light, Constable was steadily working towards mastery, Cotman was reaching heights of exquisite harmony which he could never afterwards recapture, and many a lesser man did work during these years which far outshone the average of his achievement. It is fit that Crome, the oldest in years of this brilliant group, should, for maturity of conception, grandeur of design, and passionate apprehension of the solid enduring beauty of things, for a time exceed them all.

The central picture, conceived if not painted in 1803 or 1804, is the great *Slate Quarries* (P 18, Col. Plate I). It is a remarkable achievement, without parallel in British Art; Barker of Bath's attempts at similar scenes, however

meritorious in other company, fade into insignificance beside this. Only Girtin's *Beddgelert* water-colours give some hint of it. Its low-toned, intensely prosaic statement is the chief reason why Crome has been likened to Velasquez. Depending closely upon this are four great paintings and a number of lesser paintings and drawings which capture in varying degrees the extraordinary creative passion of the time. Sadly rubbed, but still a magnificent shadow, is *Carrow Abbey* (P 15, Plate 67). It is remarkable that, whereas one of the great merits of Crome's painting is the variation in texture and consistency of his pigment, nevertheless when the ravages of time and over-cleaning have destroyed his carefully calculated surfaces still the great masses of his design reveal not merely that the picture was once great but that it still is so. Close to *Carrow Abbey* and in far better condition than that much exhibited picture is the very little known *Bell Inn* (P 12, Plate 61b), prosaically dramatic and astonishing in its economy of means. More directly related to the *Slate Quarries* is *Gibraltar Watering Place* (P 17, Plate 64). In this canvas Crome has used the flashing brushwork and the dragged impasto of his great mountain painting to reveal an essentially similar grandeur in the last glow of evening on a Norwich backwater. It is an extraordinary comment on the condition of Crome studies today that this remarkable picture should have been regarded as not by Crome. Its history goes back no further than the Anon (Rainger) Sale of 1863 but the significance of this collection is that it was disposed of several years before the rise in Crome prices made commercial forgeries of Crome a reasonable proposition. The Rainger collection included twenty-three Cromes among which were such famous pictures as *Bruges River, Ostend in the Distance* (P 82, Plate 104) and *The Temple of Venus at Baiae* (P 20, Plate 65) now at Norwich, *A Way through the Wood* (P 70, Plate 96b) in Birmingham City Art Gallery, *On the Skirts of the Forest* (P 53, Plate 87) in the Victoria and Albert Museum, the *Woodland Scene* (P 54, Col. Plate II) and *Yarmouth Jetty* (P 41, Plate 80a) in the Mellon Collection, *Scene in Cumberland* (P 14, Plate 66) at the National Gallery, Edinburgh and several other minor, identified and indubitable Cromes (Appendix G). Furthermore no false Cromes have so far been traced to this collection. It would, to say the least, be odd if a major and extraordinary work of the quality of *Gibraltar Watering Place* could have found its way into this collection as a Crome unless it were either by Crome, or a copy of a Crome which was believed to be by Crome by a collector whom we do not yet know ever to have made a mistake. But, provenance apart, it is inconceivable to us that anyone familiar with the *Slate Quarries* could fail to see that this picture is by the same hand. A similar quite unjustifiable and inexplicable doubt has attached itself to *The Cart Shed at Melton* (P 16, Plate 63b).

This very free and dramatic painting connects not only with the *Gibraltar Watering Place* and the *Slate Quarries* but with the picture known as *The Temple of Venus at Baiae* and Sir Arthur Howard's magnificent *Moonlight* (P 43, Plate 88). *The Temple of Venus at Baiae* has been called in doubt both as a Crome and as a record of a Wilson—despite an etching of it by Dawson Turner's daughter Mary Anne.

It is necessary to labour the authenticity of this group of pictures not only because in our opinion they are amongst the greatest of Crome's works but because, without them much of his development would be incomprehensible.

If Crome made a tour in 1805 there is no record of it unless it be then that he went to Hampshire. In the 1806 exhibition there were two entries which suggest this might be so, *A View in the Forest in Hampshire* and *View near Weymouth* (probably P 27, Plate 72). As Fowell Buxton, the philanthropist and a friend of the Gurneys who had been one of the party to the Lakes in 1802 and who in 1803 married Crome's pupil Hannah Gurney, lived at Weymouth, it was reasonably suggested by Dickes that Crome's visit to the South Coast may have been in his company.[26] Buxton at this time was fascinated by the study of optics which might have given his conversation a special interest for Crome.[27] Assuming that Crome made only one tour in each summer, and as 1802 and 1804 are already disposed of, we may suppose the Weymouth visit to have been in 1803 or 1805.

In 1806 Crome went again with the Gurneys to the Lake District. They were at Cambridge on 16 July and at Grantham on the following night, having seen Burleigh House during the day. They were some time at Ambleside where Samuel Gurney and Fowell Buxton, who were of the party, occupied with Crome a lodging apart from the rest of the family. The two young men dressed up as poor widows and begged assistance from the Miss Gurneys 'for themselves and their numerous children'.[28] Crome seems to have left the party while it was still in the Lakes as there is no suggestion that he continued with them to Scotland.[29] He would probably have wished to return to Norwich in time for the Society's Second Exhibition there in August.

The Third Exhibition, that of 1807, contained two entries by Crome relating to the Welsh tour of 1804, and three to the Lake District. Of these the only identification reasonably certain is the fine monochrome wash drawing, *Old Building at Ambleside* (D 27, Plate 23). This drawing connects very closely with the *Old House beside a River* (D 26, Plate 22) in Norwich Castle, which in turn relates to the *Trees on a Bank* (D 19, Plate 17) in the British Museum. Although it is possible that the Ambleside drawings were done after the 1802 trip it is more reasonable to assume that the group belongs to 1806. This sort of difficulty

is with us throughout the whole series of catalogues for Crome seems to have exhibited pictures of places several years after he visited them and it is possible that such pictures are often, in essence, the product of the earlier date rather than the later.

Similar confusion arises in the dating of the Opie-esque Cromes. The late Sir Stephen Courtauld's *Limekiln* (P 9, Plate 59a) we may reasonably date early—perhaps as early as 1798 when Crome and Opie first met—but what of *Early Dawn* (P 11, Plate 68) and *Windmill: Evening* (P 13, Plate 69)? Both are strongly Opie-esque and are most likely to have been painted about 1805; but once having learned the art of violent chiaroscuro Crome never totally abandoned it and some pictures which contain echoes of Opie are certainly later.

[1] Ada Earland, *John Opie and His Circle*.
[2] Earland op. cit., p. 31 and note. The quotation as given here is from R. and S. Redgrave *A Century of British Painters*.
[3] Earland op. cit., J. Menzies-Wilson and Helen Lloyd *Amelia, The Tale of a Plain Friend*.
[4] Redgrave op. cit., p. 127, Phaidon Edition 1947.
[5] Turner, *Memoir*.
[6] Hare, i, p. 103.
[7] I cannot now place the source of this quotation. (D.C.)
[8] Redgrave op. cit., p. 129.
[9] Dickes, p. 33.
[10] Lugt, 13758.
[11] For example there is the little water-colour *Near Lakenham*, displayed for some time at Norwich Castle as by Crome but which should now be relegated to Pearson of Ripon. The evidence which attached it to Crome is, however, interesting. It is clear that Crome had looked on Girtin's work and admired what he saw. There were four oil landscapes by Girtin in J. B. Crome's sale of 1834 which are not elsewhere recorded. It is also relevant that Opie painted a portrait of Girtin as well as of Crome.
[12] Reeve, p. 5.
[13] Reeve, p. 5. Postcard from Richard Gurney to Reeve.
[14] Hare, pp. 115, 116.
[15] Constable's first sketch there, of Saddleback and part of Skiddaw, is dated 21 September of that year. It is in the Victoria and Albert Museum.
[16] In 1783, twenty years before the Gurney's first trip, Gainsborough himself had set off in the same direction: '. . . I don't know if I told you that I'm going along with a Suffolk friend to visit the Lakes in Cumberland and Westmoreland, and purpose, when I come back, to show you that your Grays and Dr Brownes are tawdry fan-painters. I purpose to mount all the Lakes at the next Exhibition in great stile, and you know, if the people don't like them, 'tis only jumping into one of the deepest of them from off a wooded island and my respectable reputation will be fixed forever.' (Woodall, p. 96.)
[17] Hare, p. 124, where, however, it is not perfectly clear that the Welsh trip, taken in company with the Buxtons, was in this year. The activities of the Gurney family leave more room for this journey in 1804.
[18] Henry Ladbrooke's *Dottings*. Reeve.
[19] Reeve, p. 20.

[20] The sign of *The Three Cranes* is preserved in the Norwich Museum as a Crome. It was sold in 1887 for over £100 and re-sold in Bond Street in 1896 for about seventy shillings. There is an MS note by Reeve: 'I saw the above picture previous to 1870 in a cabinet-maker's shop in Norwich—It could never have been painted by John Crome. When I last saw this the whole of it had been repainted and offered for sale as a Crome.'

[21] Reeve, Album of Cotman Family Correspondence in the British Museum.

[22] The Rules and a full set of the Catalogues of their Exhibitions are in the British Museum Print Room.

[23] Turner, *Memoir*.

[24] Constable, pl. 55.

[25] Lugt 19195, of which a copy is at the Hague. Lot 58 is listed as *Pendaggon, North Wales*.

[26] Dickes, p. 53.

[27] The Gurneys, however, visited Plymouth in 1804. Was the Welsh tour made by way of the South Coast?

[28] Dickes, p. 51; their itinerary is partially disclosed in Hare's *The Gurneys of Earlham*.

[29] *Landscape Hawthornden* appeared in the Heugh Sale in 1874; in the Murietta Sale of 1883; and in the Anon Sale at Robinson and Fosters in 1892. It is probably spurious.

CHAPTER THREE

At the Royal Academy
1806

According to Dawson Turner, *Cottage at Hunstanton* by Crome, which he owned, had been 'painted shortly after Crome had had the advantage of copying *The Cottage Door*' and it was easy to recognize 'the effects of a careful study of it, in tone, and colour, and handling, and surface'. He went on to say that there was a certain similitude in composition, but he deplored the omission of the 'noble trees and the beautiful group of the mother and her children', features which he regarded as the greatest charm of Gainsborough's pictures. 'As regards the figures', Turner wrote, 'he was perhaps actuated by a consciousness of his inferiority; but such could not have been the case with the trees, with which few men have been more successful'. Unfortunately Dawson Turner could only say that this picture was painted 'at a comparatively early period of his life' when *The Cottage Door* was still with Harvey.* Harvey, we know, had parted with the picture to Crome's friend

* Miss Coppin also exhibited a copy of *The Cottage Door from Gainsborough* in the 1808 Exhibition. Turner in *Lithog.* wrote of his *Cottage at Hunstanton.* . . . 'A clay cottage coigned with red brick, to which a penthouse is attached. It is happily, very old, so as to be rich and varied in colour. Its red-brick chimney is capped with pots of clay, the air-tint whereof assimilated them in hue with the clouds. This cottage occupies more than half the picture: behind it is the bare stem of an oak; and, beyond, shrubs and bushes gradate in tints and thinness towards the horizon. In the road leading to the cottage are seen a woman and a boy engaged in conversation; and immediately in the foreground is a rough bank bordering a stream, to which another woman with a child in her arms is going to fetch water. Her red pitcher stands at her feet. The infant is habited in blue: the mother's head is covered with a white kerchief: she has a tone of red on her person. The female and lad in the middle distance partake of the same lively hues. In its colouring this picture is rich and deep; it is fine in chiaroscuro: the sky is admirably conceived and handled; the vapouring clouds mixed with blue sky float in very buoyancy: and the whole has a tone of colour, and a power and system of light and shadow, which bring to mind the works of Rembrandt.

'Whatever may have been said under the preceding picture in reference to its resemblance

51

Daniel Coppin, by 1807, who in turn had sold it by 1809 to Sir John Leicester (Lord de Tabley).* Dawson Turner's *Cottage at Hunstanton* may be the picture of that name exhibited in 1807 so that if Turner is right in saying that he had copied the *Cottage Door* shortly before we may reasonably guess that he did so as a replacement for either Harvey or Coppin when they parted with the original. There is no trace of a copy of this picture by Crome but if he made one we may accept 1809 as a non post hoc date—which is not very helpful as it leaves us with nineteen years in which it may have been done.

Another likeness to Gainsborough was mentioned by Dawson Turner in his discussion of a *View near Norwich*. This picture had been ascribed to Gainsborough himself by the painter-connoisseur, Henry Walton, who turned to this small piece, and at once exclaimed, 'but here there is no room for hesitation; for we have Gainsborough in his best style'. The likeness was less evident to Turner himself who says of it that it was painted in a 'low tone of colour and lacked Gainsborough's brilliancy'. The resemblance, he thought, depended in part upon the fact that the surface was covered with cracks 'as is too often the case with the works of our great landscape-painter'. Walton's view of the Gainsborough affinity in this picture was probably more sound than Turner's own. Again, unfortunately, no dates are available and only the date of Walton's death, 1813, gives us a limit.

That Crome and Gainsborough did, in fact, have a great deal in common Turner freely admitted, but his explanation of their likeness was the typically romantic one: 'They studied in sister counties abounding in the same scenery; and they both formed their style upon the contemplation of it, and of it alone.' This was a typical view. Philip Thicknesse, who had known Gainsborough well,

to the style of Gainsborough, I cannot but think that such a resemblance is more to be found in the subject of the present plate, where also it would rather be looked for; as this was painted shortly after Crome had had the advantage of copying one of the most esteemed of that artists' works. The piece alluded to is *that* generally known by the name of the *Cottage Door;* and those who are acquainted with that masterly production, as many must be from its having long hung in Lord de Tabley's gallery, will be at no loss here to recognize the effects of a careful study of it, in tone, and colour, and handling, and surface. The same similitude is likewise to be traced, to a certain degree, in the composition; but in that respect there is a sad falling off on the part of my poor friend: by omitting the noble trees and the beautiful group of the mother and her children, he has deprived his picture of what ought to have constituted its greatest charm. As regards the figures, he was perhaps actuated by a consciousness of his inferiority; but such could not have been the case with the trees, with which few men have been more successful.

'The time when Crome painted this picture was at a comparatively early period of his life . . . Another picture, a Cottage at Kirby Bedon, Norfolk, the counterpart of this, was painted by Crome about the same time. It is now in the possession of John Wright, Esq., of Buxton, near Aylesham.' *Cottage at Hunstanton* has recently re-appeared (P. 23x).

* Ellis Waterhouse, *Thomas Gainsborough* p. 117.

wrote of him that 'Nature was his master, for he had no other'* and Dickes much later wrote of Crome that 'Nature was his Only Guide'. It was the pleasure of the romantics in their revulsion from classical formulae to believe that all that was required was to leave the conventions of the studios behind and to go back to the fountain-head, to Nature herself. Throughout the eighteenth century the word Nature had been freely used with a variety of widely different meanings but in this case what was intended by it was not analytical accuracy of representation but a quality of unaffected directness. But the two great artists who most nearly achieved this quality, Crome and Constable, did so not by exposing their innocent vision to the world of fact but at the cost of years of effort. Gainsborough, far more naturally gifted than either, entered this rare world very young, but even he did not find his way in it unaided; nor did he pretend that he had. When J. M. W. Turner referred to Gainsborough in a lecture to the Royal Academy he spoke of his early Suffolk landscapes as being derived from Hobbema, the very name which has been so strongly urged as Crome's model. With the advantage of our greater knowledge of seventeenth-century painting there seems little doubt now that the 'little Dutch landscapes' of which Gainsborough thought so highly when he lay dying, and which he had taken for his models in his far-off Suffolk days, were not so often by Hobbema as by Jacob Ruysdael and Jan Wynants.

Pictures which we may reasonably suppose were exhibited in 1807 are the large oil, *The Blacksmith's Shop* (Plate 86), in Philadelphia and the two water-colours of the same subject (Plates 37, 38). These Blacksmith Shop pictures press the question of Gainsborough's influence for one cannot see them without being put in mind of the *Cottage Door*. It seems as though, whatever may have been the case before, that Crome became in 1806–7 particularly aware of Gainsborough. In 1806 he exhibited *Sketch in the Style of Gainsborough* and, apart from the *Blacksmith's Shop*, there were also the *Cottage at Hunstanton* with its alleged Gainsborough likeness, and *The Yare at Thorpe: King's Head Gardens* (Plate 73).[1] This, like so many of Crome's pictures, is an almost isolated phenomenon. Its prevailing colour is silvery grey-green which is only paralleled by a small group of Gainsborough's spring landscapes such as those in the Fitzwilliam Museum, and in Norwich Castle.

It is curious that even in this short time Crome found different aspects of Gainsborough to reflect. The *Yare at Thorpe* gives little more than his spring palette and a pre-Corotesque delicacy of vision, while the *Blacksmith's Shop* takes its start as a Gainsborough genre picture but somehow does not end there. The *Cottage Door* with its 'noble' trees and sentimental family, for all

* Philip Thicknesse, *A Sketch of the Life and Paintings of Thomas Gainsborough, Esq.*

its merits, belonged to a world of pictures, a world of ideas detached from the objects which had given rise to them; its essential theatricality has no echo in the Crome. The ostensible subject was not in common. Gainsborough's subject was the idea of the simple life, innocent and sweet; Crome's subject was the way the light caught old plaster and the way the simplest of familiar objects and scenes could seem to become 'the still centre of the turning world'. Crome's blacksmith is a real blacksmith; Gainsborough's peasants however well drawn are not real peasants. Crome's cottages are made of timber and clay and thatch, the decay we see will become ruin tomorrow, their weight and age will bring them down; but for Gainsborough's cottages, as for the canvas cottages of a stage-set, there is no tomorrow.

Nevertheless, although the rococo twist of manner and sentiment which Gainsborough gave to Netherlandish landscape at no time had a counterpart in Crome's work, Gainsborough's influence was otherwise very great. In *The Woodland Scene* (Colour Plate II), in Sir Arthur Howard's *Moonlight* (Plate 88), and in *The Willow* (P 92) Crome added to Gainsborough's freedom and verve the directness of vision peculiar to himself. The result was a level of achievement to which he never attained again (See also D 15, P 60, P 75).

Crome was an artist of the Picturesque. It would have been very difficult for any artist working between 1790 and 1820 to be otherwise unless he were a stylistic fossil. It happened that after the Lakeland visit of 1806 Crome did not see those staple ingredients of the picturesque, mountains and rocks, again. The Gurney girls married. The great parties of family, of friends, of servants, to which Crome had been admitted, no longer streamed out of Earlham Park in July. Apart from one extraordinary excursion in 1814, and probably some brief annual visits to London, Crome seems to have remained in East Anglia for the remainder of his life.[2] Unlike Varley and many others who drew on their early memories and reworked sketches of Welsh mountains long years after they had last seen them, Crome's art seems to have needed sustaining by constantly refreshed visual experience. The occasional appearance among his exhibits of subjects which must have been seen much earlier suggest the long delayed completion of a projected picture or the working up of a sketch to meet the exigencies of an Exhibition rather than the repetition of a formula. But the 'picturesque' was not confined to precipices and torrents, nor yet to ruined castles. It was a property of all things that belonged to the earth and which time had marked. In East Anglia, where there were no mountains, the true picturesque was to be found in old trees, in decaying cottages, in the sky, and in light on almost still water, things with no remarkable overtones of history or drama but which had nevertheless been transmuted for Crome and his patrons

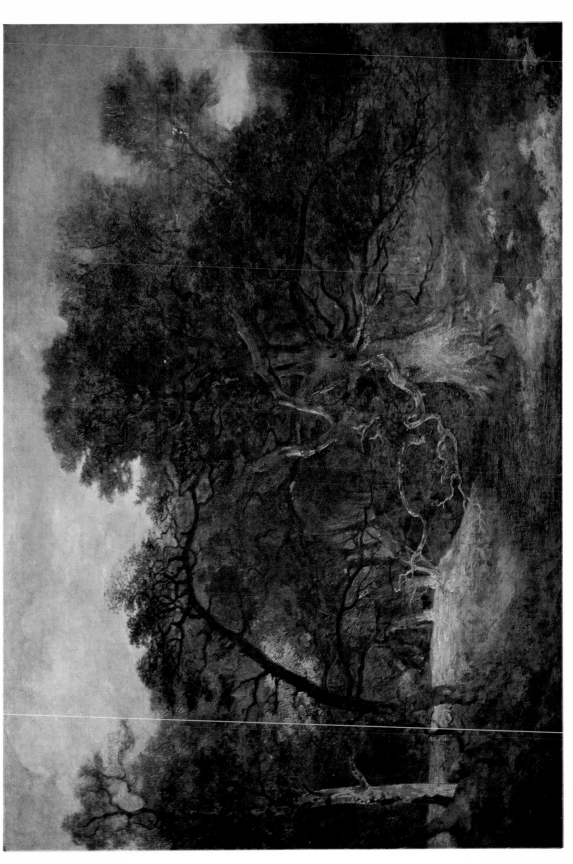

II. Woodland Scene near Norwich

(P 54) $34\frac{1}{2} \times 51\frac{1}{2}$

Mr. and Mrs. Paul Mellon

c. 1809–11

by childhood experience into symbols of life and happiness. Only in Holland had the apotheosis of ordinary everyday scenes and objects become the principal ingredient of a national art. It is to be found spasmodically in Italy and in Spain, in Germany in Dürer, and in France notably in Chardin. But in Holland in the seventeenth century the loving re-creation of delight in familiar things and happenings, Dr Johnson's picture of 'a dog I love', was raised at times well above the level of aides memoire or technical tours de force, to the condition of a unique expression of an important human experience.

So far it has been possible to follow Crome's life and work with scarcely any reference to the painters of the Netherlands. Indeed until about 1807 or 1808 on the evidence of the pictures of which we have knowledge, there is little justification for dragging in the familiar names of Dutch landscape at all. To speak of Ruysdael and Hobbema and Wynants and Cuyp before now would be to show hind-sight. Crome must have seen paintings by these men: they provided the background to much artistic experience of the time and to East Anglian middle-class experience in particular; almost certainly he must have absorbed early their air of realism and tried to emulate their technical devices, but we have no direct evidence that he did so.

At Catton Hall there was the small Hobbema which was later acquired by Dawson Turner and which, according to him, Crome passionately admired; but whatever happened later there was no direct sign by 1807 that he was aware of Hobbema at all.

There are, however, two Dutch masters without direct experience of whom it is improbable that Crome could have come so far. The first was Rembrandt. To those who conceive of Crome only as a painter of grove scenes in the manner of Hobbema it is difficult to comprehend the fascination which dramatic lighting held for him. Moonlights were common enough amongst the English pictures of the last quarter of the eighteenth century but Crome's moonlights bear no relation to the hard enamelled, colourless and cold pictures of Abraham Pether, or Wright of Derby, or of Opie himself.[3] They have a warmth of tone which, as in Aert Van der Neer, succeeds in suggesting colour in suppression. Crome exhibited eleven 'moonlights', as well as twelve pictures in which 'evening' or 'twilight' appear in the title. These crepuscular pictures are spread fairly evenly throughout Crome's exhibiting years, the first *Moonlight* appears in 1805 and the last in 1820, the first *Evening* in 1806 and the last in 1821. Because his son, John Berney, was a notorious moonlight painter there is a tendency to assume that all Crome 'Moonlights' are really the son's work, a short cut which has been responsible for an authentic Crome lying for some years misattributed in the cellars of the Tate Gallery.

It was Dawson Turner who drew attention to the relationship of Crome to Van der Neer when discussing *View on the River near Yarmouth* (now known as *Moonlight on the Yare*) (P 39, Plate 82b). 'This picture bears a considerable resemblance to some of the productions of Arnold Van der Neer; with the important difference, however, that instead of being a work finished with a remarkable neatness of pencilling, and with a touch extremely light, free and clean, it is more than commonly loose and sketchy. The subject is one that might have been selected by either Ruysdael or Van Goyen. To all these artists, as well as to many others of the same nation, Crome in his different works may not be unaptly linked. Indeed, born and educated in a county peculiarly distinguished by the flatness of its surface, and there having always lived, and there consequently formed his style, it is not wonderful that his productions should approach in their character to those of the School of our opposite neighbours upon the Continent. Mr Sherington of Yarmouth . . . has one that might really be mistaken for a Van der Neer.'[4]

Dawson Turner's dragging in of Ruysdael and Van Goyen is a clear case of hind-sight for really there was little relationship between these artists and the picture he was discussing. But it was not unintelligent hind-sight for all that, because of all the Netherlandish artists he might have hit upon to mention he picked out one whose influence Crome had certainly already felt. This was Van Goyen. Crome's *The Blasted Oak* (Plate 47) is interestingly paralleled by Jan Van Goyen's *Wooden Fence* in Brunswick. It is not necessary to believe that Crome had seen this picture, although he may have done so, because a theme once broached by one of the great masters of the Netherlands was commonly echoed, with variations, by contemporaries and followers until it became a standard type. Van Goyen's subdued near-monochromes, his occasional rough freedom of handling, the thinness of his pigment, and a relationship to Rembrandt's own rare landscapes, would have commended him to Crome. It is not possible to point to any particular Van Goyen which was at this time accessible in an East Anglian Collection but in both the sales of Crome's effects, that of 1812 and that after his death in 1821, there were Van Goyen etchings, and in the 1821 sale a Van Goyen painting as well.

These pictures of 1806 and 1807 sow confusion amongst those who would like to divide Crome's development up into Wilson, Opie, Gainsborough, and Dutch periods, for here in the space of two years it is fairly certain that Crome painted pictures which were indebted to all these (and possibly to others) and yet which remain Crome.

Looking closely at Crome's life one gets the impression that he delayed taking any step until he was ready for it, that he progressed by steady, almost

deliberate stages. Beechey's remark that he 'learned quickly' seems inappropriate for a drawing-master who did not exhibit until he was thirty-eight, but in fact he may have learned quickly, and thoroughly, one thing at a time. Simple facts about the organization of a picture and what to leave out he may have learned from Beechey; the bold handling of light and shade, the value of strong contrast, and the charm of things scarcely visible, Opie taught him and he will have seen in Rembrandt.* But with these lessons well-learned there was still much he could not do and the exhibition of 1806 suggests that one of those missing skills he now set himself to acquire. From this time on, in one form or another, studies of trees are rarely absent from his lists.

Dawson Turner, in his description of the *Cottage at Hunstanton*, hit upon a curiously persistent feature of Crome's early work: that he, known to be as great a painter of trees as Stubbs of horses, really does seem to have reached his fortieth year without having achieved a satisfactory tree formula. Richard Wilson, whose example dominated Crome's earliest struggles to become an artist, was not interested in trees. He never painted a good one. But nor was he interested in buildings, or rocks, or water, or clouds, or people. It was he who shocked Sir Joshua Reynolds by referring to some people who were walking about at Richmond as 'figures', which Reynolds took to mean statues for he could not conceive of living persons being thought of in this way.[5] Wilson, in fact, was interested in the unifying effect of light and air and the way in which this could be represented in a picture, but the *things* that the picture represented were no more than features in a landscape, stage properties to be arranged to advantage, not 'dogs that he loved'. While Crome was learning what Wilson could teach him it was enough that these things should be symbols, but once he had absorbed the art of making a picture he could pass on to making evident the reality of the thing from which the picture was made. This was what Wilson had never done, nor would ever have wished to do. It was towards this that the Dutch masters, Ruysdael, Hobbema, Cuyp, Koninck, Wynants, Wouerman, and Vermeer, pointed the way.

There is a story in John Burnet's 'Progress of a Painter' which is designed to point the contrast between Crome's practice and that of the usual professional artists of the time. A fictitious painter named Churchill says: 'I remember when I was staying at Cossey Park, painting the Jerningham family, a man used to come from Norwich to teach the young ladies to draw. One day they returned, I took up one of their sketch-books; there the trees from those in the park were captured sure enough; but it required no one from Norwich to

* Joseph Geldart claimed that a landscape in Munich which was shown as a Rembrandt was, in fact, by Crome.

teach them that. I put the book behind my back and with a few loose touches of a black lead pencil gave them an idea what a tree ought to be; they saw the difference at once and wished to take it downstairs to show to their master, who was dining with the steward, but I would not permit it. I am the last person in the world to hurt any poor man's feelings, so cut it out and put it in the fire.' Churchill had misunderstood the intention of Crome's young pupils in proposing to show their master the very type of drawing which both he and they were striving not to make.

The degree to which Crome was an open-air painter is debatable, it is, after all, impracticable to paint large pictures in a meadow. The same author in 'Landscape Painting' (1849) wrote 'I remember meeting my old friend Mr John Crome, of Norwich (some of whose landscapes are not surpassed even by those of Gainsborough) with several of his pupils, on the banks of the Yare. "This is our Academy", he cried out triumphantly, holding up his brush.' But even if we allow for the romanticizing of the 'natural' artist in the mid-nineteenth century there is no doubt that Crome not only guided his pupils to the direct experience of the scenes they sought to represent but constantly refreshed his own vision in the same way and came increasingly to value those painters of the Netherlands who had done likewise. It is the ever-present reflection of a first-hand visual experience which is the common denominator of all Cromes of 1806 and 1807 whether they relate to Opie, to Gainsborough, or to Wilson.

On 1 May 1806 Joseph Farington, R.A. called on a fellow Academician, William Daniell, who had already previewed the Academy's Annual Exhibition. Daniell told him that 'an artist from Norwich, Crome, excelled Reynolds in his own way'.[6]

Although Crome and his friends had determined to create in Norwich an ambience for artists and a market for their work, they did not therefore abandon the possibility of achieving some notice in London. Robert Ladbrooke had exhibited at the Academy in 1804 and it was natural that Crome, now that his friend Opie was Professor of Painting there, should attempt it. His two entries are catalogued in the usual unrevealing way as *Landscape*; one is credited to *Crome* and the other to *Croom* which can, if one wishes, suggest that he delivered the pictures himself, or that, at the least, they were handed in by someone who spoke the Norfolk dialect.

On opening day, 5 May, Farington went to the Academy Exhibition himself and met there two journalist art critics, Taylor of the *Sun* and James Boaden of the *Oracle* . . . 'The *latter* after looking round the room sd. He had

58

never seen so many bad pictures. On looking at Turner's *Waterfall at Schaff-hausen* He sd. "That is Madness"—"He is a Madman" in which Taylor joined.—In the anti-room, looking at an Upright landscape by Croom, Boaden said, "There is another in the new manner," "it is the scribbling of painting.—so much of the *trowel*—so mortary—surely a little more finishing might be born?" '[7]

The first of these comments looks back to Reynolds, who by 1806 had the status of an Old Master; whereas the other spoke of Crome's manner as being 'new' and likened it to that of the young madman, J. M. W. Turner. Daniell's remark was particularly discerning because Reynolds' few landscapes had never been widely known,[8] and he probably had in mind Reynolds' portraits. The notion that a portrait and a landscape painter could express essentially the same attitude should have been natural in the country of Gainsborough, but with the passing of years, had become less so.[9] Boaden's comment, on the other hand, that Crome's approach was new, was based on familiarity with the highly finished manner of those who painted as though Gainsborough and Reynolds had never been.

But whether Crome was correctly to be regarded as a revival of the glories of the past or as a flaming revolutionary, to be likened on the one hand to Reynolds and on the other to Turner was no inauspicious beginning to his first appearance in London.

[1] One reason for dating *The Yare at Thorpe* to 1806 is the signed and dated drawing in the British Museum. A drawing for a picture is exceedingly rare and, as Reeve pointed out in a letter to the Victoria and Albert Museum, a 'signed' drawing is particularly suspect. This drawing is right and the inscription may be also. (Plate 34a)

[2] On the basis of pictures exhibited it is assumed by Collins Baker that there was a visit to Derbyshire in 1811. There is no other evidence of this trip and it is likely that Derbyshire exhibits of that year were the delayed consequence of the visit five years before.

[3] A *Moonlight View of St Michael's Mount* by Opie was in the collection of Lord St. Levan. There is an engraving in the B.M.

[4] There was a Van der Neer in Crome's 1812 sale. The picture Dawson Turner referred to was *Bruges River—Ostend in the Distance* (Plate 104).

[5] Constable, op. cit.

[6] Farington, 1 May 1806.

[7] Farington, 5 May 1806. 'Trowel' and 'Mortary' does not imply use of a palette knife, which it is doubtful if Crome ever used, but refers to the open coarseness of his application of pigment. Again we are led back to Opie, for in a caricature by Gilray in 1797 he is shown with a trowel in his right hand, his palette, and a sheaf of extremely large brushes in his left, and issuing from his mouth in a scroll:

'Will it paint Thick and Fat, d'ye see?
If not, why D-n my E'. 'twon't do for me.'

Earland, p. 121.

[8] It is curious that a recent writer should have maintained that Crome's 'grand manner' was not at all like that of Reynolds. What he presumably intended to imply was that Crome admitted no histrionics. This is true, but the histrionics of Reynolds were generally superfluous to his essential grandeur.

[9] It is not unlikely that Opie, whose understanding of Crome was deepest, was originally responsible for the Reynolds simile when drawing attention to the pictures of his protégé.

CHAPTER FOUR

Cotman and the Change at Yarmouth
1807–1813

Few artists are uninfluenced by the ideas and examples of their contemporaries. When they are it is usually a sign of weakness rather than of strength, as though they dare not risk submerging the little vein of ore which is personal to them. In the interaction between men of true creative originality each takes what he can and makes it his own, but during the height of his enthusiasm what he does is visibly coloured by the man or the work that has caught his imagination.

When an artist lives in London he is likely to meet and to be on familiar terms with so many men of stature in his own profession that it is often impossible to distinguish what he has gained from an individual rather than from the common pool. In Norwich Crome had gathered about him many artists of talent and some with qualities rather greater than talent, but even the best amongst them such as John Thirtle were, and were acknowledged to be, his inferiors. It was because of this that Beechey at first and Opie later, men of established position, were important to him.

John Opie died in 1807 but for a year or two before that he had seen little of Norwich and the place he occupied on Crome's artistic horizon had been shared by John Sell Cotman. It was not that Crome would have acknowledged Cotman to be his superior, but he was certainly not his inferior. Cotman had neither been taught nor seriously influenced by Crome so that whatever he might have to give him it was not already Crome's own at second hand.[1]

Cotman (1782–1842) had been born in Norwich the son of a barber. The appearance of two landscapists of such calibre as Crome and Cotman in the same city at the same time is sufficiently remarkable, it is more remarkable that

both should throughout the greater part of their working life have kept, against the calls of London, that city as their centre. Opie, when Cotman's father asked him for advice about the boy's future, recommended that he should black boots rather than become an artist. Despite this discouragement Cotman went up to London in 1798 when the economic depression was being felt most keenly by the artistic community and very quickly succeeded in making his mark there. After working for a short time for Ackermann's, the print dealers, he was taken up by Dr Monro and admitted to the unofficial academy at which most of the leading water-colourists of the period were schooled. Like Turner and Girtin, both Monro School men, Cotman showed his quality early. Although fourteen years Crome's junior he exhibited at the Royal Academy five years before him, and by 1805 was already known in a world that had never heard of Crome. His future in London seemed assured yet in 1806 his unstable and enthusiastic temperament led him to make a remarkable decision, he left London and returned to his home city. In 1806 he showed twenty drawings at the Norwich Exhibition. In the following year he joined the Society and appeared at the Exhibition with nearly seventy entries.

It is not at first sight easy to be certain what effect the personality and competition of Cotman had upon Crome. It served, of course, to confirm the importance of the Society which Crome had founded and to underline the revived significance of Norwich as an artistic centre. But this was indirect. Directly we are concerned with the sort of artist Cotman was. He was a very individual artist indeed. Firstly he was a superbly gifted draughtsman, which Crome was not. Secondly, he was better educated than Crome and had a far wider intellectual basis for his art than Crome had. Thirdly, he was a mannerist, which Crome emphatically was not.

Already, even before Cotman's permanent return to Norwich there are signs that Crome had seen and been affected by his work. There is a drawing in the British Museum (Plate 12a) which can hardly have been produced by anyone unacquainted with Cotman of 1801 to 1805; and the water-colour in the Hansell Collection (Plate 13), is deeply impregnated with Cotman of 1803. As Cotman, even in his London period, spent Christmas in his father's house nothing is more likely than that he and Crome were acquainted well before his return to Norwich.

In general the peculiarity of Cotman's art, with the exception of a brief period at the beginning of his career in 1800 and at the end of it in 1841, consisted in an interpretation of the observed scene in terms of flat patterning. Like oriental painters he largely ignored the naturalistic use of shadow to imply

three-dimensional form but used it instead to link and point his shapes. The simplification of form and tone and colour which gave rise to this was common-ground between the two men. Cotman said 'leave out, never add . . . that is the way of the great men', and Crome would have supported him whole-heartedly. But Cotman left out and was fascinated by the strange world that resulted, his storm-clouds became shapes, his trees became shapes, his build-ings became shapes, sometimes indeed they became shapes which contained and re-created the emotion of the scene from which they were taken, but more often they achieved the sort of hallucinatory existence which is the world as the mescalin eater sees it . . . exquisite, full of wonder, but largely deprived of relevance. Crome, on the other hand, had no such vision. For him the beauty of a thing came from it as a part of man's life and experience, for him there was no reducing a tree into a pattern of branches, it was a thing which sprang from the earth and shed its leaves in winter and became rotund in summer, that the birds nested in and that he had climbed in. All these things could be re-captured and made real by art and this was the art he sought to achieve. He, too, cared for the pleasure of shapes and the subtleties of colour, but for him these were qualities which belonged to objects, derived their significance from objects, and lent their wonder to objects.

It must early have become clear to both that their art was of a totally different kind and that, though each might admire the other there was little that could be transferred. Cotman had the virtues and defects of a great mannerist. Crome's 'manner' on the other hand, consisted in the suppression of mannerism as though he were always striving to eliminate evidence of personal facility or idiosyncracy so that nothing should stand between the viewer and the picture.

Before his return to Norwich Cotman had worked only in water-colour, but when he found himself in the company of an oil-painter he began to use oils himself and his earliest, less well known paintings, contain much that he could have learned only from watching Crome. In water-colour the position was reversed, Cotman was the indisputable master and in his drawings of 1806 to 1812, the years when they were most together, it is difficult to be sure of anything in them of which Crome was the source,[2] whereas in Crome's drawings of the same period Cotman's influence can sometimes be traced.

It has been customary to write of Crome's water-colours as though they were inconsiderable, but there are a number of ambitious water-colours datable to this period which, grouped together, show the matter in a different light. Rare though they are, and uncommon as they even then may have been, they were not unknown in London. When in 1809 the Associated Artists in

Water Colours made their bid to compete with the Water Colour Society they asked Robert Dixon to obtain exhibits for them from several Norwich men, but especially did they ask for the collaboration of Crome.[3] Water-colours, because of the speed at which they could be produced were more susceptible to fashion—in the sense of almost annual changes of emphasis—than oils, and 1808 marked a distinct phase. By 1808 the high-keyed Chinese delicacy, a conspicuous feature of nearly all Cotman's drawings from 1801 to 1806, had given way to simply defined, broad areas, of dark, plummy, tones. This type of water-colour became very general throughout England from 1808 until about 1812. Cotman may have initiated it but it is more likely to have arisen in London from the need of the Water Colour Society to colour up to the golden frames and mounts which their laws required; certainly it is characteristic of many artists of the time, particularly John Varley, Luke Clennell, Prout and the Norwich water-colourist, Robert Dixon. Such drawings by Crome as *Old Houses at Norwich* (D 47, Plate 40) and the *Blacksmith's Shop* (D 36, Plate 37) are of this year.

But Cotman's influence on Crome was not confined to water-colours and although his oils bear the marks of Crome's influence some of Crome's own oils may perhaps reflect in turn the theories of Cotman. In several of Crome's paintings of this time there is a simplification of design, a reduction of form to outline, which is different in degree and almost in kind from that which he usually employed. The best known of these pattern paintings is *Moonlight on the Yare* (P 39, Plate 82b). In this the reduction of mass to outline is logical because the source of light is directly behind the landscape, but it is significant that none of the other moonlight scenes by Crome are conceived in the same un-modelled matter. Closest to this is *Wherries on Bredon* (P 47, Plate 84a) also in the Tate Gallery. This picture, at one time correctly attributed to Crome, was inexplicably re-attributed to Cotman and at present hangs in the Tate above Cotman's name. Apart from the similarity of colour and conception in these two pictures, which cannot be coincidental, although it might be explained if Cotman and not Crome were the imitator, the handling of the figures is typical of Crome and is quite unlike Cotman at any period. A third picture in which shapes again are used almost as abstractions is *Yarmouth Jetty* (P 42, Plate 80b) in Norwich Castle Museum. The clutter of objects on the beach, out of which the picture is largely composed, is resolved into a succession of almost flat shapes which are characteristic of Cotman but which occur in Crome chiefly at about this time.

The influence of Cotman upon Crome was short-lived; one looks for it in 1804 and 1807. Apart from the fundamental dissimilarity in their aims, the two men were temperamentally unlike and there seems to have been no warmth

between them. Cotman was intellectual, unbalanced, quick to take offence, and desperate for social acceptance. As Dawson Turner put it he 'offensively presumed' which Crome never did. The difference between them is strikingly revealed in a letter Cotman wrote to Dawson Turner in 1834, thirteen years after Crome's death: 'I deeply regret to find that Mr C. (John Berney Crome) fairly hinted it was a lost game to him. I deeply, deeply feel for him . . . My oft-told *dream* terminated with the success of myself and my family and the downfall (in plain English) of the family of Crome. There is at this moment a fearful appearance of its being verified to the letter, for my prospects are to all appearances blooming and fresh, and—I deeply regret to say—the prospects of the Cromes are blighted and unsuccessful. Frederick died wretchedly; Miss Crome is about to leave Norwich in debt; William has already left Norwich, for no one to know where, in wretchedness and, I am afraid, insane—and so considered by his family.'[4] It is some measure of the difference in character between them that it is impossible to conceive that Crome could ever have had such a dream, and difficult to imagine him blurting it out if he had.

Few of Crome's Cotmanesque oils survive; it is probable that there never were many; or, as they made an admirable foundation on which more profitable types of 'Crome' could be developed, this is what may have happened to them. Crome must have realized that the austerity of Cotman's vision was outside his scope. Moreover Cotman's work was not popular and Crome, never a mannerist, was especially unlikely to pursue another's mannerism if it did not pay. But Cotman's presence in the Norwich circle was a constant challenge and spur to Crome's determination to excel.

There is some indication that Crome soon after this time became in need of what in a commercial age is called a 'popular selling line'. The number of pictures Crome exhibited in each year from 1805 to 1820 does not vary consistently; some years seem to have been more productive than others but there is no pattern in it. Yet if we count the numbers in the Loan Exhibition of 1821 which were attributed to each year by the organizers we find a change takes place in 1814. Four pictures were given to 1808, only one to 1809, two each to the three succeeding years, and six to 1813. This last figure by itself would not be significant were it not that in the next year it shot up to twelve, and in the six years that followed fell only once below ten.

Of the 110 works at the Memorial Exhibition in 1821 as many as eighty-five were from the last eight years of his life. It would be wrong to assume that these figures show a disparity of output before and after 1813. Crome may, and probably did, paint more exhibition pictures in the last seven years of his life than at any time before, but he did not exhibit more pictures. There

are other possible explanations of the change. It may have been that those who chiefly bought his earlier pictures lived at a distance from Norwich, or were from a strata of society that was felt to be unapproachable by the organizers of the Loan Exhibition. Dawson Turner, for example, lent no pictures in 1821, although of the thirteen he at one time owned, several must have been in his possession at the time. Or it could be said that Crome's later work was more highly esteemed than his earlier and that those who lent the later although they possessed also the earlier, preferred to show their more recent acquisitions. If this is so we must seek an explanation in a change of manner in the artist. In fact there was a change, a change in the direction of greater finish, of more conventional construction, of less severe subject matter, and of brighter colour.

Evidence of the state of affairs in Norwich is to be found in Farington's Diary for 1812: 'Norwich is said to have suffered more from the decay of its manufactures owing to the want of exportation in these difficult times than any other town in the kingdom, and it has been lately proved that in consequence of the want of trade the population has lessened considerably within the last ten years.' There is no reason to suppose that this state of affairs was dramatically reversed in the immediately succeeding years, and although the end of the war with France reopened the markets and promised a restoration of prosperity, one would certainly not have expected a sudden upsurge of picture buying in the actual year of victory.[5]

Crome's accounts with the banking Gurneys show that in 1812 he was in their debt for over £220.[6] In September he held a three-day sale of his miscellaneous collections in Yarmouth. There is no auctioneer's name on the catalogue and it has been suggested that Crome wrote it and acted as his own auctioneer.[7] Nor is there a record of the result of the sale but only an unsubstantiated assertion made later that it realized between two and three hundred pounds.[8] It has been taken to show his unwillingness to expose his necessity that he chose to hold the sale at Yarmouth rather than in Norwich, but it may simply have been that the prospects of the market were at that time judged to be better there. None of his own works appear in the catalogue but there are 8 lots of books, 449 of prints, 40 of pictures. David Hodgson wrote long afterwards that Crome tried an exhibition of his pictures in Yarmouth which was a complete failure.[9] Some have tried to see this as a confused account of the 1812 sale. According to this story the pictures were sent by means of Hanks's water-transport and Hanks was paid for his trouble with a picture.*

* In 1821 Hanks loaned a Crome but this was attributed to 1819 in the Memorial Exhibition. In 1819 Crome could hardly have needed, or found time to arrange, an exhibition in Yarmouth. Yet it would be unwise to dismiss the possibility that some such attempt was made.

But the change of style, the abandonment of the grand scale of *The Slate Quarries* and *Carrow Abbey*, and the attempt at a more detailed, more generally appealing, but less monumental manner, pre-dates the Yarmouth Sale by at least two years. Typical of the work of 1810 is *The Beaters* (P 56, Plate 91b), *The Bridge in the Forest* (P 58), *Landscape near Blofield* (P 59, Plate 91a), and *Landscape with Cottage and Pool* (P 35). In all of which, working on a comparatively small scale, with minute touches of a laden brush—of which there are signs as early as 1806 in *The Yare at Thorpe* (P 28, Plate 73)—despite the increase in detail Crome preserves what Collins Baker happily calls 'symphonic breadth'.

Perhaps because it was thought that in the prevailing economic blizzard cheaply reproduced works of art might, like the woodcuts of the sixteenth century, spread fame wider and bring fortune more readily than unique, and necessarily expensive, paintings and drawings, several Norwich artists began to etch about 1810. Cotman's first publication, a folio of twenty-six miscellaneous picturesque views, appeared as a volume in 1811 when some plates had already been published separately (an uncollected plate is dated June 1810). Robert Dixon, one of the founder-members of the Society, published his *Picturesque Norfolk Scenery* in 1812. Some plates in this work are dated individually, the earliest to July 1810, a month after Cotman's first. Crome seems to have preceded them both, for his *Colney* (Plate 54b) is dated 1809. Of the remainder of his dated plates three are of 1812 and five of 1813.

Apart from their merit the striking feature of Crome's etchings (thirty-three in all, of which nine are soft ground) is the way in which the subjects differ from those chosen by Cotman and Dixon. None of them make use of the magnificent architectural remains which are the subject of Cotman's first series, and few of them are concerned with the picturesque cottages on which Dixon had concentrated and which Crome himself had often painted. Buildings when they appear, as they do most obtrusively in *Front of the New Mills* (E 5), have ceased to be of interest as buildings in the way that they are in Dixon's series, but have become landscape as trees and water and sky are landscape. For the most part trees and water and sky and the way in which they interweave and become one composite experience without losing their individuality is what these etchings of Crome are about, as it was increasingly what Crome's painting was about.

Crome's etchings were neglected by the critics until Sir Henry Studdy Theobald wrote on them in 1905. But they were not neglected by the public. According to Dawson Turner many of them were done in his house and he tells how Crome used to burst into his room crying 'What think you of this

Ruysdale?'[10] But it seems possible that Crome's own enthusiasm was tempered by some discouragement from his friends for although in 1812 he issued a prospectus and collected a respectable number of subscribers, there was no publication in his lifetime. In 1834 his widow published thirty-one etchings, of which seven were soft-ground, under the title *Norfolk Picturesque Scenery*. Of this edition there were sixty sets. The subsequent history of the plates is confused. Three years later in December 1837 an edition, but this time said to contain seventeen views only, together with a *Memoir* specially written by Dawson Turner and a portrait by Murphy, was advertised. It seems that, in fact, besides the sets of seventeen views (the sets do not seem to have been always of the same seventeen) other sets of the original thirty-one appeared and the title page was altered from the form advertised so that it could apply equally to an issue of seventeen or of thirty-one. How this was squared with the subscribers is difficult to understand. At some point, probably before this issue, the plates were altered.

Dawson Turner in his *Memoir* had veered between criticism and praise. 'Crome', he wrote, 'was singularly ignorant of the mechanical part of the art of Chalcography, and singularly unfitted by nature to acquire it. He had neither the patience nor the knowledge necessary . . .' Although Turner had intelligently explained that etchings were to engravings as sketches were to drawings, and that therefore a high degree of finish was not proper to them, he went on to write of the shock which the want of finish in Crome's etchings could not fail to cause to those who were unused to such things, and to admit that they were 'more than commonly unfinished.' This opinion of Turner's may have been responsible for the delay in publication. He appears to have convinced himself that had Crome lived he would have given them some 'last touches'; and as Crome had not lived he saw to it that the last touches were given.

The subsequent condition of these plates in the various issues which they underwent throughout the nineteenth century appear to be due to the engravers W. C. Edwards of Bungay and Henry Ninham of Norwich. Ninham hotly denied ruling the lines in the sky which ruined several of them, notably *Mousehold Heath* (E 3) and claimed that he had done no more than strengthen the lines where necessary.[11] Ninham was a sensitive artist and an experienced engraver, and his statement was probably true. The responsibility seems to have been that of John Berney Crome who, no doubt under pressure from Turner, indicated what alterations should be made. Edwards, whose hand wrought the damage, may also have had Dawson Turner prodding him into disastrous over-activity.

The etchings, as left by Crome, vary much in quality. Several of them are

scratchy little affairs which warrant the apologies Dawson Turner made for them. Others such as *Mousehold Heath* are sensitive and fine but these are the very ones which suffered most in their later and more familiar states at the hands of the improvers. Yet, though these are good, incomparably the best are the little group of soft-ground etchings (Plates 54a, 54b). This method, which has the advantage of being very similar in technique and in appearance to pencil drawing, was admirably suited to Crome and it is a pity that he did not persist in it. As it is this little handful represents the high-water-mark of the soft-ground process. Neither Dixon nor Morland approached their excellence and the soft-grounds of Gainsborough and of Cotman alone can rank with them. What Dawson Turner said in general praise of the whole series applies especially to them, that one could 'not fail to trace in them that happy feeling for genuine, unsophisticated nature which was the great characteristic of Mr Crome'.

The significance of these etchings in any attempt to trace Crome's development is great. Now at last we can see unmistakable signs of the passion for Dutch seventeenth-century painting which has been popularly supposed to underlie nearly all Crome's work but of which there is no certain evidence until this time. From the winter of 1809 until January 1813 we have dated evidence that to the names of Wilson, Gainsborough, Reynolds and Beechey, Rembrandt and Opie and Cotman, we must add as manifest influences on Crome's art Ruysdael, Waterloo, Wynants, and Hobbema. According to Dawson Turner it was Ruysdael whom Crome had in mind at this time, although, Ruysdael may really be allowed to stand as the type of Dutch seventeenth-century landscape painter.

Although Rembrandt, Van Goyen, Ruysdael, Wouverman, Waterloo, Wynants, and Cuyp obviously all attracted Crome's attention, the Dutchman who is generally credited with the greatest influence upon him was Hobbema. With few exceptions Hobbema is a hard and unsympathetic painter not quite in the front rank of the seventeenth-century landscapists and one must not lose sight of the possibility that some at least of the Hobbemas which Crome admired were by other men. Although we know of one genuine Hobbema which Crome knew well, it will perhaps be safest if we take Hobbema as a generic name for landscapes in which the glimpse of a distant scene is caught under and through a panoply of trees. Such a landscape contains the essence of romanticism, the sensation that there is, around the next corner or over the next hill, a valley at once of revelation and of eternal happiness. Soberly, prosaically, Crome permitted glimpses of a land which was at the same time strange because it was distant and familiar because it was known. There is little doubt that the Hobbema-type of Crome was of all his various styles the

one most popular in Norwich at the time, and no doubt at all that it has become the popular image of Crome since.

The effect of this intensive interest in the Dutch landscapists upon Crome's own painting is first seen in such pictures as *The Culvert* (P 24, Plate 71): this, despite a reminiscence of Opie in its chiaroscuro and its area of soft, warm darks, bears in the sky and in the golden illumination of its distance the distinct imprint of Ruysdael's example.

Crome's attempt to paint pictures with greater commercial possibilities, and his turning to the Dutch seventeenth-century landscapists as exemplars, may well have been urged upon him by Dawson Turner. Turner, despite his undoubted interest in art, sought to play a part in the lives of both Crome and Cotman not unlike that which Watts Dunton did in Swinburne's. His voice was the voice of sanity and worldly wisdom but it was not always the voice that artists wished to hear or were the better artists for hearing. From too frequent contact with this dominating personality Crome seems to have removed himself by the beginning of 1812.

On 6 December 1811 Cotman wrote to Dawson Turner: 'Crome, I think, is acting very wrong every way, and at some future time he may be sorry for it —should he propose bringing up his son to the same profession—for then by degrees he might have left it off to him'.[12] It is a fair inference that what Crome had in fact done was to give up the greater part, if not all, of his teaching practice in Yarmouth, and that in consequence Dawson Turner had applied to Cotman to take over the regular instruction of his daughters and to fill the gap in Yarmouth left by Crome's defection. Cotman's reluctance to do so he made very clear in the same letter '. . . I hope, with a steady perseverance, added to ambition to excel, to do something well worth having lived for. In short I think of nothing else, so much does it engross my thoughts and I have a dread of anything likely to take me from it.'[12] It seems not to have occurred to Cotman that if he dreaded the loss of time and creative energy involved in being a drawing-master Crome might equally wish to escape from it. Crome persisted in his intention, whereas Cotman was prevailed upon to abandon his and in 1812 moved to Yarmouth to take over the substantial teaching practice there, which, according to Dawson Turner might be worth £200 a year to him. If Crome withdrew from this connection it was apparently not because he felt able to give up the steady income from teaching but that, by eliminating the journeys to Yarmouth and replacing his income from that place with fees from teaching at the schools in Norwich, he had more time in which to do original work. We do not know when he became drawing-master at the Grammar School, but he was teaching there in 1813[13] and as he

was already at Miss Heazel's Seminary in 1811[14] it is probable that these appointments were partially responsible for his retreat from Yarmouth. Yet some institutional teaching there may have been even at Yarmouth for in another letter to Dawson Turner Cotman asks him about the nature of teaching there 'as I am a perfect stranger to teaching school-fashion ?'[12]

This was not the end of Crome's visits to Yarmouth for he continued a regular visitor to his favourite pupils in the Paget household[15] and on one occasion at least made a protracted stay with Dawson Turner himself. Turner wrote to James Sowerby on 5 January 1813: 'Mr Crome and his son have been for the last week staying at my house, both of them etching with an intent to publish their productions. I have stolen copies of all that they have yet done, and have much pleasure in sending you them, believing that you will agree with me that these two friends of ours promise to come nearer to Waterloo than anything the English School has yet produced.'[18] And again on the 17th he wrote to Sowerby: 'Mr Crome, too, is anxious to know what you think about his etchings. He has been at my house just three weeks, intent all the time on his new employment of etching, and more than once sitting up with me till two in the morning, without knowing or caring to know, how time went. His son has also determined in his own mind to etch on soft-ground picturesque views of all the Norfolk churches and I am in hopes he will find it a profitable undertaking.'[16]

Human motives are mixed and it is doubtful if economic considerations alone were responsible for the change in Crome's life, but his entry of four pictures at the Royal Academy in 1812, and the issue of a prospectus for his etchings in the same year, point to a determination to establish his reputation, not as a teacher, but as an artist.

[1] According to Henry Ladbrooke (*Dottings*) Cotman before he went to London was given some lessons by Robert Ladbrooke. They were probably of an elementary kind.

[2] The drawing of *Trees at Harrow* dated 1805 is distinctly Crome-like in vision, as is, perhaps, the beautiful Yorkshire scene at Edinburgh. But whether either really owe anything to Crome is less certain. The drawing by Cotman at Birmingham City Art Gallery (D 193) which has until recently been attributed to Crome is not in the least like a typical Crome but is slightly reminiscent of a Cotman-type Crome.

[3] Letters from Robert Dixon in the Album of the Associated Society of Water-colourists in the Library of the Victoria and Albert Museum.

[4] This letter is in the possession of Mr Palgrave Barker by whose kind permission it is quoted here:

'Jan 30th
Feb 1 1834

My Dear Sir,
 'As I have another opportunity of writing to you free—I will get rid at once of a perhaps silly subject and trouble you no more with my dreaming fancies . . .

'My often told DREAM*, terminated with the success of myself and family and the down-fall of (in plain English) the family of Crome—There is at this moment a fearful appearance of its being verified to the letter for my prospects are to all appearances blooming and fresh—and I deeply regret to say, on the other side, the prospects of the Cromes are blighted and un-successful. Frederick died wretchedly, Miss Crome is about to leave Norwich in debt. William has left Norwich, for no one to know where, in wretchedness and I am afraid, insane! and so considered by his family—My son Edmund the last time he saw him spent an evening with him at his lodgings in Bethel Street where Dr Lubbock lives—W. Crome very soon fell fast asleep, upon his awaking, he stared angrily around fixed his eyes full upon him and said "Who are you, I don't know you, sir, and with much abuse said I will throw you, you scoundrel out of the window", Edmund immediately threw all the liquors on to the ash-heap, defended himself, left him, called for his cloak, and sent the servant up to him. The next morning Ed. called to enquire how he did, and was told, quite well, and gone out to see his Mother, he has not since been seen or heard of.

'Everything is to be feared for Mr C. as far as pecuniary matters. He has spent two Evenings with me in considerable low spirits, and sad tales are afloat here about him, I most sincerely and deeply regret it, for I have ever found him a man strict to his honour and a man to be depended upon. May God in *his extremity* be to him what he has been to *me* and *mine*, merciful and kind—"for *man's* extremity is God's opportunity"—May this be verified to him, your kind-ness and Mrs Brightwen's to the family is well known, and may still be shown in favour of Mrs Crome who has just published her Husband's Etchings (about thirty in number)—for the benefit of herself. Her success at present is but very small, I think under 30 copies subscribed for—We have all known her to have been a most kind and affectionate honest Wife and Mother. In this hour of *her need* may she find that support the fate and genius of her Husband merit, from his once *many friends*—Crome *has not* canvassed the ground my son is about to take, not so, the other artists of Norwich!—even without the least communication to me on the subject!!! Shame be to them! With the greatest respect to yourself and family believe me to be My dear Sir. Your most obliged. J. S. Cotman. P.S.* Mr Barwell told me the other Evening that I re-lated to him more than a year before this termination to my dream, substituting as I did "one of the members of our order for the actual name of Crome".

'Mr J. Geldart Snr has seen and watched me narrowly two or three times a day since I have been in Norwich, dreading the effect of good prospects. He yesterday pronounced me *sane* and that I had only gained my *equilibrium*.

'I have seen Miss E. Rigby's, very masterly portraits, many of which I think most excellent —John goes with me, by the Magnet, on Saturday Evening—My address in Town, may be, till I have again the pleasure to write to you, No. 7 Old Burlington Street.'

[5] The present boom in all forms of collecting in a period of over-taxation, suggests a parallel. Given reasonable security and prospects of capital increase people are prepared to invest in productive enterprises. If their labour and risk are taxed beyond a certain point they give up trying and invest instead in the present—in leisure and in pleasure.

[6] Mottram, p. 122.

[7] Lugt 8238. The fact that Crome was his own auctioneer is attested by David Hodgson, a fellow Norwich artist who knew him well (Reeve p. 14). Among the more interesting (and surprising) objects in this sale were drawings by Rowlandson, Taverner, Gainsborough, Sand-by, Du Croix, Goltzius, Poussin, Bassano, Guercino, Rembrandt, and Raphael, and paintings by Borgognone, Salvator, Julio Romano, Lucas Van Leyden, Van Goyen, Both, Van der Neer, Mompert, three by Morland, 'Landscape and Cattle, fine' by Frost, and a 'Self-portrait' by Hogarth. It must not be forgotten that at this time attributions were commonly more optimistic than they are even today.

[8] Reeve, p. 22.

[9] Reeve, p. 22 in a printed account of *The Glade Cottage*.

[10] Turner, *Memoir*.

[11] Reeve, p. 23. A cutting from the *Norwich Mercury* of 4 December 1858 contains Ninham's disclaimer.

[12] Correspondence in the possession of Mr G. Palgrave Barker.

[13] Reeve.

[14] Collins Baker lists a pencil drawing *Pond and Farm Buildings* signed 'J. Crome 1811' (D 86) which is alleged to have been drawn as a lesson for the pupils at Miss Heazel's School. It was said to have been the property of Miss Gooding (b. 1800) one of the pupils at the School.

[15] Elise Paget, op. cit.

[16] Letters in the Dawson Turner papers at Trinity College, Cambridge, kindly communicated by Mr Warren Dawson.

CHAPTER FIVE

Crome's Patrons

In a letter dated 1861, Henry Ladbrooke, Crome's nephew and pupil, wrote: 'I fancy very much that if Crome were living he would often exclaim "Save me from my friends". He would not have liked so constantly to have his poverty thrust under his nose; indeed if Crome was a poor man, it was not the fault of the public. During the "Exhibitions" or rather at the close there was not a picture of his that had not the word "sold" upon it; and we have a right to suppose that he was satisfied with the price he set upon them. —Besides Crome's habits were not those of a poor man—he kept a good, rather extravagant, house and "lived like a fighting cock".'[1]

The tradition of the poor man who made good in the face of almost insuperable difficulties was partly the product of the Victorian imagination, but the foundation of it was laid by Crome himself. Dawson Turner in 1838 wrote 'privations which would have deterred the greater part of mankind were utterly disregarded; and on one occasion he was known to pawn his watch, the only article of property which he possessed. . . .' Crome, he wrote, had 'often told me that he was obliged to work for confectioners, painting Cupids, and Hearts, and Arms, on sugar-cakes to earn his daily bread', and was 'reduced to clipping hair from the tail of his landlord's cat as his only resource for supplying himself with pencils . . . and he had been glad to use his cast-off aprons, and on one occasion the ticking of his mother's bed, to supply his urgent need of canvas'.[2]

No doubt there were hardships, but Dawson Turner's concern about the pawned watch is pitched a little high, and the Crome who zestfully recounted his tricks as a doctor's boy would not have failed to enjoy painting decorations on iced cakes. As to the cat's fur, Robert Ladbrooke commented to his son, Henry, that, though they were certainly poor, Crome had clearly been pulling Dawson Turner's leg about the straits they were reduced to.[3] It is probable also

74

that the banker, writing in 1838 at the time of his estrangement from Cotman, and anxious to point the contrast between Crome's demeanour in the face of adversity and Cotman's periodic bouts of hysterical depression, would have been glad to exaggerate Crome's difficulties in order to emphasise the lesson he sought to teach.

Crome seems to have prospered quite early. The double-fronted house, 17 Gildengate Street, St Georges, in which he was living at the end of his life, was his address as early as 1802.[4] His regular income as a drawing-master must have been large. As well as teaching the Gurney family at Earlham, and the Jerninghams at Costessey, he also for some time taught Dawson Turner's own family at Yarmouth, and there were probably few houses of note within reach of Norwich at which he had not at some time given lessons. By 1811 he was drawing-master at Miss Heazel's Seminary at Norwich, and by 1813 when his eldest son, John Berney, was head-boy he held a similar appointment at Norwich Grammar School. Here, it was said, he over-sharpened the pencils so that his pupils would have to replace them—the profit on the sale of materials being his perquisite.[5] This sounds like Crome's own story. In addition to his income from teaching we know that he was painting inn signs as late as 1803,[6] and he may not have refused to do so later in life. In 1805, when his first employer, Dr Rigby, was Mayor of Norwich, he was paid £40 for cleaning and repairing the civic pictures in St Andrew's Hall, and an additional 7 guineas was allowed him to defray the expense of taking them down and replacing them;[7] and fifteen years later, in the year before his death, another bill of his for 12 guineas for cleaning pictures at St Andrew's Hall was allowed.[7] He also did some professional copying, for the City records show that he was authorized in 1813 'to copy a half-length of Charles Harvey Esq., M.P. from a picture in St Andrew's Hall—the picture not to be taken from the Hall.'[7] As there can have been little time for this sort of work it was probably exceptional and may have been done for his old patron, Thomas Harvey of Catton. Like many other artists Crome also bought and sold pictures for profit, although not on the scale of his friend Robert Ladbrooke who had become increasingly both dealer and copyist. Crome sold *A Rocky Landscape* by Isaac Moucheron for £12, and a *Vase of Flowers* by Baptiste for £13, both to Dawson Turner.[8] No doubt there were other dealings, for he bought heavily at auctions and not all that he is known to have bought reappeared in his own sales of 1812 and 1821.* He had two apprentices, James Stark and George Vincent, as well as less formal pupils

* Dickes (p. 126) quotes a sale catalogue of the Collection of John Patteson of Surrey Street, Norwich, 28th and 29th May 1819, at which Crome bought twenty lots for a total of £195. They included two Teniers for 100 guineas, and pictures by Rubens, Sebastian Bourden, Murillo, Zuccarelli, Hals, Van Dyck, Caravaggio, and others. A good haul.

such as his own children and his nephews, the Ladbrookes. From all of these he no doubt derived profit of some kind, perhaps only from their labour, but perhaps in other ways as well, for when Joseph Stannard's parents sought to have him apprenticed to Crome they were deterred by the fee of £50 that he asked.[9]

For his own pictures the prices, though not comparable with those of a successful portrait-painter in London, do not seem particularly low. Dawson Turner owned at various times at least thirteen Cromes, and we know what he paid for nine of them. Those bought from Crome himself:

Oval Moon	£ 7
River Scene, Moonlight	£ 7
Drawing	£ 5. 5s. 0d.
Holyoaks	£13

and those bought from the Rev. J. Homfray:

Grasmere	£ 8
Hunstanton Cottages	£14
Mousehold	£ 8
Cottages, 2 pictures	£ 7.[10]

Not all these pictures are recorded in Dawson Turner's *Outlines in Lithography*. *Cottage near Norwich* and *Clay Cottage* are probably the pair for which he paid Homfray £7 and which appeared as Lots 39 and 40 in Dawson Turner's Sale in 1852.[11] *Hunstanton Cottage* is no doubt the same as that illustrated facing page 23 in *Outlines* and sold in 1852 as Lot 33. *View on River near Yarmouth* (*Outlines* facing page 19), now in the Tate Gallery (Plate 82b) may, perhaps, be *River Scene, Moonlight* for which Crome charged £7. The remainder are not identifiable. A small oval *Moonlight* on card which has recently been on the market can hardly have been sold at the same price as the great *Moonlight* in the Tate Gallery and there is presumably a more substantial oval waiting to be found. Five guineas for the *Drawing*, though not particularly good, is certainly not a bad price; and £13 for *Holyoaks* suggests that there is an important flower-picture by Crome to be rediscovered.* The prices Dawson Turner paid to Homfray were presumably more than Crome had received.

According to Turner himself Crome towards the end of his life was getting between £15 and £50 for a picture.[12] Direct evidence of the prices he charged

* It is worth considering whether the admirable little panel of *Hollyhocks*, now in the Mellon Collection under the name of Constable, should be re-attributed to Crome.

is in a receipt given by him to John Bracey, Esq. 'for a painting' £15, dated 20 February 1815.[13] This is perhaps *Catton Lane Scene* (Plate 77). In 1880 the then John Bracey said that Crome had once painted a picture for his grandfather for which he had been paid £60, but that this same picture had recently been sold for £1,600.[14] Tradition of this sort is unreliable. The only recorded sale which would match this price at this date is of *Road Scene, Trees* sold in 1875 for £1,575; this was notoriously not by Crome, and may well have been not the Bracey picture either, even if the grandson thought that it was.[15] If in fact, Crome was paid £60 for a landscape (it may have been *The Beaters*) (Plate 91b) this was a good price and he is not likely to have exceeded it.*

The evidence shows that Crome was a successful man of business. He may have found poverty amusing in retrospect but he had no intention of returning to it. It is not surprising to find in the letter he wrote to his wife from Paris in 1814 . . . 'I shall make this journey pay. I shall be very cautious how I lay out my money,' (Plate 3). He seems usually to have made his journeys pay and though he, like Cotman, was a compulsive buyer at sales, he may have been cautious enough to make a profit at that too. The story that he once bought a load of old headstones from a graveyard which, as it discommoded them, his family persuaded him to sell, does not say what he paid for them, nor at what price he sold them.[16]

The employers of Crome as a drawing-master and the buyers of his pictures were not all of the status of the Gurneys and of Dawson Turner. Indeed it is curious to find that homes in which he taught seem rarely to have contained pictures by him. There is, for example, no record that Harvey ever possessed a Crome, and there is a letter from Richard M. Gurney in 1892 addressed to James Reeve in which he says 'It is very strange that though he for some years taught all the Gurneys and that so many of their sketches remain,—yet none of the family seem to have any of his pictures (those at Keswick were bought long after.)'[17] The reference to Keswick shows that this statement was not intended to refer to the Earlham branch of the Gurneys only, and it is certainly untrue, for *The Italian Boulevard, Paris* (P 83, Col. Plate III) was owned at the time of the Memorial Exhibition (1821) by H. Gurney, Esq., M.P., and a picture, now unknown, called *Hethell Hall*, was lent by J. H. Gurney, Esq. Furthermore the *Fishmarket at Boulogne* (P 98, Plate 114), which in 1821 belonged to Freeman, was already Gurney property by 1829.[18]

Any artist is to a considerable extent the creation of his patrons. Consciously or unconsciously he chooses the sort of people with whom he is best

* There was a payment into his account in 1812 for 50 guineas which is very likely to be payment for a picture, but the pictures Bracey loaned in 1821 were all later.

fitted to communicate and they, in turn, by their praise and blame, by support-ing or by deserting him, modify his output in the direction of their own need and capacity. This is particularly so in a man in Crome's situation. Had he become a London artist he would have found himself working for a largely anonymous clientele. Most successful men have had a few reliable patrons, a hard-core of support such as Turner had with Fawkes and Windham, men who bought largely from them, who trumpeted their merits, and whose opinions were likely to carry weight; but commonly their wares were bought off the Exhibition walls by strangers or by the most casual acquaintances, so that the influence of patronage became impersonal and grossly economic. If pictures pleased no one they did not sell. No one likes to have his creatures rejected, and few men like to starve and be ignored if they may instead be comfortable and praised. Crome's patrons, however, can rarely have been anonymous. He taught in their houses, in the very presence of the pictures he had sold to them, and no doubt the young whom he taught were transparent in their likes and dislikes of what he had done. Others he met in the streets while he and they were about their daily business; or in the taverns, where, at the simplest, he would have heard frank statements of what in the latest exhibition had pleased or had disgusted. Criticism of this sort has a deflating effect upon pretentious-ness.

Dawson Turner, in a burst of local patriotism (a strong force at the time when Nelson was still 'the Norfolk Hero'), listed the great collections of the county, those of Holkham, Rainham, Didlington, Wolterton, Langley, and Narford; but he mentions no Cromes belonging to them. Nor were there any pictures by contemporary local artists in the collection formed at this time in Yarmouth (upon 'expert advice', that very unreliable criterion which is still so much with us) by a Mr Penrice who, in less than thirty years, spent nearly £25,000 on pictures and retained them all.[19]

The patrons upon whom Crome depended were chiefly of another sort. The greatest of contemporary patrons, Lord Stafford, had by 1829 become the owner of a *View in Postwick Grove*.[20] Although at first this seems an isolated instance of a great national connoisseur trespassing upon what was, very largely, an East Anglian preserve Stafford had, in fact, a seat at Costessey near Norwich. In the Memorial Exhibition there were three pictures lent by Lady Jerningham of Costessey Park. Crome we know, taught there. But this was exceptional, there are no other names of equal social prestige.

The truth is that the patrons of Crome were of another sort. Harvey and Dawson Turner and the Gurneys were new men compared with the titled owners of Holkham, and Rainham, and Costessey, but those who bought

Crome's pictures so eagerly at the Annual Exhibitions, and who bespake them in such numbers that, in the last years of his life he had difficulty in meeting the demand were, for the most part, newer men still.

When Joseph Farington went to Norwich in 1812 he was visited at his inn, the Angel, by a stranger whose name Farington gave as Coppinge. Farington was often a little astray with proper names, for this was probably Daniel Coppin who, though Farington does not mention it, was an old friend of John Crome.[21] Coppin, knowing that Farington had been a pupil of Richard Wilson, wished to show him some pictures he owned. To Farington's surprise, at Coppin's house, where they were joined by a Mr Sprat, he found a three-quarter size landscape by Wilson which had been painted for the 'late Lieutenant Governor of Landguard Fort, Mr Singleton, who paid Wilson for this, and another picture of the same size 50 guineas.' After Singleton's death his collection had been sold at Christie's where Coppin had paid 120 guineas for this one picture alone. Coppin then showed Farington a second Wilson, which had been painted for Sir Peter Leicester and which Coppin had bought from Sir John Leicester. The price was not mentioned. A third Wilson was displayed, a sketch which had belonged to John Inigo Richards, R.A., the late Secretary of the Royal Academy, for which Coppin had paid 30 guineas. He then produced a picture by one of Wilson's pupils, William Hodges, R.A., and finally, to Farington's astonishment, a very early work by Farington himself which 'Mr Coppinge had placed . . . in the centre of the room, and on Hinges for turning it to the best light . . . Long as my intercourse with Artists and Amateurs has been, I have not met with anyone who appeared to be more devoted to works of art and to have more genuine pleasure from contemplating them.'

Coppin told how his wife, like himself, had been passionately fond of pictures, and had copied several, but that eighteen months before she had begun to go insane and had only died in the previous month. 'He told me that during the time His mind was deeply affected, He had found His greatest relief in retiring to his room and placing His pictures before Him, and for a long time together, contemplating the beauties He saw in them.'

Farington ends his account of the episode with this comment: 'It might surprise many were they told after such a relation of so much tenderness, of attachment, and it may be said, refinement of taste, that Mr Coppinge is a man in trade, a House-painter and Glazier. His whole appearance, however, corresponded with His sentiments, and His manner were proper for any Society. Mr Sprat is a Coachmaker at Norwich, and very much a lover of the arts. He showed me several pictures which He had collected, the works of modern artists.'[22]

79

Men like Sprat and Coppin were the hard-core of the Norwich Society and typical of the patronage Crome had to look to if he were to survive as an artist in Norwich. Coppin had shown nine pictures at the first Exhibition in 1805 and became President of the Society in 1816. Sprat was Secretary to the Society in 1816. There is no record that Coppin ever possessed any Cromes, though he can hardly not have done so, but Sprat was the biggest single contributor to the Loan Exhibition of 1821 with nine pictures which ranged in date from 1796, *Composition: style of Wilson*, to 1820, *Trees near Earlham*, one of Crome's last works.

Some of those who lent pictures in 1821 and who presumably bought them directly from Crome, are now no more than names. Of the others of whom something is known, the biggest lender after Sprat was Mr Samuel Paget with seven pictures. If we add to them the picture lent by his wife, and five lent by his daughter, the Pagets seem to have been the owners of the largest group of Cromes at that time, though others later had more. The Pagets lived in a large house on the Quay at Yarmouth, not far from Dawson Turner. Crome was a frequent visitor there and Mrs Paget and his daughter were his favourite pupils. They kept ready for him a spare room with a very high bed on to which he used to say he could only arrive by taking a flying leap from the fireplace. Paget's granddaughter tells that Crome was 'particular about his pencils, liking large soft leads, which he had specially made up in cedar for himself, with his name marked on each'. The Pagets, according to the custom of the time, kept an Album for their friends to sketch and write in. This was familiarly known as 'The Receiver General'. On one of his last visits in 1821 Crome yielded to persuasion and did a tiny sketch in 'The Receiver General'. 'There,' he said 'I have done for you the smallest drawing I ever did in my life'. The house on Yarmouth Quay was full of pictures and Elise Paget records that their visitors always picked out the little canvasses by Sharp, Morland, and Ward but never noticed the Cromes.[23] Only one of the Paget pictures, *Back of the New Mills*, is attributed to a date as early as 1806, of the other twelve the first is 1812 and the last 1819, all but one dating from after the time when he gave up teaching the Turner family.

By the time Dawson Turner published his *Outlines in Lithography* (1840) a collection limited to Cromes had been built up by James Sherrington. To Sherrington have been traced the titles of seventeen pictures and thirteen drawings. The seventeen included some of the most famous pictures that Crome painted. Sherrington was an ironmonger at Great Yarmouth and an amateur artist who had become acquainted with W. J. Müller whose style he imitated.[24] We do not know whether he bought direct from Crome, or indeed

whether he owned any Cromes in the artist's lifetime. Sherrington's widow married Dr Caleb Rose of Lowestoft. The bulk of Sherrington's pictures had been sold before 1858 but the residue, largely drawings, was sold as the collection of Mrs Caleb Rose in 1908. (Appendix G.)

Another considerable owner in 1821 was a Mr Stone who lent six pictures. Francis Stone contributed to the Exhibition of 1805 and later became County Surveyor for Norfolk. He did a series of *Bridges of Norfolk* in water-colour which were engraved by David Hodgson and published in 1833. One of the Cromes owned by Stone is said to have been *Hautbois Common* (P 126) now in the Metropolitan Museum in New York.

A Mrs de Rouillon, formerly a Miss Silke, lent five pictures. She and her husband, who was probably Swiss, taught French and kept a school in Norwich called 'The Chantry'. They published several grammars and school books for French students.[25]

The Rev. E. Valpy, who had officiated at Crome's marriage in 1792 and later became headmaster of Norwich Grammar School when Crome was drawing-master there, lent two pictures; and Mr Freeman, a personal friend of Crome, and a frame-maker in the city, lent four. The Rev. J. Homfray of Yarmouth who sold several Cromes to Dawson Turner, lent two; the Rev. Wilson of Kirby Cane lent two; and the Rev. J. H. Browne lent one. This Mr Browne was of the family in which Crome's sister was cook. Medicine was represented by the loan of *Carrow Abbey* (Plate 67) from P. M. Martineau; and an unidentified *Landscape* from Mr R. Steel, a surgeon, whose sister was married to William Henry, Crome's third son. Mr E. Sparshall, who lent *A Landscape*, was a wine-merchant to whose son Crome taught drawing, and whose wine Crome drank. His account for wine in 1803 exceeded the contra for instruction and the supply of paper and pencils so that Crome had to settle the difference. There was another bill to Sparshall in 1812 for £5. 10s. 9d.; and it may be that yet another was settled in 1818 by the transfer of a canvas.[26] Edmund Girling of Yarmouth, who lent three pictures, was a bank-clerk and an amateur etcher. Mr Barnes, who lent two was a friend both of Crome and of Freeman and was Honorary Secretary to the Norwich Society in 1819. J. Geldart junior, the son of a wine merchant, who later became an artist of some achievement, lent one. The Stark family lent four between them.[27]

At least two patrons lived farther afield in Suffolk. The well-known *Glade Cottage* belonged to Bernard Barton, the Quaker poet of Woodbridge near Ipswich;[28] and Thomas Churchyard, a lawyer and amateur artist from the same small town, owned no fewer than twenty Cromes when he died in 1866. How many of these were bought in Crome's lifetime there is no record

but work by Churchyard which is thought to be early and which preceded his Constable manner is manifestly derived from Crome whose pictures he frequently copied.

Although no doubt some of Crome's output went to strangers by far the majority of it was in the hands of men and women whom he knew personally, whom he saw frequently, and who were as familiar with the subjects which he painted as he was himself. It is, perhaps, this quality of a common knowledge and understanding which is one of the sources of difference between Crome and Constable. The Suffolk man loved and painted over and over again his boyhood neighbourhood so that it became known as Constable Country; but he sold his pictures to men who did not know it, who saw it as typifying English rural scenery of a certain sort, whose love for it was generic and not specific. It was this circumstance of Crome's working life which was perhaps more responsible for the essential similarity between his work and that of the seventeenth-century Dutchmen than any direct borrowings he made from them. The buyers of Vermeer's pictures knew and lived in Delft, it was their Delft he painted, and he painted it differently, knowing that they knew it, than he would have done had he been painting for an anonymous market in Birmingham or Buenos Aires. *The Views of the Beach at Scheveningen* by Ruysdael and Cuyp were as familiar to the men and women who owned them as *Yarmouth Jetty* and the *Back of the New Mills* were to the local connoisseurs of Yarmouth and Norwich.

[1] Reeve.

[2] Turner, *Lithog.*

[3] Reeve.

[4] The Directory of 1802 lists him as Master of Drawing of this address.

[5] Reeve.

[6] Reeve, p. 20 for Crome's receipted bill for that year.

[7] Reeve, in forefront of his Album where he gives copies from Minutes in the Committee Books in the Norwich Corporation Muniment Room.

[8] Turner, *Lithog.*

[9] Reeve.

[10] These details have been kindly supplied by Mr Warren R. Dawson from a Note in the Dawson Turner Papers. Not only does the Note not cover all the pictures included in *Outlines in Lithography* but it omits *Lane Scene near Catton* which was engraved by R. Girling as being in Dawson Turner's possession and which later passed to Turner's daughter Mrs Gunn.

[11] Lugt 20830.

[12] Turner, *Memoir.*

[13] Reeve, p. 25.

[14] Reeve, p. 25. Letter from John Bracey.

[15] Catalogued by Collins Baker as *Road through Forest* and in 1921 in Lord Hillingdon's collection.

[16] In Crome's bank-book on 31 December 1815 he had £838. 9s. 3d. to his credit. *Morning Post* 12 April 1921.

[17] Reeve, p. 14.

[18] See, however, the discussion of this picture in Chapter Seven.

[19] Turner, *Lithog.*

[20] This is presumably the *Postwick Grove* in the 1821 Memorial Exhibition which was lent by Mrs de Rouillon. If so it cannot well be the *Postwick Grove* (Plate 112) now in Norwich Castle which can reasonably be identified with the sketch in John Berney Crome's Sale of 1832. This can be traced from a Miss Mack (1878) to its present home, but there is no ground for the assumption that Miss Mack's picture was also Mrs de Rouillon's. The argument that there were at least two *Views in Postwick Grove* is further supported by the fact that in the 1821 catalogue Mrs de Rouillon's picture was said to date from 1816 (the date given to Lord Stafford's) and that the sketch in Norwich Castle is almost certainly of a similar date.

[21] The name as Farington gives it 'Coppinge' is still to be seen on a Norwich shop front.

[22] Farington, 16 August 1812.

[23] Elise Paget, *John Crome* in *Magazine of Art* V, p. 221.

[24] Biographical Note in Norwich Castle. There is a fine copy by him of *Road with Pollards* in a private collection in Bristol. We are indebted to his descendant Mr C. E. Sherrington for the information that the collector's name was 'James' and not 'Joseph' as given by Collins Baker.

[25] The grammars and school books were published at various dates between 1814 and 1840. Nearly all the publications have just Mr or M. de Rouillon, without forename on the title page. A translation of 'Peter Schleminl' from the German of Adelbert Chemiser was published by Emilie de Rouillon—no date, and also by her, a translation of Tasso's Jerusalem 1836. 'Mr de Rouillon' produced a 'Tourist's French Companion', of which the 2nd edition is dated 1816. Blyth's 'Norwich Directory' 1842 under Boarding Schools lists Mr de Rouillon, The Chantry, (Theatre St.) Norwich. There was a brief obituary in the *Norfolk Chronicle* for 15 July 1841; died at the Chantry, Norwich Monsieur de Rouillon 'an ancient professor and teacher of French, and extensively known as the author of several grammatical and other useful literary works'. This information was kindly communicated by Mr Philip Heyworth, Norwich City Librarian. It is perhaps a long shot but may it not have been through the de Rouillons that Nägler discovered Crome so early?

[26] Reeve.

[27] The Catalogue leaves blank spaces below the names of lenders. These have been, and were intended to be, interpreted as ditto signs, but there is clearly room for error.

[28] Barton at the time owned four Cromes including *Hethell Hall*.

CHAPTER SIX

The Last Seven Years
1815–1821

In 1814 James Stark, who had been apprenticed to Crome for three years, removed to London. On 3 July Crome wrote to him from Norwich:

'Friend James.—After a pleasant ride we arrived at Ipswich at five, we went down by the river side made some few sketches. One scene John sketched I think will make a good subject for his large picture. I cannot think the river Orwell will pay you the trouble and expense of a journey. John and myself set off in the vesell with ye tide on the next day morning at half past eleven reach'd Harwich in the evening at five a river twelve miles long, the first four or five miles both sides beautifully wooded but not accompanied with shipping as I expected however when you are at Ipswich it amply repays you the trouble and expence as your fare is only one shilling the men in the vessell are very civil our crew amounted to about twenty with room enough for a hundred which made it very pleasant we returned at night at about eleven setting off at about seven so you find our time was but two hours at Harwich that we dedacated to our mouths and seeing the wall as they call it, it is a sort of round Batterye with a deep fossee in the centre of this vat (for that its like) are all the rooms for the different stores officers etc., so that it is altogether a wonder. I think James if you could study near town it would be much better and less expense. I think you may make some good water scenes without going too far for them.

'My best wishes attend you, *pray paint*.
'We are all well I am brewing up something.—
 'Yours etc. etc. John Crome.
'P.S.—Pray don't forget the Norwich Room'.[1]

On 19 April there had been a Grand Festival in Yarmouth to celebrate the

downfall of Napoleon. Eight thousand and twenty-three people sat down to a meal on Yarmouth Quay and consumed 6,844 lb of Beef (all Prime Pieces) and appropriate amounts of Suet, Raisins, Loaves, Ale and Tobacco. A Souvenir Narration of the occasion with etchings by John Sell Cotman was published. The names of many of Crome's patrons were in the list of subscribers but it does not appear that Crome himself took part.[2]

The fall of Napoleon, whose life-span was so nearly coincident with his own, did however have one immediate effect upon Crome's life. In 1814 he took the uncharacteristic step of crossing the Channel to see the looted pictures in the Louvre. He travelled in the company of two fellow-members of the Norwich Society, William Freeman and Daniel Coppin. Coppin whose daughter later married the Norwich artist, Joseph Stannard, was probably that enthusiastic owner of Wilson's pictures who had so impressed Farington two years before. Freeman was a frame-maker and dealer through whose hands passed a number of Cromes, one of them the outcome of this very trip.

The French journey gave rise to the second of the four extant letters from Crome which are so important for our understanding of the man and his ideas about art. On 10 October he wrote from Paris to his wife: 'Dear Wife,—After one of the most pleasant journeys of one hundred and seventy mile over one of the most fertile country I ever saw we arrived in the capital of France. You may imagine how everything struck us with surprise; people of all nations going to and fro—Turks, Jews, etc. I shall not enter into ye particulars in this my letter, but suffice it to say we are all in good health, and in good *Lodgings*—that in paris is one great difficulty. We have been at St. Cloud and Versailes, I cannot describe it in letter we have seen three palaces the most magnificent in World. I shall not trouble you with a long letter this time as the post goes out in an hour, that time will not allow me was I so disposed. This morning I am going to see the object of my journey that is the Thuilleries I am told here I shall find many English Artist Glover as been painting I believe he has not been copying, but looking and painting one of his own composition, Pray let me know how you are going on giving best respects to all Friends I believe the English may boast of having the start of these Foreigners in many things—but a happier rase of people there cannot be. I shall make this Journey pay (. . .) I shall be very cautious how I lay out my money I have seen some shops they ask treble what they will take, so you may suppose what a set they are I shall see David tomorrow, and the rest of the artist when I can find time I write this before I know what I am going about at ye Thuilleries as the post compels me.

'I am, etc., yours till death,
 'John Crome.

85

'Mrs Coppin will give you our address If you have anything to write but If not let her say in her letter how you all are.'[3] (Plate 3.)

It comes as a slight shock to find Crome writing of David and shows the extent to which he is connected in one's mind with the world of Gainsborough and Reynolds and Ruysdael, rather than with European neo-classicism and its aggressively parochial air. Glover's meticulous near-Arcadian landscapes seem to belong to yet another world still, although one more closely related to David's than to Crome's.

We know certainly of three pictures which derive from this visit, the only three pictures with continental titles that were exhibited in Crome's lifetime. The first, *View in Paris—Italian Boulevard* (Colour Plate III) was in the Norwich Society Exhibition of 1815 and has the distinction of being the most certainly authentic and datable of Crome's paintings. It is reasonable to suppose that it was done while the excitement of the trip was still with him and the impressions of it still vivid. It was, perhaps, also the fulfilment of his promise to his wife 'I shall make this journey pay'.

Although the *View in Paris* is one of the very few pictures which even the most sceptical cannot doubt and still be regarded as sane, it is in several ways an unusual picture for Crome in as much as it is more full of incident and is finished in more detail than any other large surviving painting by him.

It is clear from the majority of Crome's pictures, drawings, and etchings, as well as from the evidence of Dawson Turner, that he was impatient and unwilling to spend much time and energy on high finish. The principles he had absorbed from the tradition of Reynolds and Gainsborough and Wilson, the lessons he had learned from watching Beechey and Opie, all reinforced a natural tendency to work freely. This was, however, contrary, then as now, to the great mass of uninformed taste. The quality of high finish is easily recognized by the least well-trained eye, a smooth surface and clearly delineated detail provides a criterion which all but the blind can recognize—the criterion of controlled manual dexterity. This same demand for greater finish had been made to Gainsborough and to Wilson themselves and although the breadth and freedom of the great Venetians continued to dominate informed taste until about 1810 the widening of the basis of patronage led to the cultivation of qualities which the untrained eye could comprehend. What was increasingly happening by the second decade of the nineteenth century was a revolution of patronage whereby the majority of purchasers were without the background of travel, training, and experience which had been the birthright of the landed classes and which would, had they possessed it, have tended to establish the new men in the great tradition of taste. As a class the new patrons had learned

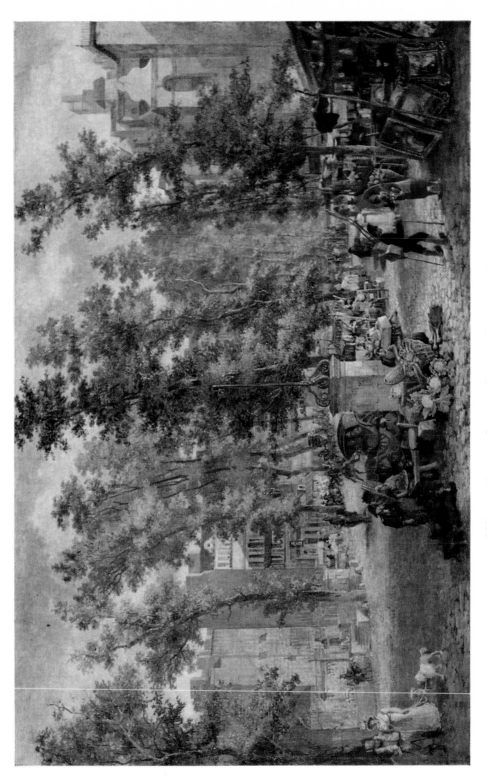

III. View in Paris – Italian Boulevard

$(P\,83)\ 21\frac{3}{8} \times 34\frac{1}{4}$

1814–15

Quintin Gurney Esq.

to depend for their very existence upon mechanical efficiency and hard work, qualities which they looked to find reflected in the pictures they bought. As dexterity came a great deal more readily to many artists than either perceptive vision, imagination, or passion, they readily fell in with the requirements of the market.

In many of Crome's finest pictures such as *Carrow Abbey* (Plate 67), *Mousehold Heath* (Plate 111), *The Slate Quarries* (Colour Plate I) all that the picture contains is subordinated to one timeless visual experience. In others such as *Yarmouth Jetty* (Plate 81b) and *Pockthorpe: Boat and Boathouse* (Plate 95) there is a strange unemphatic laying out of ingredients like a military kit inspection, so that apart from the unified impact of the picture (or is it really 'apart from'?) we are involved in a passionless progression amongst objects which we tick off in our minds with Olympian detachment. It is probably this sense of detachment which is a large part of such a picture's mysterious appeal. Here is a river-bank, on it is a shed, a plank, a tree, a man, an impersonal array of things, no one thing more important than another, merely there, bleakly illumined, raw material which the mind normally grasps and integrates in the personal conflict we call life but which now it rejects, keeps at arm's length, treats as a percept only, exterior to ourselves.

In these two pictures there is little finish and little intrusion of detail but in *View in Paris* where there is a similar accumulation of incident, the pump, the picture-stall, the pedlar, the cuirassier and his lady, and so on, the finish is higher and we are no longer kept at the same aloof distance from the scene. The subject was one which Crome had not attempted before. There is nothing particularly original about the genre which reaches back through Watteau's *Fêtes Champêtres* and their infinite brood, to the village scenes of Teniers and to Breughel. Gainsborough in his *Walk in the Mall* had done something of the same sort and, amongst English water-colourists such drawings as Edward Dayes's *Buckingham House* were not rare, indeed there was an admirable example nearer home in Cotman's *Norwich Market Place* which had hung in the Society's Exhibition in 1807. Crome applied his own peculiar quality of accidental naturalism to the scene. This is not a glimpse into a holiday-world-that-never-was in the manner of Watteau and Gainsborough, nor a pattern of shapes as with Cotman, nor a comment on the comedy of manners as in Hogarth's *Calais Gate*, but a scene in which the people and the trees, the buildings and the market-stalls, unite to become an object for delighted contemplation. It is the visual equivalent of 'but a happier race of people there cannot be . . . they ask treble what they will take, so you may suppose what a set they are'.

View in Paris was also a departure for Crome because it contained a large number of figures. In common with all landscapists Crome had staffed his pictures in a perfunctory sort of way though less perfunctorily than, for example, Wilson. The purpose of his figures was, like theirs, to provide accent and scale but it was also rather more than that. John Wodderspoon quotes Crome as saying: 'The man who would place an animal where the animal would not place itself, would do the same with a tree, a bank, a human figure—with any object, in fact, that might occur in Nature, and therefore such a man may be a great colourist, or a good draughtsman but he is no artist.'[4] Crome's figures were designed to combine with his subjects in such a way as to give a coherence which is at the same time accidental and inevitable. But although his peasants, his blacksmiths, his sheep and cattle, are an active and credible part of the landscape to which they belong, they, like the trees, or the sandy banks, or the sky itself, are generally no more than a part of it, they are not the reason for it being there at all.

Crome's painting of staffage is uneven. It is true that the best artists of the time were often incredibly bad at the human figure, so bad that one would like to believe that Crome, Cotman, and J. M. W. Turner all exaggerated the falsity and inadequacy of their drawing in order not to beguile the viewer's eye from the landscape which was their subject, but Crome alone of the three went astray in scale. The two giant figures in *Yarmouth Jetty* (Plate 78) are quite inexplicable; and the coracle and its occupant in *Gibraltar Watering Place* (Plate 64) is only one example, one of many which might have been chosen, to show how oddly wrong he could make such things appear. It could be said that all the care in the world in selecting the right figure and putting it in the right place is wasted if the figure is flat, lifeless, and incredible because of its improper size. But, in fact, Crome's figures are not uniformly bad, so that it sometimes seems that we are left with the bald choice that the bad were painted by Crome, and the good by other more competent figure draughtsmen such as Michael Sharp. But the reverse may be true and is sometimes more probable; certain good figures are clearly from Crome's hand and show no trace of having been inserted in the landscape by another; whereas some of the bad figures look as though they had been laid on by an amateur owner to 'dress' a landscape felt to be bare. We believe that in a few cases Crome, to whom figure drawing did not come naturally, worked out his figures in careful sketches before applying them to his landscape, whereas his more usual practice was to throw them in hastily with the minimum of effort or to leave them out altogether.

The second picture deriving from the French trip *The Fishmarket at Boulogne* (Plate 114), which also contains more figure interest than usual, has a slightly

curious history and it may be that Crome had some difficulty with it. It was not exhibited until 1820 when it appeared as *The Fishmarket at Boulogne, from Sketches made on the spot in 1814,* and was then described by a contemporary critic as a 'little picture . . . of unequal execution . . . producing the impression of a sketch'. It was exhibited again in the Memorial Exhibition of 1821 as belonging to William Freeman, the picture dealer, and evidently did not pass into Gurney hands until a year or two later. 'Little' is, of course, a relative term and certainly by 1820 John Berney Crome and George Vincent were exhibiting much larger canvasses than this; nevertheless by Crome's standards this is not a 'little' picture. Nor is it notably unfinished or sketch-like; it is, if anything, rather more smooth in finish than usual and it is possible that the picture as we know it was carried somewhat further after the exhibition of 1820. Crome's delay in exhibiting the subject may have been due to his awareness of difficulties not fully surmounted. *The Fishmarket* is not a picture held in one unmoving grasp of the eye, a sort of monolithic experience such as *The Slate Quarries*, it seeks rather the passionless accumulation of fact of *Yarmouth Beach*. It is, however, more difficult to regard human beings as objects exterior to ourselves than it is to see boats and anchors and carts in this way, and in order to achieve the necessary remoteness Crome removed the principal group to the middle distance where it is neither close enough to be resolved easily into individuals nor far enough to coalesce into a mass. As a freely painted sketch it might have succeeded but as it now stands the attention to detail is greater than the comprehensive nature of the construction demands and less than can give interest for its own sake.

In the third continental picture Crome exercised himself in a manner to which he was already well accustomed, this was *Bruges River—Ostend in the distance—moonlight* (Plate 104) exhibited in 1816. Were it not for the title and the fact that the picture now in Norwich Castle can be identified on the evidence of an engraving by Edmund Girling it would be difficult to date.[5] Like all such scenes by Crome it is concerned to recapture the mysterious rather than the dramatic quality of moonlight and as he had learned to do this as early as 1808 there was no reason why he should not solve the problem in a not notably dissimilar way eight years later.

From time to time other, generally large, pictures of continental scenery have appeared as by Crome. These are often the work of his eldest son, John Berney Crome, who in the company of George Vincent, his father's pupil, and Steel, his brother-in-law, visited France in 1816 and for the rest of his life exhibited many pictures of Rouen and of the Scheldt.

This second contact of the Crome family with France is referred to in the last and most important of Crome's three surviving letters. The occasion was an

exchange of compliments with James Stark:

'Norwich, January, 1816

'Friend James,

'I received your kind letter and feel much pleased at your approval of my picture. I fear you will see too many errors for a painter of my long practice and at my time of life; however there are parts in it you like, I have no doubt, so I am happy. You are likely to visit us (but mum is the order of the day about that concern), I wish it might be so; we shall be happy to see you in Norwich.

'In your letter you wish me to give you my opinion of your picture, I should have liked it better if you had made it more of a whole, that is, the trees stronger, the sky running from them in shadow up to the opposite corner; that might have produced what I think it wanted, and have made it a much less too-picture effect. I think I hear you say, this fellow is very vain, and that nothing is right that does not suit his eye. But be assured what I have said I thought on the first sight, it strengthened me in that opinion every time I looked at it. (Honesty, my boy!) So much for what it wanted; but how pleased I was to see so much improvement in the figures, so unlike our Norwich School; I may say they were good. Your boat was too small for them (you see I am at it again), but then the water pleased me, and I think it would not want much alteration in the sky. I cannot let your sky go off without some observation. I think the character of your clouds too affected, that is, too much of some of our modern painters, who mistake some of our great masters because they sometimes put in some of those round characters of clouds, they must do the same; but if you look at any of their skies, they either assist in the composition or make some figure in the picture, nay, sometimes play the first fiddle. I have seen this in Wouerman's and many others I could mention.

'Breath must be attended to, if you paint but a muscle give it breath. Your doing the same by the sky, making parts broad and of a good shape, that they may come in with your composition, forming one grand plan of light and shade, this must always please a good eye and keep the attention of the spectator and give delight to every one. Trifles in Nature must be overlooked that we may have our feelings raised by seeing the whole picture at a glance, not knowing how or why we are so charmed. I have written you a long rigmarole story about giving dignity to whatever you paint—I fear so long that I should scarcely be able to understand what I mean myself; you will I hope, take the word for the deed, and at the same time forgive all faults in diction, grammar, spelling, etc., etc., etc.

'We have heard from John; I believe he is not petrified from having seen

the French School. He says in his letter something about Tea-Tray painters. I believe most of those who visit them whistle the same note. So much for the French Artists.

'I hope they will arrive safe. Our happiness would be made complete if your tongue could be heard amongst us. "Parlez Vous", my boy, will be echoed from garret to cellar in my house. I think I hear Vincent say to John: "Why, John, what d – d French rascal was that passed us just now? Why look at his whiskers; why he must be a Don Cassack". They had a charming voyage over, Vincent belshing as loud as the steam packet, much to the discomfiture of some of the other passengers. John did not say how Steel was in the passage, but I believe they were all bad alike.

'Sunday night.—I put this last in my smooth paper epistle—that the boys are by my fireside going to take a glass of wine, quite well and happy. I wish you were with us. I have nothing more to say, only wishing you health and comfort.

'Believe me, dear James,
 'Yours etc., etc.,
 'John Crome.

'John will write in a day or two. We have just heard of the death of Mrs. Sharp.'[6]

It is odd that the two spelling mistakes in this letter, if they are spelling mistakes, should have a kind of ambiguous significance because of the form Crome gave them. By a 'too-picture effect' he presumably intended to mean a 'two-picture effect' and the context with its urging of unity confirms the reading but it has also been taken to mean 'too picturesque effect' and this also would reflect Crome's ideas. 'Breath' was clearly written for 'breadth' but if we take 'breath' to mean vibrant life this also could express something of his meaning.[7] It is an astonishing letter in the unselfconscious way in which it reveals his aims as a painter. Nor is it difficult when reading it to understand his popularity as a man.

His popularity did, however, receive a slight check at this time as a coldness developed between him and his earliest friend, Robert Ladbrooke. The Norwich Society which they had founded together had flourished. After the annual exhibitions there was always a considerable balance and the custom had been to have a supper once a month or fortnight out of the proceeds. Robert Ladbrooke thought the money would be better spent in the purchase of casts. His intention was to form the nucleus of a local academy.

The disagreement between the two founders resulted in the secession of a group of members under the leadership of Ladbrooke and the setting up of a

rival Society. The secessionists maintained themselves as a separate organization for only three years before their exhibitions collapsed and the majority returned to the fold. The quarrel between the two leaders was not made up and Ladbrooke did not again exhibit at the Society's Exhibition in Crome's lifetime.[8]

The work Crome did in the seven years after his visit to Paris has been the most difficult to identify and to establish in sequence. Although the majority of the pictures in the Memorial Exhibition of 1821 date from these years yet these are the very ones which are now most scarce. There are several possible explanations, of which the least attractive is that Crome's later work, differing little from that of his more competent followers, has been lost in theirs. If, against our conviction to the contrary, the documentary evidence that Crome painted the *Grove Scene* (P 133, Plate 123b) is unassailable, there is strong reason to fear that this is so. The most secure document for this period is a little panel which belonged to Dawson Turner, *The Wensum: Boys Bathing* (P 91, Col. Plate IV). According to Turner Crome painted it a year or two before his death, 'immediately on his return from his Midsummer journey to London, with his whole soul full of admiration at the effects of light and shade, and brilliant colour, and poetical feeling, and grandeur of conception, displayed in Turner's landscapes in the Exhibition.'[9] If this picture has been correctly identified as the one Crome exhibited called *Bathing Scene*, the year referred to was 1817. Others which can be held with confidence to have been painted within a few years of it are *Postwick Grove* (Plate 112), *Poringland Oak* (Plate 107), *Bury Road Scene* (Plate 115), and the sketch for *Yarmouth Water Frolic* (Plate 110).

In all these Crome's subject matter seems to have remained largely as it had always been: trees, cottages, water, and sky, the daily bread of the Norfolk countryside. Yet some of the old grandeur has been lost, the strangely innocent way of seeing has been overlaid by a greater sophistication, his paintings are now more picture-like. This is not to say that much of the former quality does not remain. Crome remained Crome although the nineteenth century was gaining ground. To some extent breadth was sacrificed and his pictures became more full, yet they preserved harmony and avoided resting on the merit of their detail. His foliage became crisper and harder, and his touches of impasto a shade mechanical, but his skies remained as luminous, his clouds as vaporous, his distances as airy, as before.

On 14 April 1821 in his fifty-fourth year Crome fell ill with a fever. He had stretched a large canvas on which he planned to paint the *Yarmouth Water Frolic*, and had actually begun work when he was forced to abandon it.[10] The picture, completed by his son, John Berney Crome, is now at Kenwood (Plate

119), and the sketch for it, by Crome himself, is in a private collection (Plate 110).

On the 21st Crome's second son, Frederick, a clerk at Gurney's Bank, wrote to Dawson Turner: 'Dear Sir,—My father's disorder has so much gained ground that there is not the least hope of him. At the same time he is not aware of his situation; we, of course, are obliged to appear the reverse of our feelings. Mr. J. Gurney was here this morning but could not see him. Mr. Dalrymple has no hope—what can we have? It is killing to me. He is seldom easy unless I am by his side, holding his hand or supporting his head. Excuse what mistakes I may make, but you may guess my feelings. All are in tears about me. Should there be the least alteration in the morning I will send you word, meanwhile, I am, Your Obedient Servant, Fredk. Crome'.[11]

Before he lost consciousness Crome put his hands out of bed and made movements as if painting: 'There—there—there's a touch—that will do—now another—that's it. Beautiful.' He died on 22 April. Five minutes before the end he woke from his coma. His dying words were scarcely less inappropriate than Nelson's own, for he called out 'Oh, Hobbema! My dear Hobbema! how I have loved you!'[12] One is forced to the conclusion that he was mis-heard or that he had greatly misunderstood the nature of his own achievement.[13]

[1] In April 1921 this letter was reprinted in several Norfolk papers. There are cuttings in the grangerized copy of the 1921 Exhibition Catalogue in the Colman Library in Norwich. The original, then in the possession of Mr Westley Manering the painter, is now in the Lugt Collection.

[2] *A Narrative of the Grand Festival at Yarmouth* etc. printed and published by J. Keymer, King Street 1814. Crome only twice exhibited pictures of the Quay, though many times of the Jetty; as one of them was in this year it may have been connected with the Festival. Neither of the Quay pictures is known.

[3] The letter is now in Norwich Castle. The reference to Mrs Coppin in the post-script implies either that Daniel Coppin was not Farington's 'Coppinge' or that by 1814 he had married again.

[4] Wodderspoon.

[5] See, however, the full entry on this picture, (P. 82).

[6] British Museum Additional Mss No. (43830, 73). We give the punctuation as amended by Dickes.

[7] This is discussed by Sir Charles Homes in his Introduction to Collins Baker's *John Crome*.

[8] The various accounts of the secession derive from Henry Ladbrooke's *Dottings* and other cuttings in the Reeve Album.

[9] Turner, *Lithog*.

[10] Turner, *Memoir*.

[11] Reeve, p. 20 for the original letter.

[12] Turner, *Memoir*.

[13] Reeve, p. 23 contains a Notice of an Exhibition held in the Bazaar Room Norwich in 1856. The notice was probably written by David Hodgson and contains the following . . .

'Perhaps the latest of Crome's productions . . . is No. 199 and 235 "A view of the Norwich River" the property of J. Brightwen Esq. for these both show the decided influence of the school of Hobbema, which became almost the oppression and weakness of Crome's declining years.' This is particularly interesting as it shows that the harmful influence of Hobbema upon Crome was realized far earlier than one would have supposed. It also helps to shed valuable light on the nature of Crome's latest paintings, those between 1816 and 1821, which are less well represented in his surviving and recognized work than one would expect. The writer of the note goes on to say that No. 198, 'Mousehold Heath', 'belongs to the most vigorous period of his artistic life . . .' A point of view with which the present authors emphatically agree.

CHAPTER SEVEN

The Crome 'Formula'

When an artist dies he begins to take form. Until then what he is has been coloured always by what he may become. But once dead the whole of him that is remembered coalesces and becomes . . . a unity of some sort. But this unity may be very far from the truth.

Cotman's strange letter in which he referred to the fulfilment of his dream about the downfall of the Crome family was not itself the result of hallucination. After Crome's death his family disintegrated; his wife married again; Frederick James, the bank-clerk at Great Yarmouth who etched and painted a little, died early a wretched death; Emily, the painter of flowers and still life, left Norwich in debt and her subsequent life is unknown; Hannah married Bilham, master of the Norwich Infirmary; Joseph, most stable of the family, died young;* William Henry, whom Cotman said was known to be mad, survived long enough to paint much and badly; John Berney, the eldest and most talented, whom his dying father had exhorted 'to paint for fame', became the victim of an expansive temperament, was bankrupted, left the city, and died in 1842; of the youngest, Michael Sharp Crome, traditionally supposed to have been the model for the smallest of the bathers in the *Poringland Oak*, James Reeve gave in 1878 a horrible account.[1]

Crome's popularity in Norfolk was deceptive. As a man he was widely admired and loved, but the qualities which the majority of his admirers saw in him were, as in such circumstances they usually are, the superficialities which were transferable. The mystical union with Nature which Crome shared with Wordsworth and so many of his generation had degenerated by the 1830s into sentimentalism. Those who followed saw the world in greater detail but with less passion. Lip-service was paid to the name of Crome as the figure behind the

* Or so Collins Baker writes, though on what evidence we do not know. Yet, if so, who was the Joseph Crome who gave his father's portrait to the City of Norwich in 1855?

95

cardboard confectionery of Stark, of Vincent, of the younger Ladbrookes, of the younger Cromes, of S. D. Colkett, and a dozen other not very good, and sometimes very bad, decorative painters; but these were painters men could comprehend. So Crome himself was reduced to a sort of super-formula in their minds, a man whose work they were never sure of recognizing for he was largely the creation of their imaginations. They looked for a superior Stark and could rarely find him, because the formula which they so warmly accepted had only briefly, if ever, been his at all. The real Crome had operated at a different level and had no right to the admiration they gave him. He was caviare to the general; but because the general populace confused the caviare with those little beads of coloured sugar called hundreds-and-thousands they did not complain. Seen in this way the fakers, the Pauls, A. G. Stannard, the rascal Wigger, and many others whose names have not appeared, performed a public service, they fulfilled a demand.

Some must have known the truth, not Dawson Turner perhaps although he seems to have caught glimpses of it, but the Pagets and Sherrington at least. To them Crome must have meant more than a pleasant reminiscence on a wall to be nodded at in passing, or than a fashionable garnish in a room. But despite their understanding of him the real Crome was largely lost so that the pictures he did paint were passed unrecognized and unadmired by all but few.

Genuine Cromes had often a very indifferent fate. The great *Mousehold Heath* (Plate 111) fell apart when it was in Stannard's possession and the two halves were used as blinds.[2] According to William Philip Barnes Freeman, whose father had been one of the many owners of the picture, it did not even fall apart but was cut in two in order to make it more saleable.[3] *The Slate Quarries* (Colour Plate I) may or may not have hung unframed on Dawson Turner's staircase, nobody could be sure because nobody had bothered to look at it or at whatever picture of Crome's it was that had been hanging there.[4] The *Poringland Oak* (Plate 107) bought by Freeman for £25 in 1823 remained in his shop unsold and unadmired for nearly twenty years.[5] When the Paget family fell on hard times and decided to sell their Cromes they proposed to do so through Christies. When asked what they expected to get for them James Paget suggested over one hundred pounds for the *Marlingford Grove* (Plate 106) and somewhat less for the others. He was told there was not a Crome in the kingdom that would fetch a hundred pounds. The Paget collection was consequently sold privately, some to Sherrington, some perhaps to Dawson Turner, because public interest could not at the time support an auction of them.[6]

Fifty years ago it was natural to speak in one breath of Turner, Crome, and Constable, as the great triumvirate of landscape, and not infrequently to

give the preference to Crome as the greatest in stature of the three. If recently Crome's name has been rather forgotten (Sir Kenneth Clark in *Landscape into Art*, for example, does not mention him), this is in part because so few Cromes have been publicly on view and so many pseudo-Cromes have usurped their place. It is, after all, not unnatural if those who lead the claque should find in A. G. Stannard, in Paul and in Wigger, something less than greatness. But the trouble does not lie there alone. When an artist's output is prodigious as, for example, was Turner's, or Constable's, or Cotman's, there is difficulty certainly, but not insurmountable difficulty, in forming a unified image out of his various manifestations. Turner did at least paint typical Turners as well as much else; Constable did paint typical Constables as well as some pictures which were rather less typical; Crome painted relatively little and rarely painted typical Cromes. He is, therefore, a more difficult artist to comprehend then they.

Yet, though so unlike them, Crome had inevitably much common ground with his two great contemporaries. Throughout the eighteen years from the foundation of the Norwich Society in 1803 to Crome's death in 1821 the dominant figure in English landscape painting was J. M. W. Turner. Turner had become an R.A. at a very early age and his technical resourcefulness had frequently wrung admiration from those who neither liked the man nor, painterly skill aside, his work. Much of what Turner did must have been unsympathetic to Crome; there was a spirit of competitive vulgarity about his painting which was quite alien to the artist who believed pictures should 'charm one knows not why'.

Curiously, it was not extravagant in Laurence Binyon to suppose that the influence, so far as it went, was the other way round.[7] According to him, and others have thought the same, Turner's *Frosty Morning* of 1813 was painted in emulation of Crome's manner. Binyon's use of the word 'emulation' is a clue to the essential difference between the two men. If Turner copied Crome's manner it was to show that he could do it better. If Crome copied Turner's it was because he thought he might be able to paint a better picture by doing so. The only Crome which might have spurred Turner to paint the *Frosty Morning*, and which he may have seen, was *Boy Keeping Sheep, Mousehold Heath* (Plate 100b). This is probably the picture shown at Norwich in 1812 and may also have been one of Crome's three Academy exhibits in that year. For all its Cromish qualities the *Frosty Morning* could never have been painted by Crome, just as Turner's emulations of Claude could never have been painted by Claude. There is about it a reckless over-loading of the composition which may 'give a far greater illusion of boundless space' but does so by breaking the picture

apart and scattering it with ill-co-ordinated figures in a way that would have horrified Wilson, Cuyp, and Crome, equally. The quality which Crome in his letter to Stark proclaimed as one which 'must always please a good eye' has quite gone.

If it is true that Turner learned nothing of any significance from Crome it is not so certain that Crome, so much more ready to learn than to compete, learned nothing from Turner. There are, for example, echoes of Turner's *Calais Pier* in at least one of Crome's *Yarmouth Jetty* pictures. There was a certain innocence of mind about Crome that prompted him to admiration and enabled him, not so much to learn another artist's secrets, as to discover by watching the other man, resources hidden within himself. But that was all. Both men were largely preoccupied with the painting of light and air. But this preoccupation was the right of all the heirs of Richard Wilson. The difference between their treatment of their inheritance was that Turner painted light for the sake of light whereas Crome painted it for the sake of increasing the solidity and reality of the objects which the light surrounded. The heightening of vision which Turner achieved by heaping clouds on clouds, and palaces on palaces, and waves upon waves, and throwing vaporous mists of colour over the lot, Crome sought by creating a stillness in which ordinary things could be seen not to be ordinary at all.

The factor common to Crome and Turner was their inheritance from Wilson; the factor common to Crome and Constable was their root in Gainsborough. What Gainsborough, Constable, and Crome had in common was love of place. Turner was the cat who walked by himself and all places were alike to him provided that light and colour streamed over them. Wilson painted the Campagna and Twickenham and the mountains of Wales, but just as people became to him 'figures' so places became 'landscapes'. When Constable spoke of seeing Gainsborough 'in every hedge and hollow tree'[8] he put his finger on the essence of Gainsborough's early Suffolk pictures, they were the fruit of an emotional relationship between a man and the countryside of his boyhood. In Constable himself that relationship became a lifelong love affair; it was much the same with Crome. But thereafter the likeness between Constable and Crome ends, not because of a difference in their ultimate intentions, such a difference as for instance between them both and Zuccarelli or even the later Gainsborough, but because of a difference of emphasis. When Benjamin West saw the young Constable's work he said: 'Always remember, sir, that light and shadow never stand still,'[9] and it is as though those words were to be the guiding principle of Constable's life as a painter. The glitter and flash and sparkle of the English countryside was the light in which he saw it. But

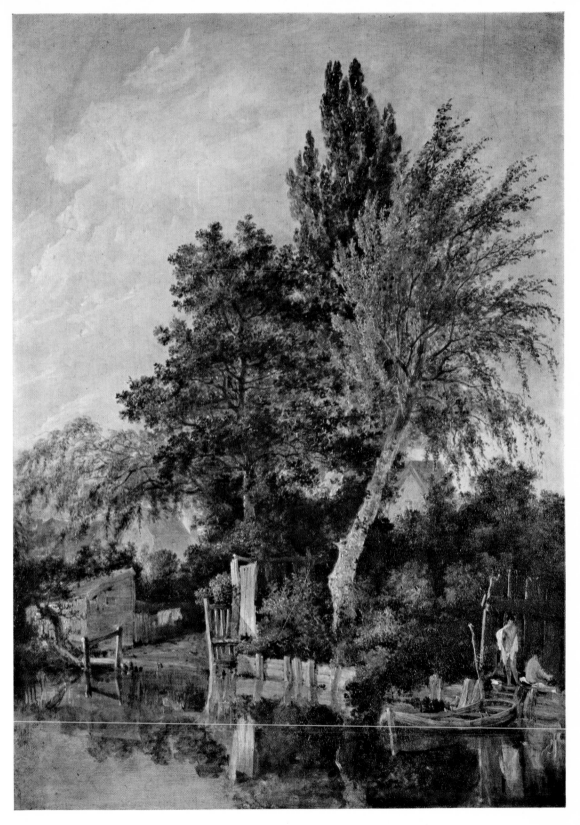

IV. The Wensum at Thorpe: Boys Bathing

1817 (P 91) $18\frac{1}{2} \times 13\frac{1}{2}$ *J. P. Stephenson Clarke Esq.*

Crome, when he lay dying, said to his son, John Berney: '. . . if your subject is but a pig-sty—dignify it,'[10] and that had been *his* guiding principle. Constable's landscapes do not lack dignity (Turner's sometimes do) but it comes second to the dance of light. Crome's do not lack sparkle—even Constable painted no brighter, fresher, and more sunlit a picture than the *Poringland Oak* —but even in that picture dignity comes first.

For many people the rough finish of many Cromes is a difficulty. When Dawson Turner wrote of his etchings he called them more than usually unfinished, and the same was often true of his painting. The example of Gainsborough had taught him to employ the ill-defined form, the apparently fortuitous dash and mark of paint, in a way that gave an air of 'having happened' to his pictures. But, as Wilson put it in a different connection, these are not pictures to smell, and as many observers desire above all things to get to terms with a painting by sticking their noses on it, they find themselves on close terms with a more than usually chaotic muddle.[11]

As may be supposed, one who was in the tradition of Gainsborough and Reynolds, who had no legitimate schooling in his art, and who for some years looked to Opie as a senior influence, was a miserable technician in the sense that the pigments he used have often suffered badly at the hands of time and restorers.* But what to some eyes appears to be the 'wreck of a Crome' is often very much nearer the picture as Crome left it than they are capable of understanding. The photographs of, for example, *The Road with Pollards* (Plate 99) before and after cleaning show that tears are being shed over the removal of repaint. The glories that have flown were not altogether the glories of Crome.

Crome's pigment, like Gainsborough's, varies extraordinarily within a picture. On the same canvas there are often areas of heavy impasto contrasted with painting so thin that the rib of the coarse canvas on which he usually worked is conspicuous. It is over these areas that the wailing is often greatest— 'Look, how thin!' they say, 'rubbed thin by cleaning'. But what has been rubbed off that would in any way have improved the picture they are unable to suggest. Any picture purporting to be by Crome needs looking at twice, but one that has no thin areas of paint needs looking at much more than twice. For those who find the sight of the weave of canvas offensive Crome is not their painter; Stark and Vincent are the men for them, and they will find even

* It was interestingly suggested by the late Martin Hardie that the fading of Crome's water-colours was due to his having obtained his pigments from local suppliers. This does not explain the deterioration of his oils—unless it can be shown that Opie, Reynolds, and Leonardo also employed inefficient colour-men. The trouble is very likely to have been not only bitumen but the use of wax as a base. Some Cromes appear to have melted—as Leonardo's great *Battle of Anghiari* did. After all, Crome owned Leonardo's *Treatise on Painting*.

greater satisfaction in Nasmyth, Leader, and the mid-century sweetness of the Suffolk artists.

But, though a great deal of nonsense which should be recognized as nonsense is talked about the condition of Crome's pictures, it remains true that they are subject to two distressing forms of deterioration. The paint, particularly in the darks, is often soft and yields to the cleaner too quickly, and the use of bitumen has led, as usual, not to cracks only, but to crevices. Some Cromes have no doubt totally disappeared for this reason,[12] others have been so over-painted in an effort to correct the faults that they are no longer recognizable as Crome's work at all.

More fundamental a cause of the misunderstanding of Crome than the condition of his pigment is the nature of his subjects. There is an almost total lack of incident in Crome. With a few exceptions we are to see a Crome picture as a whole or not at all. There may be an accent here or a passage there which, considered in isolation, is remarkable, but one never does consider it in isolation. The passing of the eye in admiration from this figure to that meadow, to this horse, to that distant spire, a process which is the very essence of, for example, our pleasure in a fully-fledged Constable, is something which Crome not only did not seek to attain but positively sought to avoid. 'Trifles in nature must be overlooked.' 'Making the picture whole and of one piece is what will always please a good eye.' And when a picture offends against this doctrine it is safe to say it is not because Crome forgot his principle but because he did not paint it. That his absence of incident offended there is ample evidence in the number of Cromes to which additions have been made. The great *Mousehold Heath* (Plate 111) was at one time enlivened by a shepherd boy and sheep by Bristow; and the *Chapel Fields* (Plate 118) of the Tate Gallery has become, with the addition of a horseman and cattle and some minor stage-property adjustments, a Shayer; and it has been allowed to remain a Shayer, which is a great pity because Shayer is one sort of an artist and Crome is another.

The reason for this distortion of Crome from the sort of artist he was to the sort of artist the public wished him to be was his essential austerity. He yielded nothing to the frivolous eye. Those who walked around the Paget's home in Great Yarmouth admiring the Morlands, Wards, and Sharps, and failing to see the Cromes, do so still. He is in general not a 'gallery' painter. Despite his frequently dramatic lighting, his 'evenings' and 'moonlights' and so on, his pictures have a certain reticence which allows the febrile and the slick, those that are clamorous for attention, to steal the show. Crome is the quiet man at the party whom chatterers fail to notice. His true subject was not the Norfolk countryside but the stillness at the heart of it, a subject not recognized

by all who spend time looking at pictures, and an experience to be savoured only in solitude. Those who at the beginning of this century found him to be like Velasquez were right. To try to grade an artist by saying that he is greater than this man or lesser than that is unhelpful; to clarify his achievement by pointing a parallel can open one's eyes to his quality. To speak of Crome with Constable and Turner involves the mind in a leap, their differences are so great; but to hold Crome in the mind with Reynolds and Velasquez is easy for there is between them a natural harmony of aim.

It is curious that nowadays we so often fall into the error of valuing an artist because of his influence on others, as though he were a road leading to Nirvana. One would have thought that the nineteenth-century doctrine of progress might now be confined to the sciences and kept clear of the arts. Unfortunately it is not, and we are still treated to the notion that Turner and Constable were important painters because they led to, or forestalled, the Impressionists. In so far as an artist is 'important' he is an art-historical phenomenon or a factor in sociological studies, but not necessarily anything else. It seems absurd to have to write that artists exist to paint pictures and not to teach others how to paint them. It is the relevance of pictures to our need for them which is significant; of another and secondary order of significance is the contribution which their example may make to later men. Nor is an artist's later manner necessarily either an improvement or a falling off from his earlier. Crome painted pictures in 1817 which in several ways were unlike those he had painted in 1807. He, no more than the rest of us, was able to step into the same river twice. Though a unique personality he was a man of his age who shared its interests and partook in its enthusiastic discoveries. In common with Turner and Constable and many other painters his palette became higher in key, his colour became stronger, his darks became less dark, his lights became brighter. For those who wish it this has been sufficient excuse to set him up as a frontiersman of art, another precursor of Impressionism. Crome would neither have understood nor approved.

It is true that the Crome-formula exercised an enormous influence on English painting for many years. There is perhaps no point in saying that the influence was on the whole a bad one. Turner, Constable and Bonington had formulas erected in their names which were equally pernicious. Formula influences are always bad. Cromesque painters are perhaps no worse in their way than, say, Leonardesque ones in theirs. The true Crome had no influence whatever; breadth and dignity were not qualities the nineteenth century felt in need of. In any case great artists are in many ways the end of a road.

Crome lived at a period when truth to nature was a criterion of excellence

and art was conceived as a branch of Natural Science. As a more than usually gifted child of his age he was an acute observer of natural phenomena and a skilful recorder of what he observed. A congenital honesty of temperament reinforced by the strongly Quaker influences with which he was surrounded, kept him from the second-hand vision and meretricious virtuosity which bedevilled most of his successors. But he was not a child of his age alone, many were that, he was also the product of a great tradition, not of Natural Scientists, nor of cameras, but of artists. The legend of Crome the untutored peasant, the instinctive painter, was a romantic fabrication, and could scarcely have been more remote from the truth. In him Reynolds and Gainsborough, Italy and the Netherlands, Rembrandt and Velasquez, met; he was a painter in the great tradition and in landscape he was that tradition's most complete expression.[13]

[1] 'Mr J. J. Colman having received a letter from Michael Sharp Crome saying he had a picture or two by John Crome, his father, which he wanted to sell, asked me, as I was going to London to see the collection of Norwich School pictures at the Old Master's Exhibition, to call and see Crome in answer to his letter, and gave me the address as sent to him, vis., Bunswick Street, Judd Street, St Pancras. I found he had just removed to Argyle Court, Argyle Square, St. Pancras, where I found him. It was between 8 and 9 o'clock and was Sunday evening. After knocking at the door two or three times a voice called out "Who's there?" On hearing that I came from Norwich I was immediately let in. On entering all was dark, but I could see that Crome had already been in bed and was in his shirt, being undressed and apparently dirty. I did not recognize this at first, I was soon, however, made aware of it by hearing a voice from the bed, which was that of his wife, telling me she was delighted to hear someone speak who came from Norfolk as it was her native place. At the same time, two or three children made themselves heard from behind the bedclothes—the door from the court opened immediately onto the room where the bed was, and being dark I intimated to Crome that I had no desire to prolong my stay there but would have liked a little talk with him about his letter to Mr Colman, and asked him if he had by him the pictures he mentioned in it. He then struck some matches for light to show me into a dirty little room or kitchen, by the side of the one in which was his own bed. In the corner of this was a made-up bed in which was his son, a boy about thirteen years of age. A little girl also made her appearance and was told to dress and go out and buy a candle. As I did not wish to see anything there with a light,—the place being very offensive—I asked Crome to put on his hat and coat and we would take a stroll, which he readily fell in with, and soon had his hat on and a comforter round his neck, but before going out he would strike some matches to find some of his own pencil sketches to show me, one a few lines only, he said was a memorandum of a picture by his father which he had bought in London for a few shillings from a man down in Holloway who, he said, had the pictures which I wanted to see. Before leaving the house his wife asked me whether I knew the Mumfords, which was her father's name. He was a cabinet-maker, and lived at St Gregory's, Norwich. This apparently was M. S. Crome's second wife, who was much younger than him, and with their little family must have been in great poverty.

'I found as soon as we got into the street Crome was quite agreeable to have a little brandy which he said would warm him. He also seemed quite ready to take me to see the pictures he had written about, and I left it to him to take me in the direction where they were to be seen, but from the several excuses he made I came to the conclusion the pictures were a myth. He, however, said he would call at my hotel on the following day and take me to see them, which

he did not do. He was full of talk, and would walk with me quite to Charing Cross, where I was staying. Amongst other things he told me was that he went to school at Turner's, and would soon be coming to Norwich with his pad, which consisted, he said, of common jewellery and some bottles of his "blue ink", invented by himself—his blue would beat Colman's he was sure. He also said he wanted to see his father's portrait by Woodhouse, at the Guildhall, this he said was his property. He wished to impress upon me that he should be independent of the Norwich people, and did not want to come there to make a market out of them because he was the son of Old Crome. He was, however, not above taking a small present from me, and appeared very grateful for it. He had an uncommon gift of the gab, and related to me much about his life as a dancing master and of his living with theatricals, and said he had been in the employ, for a few years, of a Mr Wells, an omnibus proprietor, a relative of his uncle. He spoke of the room his father painted in as the "blue room" and his brother, whom he called "Grand John", having altered it by building a studio. This was in the house in St George's Middle Street. M. S. Crome did not speak well of his brother J. B. Crome, he considered that he took from his mother and brothers more than he was entitled to, and was a great spendthrift. He was eight years of age when his father died, and 64 in 1878. At the time of his father's death he was at Turner's school with William B. Freeman. Although so young when his father died, Michael Sharp Crome evidently had a good idea of his painting, for he had bought two or three of his pictures in out of the way places in London. He informed me that the "View on the River Wensum" (Plate 58b), which is now in the Castle Museum, he met with in this way, and that it only cost him a few shillings. He also told me that he was born at the time that Michael Sharp lodged at his father's house in St George's Middle Street, and was named after him.'

[2] Reeve, p. 33, his MS. note.

[3] The Freeman MS in the archives of the National Gallery; the story is also given in Mary Heaton's article in 'The Portfolio'. There is yet another tale that Crome himself halved it for ease of sale.

[4] In 1887 efforts were made to discover the history of this picture. In the Reeve album there are the following letters:

(1) From Mr Caleb Rose to Cosmo Monkhouse 21 August 1887: '. . . With regard to the picture by Crome in the National Gallery called "The Slate Quarries" there is no doubt whatever that it is a genuine picture by Old Crome.

'It was purchased [note by Reeve? *exchanged J. R.*] from the late Mr Dawson Turner of Gt. Yarmouth by the late Mr Sherrington of the same place—At the same time Mr Sherrington purchased this picture it was called "The Cumberland Sketch" and by that name it was always known while in his possession, certainly, I think, a more appropriate name than that which it now bears.'

(2) Letters from the Rev. John Gunn to his sister-in-law Mrs Jacobsen (Ellen Turner) 7 October 1887: '. . . It's said that the celebrated picture of the "Slate Quarries" by Old Crome in the National Gallery was once in Dawson Turner's Collection at the Bank, and was exchanged by your Father with Mr Sherrington for a Wood-scene which is now in my possession. Mrs Sherrington, now Mrs Rose, is the authority, conjointly with her husband Mr Rose who married Mr Sherrington's widow.

'I am appealed to, and requested to get all possible information on this point. . . . Your father told me he had exchanged the Large Old Crome, which hung on the landing near the Drawing door on the Staircase.

'I do not think that the "Slate Quarries" picture corresponds with the Old Crome on the Landing but agrees with one of the much valued "Outlines in Lithography" a "View on the Yare" p. 18 and 19—A difficulty arises from the small size of the outline and from the absence of measurements.

'As my picture is not represented among the Outlines I am inclined to think that the exchange could not have been made in 1840 the date of the privately printed "Outlines".'

(3) Memorandum written by B. Samuel when on a visit to Wigger: '"The Slate Quarries" was seen by Mr and Mrs W. 11 years ago at the Gallery i.e. the last time they were there.

'Its possible it came from *Wedmore* if not the Sherrington collections. Opinion is divided between the 2 but both colls. were sold at Christmas.

'The impression Mr W. has on his memory is that it was a very fine work which if not Crome might have been Turner it was in the Salvator Rosa style. It was good enough for anybody but Crome could be as good as anybody. He does not think it was Fuller Maitland. ?'

(4) From Mrs Palgrave to John Gunn 11 October 1887: '. . . The story is that it hung on the staircase over the door which led to the room over the Drawing room . . . and that, on account of its size . . . it was never honoured with a frame—not being considered worthy of the distinction.

'I have seen the picture in the National Gallery—and I was never quite certain it was the same, though I believe it was, my remembrance of the picture and the staircase is not very strong.

'[Of the 'Outlines'] . . . The Slate Quarries does not appear among them—but my Grandfather may not have thought it worth including. He had certainly some which he did not include.'

(5) Eleanor Jacobsen's reply to John Gunn, 12 October 1887: '. . . I do not at all believe that the *Slate Quarries* was in my Father's possession. I never heard him mention the picture and I knew all his collections so well that I am sure, had their been alteration in the position of the pictures (such as an exchange would have caused) I should have been well aware of it.'

(6) F. T. Palgrave to John Gunn 20 November 1887: '. . . I remember that, without a frame, and in the large top room in the Old Bank which was over the "Viper Room", being, when I was a boy, a sketch by Crome of a mountain scene, which to my memory seems more or less like the Slate Quarries now in the N. Gallery. I do not remember if it had that or any other distinctive name.'

[5] Freeman MS.

[6] Elise Paget, op. cit.

[7] Binyon, *John Crome*.

[8] C. R. Leslie *Memoirs of the life of John Constable, R.A.* Dent, p. 8.

[9] Leslie, op. cit., p. 12.

[10] Turner, *Memoir*.

[11] Constable in *Richard Wilson* quoting from Field: 'In painting he frequently receded from his picture to view it, and he one day drew Sir William Beechey by the arm to the further corner of the room, observing, "This is where you should view a painting, with your eyes, and not with your nose!" '

[12] According to Collins Baker (p. 88) *The Old Oak* when Reeve saw it was almost invisible through cracking.

[13] No work on Crome can afford not to quote yet again the moving passage in George Borrow's 'Lavengro': 'A living master? Why there he comes! Thou hast had him long; he has long guided thy young hand towards the excellence which is yet far from thee, but which thou can'st attain if thou shouldst persist and wrestle, even as he has done midst gloom and dispondency—ay, and even contempt; he who now comes up the creaking stair to thy little studio in the second floor to inspect thy last effort before thou departest, the little stout man whose face is very dark, and whose eye is vivacious; that man attained excellence, destined some day to be acknowledged, though not till he is cold, and his mortal part returned to its kindred clay. He has painted, not pictures of the world, but English pictures, such as Gainsborough himself might have done; beautiful rural pieces, with trees which might well tempt the little birds to perch upon them. Thou needst not run to Rome, brother, where lives the old Mariolater, after pictures of the world, whilst at home there are pictures of England; nor needst thou even to go to London, the big city, in search of a master, for thou hast one at home in the Old East Anglian town who can instruct thee whilst thou needst instruction. Better stay at home, brother, at least for a season, and toil and strive midst groanings and dispondency till thou hast attained excellence even as he has done—the little dark man with the brown coat and top-boots, whose name will one day be considered the chief ornament of the old town, and whose works will at no distant period rank amongst the proudest pictures of England—and England against the world!—thy master, my brother, thy, at present, all-too-little considered master—Crome.'

THE CROME 'FORMULA'

There are ten known portraits of John Crome. At Norwich Castle are the portraits by Opie (Plate 1) and by Michael Sharp (Plate 2). There is also in the Castle, on loan from the City, an oil by J. T. Wodehouse upon which in some degree depends a slightly debatable pencil and wash 'self-portrait' recently at Sotheby's. There is also an oil portrait said to be of Crome in the collection of Constance, Lady Mackintosh. In the National Portrait Gallery is the water-colour portrait by D. B. Murphy which was reproduced as the frontispiece of Dawson Turner's *Memoir*. In the British Museum is the well-known pencil and wash drawing by J. S. Cotman (B.M. 1885.5.9.1399). This last has been consistently mis-dated. In Martin Hardie's *Watercolour Painting in Britain* Vol. ii the error has been perpetuated that this portrait was made in 1806; but the water-mark is 1814. There are, in addition, three portraits by Crome's pupils. The first, monochrome and wash, is by Hannah Gurney and was lent to the 1921 Memorial Exhibition by Mrs Charles Backhouse; the second, by Jane Gurney, is an unattractive profile lent to the same Exhibition by Major Henry Birkbeck; and the third is a pencil portrait by Mary Anne Turner in a volume of drawings and etchings by Mrs Dawson Turner and her daughters now in the British Museum. In addition there is a marble bust by Mazzotti in the Castle at Norwich of which a cast is in the National Portrait Gallery. None of these portraits compare in quality with the literary portrait by Crome's fellow townsman, Borrow. John Borrow went to Rome and died there and seems never to have attained the excellence which George, his brother, urged him to seek in Norwich.

CATALOGUE

Note to Catalogue

Arrangement is made in estimated chronological sequence. Title appears in small capitals followed by alternative title(s) in brackets.

Paper is white unless otherwise indicated. Where possible, information concerning type of paper and watermark has been included.

Measurements are in inches, height before width.

Number following title of Museum is Museum's inventory number.

Sale date followed by number in brackets indicates Lot number. If sale room is not identified it is assumed to be Messrs Christies.

Left and Right are read conventionally from the viewer.

X numbers have been used for late insertions which would otherwise have disturbed the established numerology.

ABBREVIATIONS

L. Left; R. Right; C. Centre.

WM. Watermark.

Prov. Provenance.

Coll. Collection.

Lit. Literature.

Exh. Exhibition or exhibited.

Ms. Manuscript.

Mus. Museum.

Nor. Norwich.

Nor. Soc. Annual Exhibition of Norwich Society.

N.C.M. Norwich Castle Museum.

B.M. British Museum.

Witt. Witt Photographic Reference Library, 19 Portman Square, W.1.

R.A. Royal Academy.

B.F.A.C. Burlington Fine Arts Club.

B.I. British Institute.

Norf. Norfolk.

Suff. Suffolk.

Repr. Reproduced.

Cat. Catalogue.

Nat. National.

bt. bought.

Coll. Collection.

Inst. Institute.

p.c. Postcard

Nat. Gal. National Gallery.

Assoc. Association.

Drawings

D 1 LANDSCAPE AT HETHERSETT, NEAR NORWICH (Plate 4)

Pencil on laid paper. $6\frac{2}{5} \times 7\frac{9}{10}$.
WM: Whatman 1794.
Coll.: N.C.M. (130–41–98).
Inscribed: Reverse in pencil: *Hethersett*.
From an album of sketches given by Mrs D. Hodgson in 1898. Although the
drawings are at present attributed to David Hodgson (1798–1864) several are
by other hands. No. 132 from the album (also by Crome) is inscribed *Crome
Senior* (D 72). This drawing, already showing Ruysdael influence, relates to
Wooded Landscape (D 2). Probably in or shortly after 1794, but before 1802.

D 2 WOODED LANDSCAPE (Plate 5)

Pencil on laid paper. $10 \times 7\frac{1}{2}$.
Coll.: Private.
Prov.: H. S. Reitlinger; Norman Baker; with Levine, Cromer, 1965.
Lit.: Mary Woodall. *Gainsborough's Landscape Drawings*, p. 88, pl. 112 (as Crome) and
Cat. 143, pl. 16.
Woodall pointed out that this is a copy of a Suffolk period Gainsborough draw-
ing in the B.M. (Oo 2–4). There are many slight differences, a figure standing
R. of path is omitted as also a thistle and burdock R. The drawing is thin and
scratchy with none of Gainsborough's leady chiaroscuro. The B.M. drawing may
have formed part of Harvey's cabinet at Catton and have been copied there by
Crome. Alternatively Crome may have owned the B.M. drawing. In the Yar-
mouth sale of 1812 were two sketches in '*black and white*' by Gainsborough.
c. 1794–1802.

D 3 ROCKY RIVER SCENE (Plate 6a)

Pencil and water-colour on laid paper. $15\frac{3}{10} \times 24\frac{1}{5}$.
Coll.: Norman Baker, Esq.
Prov.: Leonard Bolingbroke; Fairhurst.

Condition: Badly faded and soiled, tears skilfully restored.

Palette of bottle green, dark blue and chocolate brown has now faded to pale green, pink and yellow brown. Composition is similar to *Rocks near Matlock* (D 5) and the handling of scrub and banks seems close to *Castle in a Hilly Landscape* (D 4). Pencil basis of foliage with a diagonal broken branch to R. similar to *Landscape at Hethersett* (D 1). Perhaps made on the Cumberland visit of 1802. 1797–1804.

D 3x MOUNTAIN SCENE

Pencil and water-colour on laid paper. About 14 × 21.

Coll.: H. Birbeck.

Prov.: Family descent.

High hills with ravine C. and small trees R. Palette of pale green and fawn relieved with touches of salmon pink. Found with a group of drawings some inscribed as by Jane Gurney. This must be largely by Crome. *c.* 1802–4.

D 4 CASTLE IN A HILLY LANDSCAPE (Plate 7)

(?) Indian ink wash on laid paper. 16¾ × 12.

Coll.: Untraced.

Prov.: Prof. W. Bateman in 1921.

Exh.: Nor., Crome Centenary 1921 (58).

The title and history of this drawing are speculative. All that is certainly known is a photograph in the Witt Library. From this it can be seen that the drawing is on laid paper: assuming that the interval between the wire-lines is the common one, the measurements would seem to be about 16 × 12. *Castle in a Hilly Landscape* shown by Bateman in the 1921 *Crome Centenary* measured 16¾ × 12. Perhaps connected with *Rocky River Scene with Castle on Height* formerly in Sherrington Collection, or *Scene in Wales* (P 118).

The castle may be the same as that in Turner's *Liber Studiorum* pl. XXVIII called *River Wye*. It is more likely to be Chepstow than Goodrich and may be *Part of Chepstow Castle from the Wye* exhibited by Crome at Norwich in 1805 (139). A painting of Chepstow Castle by John Inigo Richards is at the Nat. Mus. of Wales. (See: Constable. Richard Wilson fig. 159a.) Like it are *Rocks near Matlock* (D 5) here dated 1803–5. *River Landscape with Church* (P. 5) and *Distant View of Norwich* (P 19). Probably 1804. *c.* 1803–5.

D 5 ROCKS NEAR MATLOCK (SKETCH OF MATLOCK, RIVER AND ROCKS) (Plate 6b)

Water-colour on laid paper. 15⅞ × 22⅜.

Coll.: N.C.M. (739–235–951).

Prov.:	Original frame bore label of framemaker *J. Thirtle, Magdalen Street, Norwich*; probably Samuel Paget; Miss Elise Paget; Miss Mary Maud Paget; Dr Meyrick Yare Paget[1] bt. from him by R. J. Colman Sept. 1934 (£125).
Exh.:	(?) Nor. Soc. 1811 *Drawing of Rocks Near Matlock*, (146).
	Norwich 1860.
Lit.:	Dickes pp. 69, 70, 147.
	Baker (by whom it was not seen) pp. 147, 179, 194.
	Iolo Williams p. 154.
	Colman Cat. 739.
	Magazine of Art, April 1882, p. 244.
Condition:	A little faded, top corners damaged by having been glued to a window mount with rounded corners. Several small horizontal tears on L. edge, a long tear near summit of mountain to the L.
Versions:	An oil from a similar viewpoint but further down the Derwent is at Cambridge (P 31).
	Coloured in fresh pinks, buffs, orange, and pale green blues. Relates to *Hollow Road* (D 15); compare also with *Castle in a Hilly Landscape* (D 4).

The drawing is made from a position very near the iron bridge at Matlock Bath looking North.

Crome visited Matlock in 1802 and 1806.

D 6 VALLE CRUCIS (Plate 8b)

Pencil and indian ink wash on laid paper. $11\frac{1}{5} \times 18\frac{1}{2}$.

Coll.:	Norman Baker, Esq.
Prov.:	Arthur Kay; Augustus Walker, 1947.
Inscribed:	Top R. verso in brown ink: *Valle Crucis Priory* [and in lead pencil] *J. M. W. Turner*.
WM:	1796.
Condition:	Slight foxing and an accidental (?) touch of blue in sky to R.
	Valle Crucis Abbey is just North of Llangollen on the road to Oernant. This is probably one of Crome's rare drawings from the 1804 trip. A pair to *Llanrug* (D 7). Photograph in Witt when in Kay Coll.

D 7 LLANRUG (Plate 8a)

Pencil and indian ink wash on laid paper. $11\frac{1}{2} \times 18\frac{1}{5}$.

Coll.:	Norman Baker, Esq.

[1] Letter to R. J. Colman from M. Y. Paget (dated 6 September 1934) at N.C.M. 'it is believed that this picture was obtained from John Crome by Samuel Paget of Great Yarmouth probably about 1805'. Dickes gives it a provenance from A. T. Paget through Sir James Paget to Miss Paget.

DRAWINGS

Prov.:	(?) Arthur Kay; Augustus Walker, 1947.
Inscribed:	Recto in pencil top R.: *Llanrug*.
WM:	1796.
Condition:	Good.

Llanrug is East of Caernarvon in the Llanberis Pass. This is a pendant to *Valle Crucis* (D 6) in the same collection.

D 8 MOUNTAINOUS LANDSCAPE (Plate 9b)

Pencil and water-colour on laid paper. $6\frac{15}{16} \times 10\frac{15}{16}$.

Coll.:	L. G. Duke, C.B.E.
Prov.:	James Ward, R.A.[1]
	Appleby.
Lit.:	D.C. pp. ix, 19 and pl. 8a (dated *c.* 1801).
Condition:	Good and unfaded.

Slight pencil outline, indian ink wash, yellow-brown wash on land, touches of pale blue sky breaking through the clouds. The mannered broken branch to L. and the pair of small figures in the distance have parallels in the Cotmanesque *Palings and Trees by Pond* (D 13). Relates to *Llanrug* (D 7) and *Valle Crucis* (D 6). Treatment of sky similar to *Slate Quarries* (P 18). Probably drawn in Wales, 1804.

D 9 DOLGELLEY, NORTH WALES (A VIEW IN CUMBERLAND)[2] (Plate 9a)

Pencil and water-colour on laid paper. $6\frac{7}{8} \times 12\frac{1}{4}$.

Coll.:	N.C.M. (252–235–951.)
Prov.:	J. N. Sherrington; Mrs Caleb Rose (Sherrington's widow), her Sale, Christies, 30 March 1908 (30) bt. R. J. Colman; by whom presented.
Exh.:	Nor. 1921 (64). Crome Centenary.
Copy:	J. S. Cotman's water-colour ($11\frac{1}{4} \times 17\frac{3}{4}$) at Fitzwilliam Mus. (S. D. Kitson Bequest 1937–2303).
Lit.:	Colman Mss. Cat. Vol. II p. 252.
	Colman Cat. No. 252.
	Baker p. 132, 180, 185.
	Kitson p. 42 pl. 18 (Fitzwilliam drawing).
Condition:	Faded.

The view is not at Dolgelley but near by at Llanelltyd. It shows Cymmer Abbey

[1] May have come to Ward via the Pagets of Yarmouth. The Pagets possessed many Ward paintings and it seems possible that he was on intimate terms with the family. See Elise Paget, *Magazine of Art*. April 1882.
[2] Called a 'View in Cumberland' in the Caleb Rose Sale Cat. but is inscribed with Dolgelley title on the back. (See Colman Mss. Cat.)

with a stretch of the river just before it flows out into the Mawddach Estuary. This is a rapid pencil drawing covered with loose washes of pink-browns and yellow-browns, highlights scratched out. There is nothing to suggest, as stated by Kitson, that its shadows were *'washed in at a later date'*. It has an excellent provenance, a traditional attribution, and the subject could have been drawn by Crome on his Welsh journey of 1804. It is not technically far removed from *Tintern Abbey* (D 12) at N.C.M. (*c.* 1804) and Mr Hansell's *River Scene with Buildings and Barges* (D 211). Kitson attributed it to Cotman as the sketch for his own drawing, which is now at the Fitzwilliam.[1] He cited no comparable Cotman sketches and we know of none. Cotman frequently based water-colours on other's work and it is probable that the Fitzwilliam drawing is based on this Crome or upon a lost intermediate work. *c.* 1804.

D 10 WOOD SCENE WITH POOL AND PATH (Plate 12b)

Indian ink wash on laid paper. $7\frac{1}{10} \times 12\frac{1}{5}$.

Coll.: Norman Baker, Esq.
Inscribed: Verso top L. in pencil: *August 3d 1804*.
Prov.: Passed through Christies, bt. in Richmond, Surrey about 1925.
Condition: A little rubbed.
 One of Crome's most sensitive drawings. Similar to *Boathouse, Blundeston, Suffolk* (D11) in Bacon Collection. 1804.

D 11 THE BOATHOUSE, BLUNDESTON, SUFFOLK

Pencil and indian ink wash. $7\frac{1}{5} \times 12\frac{2}{5}$.

Coll.: Sir Edmund Bacon, Bart., K.B.E., T.D.
Prov.: J. B. Crome; C. J. Steward, sold by his exors after 1910.
Lit.: Theobald p. 32, No. 24.
 Baker p. 123.
 Study for an oil of this title formerly in Steward Collection (Canvas $18 \times 24\frac{1}{2}$). According to Theobald the oil was in very poor condition. Compare *Woodland Scene* (D 24) and *Wood Scene with Pool and Path* (D 10).
 c. 1804–6.

D 12 TINTERN ABBEY (AN INTERIOR VIEW OF TINTERN ABBEY) (Plate 15)

Pencil and water-colour on laid paper. $21\frac{3}{8} \times 16\frac{3}{8}$.

Coll.: N.C.M. (26–964).

[1] Dated by Kitson *c.* 1804/5, the N.C.M. drawing dated by him between 19 and 23 July 1802 when we know Cotman was at Dolgelley. The Fitzwilliam drawing is more likely to date from *c.* 1808/9.

Prov.: Possibly Dr Dalrymple of Norwich (Crome's doctor); by descent to Canon Basil Murray Downton, Vicar of Eaton; presented in memory of him by his sons and daughters. (1964).[1]

Exh.: (?) Nor. Soc. 1805. *An Interior View of Tintern Abbey* (159) or *Interior of Tintern Abbey* (210).
Bedford, Cambridge, Norwich. 1966 (21).
Rouen. May, June 1967.

Lit.: Dickes pp. 46 or 62.
Baker pp. 75, 77, 166.
D.C. pp. 20, 38.

Condition: Faded, restored by B.M. 1964. One inch wide band along bottom repaired, bottom R. corner missing and replaced, a diagonal tear (over three inch long) running from this corner to L.

Interior of the Church looking East towards the High Altar. Faded to reddish browns, greys, dull greens and blues. There is a controlled pressure of the pencil point in the architectural details and a use of dots which is combined with continuous and broken lines but there is no hatching. Branches are lightly suggested and the leaves drawn in fan-shaped zig-zags. In general the hanging foliage treatment is reminiscent of Wilson (cf. B.M. drawing *Villa of Maecenas*) D.C. (op. cit.) suggested that this drawing may have been the *Tintern Abbey* exh. in 1807 but this form of pencil framework cannot be paralleled in drawings of 1806/7. Its use with wash is closer to the *Hollow Road* (D 15) and *Glade Scene* (D 14). Crome exhibited two *Interiors of Tintern Abbey* at Norwich in 1805, based on his visit to Wales of 1804.

D 13 PALINGS AND TREES BY A POND (Plate 12a)

Pencil and indian ink wash. $4\frac{3}{4} \times 10\frac{7}{8}$.

Coll.: B.M. (1902–5–14–381).
Inscribed: In pencil on mount recto; *Old Crome from his nephew J. B. Ladbrooke to J. Norgate.*
Prov.: J. B. Ladbrooke; Jonathan Norgate; Messrs Boswell; James Reeve.
Lit.: K. Smith p. 174.
Baker pp. 155, 179, 184, 193, 195.
Hardie, Vol. II pl. 48.
Reeve Cat. p. 70. no. 7c.
Close to J. S. Cotman of *c.* 1803–4 see Cotman's *Backwater in a Park* and *Kirkthorp Church, Yorkshire* both 1804 (Kitson pls. 19 and 20). J. B. Ladbrooke is not to be considered a reliable source but this untypical drawing is almost certainly authentic.

[1] See Historic File at N.C.M. In it are letters concerning prov. from Canon Downton's daughter — 'An ancestor, Dr Dalrymple of Norwich, attended Crome in his last illness . . . (and this is a) possible reason why the picture came into the family originally'.

D 13x

INTERIOR OF A CASTLE
(CAISTER)

Pencil and water-colour. 16½ × 11¾ (sight).

Coll.: Miss Helen Barlow.

Inscribed: Faded brown ink bottom L.: *J. Crome Senʳ.*

Prov.: (?) Dawson Turner Sale, May 1859 (2540) as *Rigland* (? Raglan) *Castle, Monmouthshire;* Palgrave; L. G. Duke; bt. Barlow from Squire Gallery.

Exh.: ? Nor. Soc. 1805 (118).
 Art Exh. Bureau. 1952–3.

Condition: Rubbed and faded, 'U'-shaped tear upper C. R.
 Interior of semi-circular ruined tower which fills two-thirds of drawing. There are blind pointed arches C. and L. Blue green foliage, red, brown and fawn building materials, pale blue sky. Use of soft and hard pencil, hard being confined to figure group. Although connected with Caister Castle exhibits of 1807 this is probably of one of the Wye Castles. It is close in style to *Interior View of Tintern* (D 12) and *Glade Scene* (D 14). It is probably the red sandstone *Great West Tower from the Inner Bellgium, Goodrich Castle,* Exh. 1805.

D 14

GLADE SCENE (Plate 13)

Pencil and water-colour on laid paper. 20⅞ × 17⅞.

Coll.: E. P. Hansell, Esq.

Prov.: Probably Mrs Maria Brown[1] (*née* Chase, wife of Crisp Brown); to daughter Maria Brown (later Mrs Henry Hansell); thence by descent to the present owner.

Exh.: N.C.M. April/May 1965.

Lit.: D.C. pp. 20, 46–7.
 O.W.C.S. 1966, Vol. XLI, p. 37, pl. XVII. (as influence of Cotman *c.* 1801).

Condition: Central horizontal fold, faded uniformly, slight scratches, white chalk heightening in sky added later.[2]
 Faded to chocolate browns, fawns, pinks, greens and yellows. Some pencil work underlying foliage of zig-zagged fan-shapes like that of the B.M. *Hollow Road* (D 15) and N.C.M.'s *Tintern Abbey* (D 12) (*c.* 1804, Ex. 1805?). This foliage technique may have been Crome's attempt to obtain an effect similar to Cotman's of the same period consisting of fan shapes of short strokes of the *brush point.* The tortoiseshell-like variation of the wash upon the banks and in the

[1] The prov. is *from Maria Brown*. The situation is confusing. Among Mr E. P. Hansell's ancestors there were two Maria Browns (see letter from Hansell dated 22 October 1965). He has suggested that the scene is *At Trowse.*

[2] The sky was probably *improved* in the 1830s or 40s. A more marked example of chalk retouching of this date is found on a pair of Crome School drawings of *Tintern Abbey* now belonging to Mr Quintin Gurney (D 42c *and* D 99c).

foliage combined with the unusual twists of the branches (that are now seen in depth), suggests the influence of J. S. Cotman 1803/4 (see *The Gnarled Oak* N.C.M. 126–235–951 or *Backwater in a Park* ill. Kitson pl. 19). The situation and size of the two figures in relationship to the rest of the composition is like *Carrow Abbey* (P 15) (Exh. 1805). Both the first owner of *Glade Scene* Maria Chase and her daughter Maria Brown (b. 1805) were pupils of Crome. Maria Chase married Brown in 1804. Was this drawing a wedding present to her from the artist?

D 15 THE HOLLOW ROAD WITH CART AND HORSES (Plate 14)

Pencil and water-colour. $16\frac{1}{4} \times 24\frac{1}{4}$.

Coll.: B.M. (1871–12–9–3461).
Prov.: Bt. from Mr Pearce 1871.
Lit.: Dickes p. 146.
 B.M. Cat. *Drawings of British Artists* (1898), Vol. I, p. 279.
 Binyon p. 27.
 K. Smith pp. 149, 174.
 Baker pp. 45, 179, 184 and pl. XXIV.
 The Queen 16 April 1921 (repr.).
 Iolo Williams p. 153.
 Hardie Vol. II, p. 63 (with wrong B.M. accession No. identifying it with D 196).
Condition: Faded, soiled and rubbed, vertical folds runnning parallel to R. and L. edges. Derived from a plate engraved by Laporte in Gainsborough's *English Scenery*, 1802.
 In photograph figure standing with sack on his shoulder to R. of L. tree is invisible. The drawing is now faded to an all-over dull-green brown with touches of pink and russet. The pencil work underlying the foliage is of zig-zag shaped fans. This formula combined with a wet use of wash is found in *Glade Scene* (D 14) and *Tintern Abbey* (D 12). A similar feathered silhouette of the foliage against the sky is found in *The Mill Wheel* (D 16). Despite the ruinous condition of *The Hollow Road*, Baker referred to it as the *noblest in style* of Crome's water-colours and Williams wrote of *its essential breadth and nobility. c.* 1804–5.

D 16 THE MILL WHEEL (Plate 16)

Water-colour on laid paper. $11\frac{1}{2} \times 16\frac{1}{4}$.
Signature partly erased lower L; *J. Crome.*

Coll.: Mr and Mrs D. P. Clifford.
Prov.: A dealer at Harrow; C. Torboch (Christies 17 May 1955 (46), bt. Agnew); H. C. Green (Sothebys 3 June 1964 (52)).
Exh.: Maidstone, Worthing and Eastbourne 1966–7 (8, cat. pl. 4).
Lit.: D. C. pp. vii, 19, 20 and pl. I.
 F. Hawcroft, *Burlington.* May 1966, p. 268.

Condition: Vertical central fold, clean and unfaded.

The appearance is unusual for it is probably one of Crome's earliest set-piece water-colours, and has retained the freshness of its original colour, grey green, blue, soft pinks merging into orange, touches of yellow and pale buff. A similar colour range is found in *Rocks near Matlock* (D 5) and the *Tintern Abbey* sketch (D 42). Of the date D.C. wrote (op. cit., p. 19) that the '*technique suggests a date perhaps as early as 1795*'. Hawcroft (op. cit.) wrote '*certainly, the Mill Wheel looks as though it could belong to the last years of the Eighteenth century, but was Crome really capable of producing water-colours of this quality as early as 1795?*' The technique relates to the eighteenth century stained drawing tradition. The figure and two horses in pen outline in the foreground are reminiscent of the work of J. C. Ibbetson (d. 1817) and Peter La Cave (fl. 1803). From Kitson's *Life of J. S. Cotman* (pp. 69–70) we learn that Dawson Turner possessed a great many drawings by La Cave and that Cotman traced some of these, their influence being seen in Cotman's drawing of cattle produced after 1804. It is possible that Crome traced this foreground group from a Dawson Turner La Cave. Although more contrived as a composition it relates closely in treatment of wash to *Old Building at Ambleside* (D 27), *The Hollow Road with Cart and Horses* (D 15) and *Trees on a Bank* (D 19). *c.* 1805–6.

D 17 TREES IN A ROCKY LANDSCAPE (Plate 21a)

Indian ink wash, traces of black chalk. $9\frac{1}{5} \times 7$.

Coll.: Mr and Mrs D. P. Clifford.

Prov.: J. Pierce Higgins; G. D. Lockett, Christies, 5 July 1966 (139).

Exh.: Maidstone, Worthing, Eastbourne. 1966–7 (20) as Frost.

Acquired as Crome but for a short time attribution altered to George Frost (1754–1821) on the basis of its chalk underdrawing and Gainsborough-like vision. Relates to N.C.M. *The Glade* (D 20) and *Entrance to a Castle* (D 18). ? *c.* 1805–6 but perhaps later.

D 18 ENTRANCE TO A CASTLE (Plate 21b)

Indian ink wash on laid paper. $11\frac{1}{8} \times 9\frac{5}{8}$.

Coll.: Private.

Prov.: Leonard Bolingbroke; Fairhurst; Norman Baker; Levine of Cromer, 1965–6.

May be a capriccio but might be a romanticized view of Warwick. Crome could have passed through Warwick on his journey to South Wales. The scene may be an untidy attempt at a Cotman Sketch Club composition. Handling of boulders foreground similar to *Trees in a Rocky Landscape* (D 17). *c.* 1804. Not seen.

DRAWINGS

D 19
<center>TREES ON A BANK (Plate 17)</center>
<center>(TREES BETWEEN ST. MARTIN'S GATE AND HELLESDON)</center>

	Pencil and indian ink on laid paper. $11\frac{1}{5} \times 16\frac{3}{5}$.
Coll.:	B.M. (1902–3–14–382).
Inscribed:	Indistinctly bottom L.: *Between St*
Prov.:	J. B. Crome Sale, St George's Colegate, September 1834;[1] bt. A. Sandys, from whom bt. James Reeve.
Lit.:	K. Smith p. 174.
	(?) Binyon p. 27.
	Baker pp. 167, 179, 184, 195.
	Reeve Cat. p. 70 no. 7d.
	Iolo Williams p. 155.
	D.C. ix, 19 and pl. 8b (implying a dating of *c.* 1801).
Condition:	Slightly rubbed and soiled, vertical central fold.

Relates to a large group of similar indian ink drawings. Compare *Barn and Cart* (D 23), *Mountain Scene* (D 22), *Trees and Palings* (D 21), *Overshot Mill* (D 26) and *The Glade* (D 20). The group seem to have been made at about the time of Crome's second visit to the lakes in 1806 as they are stylistically related to *Old Buildings at Ambleside* (D 27).

[1] This must be Reeve's mistake; J. B. Crome's Sale was 1831.

D 20
<center>THE GLADE (Plate 18b)</center>

	Indian ink wash. $12\frac{1}{8} \times 8\frac{9}{16}$.
Coll.:	N.C.M. (3–59–935).
Prov.:	W. W. R. Spelman; P. M. Turner Gift, 1935.
Exh.:	Nor. Crome Centenary 1921 (86) (Exh. label verso).
Condition:	Slightly rubbed and soiled, paper laid down.

Although less sensitive than B.M.'s *Trees on a Bank* (D 19) related to it both in vision and technique. Another similar drawing is *Trees and Palings* (D 21). Probably 1805–6.

D 21
<center>TREES AND PALINGS (Plate 18a)</center>

	Indian ink on laid paper. $9 \times 6\frac{1}{2}$.
Coll.:	B.M. 1902–5–14–375.
Prov.:	J. B. Ladbrooke; Robert Nurse bt. James Reeve.
Condition:	Good, unfaded. Slight damage to centre of tree.
Lit.:	K. Smith p. 174.
	Reeve Cat. p. 70. no. 4.

<center>118</center>

DRAWINGS

Dickes p. 147.

Baker pp. 166, 179, 184, 195.

Relates to N.C.M.s *Glade* (D 20) and *Trees on a Bank* (D 19), *c.* 1805–6.

D 21X LAKELAND LANDSCAPE

Indian ink wash over slight traces of pencil on buff laid paper. $12\frac{1}{10} \times 18\frac{2}{5}$.

Coll.: Mr & Mrs D. P. Clifford.

Prov.: Prof. J. Isaacs, his Sale Sothebys 1963; bt. J. Maas (as *W. Gilpin*).

Condition: Faded and a little soiled.

Mountainous landscape. Track C. Trees L., behind trees buildings suggested. River R. running at foot of tall cliff-like hills. Probably near Matlock, compare *Trees on a Bank* (D 19) and *Mountain Scene* (D 22). *c.* 1806.

D 22 MOUNTAIN SCENE (Plate 19a)
 (MOUNTAIN SCENE, COTTAGE AND BRIDGE)

Pencil and Indian ink wash. $5\frac{3}{4} \times 8\frac{1}{2}$.

Coll.: B.M. (1902–5–14–379).

Prov.: James Reeve.

Prov.: J. B. Ladbrooke's Sale October 1879 bt. James Reeve.

Lit.: Smith p. 173.

Baker p. 128, (omitted on p. 180), pp. 184, 195.

Reeve Cat. p. 70, no. 7a.

Condition: Soiled, parallel diagonal scratches across bridge, diagonal fold across L. corner, fold running from top R. across foreground, cottage to bottom R.

Probably a demonstration piece for students. It may date from the Welsh trip of 1804 or the Lakes trip of 1806. *c.* 1804–6. J. B. Ladbrooke probably used this drawing as the basis for his own *View in Snowdonia* (D.C. pl. 63a).

D 23 BARN AND CART (SHED AND TREE, CART IN FRONT) (Plate 20)

Pencil and Indian ink wash. $7 \times 8\frac{4}{5}$.

WM: Seated Britannia inscribed in an oval surmounted by a Crown.

Coll.: B.M. (1902–5–14–380).

Prov.: Messrs Boswell, bt. James Reeve.

Lit.: K. Smith p. 174.

Reeve Cat. p. 70, no. 7b.

Baker pp. 163, 179, 184, 195.

Condition: Scratched, soiled, 'L'-shaped tear running from centre L. towards R. top corner.

The cart to L. serves as a repoussoir in the same way as do the water-butt in *Farm Buildings* (D 25) and the village cross in *Old Building at Ambleside* (D 27). In the strong chiaroscuro he comes close to some Rembrandt drawings; compare *Cottage near the entrance to a Wood* (1644) in the Lehman Collection. *c.* 1805–6.

D 24 WOODLAND SCENE (Plate 19b)

Indian ink wash on laid paper. 6½ × 8¾.
Coll.: Sir Edmund Bacon, Bart, K.B.E., T.D.
Prov.: ? Carfax; Sir Hickman Bacon, Bart.
Condition: Laid down, rubbed and folded.
Relates closely to *Barn and Cart* (D 23) and *Farm Buildings* (D 25) *c.* 1804–6.

D 25 FARM BUILDINGS (FARM PREMISES) (Plate 25)

Pencil and indian ink on laid paper. 7¾ × 6.
Coll.: N.C.M. (738–235–951).
Prov.: J. N. Sherrington; Mrs Caleb Rose (Sherrington's widow); her sale, Christies, 30 March 1908 (6) bt. R. J. Cotman; by whom presented.
Exh.: Nor. Crome Centenary 1921 (63).
Lit.: Baker pp. 134, 180, 185.
Colman Cat. 738.
Colman Mss Cat. Vol. II p. 252.
Condition: Rubbed and soiled.
Details in the photograph are unclear. A second figure stands middle distance centre beside a wall. She wears a full skirted dress and a bonnet. A diagonal shadow extends from the roof L. to the head of the figure carrying a basket R. Composition and handling relate to *Barn and Cart* (D 23) and *Old Building at Ambleside* (D 27). A water-butt used as a repoussoir is found in a J. S. Cotman indian ink drawing *c.* 1802, in Mr Quintin Gurney's Coll. *c.* 1804–6.

D 26 OLD HOUSE BESIDE A RIVER WITH OVERSHOT MILL (Plate 26)

Pencil and indian ink wash on laid paper. 11½ × 18.
Coll.: N.C.M. (38–59–935).
Prov.: Gift of P. M. Turner, 1935.
Exh.: Arts Council. 1947 (40).
Empire Art Loan 1948/49 (55).
Kidderminster 1954 (7).

Condition: Rubbed and soiled, central fold, several vertical scratches.

Closely connected with *Old Building at Ambleside* (D 27) and the *Trees on a Bank* (D 19). In the first Crome uses atmospheric dabs of wash to indicate the texture of building materials and in the second uses a similar technique to express the pattern and rhythm of trunks and foliage. All three are ink monochromes of roughly similar dimensions and were probably produced in 1806. Not unrelated is leafage in full water-colour of the *Hingham, Blacksmith's Shop* (D 36). 1806.

D 27 OLD BUILDING AT AMBLESIDE (HOUSES AND VILLAGE CROSS) (Plate 27)

Indian ink wash on laid paper. 12 × 17½.

Coll.: Mr and Mrs D. P. Clifford.

Prov.: Inscription '*Bt. at Crome's Sale*' said by Baker to be on back of old mount is no longer there. The 'sale' referred to was probably that of Crome's bankruptcy in 1831. ?J. Wodderspoon by 1844 offered to Churchyard in Exchange (B. Barton letter, 25 June 1844, B.M. Add. Mss 37,032) Stansby (sale Robinson & Foster 28 January 1903, bt. Holmes). Sir Charles Holmes, Director of the Nat. Gal., still in his coll. 1920. Rev. A. Neale.

Exh.: Nor. Soc. 1807. (39 or 180) *Old Building Ambleside* or *An old house, Ambleside, Westmorland.*

Maidstone, Worthing, Eastbourne. 1966–67 (7) Cat. pl. 3.

Lit.: Dickes p. 62, 119.

Baker pp. 141, 179, 190, 197.

Condition: Rubbed and a little soiled; central vertical fold and some small tears. Cleaned (1967) by Mr M. Warnes.

The drawing has been identified as of a building at Ambleside on the basis of J. C. Ibbetson's *Ambleside Market Place* in the City Art Gallery, Leeds. This shows the buildings as they stood in 1801: The Black Cock, Old Ladies, Kit Thwaites bake-house, and a galleried private house (R. M. Clay, *Julius Caesar Ibbetson* p. 79, pl. 86). Crome is known to have visited Ambleside in 1802 and 1806 with the Gurney family of Earlham (Augustus Hare, *The Gurneys of Earlham* 1896 Vol. I, pp. 115 and 151) and he exhibited two Ambleside subjects in 1807. The drawing is closely related to *Old House beside a River with Overshot Mill* (D 26) and *Trees on a Bank* (D 19). 1806.

D 28 MALTINGS ON THE WENSUM (Plate 28)

Chalk, sepia wash on laid paper. 10⅗ × 17¾.

Inscribed: In pencil top R.: *Sketch by J. Reynolds.*[1]

Coll.: N.C.M. (733—235–951).

[1] Some five landscapes still exist by Reynolds. One is now in the Tate (No. 5635). Landscape drawings are in both the B.M. and the Soane sketchbooks. On the basis of this evidence an attribution to Reynolds is not tenable.

Prov.: J. N. Sherrington; Mrs Caleb Rose (Sherrington's widow) her sale, Christies 30 March 1908 (lot 28) bt. R. J. Cotman; by whom presented.

Exh.: Nor. 1921 (61) Crome Centenary.

Lit.: Colman Cat. No. 733.
Colman Mss. Cat. Vol II, No. 70k.
Cundall. pl. XXVIII.
Baker pp. 146, 180, 185.

Condition: Ruinous: faded, rubbed, hole to R. of buildings.
Medium similar to *Whitlingham* (D 29) with a wash made from a combination of sepia and indian ink. There are traces of black chalk underlying the L. bottom corner of the buildings. Although sadly damaged, it retains some of the grandeur and luminosity of *Whitlingham*. ? *c.* 1805–6.

D 29 WHITLINGHAM (Plate 29)
(WHITLINGHAM—A COMPOSITION, WHITLINGHAM CHURCH)

Sepia on buff paper with slight touches of white. 10⅞ × 17½.

Coll.: N.C.M. (734–235–951).

Prov.: J. N. Sherrington; Mrs Caleb Rose (widow of Sherrington), her sale, Christies 30 March 1908 (28) bt. R. J. Colman by whom presented.

Exh.: Nor. 1921 (60) Crome Centenary.

Lit.: Colman Mss Cat. Vol. ii., p. 250., No. 70 j.
Colman Cat. 734.
Baker, pp. 170, 180, 185.
Williams, p. 154, pl. CXII, fig. 250.
D.C. p. 19.

Condition: Good, although most of the white heightening has rubbed off.
The church is not Whitlingham which had a round tower. It has been suggested that the drawing is based upon the church of Thorpe St. Andrew near by, however that tower cannot be seen in conjunction with tall sand hills. It is more likely to be of Shottesham.

Sepia and indian ink have been combined to form a grey-brown wash. Most drawing has been done with point of brush; there are touches of body colour to trees centre and bank R.

Unlike any other by Crome except *Maltings on the Wensum* (D 28) (with the same provenance). There are relationships with Girtin, see *On the Wharf, Bolton Abbey* in the Girtin Collection. ? *c.* 1805–6.

D 30 WAITING FOR THE FERRY[1] (Plate 27)

Water-colour. 7¾ × 12¾.

Coll.: B.M. (1902–5–14–372).

[1] Dickes (loc. cit.) suggests wooded hill to L. is Postwick. It could be *Scene on the River Wye* exh. Nor. Soc. 1807 (108).

Prov.: Inscribed on old mount: *From Mr Crome, Kirby Cane.*[1]
Said to have been given to Robert Dixon (1780–1815) by a relative of one of Crome's pupils,[2] and then passed from Arthur Dixon, his son, to Miss Pallant, Carlton Colville; her Sale, Corn Hall, Norwich, May 1893, bt. James Reeve.

Lit.: Dickes p. 148, ill.
Reeve Cat. p. 68 no. 1.
Cundall pl. XXX.
Smith p. 174.
Baker. pp. 167, 179, 184, 194, 195.
Were it not for its convincing provenance this drawing would probably not have been attributed to Crome. Elements in it recall drawings of J. S. Cotman (*c.* 1801–3) and there is something of Clennell. However the deeper tone and richer colouring of the drawing with scratched-out highlights, makes a dating of *c.* 1806–7, closer to Tintern drawings, more likely; nevertheless the technique and way of seeing is a little inconsistent with other Crome works of this time. An alternative attribution to Robert Dixon is unconvincing. ? *c.* 1806–7.

D 31 KING'S HEAD GARDENS, THORPE (Plate 34a)

Pencil on laid paper. 6⅝ × 12.
Coll.: B.M. (1898–5–20–21).
Prov.: bt. from Mr T. Jacob 1898.
Signed and Inscribed: In pencil top L.: *View from King's Gardens at Thorpe July 3rd 1806 J. Crome.*
Lit.: B.M. Cat. *Drawings of British Artists* (1898) Vol. I. p. 279.
K. Smith p. 174.
Baker pp. 175, 179, 184.
Connoisseur, Dec. 1959, p. 235, fig 14.
Condition: Slightly trimmed all round.
Leaf probably from same sketchbook as *Drayton* (D 32) and *Shed with Boy Standing Cross-legged* (D 33) which are on similar paper and have a roughly similar measure. The same type of inscription occurs on *Drayton* and *Trees over a Stream* (D 34). Study for an oil, see (P 28). 1806.

D 32 DRAYTON (Plate 33a)

Pencil on laid paper. 6⁷⁄₁₀ × 12½.
Coll.: L. G. Duke, C.B.E. (D. 37–37).

[1] Crome painted a *Cottage at Kirkby Bedon, Norfolk* (ex coll. J. H. Wright) which according to Dawson Turner showed strong Gainsborough influence (i.e. 1806/7). See Dickes p. 57, Baker p. 200. Three Cromes were shown at the Memorial Exh. of 1821 by a Rev. Wilson of Kirby Cane; see Baker p. 200. Reeve (loc. cit.) wrote that Crome taught at Kirby Cane.
[2] Dickes (loc. cit.) states, probably inaccurately, that it was given by Crome to *Arthur* Dixon.

Prov.:	Canon Smythe.
Signed and Inscribed:	Top R. Corner: *Drayton J. Crome, July 1806* and verso in pencil *John Crome*.
Condition:	Washed with glue as fixer which now looks like a grey wash (as had also happened to a Dixon drawing N.C.M. (751–235–951) which has now had the fixer removed). Slight brown stains to L.

From a sketchbook; the L. margin untrimmed. Drawn in two pencils a soft and a hard. The Cock Inn still stands where the roads fork at Drayton but has been rebuilt. May be connected with *A Cottage Scene near Drayton* lent Memorial Exh. 1821 (69) with alleged date of 1815. Similar inscriptions and signatures occur on *Trees over a Stream* (31 August 1806) (D 34) and on *King's Head Gardens, Thorpe* (3 July 1806) (D 31).

D 33 LANDSCAPE WITH SHED: BOY STANDING CROSS-LEGGED (Plate 33b)

	Pencil on laid paper. $6\frac{7}{10} \times 12\frac{1}{2}$.
Coll.:	L. G. Duke, C.B.E. (D. 37–38).
Prov.	Canon Smythe (his mark twice verso).
Inscribed:	Verso in pencil: *John Crome*.

From the same sketchbook as *Drayton* (D 32); Summer 1806.

D 34 TREES OVER A STREAM (Plate 31)

	Pencil. $10\frac{3}{4} \times 8$.
Coll.:	N.C.M. (753–235–951).
Prov.:	Sir H. S. Theobald; bt. R. J. Colman, Feb. 1910 by whom presented.
Signed and Inscribed:	Top R.: *J. Crome August 31. 1806* and bottom R. *Crome Senior* and *Crome Senior* in another hand.

Study for water-colour in coll. of the late Sir Stephen Courtauld. *River Scene: Trees on the bank*. Etched later with differences (Theobald No. 15, p. 84–5), as *Wickerswell, Somerleyton* (E. 15). Similar inscriptions to top R. are on *The Yare at Thorpe from King's Head gardens* (D 31) and *Drayton* (D 32). Inscription bottom R. corner similar to that on *Trees and Bushes* (D 72). 1806.

D 35 RIVER SCENE: TREES ON THE BANK AND A MOORED BOAT (Plate 30)

	Pencil and water-colour on laid paper. $20 \times 15\frac{1}{2}$.
Coll.:	The late Sir Stephen Courtauld.

Prov.: J. E. Fordham, Christies, 9 April 1910. (49) £115/10/– bt. Agnew;[1] perhaps
 W. J. Jones;[2] bt. by the present owner from Agnews, 9 January 1920.[3]

Exh.: Nor. 1921 (79a) Crome Centenary.
 R. A. 1934 (726) Cat. fig. 735.
 Hardie Vol. II p. 63.

Lit.: *Studio*, Jan. 1934. ill p. 21.

Condition: Not seen; according to owner, excellent and unfaded.
 Palette of silver green, grey and yellow. Etched by Crome in reverse *c.* 1812–13.
 Lake and Boat on it, Wickerswell, Somerleyton or *Back of the Mills* (E 15). A pencil
 drawing is at N.C.M. *Trees over a Stream* (D 34). Treatment of wash in foliage
 corresponds to *Hingham, Blacksmith's Shop* (D 36) which was probably exhibited
 1807. Probably *c.* 1806–7 but in any case before 1813.

D 36 HINGHAM, BLACKSMITH'S SHOP (Plate 37)
 (AT HINGHAM, BLACKSMITH'S SHOP, NORFOLK)

 Pencil and water-colour. 16 × 12.

Coll.: Doncaster Museum and Art Gallery.

Prov.: W. W. R. Spelman, Norwich 1920; Paul Waterhouse; Miss E. M. Colman;
 bequeathed by her through N.A.C.F. 1949 to Doncaster.

Exh.: Probably Nor. Soc. 1807 (19 or 100) *Blacksmith's Shop from Nature*.
 Nor. 1921 (83) Crome Centenary.
 Sheffield, Graves Art Gall. 1952.
 Manchester, Whitworth, 1961 (34).
 Jacksonville, Nashville, and New Orleans. 1967 (16) Rpr.

Versions: (*a*) Autograph oil at Philadelphia (P 37) based upon this drawing.
 (*b*) A related water-colour is at N.C.M. (D 44).

Lit.: Dickes p. 61.
 Baker pp. 122, 179, 197, pl ix.
 Hawcroft, *Connoisseur*. Dec. 1959, p. 234, fig. 9.
 D.C. pp. ix, 20 and pl. 108.
 Hardie Vol. II p. 63 (with Coll. still as Ethel Colman).
 The blacksmith's shop was probably at Hardingham near Hingham (see Baker
 p. 76). Hawcroft (op. cit.) pointed out that the composition derives from *The
 Cottage Door* by Gainsborough which was formerly in the Coll. of Crome's patron,
 Thomas Harvey of Catton, and is now in the Huntington Library, California.
 This drawing precedes the Philadelphia oil: the most obvious of the pentimenti
 is the alteration in position of the horse's head. 1806–7.

[1] Described as *River Scene with Boat* (20 × 17). [Graves: Sales.]
[2] Baker p. 179, *River Scene with Trees and Boat* (20 × 17) W. J. Jones Coll.
[3] Sir Stephen Courtauld's letter dated 22 February 1967.

DRAWINGS

D 37 YARMOUTH JETTY (Plate 34b)

Pencil. $9 \times 16\frac{7}{10}$.

Coll.: B.M. (1935–7–16–1).

Prov.: Said to have been given to James Stark by Crome; by descent to James A. Stark from whom bt. through H. L. Florence Fund, 1935.

Lit.: Anne Carlisle, *Les Dessins Anglais* (1950) pl. 40.

Close to *Old Jetty, Norwich* (D 38), each has shakily drawn wheels. This may have been slightly strengthened and added to by a pupil (see small boat to R.). *c.* 1806–7.

D 38 OLD JETTY, NORFOLK (Plate 35b)

Pencil. $9\frac{1}{2} \times 15$.

Coll.: Untraced.

Prov.: Samuel Paget; Sir James Paget Bart.

Lit.: Dickes pp. 118–9.

Elise Paget. *Mag. of Art.* 1882, p. 244 repr.

Connects with series of oils and water-colours made shortly before the jetty was pulled down and when Crome was teaching the Paget family at Yarmouth. Described by Dickes as being drawn with two pencils, a technique also found in *Drayton* (D 32), probably similar in handling to B.M. pencil drawing of *Yarmouth Jetty*. Note equally incompetent drawing of wheels. Not seen. *c.* 1806–8.

D 38x COTTAGES WITH A BIRD CAGE

Pencil and indian ink wash. $12\frac{1}{2} \times 17$.

Coll.: Mr and Mrs D. P. Clifford.

Prov.: Leonard Bolingbrooke; Fairhurst.

Two thatched cottages; part of one close up R. and the other in middle distance, C. broken ground and tree L. with four figures lightly indicated. Washing line hangs between cottages, beneath it two pigs; bird cage or lobster pot hangs from nearer cottage wall. Similar to *Farm Buildings* (D 25) and *Cottage Gable in Ruins* (D 39). *c.* 1806.

D 39 COTTAGE GABLE IN RUINS (Plate 24)
 (THE BEE SKEP)

Pencil and water-colour on laid paper. $9\frac{9}{10} \times 8\frac{1}{4}$.

Coll.: N.C.M. (732–235–951).

Prov.:	J. N. Sherrington; Mrs Caleb Rose (Sherrington's widow); her Sale Christie's 30 March 1908 (7); bt. R. J. Colman by whom presented.
Exh.:	Nor. Crome Centenary 1921 (62).
Lit.:	Baker pp. 180, 185.
	Colman Cat. p. 129, No. 732.
	Colman Mss. Cat. Vol. II, p. 250, No. 70l.
Condition:	Very faded and soiled, trimmed all round except at the bottom, laid down, thin in places, hole to R. of group of children.

Unfinished. Colour is predominantely buff, but touches of grey, blue green and brick red can be made out. In the middle distance two children at play embracing each other underneath the bee skep, in the foreground is a pool and around it in outline some ducks. When fresh this drawing must have looked very like the *Tintern Abbey* sketch (D 42). In vision, palette and technique it is not far removed from water-colours of Cotman and Thirtle of 1805–7. *c.* 1805–6.

D 40 BOAT BY RIVER BANK, EVENING (Plate 36b)

Water-colour on laid paper. $8\frac{3}{5} \times 12\frac{1}{2}$.

Inscribed:	Or signed, verso in pencil: *J. Crome.*
Coll.:	Mr and Mrs D. P. Clifford.
Prov.:	Dr and Mrs D. Kirkham.
Exh.:	Maidstone, Eastbourne, Worthing. 1966/7 (53) (*as* Nor. School).
Condition:	Burn bottom L. corner; faded.

Palette of pale pink, soft browns, pearly greys and greens, like that of *The Mill Wheel* (D 16). The inscription verso seems autograph. It is probably a coloured field sketch like *Tintern Abbey—Sketch* (D 42) and Mellon's *A Boatload* (D 46). Composition is similar to *King's Head Gardens* (D 31). The influence of Turner is apparent. *c.* 1805–10, or later.

D 41 STUDY OF A MOATED HOUSE (Plate 11)

Pencil on laid paper. $9\frac{3}{5} \times 12$.

Coll.:	Mr and Mrs D. P. Clifford.
Prov.:	From a Suffolk album of drawings.
Inscribed:	Verso in pencil: *Mr. Crome, Norwich.*
Condition:	Rubbed, top corners clipped.

?Hunstanton Hall. Two slight pencil sketches of a donkey's head on the reverse. Pencil work is similar to that underlying *Tintern Abbey—Sketch* (D 42). *c.* 1802–7.

D 42 TINTERN ABBEY—SKETCH (Plate 10)

	Pencil and water-colour on laid paper. $13\frac{1}{2} \times 9\frac{1}{10}$.
Coll.:	N.C.M. (1311–235–951) as James Stark.
Inscribed:	In pencil top L. *No. 30* (? artist's hand), bottom L.: *T. Hearn* and top R. indistinct writing + *227* (? artist's hand).
Prov.:	R. J. Colman, by whom presented.
Copies:	*See below.*
Condition:	Excellent, unfaded.

Palette of pale greeny blues, grey, yellow-green and pink. Pencil work underlying architectural details consists of broken lines, dots and small areas of diagonal hatching. There is very little pencil indication beneath foliage. Composition quartered in pencil probably not for transference but to establish horizontals and verticals. Handling similar to *Dolgelley, N. Wales* (D 9) and *River Scene with Buildings and Barges* (D 211). All three are sketches made in the open air. The colouring would probably be similar to *Cottage Gable in Ruins* (D 39), had that not faded. This is a view of Tintern Abbey from the crossing looking N.W. at the nave and N. aisle. Crome went to Tintern in 1804 with Robert Ladbrooke.[1] In 1805 Crome exh. at Nor. *An Interior view of Tintern Abbey* (159), and *An Interior of Tintern Abbey* (210); in 1807 *Tintern Abbey* (13). Ladbrooke exhibited four pictures of Tintern between '05 and '07.

Crome was drawing master to the Gurney children from 1797 until probably *c.* 1808–9.[2] Three elaborate water-colours based upon this sketch still exist [copies a, b and c]. Although competent and Crome-like in places they are greatly inferior to this. The architectural drawing is weak, the drawing of foliage is too tight, and the figures lack conviction. In all three difficulty has been found in relieving the emptiness of the upper third of the drawing. Versions (*b*) and (*c*) still belong to the Gurney family. Version (*c*) according to family tradition is by Richenda Gurney (1782–1855). If we accept version (*c*) as by Richenda, the authors of versions (*a*) and (*b*) are still not clear. If all the drawings were made in 1805 Richenda would have been 23, Hannah 22, Priscilla 20, Samuel 19, Joseph John 17, and Daniel 14.[3] None of these drawings show Crome's idiosyncratic pencil-work underlying fan-shaped foliage which we have come to associate with 1804/5. Thus an 1806–7 dating would be preferable. There is no evidence, however, that Crome visited Wales at that time.

Versions (*a*) and (*b*) contain figures in the same positions. One figure sits on fallen masonry in the N. aisle sketching, while in the nave there are two figures in conversation, one seated, one standing. Their existence argues that between *Tintern Abbey — Sketch* and these three versions there may have been an elaborate exhibition water-colour by Crome now lost which contained these figures.

[1] Henry Ladbrooke's *Dottings.*

[2] It is not known when Crome ceased teaching the Gurneys. Louisa married in 1806, Hannah and John in 1807 and Samuel in 1808. The father, John Gurney, died in 1809. (Hare pp. 2 and 3.)

[3] See Table in Hare pp. 2 and 3.

In the same three collections as copies (*a*), (*b*) and (*c*) there are identical pendants. This is of Tintern Abbey from the crossing looking S. through windows of the S. aisle and S. transept. Neither the Crome sketch (see D 99) nor the more elaborate exhibition piece (if there was one) from which these derive is known. *c.* 1805–7.

COPIES:

(*a*) Pencil and water-colour. 19¼ × 15. (Plate 125b)

Coll.:	N.C.M. (740–235–951).
Prov.:	(?) John Thirtle; William Boswell by 1839; Samuel Howard Boswell; 1877, Bernard Boswell 1928; Sydney D. Kitson; P. M. Turner 1932; R. J. Colman 1934, by whom presented.
Lit.:	S. D. Kitson, *Life of J. S. Cotman* p. 104. Colman Cat. p. 740. D.C. p. 20, 38.
Condition:	Green washes now faded to tawny.

(*b*) Pencil and water-colour. 20 × 15. (Plate 126b)

Coll.:	J. H. G. Firth, Esq.
Prov.:	Dr Firth, Cotman's physician; to his grandson Owen Firth.

(*c*) By Richenda Gurney (later Mrs Francis Cunningham). 1782–1855. Pencil, water-colour and coloured chalks. 20¾ × 15¾ (sight). (Plate 127b)

Coll.:	Quentin Gurney, Esq.
Prov.:	By descent from the Cunningham family.
	Although drawn *c.* 1805–7 considerably altered and retouched in yellow, green and blue chalks in the 1830s or '40s as by then it was probably darkened and faded. A group of three (? Gurney) girls in long dresses and bonnets added in nave to L. Drawings of girls in similar costumes and studies in coloured chalks are in a Gurney family album at Bawdeswell Hall. Although the album is dated 1843 many of the drawings date from the early 1830s.

D 43 NEAR CAISTER, STUDY OF TREES (Plate 32)

Pencil and water-colour on laid paper. 20½ × 16½.

Coll.:	B.M. (1934–1–3–12).
Inscribed:	On old backboard in ink (possibly artist's hand) *Caister Castle, John Crome*, and inside in white chalk *Mrs De Rouillon, Chantry*.[1]
Prov.:	Said to have been given by Crome to Madame de Rouillon, by descent to the

[1] Madame de Rouillon with her two sisters the Misses Silke established a girls' school at the Chantry, Norwich after their father's death in 1795.

Misses Silke, Miss J. Oakley (*not* John as stated by Hind); her Sale, Sothebys, 19 December 1933 (88) bt. through H. L. Florence Fund.

Exh.: B.M. *English Art* 1934 (repr. in Cat. as frontispiece).

Lit.: A. M. Hind, *A Drawing by John Crome. B. M. Quarterly*, Vol. VIII, No. 4, 1934. p. 139 (ill).
Ritchie, *English Drawings*. 1935. ill p. 47 (detail).
Iolo Williams. p. 158.
Hardie. Vol. II p. 63 (with incorrect B.M. accession number).

Condition: Laid down; very faded but broad unfaded margin running all round.
Unusual appearance because basis of soft pencil underlies the wash. In original condition palette was of shades of rich green, brown and navy blue. Comparable wash handling is found in *Tintern Abbey* (D 42a) by one of the Gurney girls (*c.* 1807). Crome exhibited at Nor. Soc. in 1807 three Caister subjects: *Caister Castle* (17), *Caister Castle* (135), *Caister Castle coloured on the spot* (155). 1806–7.

D 44 HINGHAM, BLACKSMITH'S SHOP (Plate 38)

Water-colour on laid paper. $21\frac{1}{4} \times 17\frac{1}{4}$.

Coll.: N.C.M. (123–942).

Prov.: J. N. Sherrington; Mrs Caleb Rose (Sherrington's widow) her Sale, Christies, March 30 1908 bt. Sherwood (£52. 10s.); presented by P. M. Turner 1942.

Exh.: Lowestoft, 1948 (22).
Arts Council, 1948 (14).
Kettering, 1952 (13).
Harrogate, 1953 (30).
Art Exhibitions Bureau (Southsea), 1953/54 (23) ill. pl. 3.
Worthing, 1957 (46).
Derby and Nottingham, 1959 (30).
Manchester (Whitworth), 1961 (35).
China, 1963 (44).
East Berlin, 1963.
Bedford, Cambridge, Norwich, 1966 (22).
Rouen, May/June 1967.

Versions: (*a*) Oil at Philadelphia, U.S.A. (P 37).
(*b*) A related drawing is at Doncaster Mus. and Art Gal. (D 36).
(*c*) Copy. Water-colour. $22\frac{3}{4} \times 17$. Sothebys. 2 November 1967 (65) as Prout.

Lit.: Baker, p. 76, 115, 122, 180.
Dickes, p. 61.
Hawcroft, *Connoisseur*, Dec. 1959, pp. 234–5, pl. 9.
Hawcroft, *Burlington*, May 1966, p. 269.

Condition: Rubbed and faded: horizontal fold through centre; small hole top R; features of girl standing in shed probably strengthened with pencil later.

Strong toned water-colour now faded to dark blues, slate greys, pinks, dull crimsons and yellows. The sky originally blue and white is now fawn. Crome exhibited at Norwich in 1807 two *Blacksmith's Shops from Nature* (19, 100) and *Blacksmith's Shop, Hardingham* (81). An oil of the same subject was exh. at R.A. in 1808 (591). *Outside of Blacksmith's Shop* (83) was exhibited in 1811. Hingham and Hardingham are small adjacent villages. Probably one blacksmith served them both. The Doncaster drawing (D 36) was probably exhibited in 1807 and the oil at Philadelphia based upon this drawing is likely to have been exhibited at the R.A. in 1808. This drawing is likely to have been produced a little later than Doncaster's (i.e. *c.* 1806–7). The preoccupation with strong tonal contrasts and simplified mass suggests late 1807 or 1808. In an unfaded condition it must have looked like a Cotman of *c.* 1808/9. Hawcroft in the Burlington (loc. cit.) related it to N.C.M.'s *Silver Birches after Pijnacker* (but this we believe not to be by Crome) for colour and described it as '*probably no later than 1811.*'
c. 1807–9.

D 45	AN ENTRANCE TO EARLHAM PARK, NEAR NORWICH (Plate 39)

Pencil and water-colour on laid paper. $22\frac{1}{4} \times 18\frac{1}{8}$.

Coll.:　Mr and Mrs Paul Mellon.

Exh.:　Washington, 1962 (27, cat. ill. pl. 25).
　　　　Richmond, Va. 1963 (167).
　　　　Colnaghi, London 1964 (47).

Copies:　(*a*) *Walnut Tree Walk, Earlham* attr. to Crome but by George Vincent, oil on canvas ($23\frac{1}{2} \times 19$) in City Art Gallery, Birmingham (No. 597 '28). It differs in many respects. It has a group of four black headed sheep to L. of open gate.
　　　　(*b*) Water-colour copy ($22\frac{1}{2} \times 17$) in collection of Quintin Gurney, Esq.; exh. as *by Crome* at Jacksonville, Nashville, and New Orleans (1967 (17) Repr. with Dr Goldberg's notes in Cat.

Lit.:　*Apollo*, Vol. LXXVII, no. 14, April 1963. Repr.
　　　　D.C. pp. ix, 20 and pl. 10a.
　　　　D.C. O.W.C.S. 1966 Vol. XLI, p. 37.

Condition:　Faded to a uniform brown.
Earlham Park was the seat of John Gurney. Crome was drawing-master there in January 1798 and probably continued until circa 1809. This drawing is a little lacking in assurance, the palings are insubstantial and branches are superficially drawn. Probably a studio work based on a pencil drawing in which the branches were only inadequately indicated. This feature occurs in *Trees over a Stream* (D 34). Drawn probably not long after *Hingham, Blacksmith's Shop* (D 44), may be connected with *Walnut Grove* exhibited Nor. Soc. 1808 (197).
　　Version (*b*) is a copy probably by one of the Gurney girls. Dr Goldberg, however, accepts it as autograph and identifies the spot as the *Chestnut* (? not Walnut) Walk leading from Earlham Woods into Earlham Park.
c. 1807–8.

D 46

A BOATLOAD (Plate 36a)

Water-colour. $4\frac{7}{8} \times 9\frac{1}{8}$.

Coll.: Mr and Mrs Paul Mellon.
Prov.: Sir Bruce Ingram; L. G. Duke, C.B.E.
Exh.: Washington, 1962 (27).
Richmond, Va. 1963 (166).
Colnaghi, London, 1964/5 (70).
Lit.: Hardie, Vol. II, pl. 49.
Study made probably at Yarmouth when Crome was working on his series of oils of Yarmouth Jetty (*c.* 1807–9). Compare the figure drawing especially in Mellon Coll. oil of *Yarmouth Jetty* (P 41). Similar figures are found in *Blacksmith's Shop, Hingham* (D 44) and in *Entrance to Earlham Park* (D 45). Dr Goldberg suggests that this is '*a preparatory study*' for Sir Martyn Becket's oil of *A Barge with a Wounded Soldier* (P 48) which he dates *c.* 1815/16. We would prefer an earlier date relating it to *Below Cliff, Cromer Beach* (P 49) which was probably Exh. in 1809. Nor does it seem to be a preparatory study for the Becket picture. Perhaps connected with *Fisherman in Boats* Exh. in 1808 and now not known. *c.* 1808.

D 47

OLD HOUSES AT NORWICH (Plate 40)
(RUINED HOUSES)

Pencil and water-colour on (?) laid paper. 28×21.

Coll.: Victoria and Albert Museum (S. ex. 8–1885).
Prov.: bt. by Mus. in 1885.
Lit.: V. & A. Mus. Cat. p. 149, repr. as picture p.c. 1927.
K. Smith, p. 175.
Baker p. 160, 179, 199, pl. LI.
Hardie, Vol. II, p. 63.
Condition: Faded; tear top L. of centre and bottom R. of centre.
The largest of Crome's water-colours. Buildings have now attained solidity and texture; the figure drawing is competent and there is a Cotman-like interest in pattern making. Comparable with N.C.M.'s *Blacksmith's Shop, Hingham* (D 44) and Manchester City Art Gal.'s *Houses and Wherries on the Wensum.* (D 52). *c.* 1807–9.

D 48

BACK RIVER, NORWICH (Plate 26a)
(VIEW AT HELLESDON)

Pencil and indian ink wash. $4\frac{5}{8} \times 10\frac{5}{8}$.

Coll.: N.C.M. (737–235–951).
Verso: Slight pencil drawing of foliage.

Prov.:	James Stark; Mrs Arthur Stark; Sir H. S. Theobald, K.C.; bt. from him by R. J. Colman, February 1910; by whom presented.
Exh.:	Nor. Loan Exh. 1903 (66) lent Mrs Arthur Stark.
	Nor. 1921 (70) Crome Centenary.
Version:	(*a*) Oil in Coll. of Hon. Doris Harbord (P 34). This picture was in Dawson Turner's Coll. and was engraved in his *Outlines in Lithography*.
Lit.:	Colman Mss. Cat. Vol. II, p. 254.
	Colman Cat. 737. Baker pp. 120, 180, 185, 198.
Condition:	Rubbed and faded, central vertical fold, top R. corner made up. Pencil outline can be seen under house to far L.

Study for the Dawson Turner oil. One of the last of the group of indian ink drawings that seem to begin *c*. 1804. Treatment of foliage similar to N.C.M.'s *Thatched Cottage* (D 49).

c. 1807–8.

D 49 THATCHED COTTAGE (Plate 26b)

Pencil and indian ink wash. $6\frac{1}{2} \times 8\frac{1}{4}$.

Coll.:	N.C.M. (731–235–951).
Prov.:	James Reeve; Sir H. S. Theobald; bt. R. J. Colman February 1910, by whom presented.
Exh.:	Nor. Crome Centenary 1921 (73).
Version:	An oil, formerly with P. M. Turner (photo in Witt), freely painted with heavy impasto, a figure added to the R. Probably a forgery based on this water-colour.
Lit.:	Baker, p. 130 (measurements given in reverse), pp. 180, 185 (but omitted under Reeve coll., p. 195).
	Colman Cat. No. 731.
Condition:	Poor; sky rubbed and retouched, foxing scratched out. Tear L. of centre, puff of smoke to L. of chimney stack put in by restorer to cover rubbed area.

Probably a demonstration piece for pupils. *Mountain Scene* (D 22) also from Reeve's coll., perhaps served the same purpose. The delicate nervous pencil work beneath the door of the cottage is like that underlying the bank on the L. of *Old House Beside a River with Overshot Mill* (D 26).

c. 1806–8.

D 50 YARMOUTH JETTY (Plate 35a)

Pencil and water-colour. $3\frac{1}{2} \times 8\frac{1}{4}$.

Coll.:	Tate Gallery (3211).
Prov.:	Miss Fanny Martineau of Bracondale, Norwich to Miss Harriet Higginson, given by her in 1917.
Lit.:	K. Smith, p. 173.
	Baker, p. 179.

DRAWINGS

Condition:	Faded to fawns and russets, paper laid down.

This drawing seems to have been made in connection with an oil (P 45) now in the coll. of Sir Edmund Bacon Bt. Style is generally reminiscent of Francia. Handling is similar to Crome's *Houses and Wherries on the Wensum* (Whitworth version) (D 51).

c. 1808–9.

Copy: Water-colour on wove paper. $3\frac{7}{10} \times 8\frac{2}{5}$.

Coll.: Mr and Mrs D. P. Clifford.

Exh.: Maidstone, Worthing, Eastbourne. 1966–7 (16) (Cat. repr. pl. 6).

Condition: Good, slight fade. A meticulous less faded replica, probably not by Crome.

D 50x FISHING BOATS OFF SHORE

Pencil and water-colour. $6\frac{1}{2} \times 9\frac{7}{8}$ (sight).

Coll.: R. T. Gardner, Esq.

Prov.: ? Anon (Rainger) Sale, 28 Feb. 1863 (4) Walker; bt. Fine Art Soc. 1953, sold May 1954 to H. M. Langton; his Sale Christies. 12 Dec. 1967 (159) bt. Beckett. Evidently at Yarmouth. Wedge-shaped shore broadening to L. Group of fishermen and boats dragged up on sand, more vessels further out to sea. Grey and fawn washes with touches of yellow, brown, and pink. Reminiscent of *Old Jetty* (D 38) and *Yarmouth Beach and Mill* (P 50).

See D 79. *c.* 1808–9.

D 51 HOUSES AND WHERRIES ON THE WENSUM, NORWICH (Plate 44)
 (HOUSES AND WHERRIES ON THE YARE)

Pencil and water-colour on laid paper. $11\frac{3}{4} \times 15\frac{5}{8}$.

Coll.: Whitworth Art Gallery, Manchester (1815).

Prov.: Colnaghi, 1945, bt. Sir Thomas D. Barlow, Bart., pres. by him and the Friends of the Whitworth.

Exh.: Huddersfield 1946 (127).

Agnews 1954 (40).

Arts Council, 1960 (28).

Manchester, Whitworth, 1961 (39).

Washington and New York, 1962 (31), Colnaghi, 1967 (37).

Version: Finished water-colour with differences at City Art Gallery, Manchester (D 52).

Lit.: Williams p. 156.

D. C., pp. ix, 21, 38, pl. 13.

Twenty Early English Water-Colour Drawings in the Whitworth Art Gallery. 1951, pl. 13.

Hawcroft, *Burlington*, 1966 p. 268.

Condition: Good, but faded.

Hawcroft (op. cit.) identified scene as River Wensum at back of King Street, Norwich. It was formerly, like the Manchester City Art Gal. version, catalogued as *On the Yare.*

Washes of pink, grey and yellow overlying a basis of soft pencil. Artist has established his vertical by a pencil line cutting into sky L. of apex of house roof, to L. A typical Crome compositional device in ogee-line bottom L. corner. Rigging of wherry under full sail (in front) to R. is scratched out. According to Williams, in 1945 *'caused considerable argument whether it was by Crome or Thirtle.'* We believe it to be autograph and to have been drawn at about the same date as *Old Houses at Norwich* (D 47) and *Yarmouth Jetty* (D 50). Precedes City Art Gallery version.

c. 1808–9.

D 52 HOUSES AND WHERRIES ON THE WENSUM, NORWICH (Plate 45)
 (HOUSES AND WHERRIES ON THE YARE, NORWICH)

Pencil and water-colour. $16\frac{1}{2} \times 22$.

Coll.: City Art Gallery, Manchester (1947–125).

Prov.: James King, Liverpool; Lt.-Col. J. B. Gaskell, bt. 1916, in his coll. 1920, G. Beatson Blair, bequeathed to Mus. 1941.

Exh.: Possibly Nor. and Eastern Counties. 1867 (789).[1]
Nor. 1921 (80) Crome Centenary.

Version: Preliminary water-colour at Whitworth (D 51).

Lit.: Baker, p. 141, 179, pl. LII.
Williams, p. 156.
Hawcroft. Note to Nor. School Exh. Cat. Whitworth, 1961 (39).
Hardie Vol. II [with footnote wrongly identifying it with D 51].

Condition: Good, but faded, laid down.
Palette generally grey with washes of pink, sandy brown and blue.
Later than (D 51), in which the mast of centre wherry is visible through foreground rowing boats and alterations in pencil can be seen to stakes bottom L. This drawing is larger, and seems finished for exhibition. Hawcroft suggests by a close follower. Compare *View of the Thames at Battersea* (D 56) and V. and A. Mus. *Old Houses* (D 47).

c. 1808–19.

D 53 BY THE ROADSIDE (Plate 42)

Water-colour on (?) laid paper. $10\frac{1}{4} \times 8\frac{1}{4}$.

Coll.: Whitworth Art Gallery, Manchester (138).

[1] A water-colour drawing was loaned by Mr John King of Princes Street, Norwich. (See Cat. of Exh. in B.M.)

Prov.: bt. from Agnew. 1905.
Exh.: Nor. 1921 (81) Crome Centenary.
 Arts Council 1948.
 Agnew 1954 (41).
 Arts Council, Switzerland (1955/6) (51). Liverpool University, 1961.
Lit.: K. Smith, p. 175.
 D.C., pp. viii, 19 and pl. 7b.
 Hawcroft, *Burl. Mag.* May 1966, p. 268.
Condition: Faded, slightly scratched and rubbed.
 Colouring: rich blue sky; above horizon soft pink glow of evening. Road tan and olive brown, green-blue foliage.
 Slightly earlier than *Wood Scene* (D 58), it relates more closely to *River through the Trees* (D 54). The composition is reminiscent of the first two states of the etching *At Colney* (E 1) which dates from, probably, *c.* 1810–12.
 c. 1808–10.

D 54 THE RIVER THROUGH THE TREES (Plate 41)

 Pencil and water-colour on laid paper. $13\frac{7}{8} \times 18$.
Coll.: Sir Edmund Bacon, Bart., K.B.E., T.D.
Prov.: Sir Hickman Bacon, Bart., Coll. No. 837.
Exh.: Agnew 1945.
 Arts Council 1946.
Lit.: Williams p. 1954.
 D.C. p. ix, 19, pl. 9a.
 Hawcroft, *Burlington*, May 1966, p. 268 (mistitled as *Trees on a Bank*).
 Hardie, Vol. II, p. 63.
Condition: Laid down, creased by having been folded into small squares, rubbed, faded. Middle distance a pencil outline of man wearing a top hat and holding a shot gun. Palette of rich greenish blues, slate greys and yellows, similar to N.C.M.'s *Blacksmith's Shop* (D 44) (*c.* 1808). It is probably of a similar date to *By the Roadside* (D 53) but precedes *The Beaters* (P 56). The influence of Gainsborough's Suffolk landscapes is apparent. D.C. (op. cit.) suggested a date of *c.* 1802 but it is clearly later.
 c. 1807–8.

D 55 LANDSCAPE WITH COTTAGES (Plate 46)
 (THE SHADOWED ROAD)

 Water-colour. $20\frac{1}{2} \times 16\frac{3}{4}$.
Coll.: Victoria and Albert Museum (620–1877).
Prov.: bt. Christies, S. Redgrave Sale, 24 March 1877 (240).

DRAWINGS

Lit.: V. & A. Cat. p. 149; repr. as an official p.c. (1927).
Smith, pp. 149, 175.
Baker, pp. 45, 162, 179, 199, pl. XXV.
Williams, p. 154, pl. CXXI, Fig. 249.
D.C. O.W.C.S. 1966, Vol. XLI, p. 37.
Jellicoe, *Studies in Landscape Design*, pl. 24.
T. S. R. Boase, p. 35, pl. 18(a).

Version: Water-colour. 15 × 17¼. Probably by Robert Dixon (1780–1815) in coll. of Miss U. P. Terry, Detling. (Plate 128).

Condition: Faded and rubbed.

The Terry water-colour, a horizontal composition, is inscribed verso in pencil: (?) *Stanley's Cottage* followed by a less distinct word that might be *Poringland* (or *Borryland* ?). If by Dixon it provides us with a *terminus ante quem* for Dixon died in 1815. Vision is entirely Crome, handling of trees to R. similar to parts of *By the Roadside* (D 53). Probably precedes *Wood Scene* (D 58).

c. 1808–10.

D 56 VIEW ON THE THAMES AT BATTERSEA (Plate 43)

Pencil and water-colour on wove paper. 8⅛ × 11⅜.

Coll.: Whitworth Art Gallery, Manchester (2072).

Prov.: Agnew; Sir Thomas D. Barlow Bart, by whom pres. 1956.

Condition: Badly faded.

Some features lack assurance although the drawing has many Crome-like characteristics. The bark of the pollards is indicated by sharp emphatic parallels overlaying an uneven wash; the washes of the bank are interrupted by dots of the brush point; the delicate handling of the distance recalls the Tate's *Yarmouth Jetty* (D 50). On the other hand the distance between a tree trunk to the L. and a boat moored behind it is ill-defined and the branches and foliage of the pollards have little depth or variety. This, in the main, is due to fade. In composition compare De Wint's water-colour *On the River Witham* at the Laing Art Gallery which is perhaps nearly contemporary. The type probably derives from Rembrandt's etching *The Omval*, 1645 (Hind. 210).

c. 1807–10.

D 57 THE BLASTED OAK (Plate 47)

Pencil and water-colour. 23 × 17¼.

Coll.: Sir Edmund Bacon, Bart. K.B.E., T.D.

Prov.:	Probably Palser Gallery, 1908. £63.[1] bt. Sir Hickman Bacon, Bart.
Exh.:	Agnew 1945.
	Arts Council 1946 (54).
	Arts Council 1951 (57).
	Norwich 1955 (30).
	Geneva and Zurich 1955/6 (50).
	Manchester (Whitworth) 1961 (38) ill. in cat.
	King's Lynn. 1967.
Lit.:	Iolo Williams p. 153–4
	Hawcroft O.W.C.S. XXXVII, 1962, p. 23 and 33.
	D.C. p. ix, pl. 11a.
	Illustrated London News, 22 September 1951 (repr.).
	Hardie Vol. II, p. 63 pl. 50.
	Illustrated London News 29, July 1967 (repr.).
Condition:	Faded to fawn all-over, slightly scratched and rubbed. Damaged in Tate Gallery flood.

The drawing's chief glory must have been the sky which is now gone. A seated figure half-way up the track stroking the head of a dog has been outlined in pencil. A similar figure recurs in the *Walnut Grove, Entrance to Earlham Park* an oil after Crome (by Vincent) at the City Art Gallery, Birmingham. A similar treatment of foliage and palings is found in N.C.M.'s *Hingham, Blacksmith's Shop* (D 44). The dotted treatment of the cart ruts and indication of certain areas of foliage and bark of tree trunks is like *Wood Scene* (D 58).

Probably *c.* 1808–9.

D 58 WOOD SCENE (Plate 48)
(GROVE SCENE, LAKE IN DISTANCE)

	Water-colour. $22\frac{1}{4} \times 16\frac{1}{4}$.
Coll.:	Victoria and Albert Museum (1749–1871).
Prov.:	William Smith gift, 1871.
Exh.:	B.I. 1850 (99) lent W. Smith.
	Probably Soc. of Arts 1861 (23).
	V. & A. 1896 (68), First Circulating Exhibition (cat. pp. 19–20).
	Whitworth, Manchester 1961 (37).
	U.S.A. 1967.
Lit.:	V. & A. Cat., p. 149.
	K. Smith, p. 174.
	Dickes, pp. 147–8.
	Baker, pp. 45, 138, 179, 197, 199.
	Williams, p. 154.

[1] See Hawcroft, op cit. (O.W.C.S.).

D.C., pp. ix, 20, 38, 43, pl. 12.

Reynolds, *Introduction to English Water-colour painting*, p. 58, pl. 36.

Hardie, Vol. II, p. 63.

Condition: Rubbed and faded, horizontal fold above centre, small tears along L. edge.

Original of *Lane Scene near Norwich* (version *a*). Made when Crome was trying to draw trees more realistically. Branches and trunks have variety in rhythm and texture, and types of foliage are differentiated. Produced a little later than *River through Trees* in which branches are seen more flatly. Baker suggested that this drawing is *Grove Scene, drawing in water-colours*, Exh. Nor. Soc. 1809. Sinuous branches like those in centre are found in soft ground etchings.

c. 1809–10.

Version:

LANE SCENE NEAR NORWICH
(GROVE SCENE, LAKE IN DISTANCE)

Pencil and water-colour on laid paper. $22\frac{5}{8} \times 16\frac{5}{8}$.

Verso: Slight pencil drawing of tree trunks and branches.

Coll.: N.C.M. (735–235–951).

Prov.: J. N. Sherrington; Mrs Caleb Rose (Sherrington's widow), her Sale, Christies, 30 March 1908 (26) bt. R. J. Colman by whom pres. to Mus.

Exh.: Nor., 1921 (59), Crome Centenary.

Ipswich, 1927 (199).

Brussels, 1929 (179).

R.A. 1934 (713).

Lit.: Colman, Mss. Cat. Vol. II, p. 250, no. 70i.

Colman, Cat. 735.

Cundall, pl. XXVI.

Baker, pp. 45, 138, 180, 185.

Williams, p. 154.

Barnard, pl. 38.

Hardie, Vol. II, p. 63.

Condition: Blue and white sky, chocolate browns and green trees are now faded to all-over tawny brown.

Excellent replica of V. & A. Mus. *Wood Scene* (c.f.). Although generally accepted as autograph, lacks assurance and substance. Rocks bottom L. corner are less solid, sinuous branch growing out from behind large tree to L. of centre path is ambiguously placed, obvious pentimenti above centre path in sky are missing, foliage to R. of tree to extreme R. is left empty as though Crome's tonal patterning is too complicated to imitate. By a very good Crome pupil? Early J. B. Crome.

D 59 TO D 64 WERE TAKEN FROM AN ALBUM BELONGING TO THE ROUND FAMILY OF SUFFOLK. MANY HAD BEEN INSCRIBED *CROME*. THEY WERE PROBABLY DRAWN *c.* 1810–12.

DRAWINGS

D 59

FIGURES BY A BUILDING

Pencil on wove paper. $8\frac{3}{10} \times 6\frac{1}{10}$.

Coll.: L. G. Duke, C.B.E. (D. 504).

(Tree L. Thatched building behind, 4. figs. and dog in foreground.)

This may be by Thomas Harvey of Catton (cf. album in B.M.).

D 60

HEAD OF A DONKEY

Pencil on wove paper. $4\frac{1}{5} \times 3\frac{3}{5}$.

Coll.: L. G. Duke, C.B.E. (D. 613).

D 61

MANED LION'S HEAD

Pencil on wove paper. $4\frac{1}{5} \times 6\frac{3}{5}$.

Coll.: L. G. Duke, C.B.E. (D. 3264).

Drawn from life in August 1811 when a lion was shown in Norwich and Yarmouth.

See: *Norwich Mercury*. August 3, 1811.

'*The Royal Menagerie on Castle Hill Norwich* from Exeter' Change, London. S. Polito's private zoo. *a Grand Exhibition of Living Curiosities*. [including] *A Noble Lion*. From Senegal, which has always been considered, even from its infancy, one of the finest of its species, is now the only full grown lion in this Kingdom; his Majestic appearance justly entitles him to the ancient name, 'The King of Beasts' striking every beholder with the idea of magnanimity and grandeur. . . .'

The advertisement incorporated an engraving of the lion. The zoo was to stay at Norwich for a week and then to move on to Yarmouth.

D 62

FIGURES ON SHORE, BOAT COMING IN

Pencil on wove paper. $4\frac{1}{2} \times 7\frac{1}{2}$.

Coll.: L. G. Duke, C.B.E. (D. 574).

Probably made at Yarmouth.

D 63

SHEPHERD WITH GROUP OF SHEEP, DISTANT LANDSCAPE WITH MOUNTAINS

Pencil on wove paper. $4\frac{3}{5} \times 7\frac{1}{2}$.

Coll.: L. G. Duke, C.B.E. (D. 479).

Possibly connected with P 66, that was probably exh. Nor. Soc. 1812 (100).

D 64 STANDING GIRL WITH BASKET

Pencil on wove paper. $4\frac{3}{8} \times 2\frac{4}{5}$.
WM: 1810.
Coll.: L. G. Duke, C.B.E. (D. 450).

D 65 BIXLEY—TREES ON A STREAM (Plate 50)
 (BIXLEY, A STUDY OF TREES BY A POOL)

Pencil, indian ink and light grey-brown wash. $6\frac{1}{8} \times 8\frac{7}{8}$.
Coll.: B.M. (1902–5–14–376).
Prov.: John Utling, friend of Crome, by inheritance to Mrs Copeman from whom bt. by James Reeve.
Version: Etched in soft ground in reverse (E 32).
Lit.: K. Smith, p. 174.
 Baker, pp. 179, 184, 195.
 Ritchie, *English Drawings* (1935) ill., p. 48.
Condition: Top L. corner missing and restored, pen line border all round.
 Drawing for soft ground etching. There are several minor differences. Single pollard to L. (to R. in etching) has more branches and foliage and it is raised upon a bank. Similar style of drawing without wash at N.C.M. *Pollards and Oaks* (D 66).
 c. 1809.

D 66 POLLARDS AND OAKS (Plate 52b)
 (THE BLASTED OAKS)

Pencil on laid paper. $6\frac{3}{4} \times 5\frac{3}{8}$.
Coll.: N.C.M. (37–59–935).
Prov.: J. B. Crome, pres. by P. M. Turner, 1935.
Inscribed: Top R.: *Old Crome*, and verso: *J. Crome, Norwich, Crome, J. Crome* and also bears the stamp (not in Lugt) of J. Berney Crome of five ostrich feathers rising from mantling surmounted by a label on which is inscribed his name.
Exh.: Arts Council, 1948 (17).
 Lowestoft, 1948 (25).
 Wisbech, 1960.
 Perhaps made in connection with a soft ground etching not completed. Compare D 65.
 J. B. Crome may have used this personal mark after 1819 when he was made court painter to H.R.H. Duke of Suffolk.
 c. 1809–10.

D 66x STUDY OF OAKS AND BEECH

Pencil and water-colour on wove paper. $12\frac{1}{2} \times 10$.

Coll.: F. L. Wilder.

Prov.: bt. from James Hayman before 1939.

Inscribed: *Drawn about the year 1820 in the garden of a cottage at St Gile's Gate, Norwich.* Detailed study of oak (?) branches in front of beech. Faded. The palette in grey and soft apple green with dull russet behind.

c. 1809–20.

D67 HEDGEROW WITH GRINDSTONE AND STILE (Plate 49b)

Pencil and water-colour on buff paper. $8\frac{2}{5} \times 13$.

Coll.: The Ipswich Museum (1954–96).

Prov.: ? Crome Sale; John Cockredge Bignold, given by him to his cousin, Isabella Cockredge (later Mrs Bulton) 1874, by descent to her daughter Isabella Cockredge Colman; Garrod Turner, his Sale, Arcade Hall, Ipswich July 30 1954 (140); bt. by the Museum.

Inscriptions: On verso:

Purchased at Old Crome's sale by John Cockredge Bignold who gave it to his cousin— Isabella Cockredge (afterwards Mrs Bulton)—who wrote this April 1874, Isabella Bulton, Hopton.

Beneath this is written:

Carshalten Park, Surrey, June 27, 1874. My Mother (Mrs. Bulton) thinks 'Old Crome' sketched this, she remembers it in his portfolio; 'Old Crome' sometimes inspected her drawings when (as Miss Cockredge) she was a pupil of Mrs. Frewer,[1] Norwich.

And beneath this is written:

John Crome—(known as 'Old Crome') born Dec. 21st 1769 [sic] died April 22nd 1821. John Burney Crome, son of the above died Sept. 4th or 15th 1842 aged 49 years. Isabella Cockredge Colman.

Condition: Very good, although slightly faded all over.

A rich deep-toned water-colour of chocolate browns, yellow browns, reds and blueish greens—the sky to the L. is blue. Highlights on the handles of the grindstone are scratched out.[2] The colouring is like that of Dixon and Thirtle circa 1808–10. We know of no other Crome water-colours using quite the same general technique yet all individual features are Crome-like. In the *Blacksmith's Shop at Hingham*, Doncaster (D 36), is a grindstone in proximity to some similarly drawn dock leaves. The closest point of contact is Crome's soft ground etching of *Waggon Wheels, c.* 1809 (E 27) where the close-up vision is the same, as is also the drawing's deep tonality, both contain objects that are notably solid, together with a similar type of foliage with broken hooked tips.

c. 1809–10.

[1] Mrs Frewer, the School mistress, was a founder member of the Nor. Soc. (D.C. p. 82).

[2] Scratched-out highlights are found in the water-colours *At Dunham, Norfolk*; *Waiting for the Ferry*; and *Landscape with cottages.*

DRAWINGS

D 68 POLLARD—TREE STUDY (Plate 49a)

Pencil and water-colour on wove paper. $9\frac{1}{3} \times 12\frac{1}{10}$.
Signed bottom L. in pencil: *Crome*.

Coll.: Ipswich Museum (1929–14).

Prov.: ? Thomas Churchyard;[1] apparently came in with the Churchyard gift 1913.

Condition: Slight fade.

Palette of slate-grey, blue-grey, pale green and russet browns. Handling of tree trunk similar to bark of pollards in Whitworth's *View of the Thames at Battersea* (D 56) and foliage a little like Bacon's *Oak Tree* (D 69). Although it is greatly superior to anything produced by them, it shows the source of Stark and Churchyard's tree style; Crome exh. at Nor. Soc. 1812 (197), *Study of Pollards—water-colours*.
Post 1810.

D 69 THE OAK TREE (Plate 51)

Pencil and water-colour. $11\frac{7}{8} \times 14$.

Coll.: Sir Edmund Bacon, Bart., K.B.E., T.D.

Prov.: Sir J. C. Robinson, his sale, Sothebys February 24 1914;[2] Sir Hickman Bacon, Bart. (coll. No. 754).

Condition: Slightly faded, on three irregular sheets of paper joined and laid down; disfigured by indentations over pencil lines perhaps made in preparation for an engraving.

One of the most faithfully observed of Crome's tree studies. Palette of dark olive green, brown and saffron yellow on pale buff paper. After 1809, but, if in connection with an engraving, probably before 1813. The form of the tree is similar to that shown in two Cotman pencil drawings at Fitzwilliam inscribed *Monarch of Kimberley* (D 187, 188). If of the same tree Cotman made it appear larger. At Crome Memorial Exh., Nor. 1821 (72) lent Mr Crome was *Sketch of an Oak in Kimberley Park*; the date given was 1813.[3]
? 1809–13.

[1] Churchyard's name is on the mount with that of Crome. Miss Butler gives (letter dated 1 March 67) Churchyard as apparent prov. Baker does not include it amongst known Churchyard owned Cromes. However in Freeman MS. at Nat. Gal. a *Pollard Tree* is listed as bt. by Freeman and sold to Thos. Churchyard. It has been tentatively identified as that which was later in T. Woolner's coll., and at his sale made £147. This drawing may be connected with that oil.

[2] Sir J. C. Robinson (1824–1913) married the daughter of Alderman Newton of Norwich (see Lugt. *Marques des Collections* p. 259).

[3] This was probably later in the Paget Coll. See Elise Paget, *Magazine of Art*, 1882 p. 224.

DRAWINGS

D 70 A VIEW AT OULTON, SUFFOLK (Plate 53a)

Pencil on wove paper. $5\frac{1}{2} \times 11\frac{1}{2}$.

Signed and
inscribed: With title bottom L.: *A View at Oulton Suff: J. Crome.*
Coll.: Ipswich Museum (18, 1942–56.)
Prov.: Gift of Mrs Marion E. Montagu of Bridport, who was connected with the Doughty family of Suffolk. The scene is said to be on land that belonged to her grandfather.
Related to *Glade of Trees overhanging Pool* (D 71) and *Trees and Bushes* (D 72).
It is just possibly by J. B. Crome. cf his (?) soft ground of *N.W. view of St Mary's Church, Hadiscoe.* Impression in B.M. (1902–5–14–674).
Probably after 1810.

D 71 GLADE OF TREES OVERHANGING POOL (Plate 53b)

Pencil on wove paper. $8\frac{1}{2} \times 12\frac{2}{3}$.

Paper mark: top R. corner impressed crown surrounded by label on which impressed (BRIS)TOL (PA)PER
Coll.: N.C.M. (22–59–935).
Prov.: given by P. M. Turner.
Inscribed: Top L.: *Old Crome* in pencil.
Related to *A View of Oulton Suffolk* (D 70). The style is close to J. B. Crome.
c. 1810–21.

D 72 TREES AND BUSHES (Plate 52a)

Pencil on wove paper. $7\frac{1}{3} \times 6\frac{2}{3}$.

Inscribed: Bottom R. corner in pencil: *Crome Senior.*
Coll.: N.C.M. (132–41–98).
From an album of drawings attributed to David Hodgson (1798–1864) and given in 1898 by Mrs D. Hodgson. Some drawings obviously not by Hodgson. Simplified drawing probably made for pupil, very similar to *Tree Trunks and Fence* (D 74) in same album with W.M. of 1817, although also like drawings made before 1810.
Perhaps 1810–17.

D 73 LANDSCAPE WITH TREES AND DISTANT HILLS

Pencil on wove paper. $6\frac{3}{5} \times 15\frac{1}{2}$.

Coll.: N.C.M. (99–41–98).

Prov.: From an album given by Mrs D. Hodgson, 1898.
Formerly attributed to David Hodgson (1798–1864) but by Crome. Group of four trunks L., around their base weeds and grasses, rolling hills R. Relates to *Trees and Bushes* (D 72) and *Tree Trunks and Fence* (D 74) in the same album. Similar type of broken tipped grass appears in soft ground etching of *Waggon Wheels, c.* 1809–10.
? *c.* 1810–18.

D 74 TREE TRUNKS AND FENCE

Pencil on wove paper. 7⅘ × 9.
WM: TURKEY MILLS. J. WHATMAN 1817.
Coll.: N.C.M. (225–41–98).
Prov.: From an album given by Mrs D. Hodgson, 1898.
Two trunks C. at their base scrub, palings L. Similar in technique to *Trees and Bushes* (D 72), from the same album, which is inscribed: *Crome Senior. c.* 1817–21.

SOME DRAWINGS PUBLISHED AS BY CROME AND PROBABLY BY HIM BUT NOT TRACED

These may in some cases duplicate drawings which appear in either the preceding or the succeeding list.

D 75 PENCIL DRAWING

Exh.: Nor. 1860 (234) lent Norgate.
Lit.: Baker, pp. 89, 156, 193.

D 76 HOLE FARM, KETTERINGHAM

Coll.: 1874. Sir Francis Boileau Bt.,
Exh.: Nor. 1867 (859).
Nor. 1874 (117) lent Boileau.

D 77 SKETCH OF MISS ANNE FISHER

Coll.: 1920. Mr N. E. H. Fisher.
Lit.: Baker, p. 135.

Drawings

D 78 FISHMARKET, BOULOGNE

 Pencil. 6 × 9¼.
Coll.: Frank Brown.
Exh.: Nor. 1921 (108) Crome Centenary.
 Presumably a Study for P 98.

D 79 YARMOUTH BEACH *with many figures charmingly grouped*

 Formerly coll. of Sir Richard Palgrave.
Lit.: Binyon, p. 27.
 Possibly D 50x.

D 80 PORTRAIT OF REV. RICHARD TURNER'S MOTHER
 OR MOTHER-IN-LAW

 Sitting reading in an armchair. c. 1811.
 Pencil.
Coll.: 1905. W. R. Fisher of Harrow.
Prov.: Rev. R. Turner.
Lit.: Dickes, p. 71.
 Elise Paget, *Magazine of Art*, April 1882, p. 221.

D 81 OLD SNAP THE LOCAL MONSTER *with long tail and man's legs*

 Pencil.
Coll.: Paget Family, Yarmouth.
Lit.: Elise Paget, *Magazine of Art*, 1882, p. 222.
 Dickes, p. 118.

D 82 MILL IN LANDSCAPE

 4 × 6½.
Lit.: Baker, (p. 147) No data; may have been a water-colour in Wynn Ellis Sale,
 May 6, 1876.

D 83

OLD SOUTH GATE, NORWICH

Sepia, rounded top. 6 × 6.
Coll.: Sir James Paget.
Lit.: Dickes, p. 146–7.
C. and L. ivy top ruin, on R. a street with tavern sign in front of one of the houses. Foreground river shore with an anchor and 2 boats drawn up against wall.

D 84

ASH AND POPLAR

Coloured wash. 15 × 15.
Coll.: 1920. Brown and Phillips
Prov.: T. Woolner; Augustus Walker.
Lit.: Baker, pp. 120, 179, 200.
Ash R. foreground: poplar c. middle distance. Wooded hill R. background, sand and scrub foreground.

D 85

COTTAGE AND RIVER

Exh.: Nor. 1860 (282) lent W. Wilde.
Lit.: Baker, pp. 89, 179.

D 86

POND AND FARM

Pencil. 7¼ × 9.
Signed and dated. 1811.
Coll.: 1921. Mrs Conrad Howell, Crowborough.
Prov.: Miss Gooding (b. 1800).
Drawn as a lesson for pupils at Miss Heazel's School, Nor.
Lit.: Baker, pp. 17, 156, 179, 191.
K. Smith, p. 45.
Pond with high sandy bank R. a thatched barn, C. a stile, in front of a low tiled shed, beyond a silver birch, trees across background.

DRAWINGS

D 87, D 88 RIVER SCENES Pair

$3 \times 4\frac{1}{2}$.
Coll.: W. S. Hobson, 1921.
Lit.: Baker, p. 179.

D 89 KIMBERLEY OAK

Exh.: Nor. 1821 (72). Memorial. lent J. B. Crome.
Lit.: Baker, p. 142.
 c. 1813?
 See D 69 note.

D 90 LANDSCAPE WITH AN OLD CASTLE

 Water-colour.
Coll.: Thomas Churchyard, his Sale Forsters 4 December 1867 (63) bt. Booth 4 gns.
 Possibly D4.

D 91 RUINS NEAR NORWICH

 Water-colour.
Coll : Thomas Churchyard, his Sale Forsters 4 December 1867 (64) bt. in £4 14*s.* 6*d.*

D 92 LANDSCAPE

Coll.: Thomas Churchyard, his Sale Forsters 4 December 1867 (65) bt. in £4 14*s.* 6*d.*

NOS. D 93 TO D 98 ARE DRAWINGS NUMBERED IN A TYPEWRITTEN
LIST PREPARED BY SIR CHARLES SHERRINGTON FOR CHRISTIES
AT THE TIME OF MRS CALEB ROSE'S SALE IN 1908. The titles were in some
cases changed in the printed catalogue and cannot always be identified there. Where drawings
in the Sherrington typescript are known to have appeared elsewhere in the list they have been
omitted here. Sherrington's identification of *Sepia* is unreliable for he confused it with indian
ink. These are at present untraced:

DRAWINGS

D 93 ROAD SCENE AND WATERMILL

Sepia. 8 × 12½.
This seems to have re-appeared as *A Landscape with old Cottages* (Lot 29).

Lit.: Baker, pp. 129, 130, 180.

D 94 GRANGE BRIDGE, NEAR ENTRANCE OF BORRODALE, CUMBERLAND

Sepia. 10 × 14.
Inscribed: *Verso* in ? artist's hand with name of the place
Re-appeared as *Grange Bridge, Borrodale* (Lot 4).

Lit.: Baker, pp. 137, 180.

D 95 OLD FARM BUILDINGS IN A WOODLAND GLADE

10½ × 14.
Perhaps re-appeared as *A Cottage among Trees* (Lot 5), but see also D 97.

Verso: Rough sketch in blue, mountain and lake scene.

D 96 SEA PIECE

7½ × 10½.
Verso: Inscribed in pencil: '*Sir my paper is bad. Mister Crome, my paper is bad*'.
Re-appeared as *Coast Scene with Shipping* (Lot 6). (Fishing smack with three figures, hailing a large vessel.)

Lit.: Baker, pp. 127, 180.

D 97 GABLED FARMHOUSE AMID TREES

13 × 9½. (rounded at one end)
Verso: More finished sketch of trees by a river bank with boat.
Perhaps re-appeared as *A Homestead* (Lot 30), but see also D 95.
Attributed to Crome.

D 98

STONE PIT

Water-colour. $22\frac{1}{4} \times 16\frac{3}{4}$.
Re-appeared with above title (Lot 27).
According to a letter that belonged to the Sherringtons Louis Huth wanted to buy this and the *Blacksmith's Shop* (now at Doncaster).

Lit.: Baker, pp. 165, 180.

D 99

LOST DRAWING OF TINTERN ABBEY
(TINTERN ABBEY, WINDOW)

This drawing is deduced from the existence of three pupils' copies of it.
(a) Pencil and water-colour, $19 \times 14\frac{3}{4}$. (**Plate 125a.**)

Coll.: N.C.M. (741–235–951).

Prov.: (?) John Thirtle; William Boswell, 1839;
Samuel Howard Boswell, 1877; Bernard Boswell, 1928; Sydney D. Kitson; P. M. Turner, 1932; R. J. Colman 1934, by whom presented.

Lit.: Colman Cat, 741.
S. D. Kitson. *Life of J. S. Cotman*, p. 104.
D. C., pp. viii, 20, 38, pl. 7a.

Condition: Green washes now faded to tawny brown.

(b) Pencil and water-colour, 20×15. (**Plate 126a.**)

Coll.: J. H. G. Firth, Esq.,

Prov.: Dr Firth, Cotman's physician; to his grandson, Owen Firth.

(c) By RICHENDA GURNEY (later Mrs Francis Cunningham) 1782–1855. Pencil, water-colour and coloured chalks. $21\frac{1}{2} \times 15\frac{3}{4}$. (**Plate 127a.**)

Coll.: Quentin Gurney, Esq.

Prov.: By descent from the Cunningham family.
Retouching in chalks and chalk washes of yellow, blue and green added *c*. 1830–40. See note to copy (*c*) of *Tintern Abbey—Sketch* (D 42).

View from the crossing looking S. through windows of the S. aisle and S. transept. D. C. accepted copy (*a*) as autograph but now agrees that it is by the same Gurney hand as *Tintern Abbey—Sketch* copy (*a*). Although the most competent drawing of the group, the architectural drawing is too weak. Possibly Crome worked on parts of the drawing like the foliage and figures to R. These figures may be intended to be of Crome, and Robert Ladbrooke. See note to *Tintern Abbey—Sketch* (D 42) as copies (*a*), (*b*) and (*c*) are pendants to the versions there described.

c. 1805–7.

DRAWINGS INCORRECTLY OR DOUBTFULLY ATTRIBUTED TO
CROME IN PUBLIC COLLECTIONS, AND DRAWINGS IN PRIVATE
COLLECTIONS WHICH HAVE BEEN PUBLISHED OR EXHIBITED AS
BY CROME. This list does not normally include drawings not by Crome which have
recently passed through the Trade. Unless otherwise stated all these drawings are regarded as
NOT BY CROME.

AT NORWICH CASTLE MUSEUM

D 100 (71–930) WROXHAM REGATTA

Pencil and water-colour. $7\frac{1}{4} \times 12\frac{1}{2}$.

Prov.: Possibly J. B. Crome Sale, Nor. 1831 (192).
 The Misses Thirkettle, by whom presented, 1930.

Exh.: Nor. 1921 (116) Crome Centenary.
 Kettering, 1952 (20).
 Harrogate, 1953 (33).
 Art Exh. Bureau, 1953/4, Southsea (24).
 Worthing, 1957 (18).
 Derby and Nottingham, 1959 (32).
 Manchester, 1961 (40).
 R.A., 1962 (390).
 Bedford, Cambridge, Norwich, 1966 (20).
 Jacksonville, Nashville, and New Orleans, 1967 (21) repr. in cat.

Lit.: K. Smith, pp. 56, 124, ill opp. p. 60.
 Hawcroft, *Burlington*, July 1959., p. 291, ill. fig. 49.
 D.C., p. 41.
 Mottram, p. 179.

Condition: Good and unfaded.

In the 1921 Exhibition it appeared not as *by J. Crome* but among the personalia
with a tentative attribution to Crome. Dr Goldberg (Nashville cat.) states that
the drawing seems to be a preparatory study for Barne's *Yarmouth Water Frolic*
and dates it to *c.* 1817–18. This may be, but we have no evidence. J. and J. B.
Crome worked on the *Yarmouth Water Frolic* and the snatches of landscape of this
drawing relate to the doubtful J. or J. B. Crome group of drawings (see note to
At Dunham). Although close to J. B. Crome it may be by his father, *c.* 1818–21.

D 101 (68–3–935) DRAMATIC ROCKS, Chalk and Wash, $12\frac{1}{5} \times 16\frac{3}{4}$. Possibly by
 Crome.
D 102 (1–59–935) by George Frost.
D 103, 104, 105 (4–6, 59–935).

D 106	(8–59–935)	by George Frost.
D 107, 108	(7, 9–59–935)	
D 109	(10–59–935)	WOOD SCENE WITH HORSE AND CART. Sepia. $6\frac{2}{5} \times 7\frac{9}{10}$. Possibly Crome or R. Ladbrooke.
D 110	(11–59–935)	SHED.
D 111	(12–59–935)	HAUTBOIS COMMON. (see P 126)
D 112	(13–59–935)	FARM AND POND. (see P 62)
D 113, 114, 115	(14–16, 59–935)	by hand of groups D 127–143.
D 116	(18–59–935)	by George Frost.
D 117	(19–59–935)	? by Laporte.
D 118	(20–59–935)	TWO TREES AND A COTTAGE.
D 119	(21–59–935)	WAYSIDE INN.
D 120	(23–59–935)	BACK OF THE NEW MILLS, early E. T. Daniell?
D 121	(24–59–935)	THATCHED COTTAGE WITH FOUR-BAR GATE, by J. B. Ladbrooke?
D 122	(25–59–935)	COTTAGE WITH GATE.
D 123	(37–59–935)	VIEW OF THE SEINE, PARIS.
D 124	(28–59–935)	(Pair to D 120) BACK OF THE NEW MILLS, early E. T. Daniell?
D 125	(29–59–935)	TREES.
D 126	(30–59–935)	LANDSCAPE WITH TREES, PATH TO L.
D 127	(34–59–935)	GROUP OF TREES WITH GATE.
D 128	(35–59–935)	LANDSCAPE WITH DISTANT VIEW OF TOWN.
D 129	(36–59–935)	
D 130, 131, 132	(44–46, 59–935)	by a hand close to Thomas Hearne.
D 133	(36–942)	TROWSE, NORWICH.

D 134	(112–936)	SILVER BIRCHES; AFTER PYNAEKER

Water-colour and body colour on wove paper. $9\frac{3}{4} \times 7\frac{7}{8}$.

Signed: Lower L., point of brush; *J. Crome.*

Prov.: Major Grant ?[1] P. M. Turner, by whom presented through N.A.C.F. 1936.

Exh.: Nor. 18? (145).
Kettering, 1952 (19).
Kidderminster, 1954 (4).
Worthing, 1957 (5).
Derby and Nottingham, 1959 (31).
Manchester, 1961 (36).
Bedford, Cambridge, Norwich, 1966 (19)
Jacksonville, Nashville, New Orleans, 1967 (19).

Lit.: *33rd Annual Report of the N.A.C.F.* 1937, p. 31, No. 1009.
Hawcroft, *Connoisseur*, December 1959, p. 236, fig. 12.

[1] Information from backboard of frame now in historic file N.C.M.

DRAWINGS

D.C., pp. ix–x, 21, 41 and pl. 14a.
Hawcroft, *Burlington*, May 1966, pp. 268–9.

Condition: Good, unfaded.

Dark greens, blues, browns and russets. Copied from L. half of *Landscape with Sportsmen and Game* by Adam Pynaecker (1622–73) in the Dulwich Gallery. (No. 86 see: A Brief Cat. of the Pictures in the Dulwich Coll. Picture Gal. 1953.) Dulwich was opened in 1814 and D.C. suggested that this copy was likely to have been made by Crome on his journey to France in that year. Hawcroft (*Burlington*) thought that this dating seemed *entirely acceptable*. However it is equally possible that J. B. Crome made this drawing on his journey to France in the following year. Crome's, or J. B. Crome's, *Trees by Water; After Cuyp* (Clifford Coll.) is also copied from a Dulwich picture and is by the same hand. A third unpublished water-colour, perhaps of this series although much inferior, is at Mount Allison University (Owens Coll., Department of Fine Arts, Sackville, N.B. Canada). It is *Landscape with Windmills: After J. Van Ruysdael* copied from Dulwich No. 168. Inscribed or signed, bottom R. corner, point of brush, *J. Crome* in a similar hand to that on *Silver Birches* although poor and inconceivably by John Crome it might be by J. B. Crome. In technique similar to *At Dunham, Norfolk* (B.M.). In both drawings after Dulwich pictures there is scratching and stopping out like that in an inscribed J. B. Crome of *Yarmouth Beach* (dated 1840), (D.C., p. xiv, pl. 43b). Hawcroft in the *Burlington* saw a relationship in palette to N.C.M.'s *Blacksmith's Shop*. We are strongly of the opinion that this is by J. B. Crome. Drawn in 1814 or 15.

D 135–151 (1–17, 133–942) sixteen drawings by the same hand, other than 6–133–942 which is by a hand close to Frost. Two drawings by this hand are at the Whitworth.

D 152 (729–235–951) LANDSCAPE NEAR LAKENHAM (VIEW NEAR LAKENHAM)

Water-colour on laid paper. $5\frac{1}{8} \times 10\frac{1}{2}$.

Prov.: R. Dixon; A. Dixon by 1815; Miss Pallant, Carlton Colville by 1891, her Sale, Cornhall, Norwich, 31 May 1893 bt. J. Reeve; Sir H. S. Theobald, K.C.; bt. from him February 1910 by R. J. Colman by whom presented.

Exh.: Nor. Loan Coll., 1903 (63).
Nor., 1921 (69) Crome Centenary Exh.

Lit.: Colman Cat. No. 729.
Colman Mss. Cat., Vol. 11, p. 254.
Baker, pp. 143, 180, 185, 195, 199.
Cundall, pl. XXVII.
D.C., pp. viii, 19, 38, pl. 6a.
Hawcroft, *Burlington*, May 1966, p. 268.

Condition: Rubbed and faded.

DRAWINGS

Bottle green, dark brown and indigo washes cover a basis of sepia. D.C. (p. 19): *not far from Girtin c. 1800.* Hawcroft agreed (op. cit.) but challenged its attribution: *it is surely by an artist more intimately connected with Girtin's circle, and not by Crome.* The title and Dixon provenance suggests that it may be by a Norwich artist. Robert Dixon himself in *c.* 1809/10 seems to have looked back to Girtin of *c.* 1800, and he was working in London in 1800. Both Cotman and Thirtle at times are close to Girtin. On the basis of this drawing another landscape of a similar subject (with Spinks 1964) has been attributed to Crome, but without traditional title or provenance this drawing is of little assistance. The Spink drawing has a pencil framework and, unlike *Lakenham*, the foreground is not broken up by strokes of the brush point interrupted by dots. It is close to William Pearson (see Hardie, Vol. II, p. 21, pl. 13).

D 153	(745–235–951)	COTTAGE WITH HIGH GABLE

Pencil and indian ink. 5 × 7.
Prov.: Sir H. S. Theobald; bt. February 1910 by R. J. Colman, by whom presented.
Lit.: Colman Cat. 745.
Condition: Laid down, circular stain and E-shaped tear R. of centre, rubbed.

Figure stands to R. of cottage, in centre distance another building. Nothing directly similar but compare *River Scene with Buildings and Barges* (D 211), and *Dolgelley, North Wales* (D 9). Possibly by Crome.
Perhaps *c.* 1805–10.

D 154	(730–235–951)	THATCHED BUILDINGS WITH FIGURES, Robert Dixon.
D 155	(736–235–951)	by George Frost.
D 156	(742–235–951)	TEMPLE OF VENUS, BAIAE (copy of P 19).
D 157	(743–235–951)	ROAD WITH POLLARDS, probably by W. H. Hunt of Yarmouth who was bequeathed the painting by J. N. Sherrington of which this is a copy.
D 158	(744–235–951)	FIGURE ON SHORE.
D 159	(748–235–951)	ROAD SCENE WITH HORSES AND CART. Indian ink. 8¾ × 6¾.

Prov.: Mr E. A. Bracey, grandson of the owner of the 'Bracey Crome'. bt. by R. J. Colman; by whom presented.
Lit.: Colman, Cat. No. 745, 8.
Colman, Mss. Cat. Vol. II, p. 252.
Baker, pp. 159, 180, 185 (?), 195.
Condition: Rubbed, area around horses very badly damaged by scratches and holes.
Although not of high quality, this modest little drawing would look finer in

better condition. Baker, p. 195 seems confused in stating that it was in James Reeve's Coll. The drawing is of the 1806/7 group but the quality is a little sub-standard. It is perhaps by a Crome pupil.

D 160	(749–235–951)	NEAR HINGHAM. There are drawings by this unknown hand in the collections of Lord Mancroft and of Constance, Lady Mackintosh.
D 161	(750–235–951)	VIEW NEAR NORWICH. (see P 103).
D 162	(751–235–951)	THATCHED BUILDINGS, by Robert Dixon.
D 163	(?–235–951)	LOWLAND LANDSCAPE, Dutch Seventeenth Century.
D 164	(?–235–951)	WALSINGHAM PRIORY, by J. B. Ladbrooke.
D 165	(752–235–951)	TREES AND COTTAGES.
D 166		(Thetford Museum Permanent Loan). CAISTER CASTLE, by J. B. Ladbrooke.
D 167	(135–922)	DEMOLITION OF INFIRMARY BUILDINGS, by Charles Hodgson, 1805.
D 168	(2–59–935)	OLD NORTH GATE, YARMOUTH, pencil, $7\frac{1}{2} \times 7\frac{3}{4}$. *Exh.:* Nor. 1921 (90) Crome Centenary.
D 169	(31–59–935)	HARDINGHAM COMMON, NEAR NORWICH, pencil and wash. $8\frac{1}{4} \times 12\frac{1}{2}$.
D 170	(32–59–935)	COTTAGE WITH SMALL TREES, pencil, $6\frac{1}{2} \times 7\frac{1}{5}$.
D 171	(33–59–935)	COTTAGE WITH TREES L. AND PATHWAY R. pencil, $5\frac{7}{10} \times 8\frac{1}{5}$.
D 172	(746–235–951)	CHURCH TOWER, pencil, $5 \times 8\frac{9}{10}$. Probably by Crome.
D 173	(747–235–951)	COTTAGE WITH HIGH GABLE, pencil, $6\frac{2}{5} \times 7\frac{1}{5}$. Probably by Crome.
D 174	(No number)	WHITEFRIAR'S BRIDGE, pencil, $13\frac{2}{5} \times 11\frac{2}{5}$.
D 175		THE ROEBUCK, THORPE, water-colour, $8\frac{1}{2} \times 12\frac{1}{2}$.

AT THE VICTORIA AND ALBERT MUSEUM

D 176	(643)	RUINED CASTLE—EVENING, by Robert Dixon.
D 177	(623–1877)	STUDY OF TREES, by George Frost. A chalk drawing by Frost of this was in the Esdaile Collection. *Exh.:* Jeudwine, Alpine Club, May 1966 (42).
D 178	(E.5767–1910)	STUDY OF FOREST TREES. Probably not by a Norwich hand.
D 179	(213)	MAGDALEN GATE, NORWICH

Black chalk heightened with white, indian ink wash on grey-blue paper. $4\frac{1}{4} \times 7\frac{1}{4}$.

Prov.: Gift of Sir J. C. Robinson about 1859.
Mark bottom R. and L. of Mus. (Lugt. 80).

Lit.: V. & A. Cat., p. 148.
Binyon, p. 27 (?).
Dickes, p. 146.
K. Smith, p. 174.
Baker, pp. 146, 179, 196, 199.
Pair to *King Street, Norwich* (D 180) in same Mus. Not signed as stated in V. & A. Cat. In medium unlike anything attributed to Crome other than *Dramatic Rocks* (D 101). The handling of the wash recalls Fitzwilliam Mus. *River Scene.* If by Crome probably produced after *c.* 1812. Possibly by Thirtle.

D 180 (214) KING STREET, NORWICH

Black chalk heightened with white, indian ink wash on grey-blue paper. $4\frac{1}{4} \times 7\frac{1}{4}$.

Prov.: Gift of Sir J. C. Robinson about 1857.[1]
Mark bottom R. and L. of Mus. (Lugt 80).

Lit.: V. & A. Cat., p. 148.
Binyon, p. 27 (?).
Dickes, p. 146.
K. Smith, p. 174.
Baker, pp. 142, 179, 196, 199.
Pair to *Magdalen Gate, Norwich* in same Mus. (see note). Not signed as stated in V. & A. Cat.[2] The medium incorrectly described by Baker as sepia. For a view of *King Street* in the opposite direction see the two Manchester water-colours *Houses and Wherries on the Wensum.* If Crome after 1812, but closer to Thirtle.

IN THE WITT COLLECTION, COURTAULD INSTITUTE

D 181 (4294) BURDOCK, just possibly by Crome.
D 182 (1397) COTTAGE AMONG TREES.
D 183 (4536) PIGS, a sketch, by George Frost.
D 183x LANDSCAPE WITH TREES AND COTTAGES, indian ink with traces of pencil on laid paper, $5\frac{7}{8} \times 8\frac{1}{2}$. Possibly by Crome.

IN THE WHITWORTH INSTITUTE, MANCHESTER

D 184 (1463) EDGE OF STREAM } by same hand as (D 135–151)
D 185 (1464) COTTAGE IN A WOOD

[1] Sir J. C. Robinson (1824–1913) married a daughter of Alderman Newton of Norwich (see Lugt. *Marques des Collections*, p. 259).
[2] J. C. paraph. top R. corner probably an unrecorded collector's mark. As Berney Crome had a personal stamp (see D 66), it is possible that his father had one also but unlikely.

DRAWINGS

IN THE FITZWILLIAM MUSEUM, CAMBRIDGE

D 186	(3232)	TREES ON A BANK, water-colour.
D 187	(3252 'a')	MONARCH OF KIMBERLEY, pencil, by J. S. Cotman, c. 1803–4.
D 188	(3252 'b')	MONARCH OF KIMBERLEY, pencil, by J. S. Cotman, c. 1803–4.
D 189	(1679)	MOUNTAIN SCENE, indian ink, $8\frac{1}{2} \times 12\frac{1}{2}$, published by D.C. (pp. viii, 19 and pl. 6b) as by Crome. Possibly by Crome, but an attribution to P. S. Munn is more attractive.
D 190	(PD 4–1965)	LANDSCAPE WITH FIGURES BY A POOL

D 191	(3266)	RIVER SCENE
		(RIVER LANDSCAPE)

Pencil, indian ink wash on coarse grey brown paper. $4\frac{5}{8} \times 9\frac{9}{16}$.

Prov.: Gift of Sir Frank Brangwyn, R.A. 1943.

Condition: Laid down.

The untidiness of the drawing is partially dictated by the quality of the paper. The dramatic sky, treated in horizontal streaks, does not exist in other well-established Crome water-colours, although it does in two possible drawings at the V. & A. Mus.—*Magdalen Gate, Norwich* (D 179) and *King Street, Norwich* (D 180). The partial overlaying of wash to create a dappled effect in the foliage is found in several drawings, e.g. *The Glade* (D 20) and *Lakeland Landscape* (D 21x).

Probably by Crome c. 1806.

AT NEWPORT MUSEUM AND ART GALLERY, MONMOUTH

D 192	(453)	WAGGON WHEELS

Sepia. $6\frac{1}{2} \times 3\frac{1}{2}$.

Prov.: Brewer-Williams.

Waggon Wheels etched twice in soft grounds, *Waggon Wheels*[1] (E 27), *Colney* (E 31). As a motif recurrs in *Ruins Evening* at Ottawa (P 32). This is much feebler than E 28 but is on a much smaller scale. Belongs to a group of drawings produced by J. or J. B. Crome—like *At Dunham, Norfolk*.

[1] *The Shed*, a sepia deriving from this is at N.C.M. (D 110). It is by neither Crome but perhaps by W. H. Hunt (1806–79).

DRAWINGS

AT BIRMINGHAM CITY ART GALLERY

D 193 (325–'30) STUDY OF TREES, water-colour, by J. S. Cotman 1802–3.

D 194 (239–'34) DEMONSTRATION WATER-COLOUR, not by a Norwich hand.

AT BRITISH MUSEUM

D 195 (1864–6–25–101) by R. Crone. See: Brinsley Ford. *Drawings of Richard Wilson*, p. 63, pl. 80.

D 196 (1902–5–14–374) SUNKEN LANE, by the same hand as a drawing of Harvesters in Mr L. G. Duke's collection. Possibly Robert Ladbrooke; derives from Wynants.

D 197 (1902–5–14–377) Probably by Leman.

D 198 (1902–5–14–378) by George Frost.

D 199 (1940–6–1–6) WINDMILL AND OAK TREE (? Vincent).

D 201 (1902–5–14–373) AT DUNHAM, NORFOLK

Water-colour on wove paper. $6\frac{3}{4} \times 9\frac{2}{5}$.

Prov.: J. B. Crome to Thomas Palmer of Swaffham in 1882, given by him to Edward Barwell; Mr E. Barwell, her Sale Attleborough 1883, bt. James Reeve.

Exh.: Nor., 1874 (146) B.M.A. Loan.

R.A., 1890.

R.A., 1892 (74).

Version: According to Dickes an oil exists.

Lit.: K. Smith, p. 173.

Reeve Cat. p. 69, no. 2.

Repr. Autotype Co. April 1897.

Dickes, p. 149, ill. opp. p. 148.

Cundall, p. 15, pl. XXI.

Baker, pp. 89, 132, 179, 184, 194, 195.

Autumnal colouring of chocolate brown, blue green and russet, with scratched out highlights. This is one of a distinctive group of drawings on wove paper which have trees with 'spidery' branches, foliage formed of dots and blotches and insubstantial palings, buildings, etc. Compare with *Waggon Wheels* (Newport). (D 192). As *Waggon Wheels* is a memory of a soft ground etching (E 28), the group probably dates from after 1809/10. The closest related oil is N.C.M. *Grove Scene* which tradition says is J. but is probably by J. B. Technically not dissimilar is *Trees by Water after Cuyp* (D 212). Probably by J. B. Crome. *c.* 1810–21.

158

DRAWINGS

D 202 (1940–6–1–5) TUDOR FARMHOUSE WITH TALL CHIMNEY

 Pencil and indian ink wash. $6\frac{1}{5} \times 4\frac{1}{5}$.

Prov.: Mrs Arthur Acland Allen.

 By John Thirtle. Compare fluent use of wash and pencil point in *Backwater Norwich with Figure on Steps* (B.M. 1902–5–14–479) and N.C.M.s *South Transept of Norwich Cathedral* (Cot. and Haw. p. 48, pl. 16).

IN THE U.S.A.

SMITH COLLEGE, NORTHAMPTON, MASSACHUSETTS

D 203 THATCHED COTTAGE $9\frac{1}{2} \times 12\frac{7}{8}$.

 Repr. *Connoisseur*, November 1960. p. 217.

 Not seen.

MELLON COLLECTION, YALE UNIVERSITY

D 204 OLD COTTAGES, probably by Joshua Cristall, inscribed and initialled.

ROBERT LEHMAN COLLECTION, NEW YORK

D 205 LANDSCAPE WITH BOY FISHING

 Water-colour. $4\frac{1}{16} \times 10\frac{13}{16}$.

Prov.: Mrs Frederick C. Havemeyer.

Inscribed: Verso in an irregular grey wash: 18 *May* 1818.

Exh.: Jacksonville, Nashville and New Orleans, 1967 (18) ill.

 Not seen. T.C. is inclined to accept it; D.C. doubts it and suggests J. B. Crome.

CANADA

MOUNT ALLISON UNIVERSITY, SACKVILLE, N.B.
(OWEN'S COLL.)

D 206 POCKTHORPE BOAT AND BOATHOUSE. 11 × 13.

 Amateur copy of oil (P 68).

DRAWINGS

D 207 LANDSCAPE WITH WINDMILL. $11\frac{1}{2} \times 12\frac{1}{4}$.
 Copy of a Ruysdael at Dulwich. Just possibly by J. B. Crome. See D 134 note.

D 208 HEATH STUDY WITH POLLARD.

IN BRITISH PRIVATE COLLECTIONS

D 209 THE GLADE COTTAGE

 Water-colour and body colour. $25 \times 21\frac{3}{4}$.
Coll.: Constance, Viscountess Mackintosh of Halifax.
Prov.: Bignold family, Sir Robert Bignold, J.P.; bt. first Viscount Mackintosh.
Versions: (*a*) Oil $43\frac{3}{4} \times 36$. Said to be in a private Coll. N.Y.
 (*b*) Engraving of oil, Cunningham's *Cabinet Gallery*, 1833.
Exh.: Lowndes Lodge, 1965 (26).
 Jacksonville, Nashville, and New Orleans, 1966–67 (20) ill.
Lit.: Mackintosh, Mss. Cat. 41.
 D.C., pp. ix, 20, pl. 118.
 Palette of pale blue, lime green, chocolate brown and yellow. Highlights are
 stopped and scratched out. D.C. (op. cit.): *very odd and unlike in handling to any
 other*. Dr Goldberg related it to Mr Quintin Gurney's *Entrance to Earlham Park*
 (D 45b note) and to *Silver Birches after Pynaecker* (D 134) giving it a date of 1817.
 We believe that the Gurney picture is a copy of Mellon's (D 45) dating from
 c. 1807–8 and that *Silver Birches* by J. B. Crome dates from *c.* 1815. Similar in
 handling is *Trees by Water after Cuyp* (D 212) which again dates from *c.* 1815.
 If a comparison is made with a photograph of the oil version (*a*), it is evident
 that the water-colour is a painstaking and not very brilliant record. The slender
 serpent-like drawing of the branches and use of jumpy tonal contrast suggest
 that it is by J. B. Crome or by an artist of his generation.

D 210 HOUSE IN WOODED LANDSCAPE *with two figures on a Road*

 Pencil and water-colour. $7 \times 11\frac{1}{4}$.
Inscribed: C. foreground: *J. Crome*.
Coll.: Constance, Viscountess Mackintosh of Halifax.
Prov.: Rev. G. B. Mountford, M.C.; Spink & Son, 1963, bt. by first Viscount Mackin-
 tosh of Halifax.
Lit.: Mackintosh, Mss. Cat. 43.
Condition: Slightly faded.
 Palette of grey greens, pinks, and pale buff; red brick gable of building C. is
 sensitively indicated. The appearance of Crome's signature on so modest a
 drawing is suspicious. The composition is a little too pretty and contrived. The

drawing has however Crome-like characteristics. Its unusual appearance may be explained by it being half-way between a field sketch and an exhibition piece. Figure drawing similar to *Castle in a Hilly Landscape* (? *c.* 1804–5), palette similar to *The Mill Wheel* (D 16) and *Tintern Abbey—Sketch* (D 42). Doubted by D.C. who suggests J. B. Crome; T.C. accepts it.

D 211 RIVER SCENE WITH BUILDINGS AND BARGES
(SURLINGHAM FERRY[1])

Pencil and indian ink wash. $6\frac{5}{8} \times 10\frac{11}{16}$ (Sight).
Coll.: E. P. Hansell, Esq.
Prov.: Inscription in faded ink on an old label stuck to the back of the frame:
From my Mother's Portfolio who was a pupil of Crome. The writing is that of Maria Hansell (*nee* Brown) (1805–92)[2] wife of Henry Hansell, thence by descent to the present owner.
Exh.: N.C.M., April/May 1965.
Condition: Good, except for oval burn R. of L. top corner.
A rapid field sketch. Drawings of this type by John Thirtle (1777–1889) exist but few survive by Crome. There is little pencil work, much of the mass being indicated by wash. There are isolated areas of diagonal hatching and a use of dots and broken lines in the buildings. Difficult to parallel although quite possibly by Crome.

D 212 TREES BY WATER, AFTER CUYP

Pencil and water-colour on wove paper. $10\frac{1}{8} \times 11\frac{1}{2}$.
Coll.: Mr and Mrs D. P. Clifford.
Exh.: Maidstone, Eastbourne, Worthing, 1966/7 (19).
Lit.: D.C., pp. x, 21, 41, pl. 14b.
Goldberg. Jacksonville Cat. 1967, p. 48.
Condition: Faded to russet, perhaps slightly trimmed all round.
Copied from the centre of *Evening Ride near a River* by Aelbert Cuyp (1620–91) in the Dulwich Gallery. (Bourgeois Bequest No. 96, see: *A Brief Cat. of the Pictures in the Dulwich Coll. Picture Gal.* 1953.) Dulwich was opened in 1814 and this copy was thought to have been made by Crome on his journey to France in that year. *Silver Birches; after Pynaeker* (D 134) was also copied from a Dulwich picture and is by the same hand. J. B. Crome on his journey to France in the

[1] So called by the present owner; title may be traditional and correct. Surlingham Ferry Inn had two gables, the third was added in the 1870's. These gables were never orientated as shown in this sketch.
[2] Handwriting identified as that of Maria Brown by her son (?) P. E. Hansell (1831–1921); a label written by him is also on the back of the picture. Information concerning the dates of the Hansell family kindly supplied by the present owner (letter dated 18 October 1965).

following year probably visited Dulwich. An attribution to J. B. Crome is now preferred.

c. 1815.

D 213 OAK TREE WITH STILE

Pencil. 8 × 7¾.

Coll.: The Rt. Hon. Lord Mancroft, K.B.E.

Prov.: A. M. Samuel, M.P.

Lit.: Cundall, pl. XXXII.

Baker, pp. 129, 164, 196.

By same unidentified hand as (D 160) and a drawing in Constance, Lady Mackintosh's Coll. (her Mss. Cat. No. 44).

D 214 SHIPPING OFF YARMOUTH JETTY

Pencil on wove paper. 7⅞ × 9¼.

Coll.: E. D. Levine, Cromer.

Prov.: Spinks; Norman Baker, Esq.

Close to John Berney although possibly by the father.

c. 1810–21.

D 215 THE SHEPHERD

Gouache. 9¾ × 13⅝.

Coll.: Norman Baker, Esq.

Prov.: ? John Crome's widow; Mrs [Sarah] Devereux, her Sale (Spelman's, Norwich) 20 May 1846 (216); W. Spelman; E. D. Levine.

Inscribed: On verso of frame:

This is to certify that the two sketches sold at my Sale of Furniture in 1846 were by John Crome the Elder and were given to me by his widow. Signed Sarah Devereux.

The above named sketches were sold by me at the Sale of Mrs Devereux's Furniture. 20 May 1846. Norwich. Wm. Spelman.

 [Then follows a cutting from a printed catalogue:]

 216 Shepherd.

 217 Landscape.

Condition: Good, but a signature seems to have been erased about two inches from the bottom R. corner.

Owes more to George Morland (1763–1804) than Crome. Some of the foliage treatment can be paralleled with indian ink drawings of *c.* 1805–7. Drawing may be by same hand as *The Waggoner and Oak* (D.C. fig. 15a). The Norwich artist Charles Hodgson worked in gouache. A signed work by him at N.C.M. (D.C. fig. 5b) is dated 1797. If by Crome probably amongst his earliest productions.

Etchings

The list follows that given by Sir H. S. Theobald in *Crome's Etchings* (1906) pp. 68–97. We believe that ten etchings listed there are not by Crome. Their omission alters his numerology. They are:

T.26 Described by T. as 'almost certainly not by Crome'. It is probably by a Dutchman.

T.35
T.37 } Both typical examples of Thomas Harvey of Catton's work. (cf. his B.M. album.)

T.38–44 *Etchings of Churches* by J. B. Crome, as pointed out by S. D. Kitson (see *John Sell Cotman*, p. 156a). However, T.39 *N.W. View of St Mary's Church, Hadiscoe* is very close to his father's work.

Abbreviation: D.T. Dawson Turner Collection at N.C.M.

E 1 AT COLNEY $8\frac{7}{10} \times 6\frac{3}{5}$

 Clump of trees on rising ground R., to L. an open landscape with rows of bushes and farmhouse (?) beyond. Rough road from L. passes round the rising ground.

First State Donkey in C. foreground; rising ground behind donkey is blank. Plate lightly bitten; silvery effect like a delicate pencil-drawing. B.M.

Second State Donkey remains; plate worked upon and rebitten. Foliage of trees and foreground elaborated and darkened. Silvery effect has gone. B.M.

Third State Donkey has been taken out; space behind it is blank. In this state plate left by Crome, and printed in Mrs Crome's set in 1834.

Fourth State Title: *At Colney* added in etched letters at bottom within line enclosing subject. Plate was rebitten by H. Ninham loosely in accordance with an impression touched by J. B. Crome. Space where donkey stood is filled in with etched lines.

E 2 ROAD SCENE, TROWSE HALL (NEAR NORWICH) $8 \times 10\frac{4}{5}$
 third state and after 8×7

 Two woodland roads converge in foreground. In front bank of dock leaves, behind a tumble-down paling, and beyond fine trees with spreading branches. Across each road is a closed five-barred gate. R. foreground seated youth holding large stick; behind him rising ground with trees. Road to L. runs between trees, and open country is suggested beyond. Scene is full of sunshine; rays of sun come through trees and light up road, and sunshine is on trees and foliage. In R. corner of the plate at bottom, 'J. Crome, 1813', in etched letters.

First State As described. On copy in Dawson Turner's collection is written in pencil, probably by Dawson Turner himself: *Unique—plate destroyed*. Though called by Dawson Turner 'A Composition', there can be little doubt that it is a sketch from nature.

Second State Some of work has been taken out, probably by mistake in rebiting, and in particular face of young man seated on R. has been injured and blurred. Two impressions of this state are in B.M., one, which is fine in black ink, and the other in brown ink. Underneath later is written in pencil: *some of the work taken out*. In this condition plate left by Crome.

Third State After Crome's death, and with a view to Mrs Crome's publication, $3\frac{4}{5}$ inches were cut off R. side of plate, so that its width became 7. Impression from piece cut off was given by H. Ninham to Miss Brightwell and afterwards came into Reeve's possession; now in B.M. Subject is now 7 wide. In this state plate was printed in Mrs Crome's set.

Fourth State Title, *At Trowse*, added in etched letters underneath. Plate rebitten by Ninham.

E 3 MOUSEHOLD HEATH, NORWICH $8\frac{1}{8} \times 11\frac{1}{8}$

Stormy day in late spring. Sunlight and shadow sweep across heath. In distance on L. sharp shower of rain, and above, great storm-cloud is blowing up and spreading across sky. Distance, a little to R. of C., a windmill facing the wind; to its R. are cottages, and further to R. again, another windmill facing in same direction. Foreground, towards L. is pool with high banks behind it and to L. In front road leads to edge of pool, winds round it, and turns L. Here and there are trees and shrubs with scanty foliage. In foreground, to R., donkey stands beside cow, which is lying down.

First State As described. D.T.

Second State Plate rebitten. Sky much darkened and plate darker throughout. Recumbent cow almost obliterated by cross-lines. In this state plate left by Crome, and printed in Mrs Crome's set. B.M., D.T.

Third State Plate rebitten by H. Ninham and sky entirely removed. Ninham disclaimed responsibility for anything but the rebiting (see the *Norwich Mercury*, December 4, 1858, in Mr Reeve's collection of documents about the Crome family at B.M.) and blamed Edwards.

Fourth State A dull, uninteresting sky ruled in with diamond point by W. C. Edwards of Bungay. A portion of work in water burnished out, thus destroying balance of light and shade. Parts worked over with the graver. Beneath in etched letters *Mousehold Heath*. B.M., D.T.

E 4 BACK OF THE NEW MILLS $8\frac{1}{2} \times 11\frac{3}{10}$

Stream broadening towards foreground. Mid-distance house with bay window, built out and overhanging water; a disused windmill without sails rises behind

house; to R. another gabled house. On L. bank a row of trees; foreground two boats with two men, one standing. In distance to L. are buildings, trees, and rising ground. Top L.-hand corner: *J. Crome, Fecit 1812*, in etched letters.

First State Before heavy lines in sky on L. There is a double line at top of plate, which is faintly traceable on other three sides. B.M., D.T. There is also in B.M. an impression inscribed 'first state' in which trunk of tree rises to R. of tall tree on L. and is reflected in water. It forms no part of the composition, and may have belonged to another subject originally etched on the copper. Impression hardly deserves to be called a state. Offending trunk was afterwards removed.

Second State Heavy lines added in the sky on L., and on R. in a well-defined outline. Double lines still visible. Plate rebitten and darkened. In this state plate left by Crome, and printed in Mrs Crome's set. B.M.

Third State The plate much rebitten by Ninham. Tall tree made darker. Sky was worn and is much fainter. Title, *Back of the New Mills*, added in etched letters underneath.

E 5 FRONT OF THE NEW MILLS, NORWICH $8\frac{1}{2} \times 11\frac{1}{2}$

A mill pool. Water fills foreground and forms triangle in middle distance towards R. an old wall R. with foliage hanging over it. At steps, where water ends, boat with two figures in it, beyond in background a gabled house. L., buildings and a large tree with luxuriant foliage, two boys standing in shallow water, broken wall and tall wooden paling on rising ground behind them. Top L. in etched letters: *J. Crome, 1813*.

First State Gabled house in background very lightly etched, lower part of it left vague; the effect, light and silvery. B.M., D.T.

Second State Gabled house worked up, plate rebitten and darkened, especially broken wall on extreme L.; reflections on water have also been elaborated and not improved. In this state plate left by Crome, and printed in Mrs Crome's set.

Third State Plate rebitten and worked with graver by W. C. Edwards and blackened throughout. Underneath, within the subject in white engraved letters on a black ground, 'FRONT OF THE NEW MILLS'.

E 6 GRAVEL PIT, MARLINGFORD $8\frac{3}{4} \times 6\frac{2}{3}$

Two large trees cut down and stripped of foliage fill middle distance, stretching from L to R.; at back two old trees with many bare branches and scanty foliage. On R. tall tree stump, with smaller withered stump to L. At foot of tall tree boy is seated facing to R.

First State No foliage on branch which springs from tall tree stump on R.; tall tree trunk which rises on L. is also without foliage. B.M., D.T.

Second State Foliage has been added to stump on R., and also to topmost branches of the tree on L. Heavy ruled lines added in sky. In this state plate left by Crome and printed in Mrs Crome's set. B.M., D.T.

Third State Foliage on R. has been worked over and altered; plate darkened throughout. Title *At Marlingford*, added in etched letters underneath.

E 7 (AT) DEEPHAM, NEAR HINGHAM first state $6\frac{1}{4} \times 9\frac{3}{8}$

second state $6\frac{1}{4} \times 7\frac{1}{8}$

third and subsequent states $6\frac{1}{4} \times 6\frac{3}{4}$

Oak trees round a pool; on L. a country road; on R., hilly ground with windmill; some trees in distance to L. of mill. On R. withered oak close to water's edge, with one bare branch striking up into sky-line to L. of mill. Summer clouds on horizon near windmill, and above them other clouds.

First State As described. Underneath his impression Dawson Turner has written 'unique', D.T.

Second State Plate cut down on R., thus removing windmill and part of trees nearest to it. Part of withered tree remains. D.T.

Third State Plate still further cut down by removing whole of tree nearest mill, and also withered oak by water. D.T.

Fourth State *J. Crome. 1813*, added in etched letters in top L. corner and lines added in sky. In this state plate left by Crome, and printed in Mrs Crome's set. B.M.

Fifth State *Near Hingham* in etched letters underneath. Plate worked over. Water in the R. bottom corner shaded.

E 8 (FOOT)BRIDGE AT CRINGLEFORD $8\frac{7}{10} \times 6\frac{3}{5}$

Rough wooden footbridge crosses stream to group of trees; on R. in the distances posts and rails, and beyond hills.

First State Before the hills on R. and before lines in sky by tree on L. *J. Crome* in the R. bottom corner. B.M., D.T.

Second State Hill on R. behind palings filled in and shaded lines in sky added behind and by side of tree on L. Water to L of bridge darkened by horizontal lines; plate darkened throughout. In this state left by Crome and printed in Mrs Crome's set. B.M., D.T.

Third State Plate still more worked upon, especially in foreground, with drypoint.

Fourth State Crome's signature plainly visible. '*At Cringleford*' in etched letters underneath on L. of plate.

E 9 AT WOODRISING (Plate 55c) $2\frac{1}{10} \times 7\frac{1}{3}$

Portion of pool in foreground surrounded by trees, a boat on R. This and two following etchings were etched on one copper, close together, without any space between them. There are in the B.M. impressions of first and second states of plate before it was divided into three. First state is before boat and before some foliage was added to tree in C. In second state boat and foliage are added.

First State Before addition of boat and foliage already mentioned.

Second State With boat and added foliage, but printed before copper was cut into three pieces. Impressions of first and second states have therefore plate-mark only at top and sides; whole of boat is shown.

Third State With a view to Mrs Crome's publication copper cut into three pieces. In this state plate-mark shows on all four sides. In cutting copper, boat was almost cut away, and on R. of plate some tree trunks, which are confused in earlier states, are clearly etched. Horizontal lines are added in sky on R.

Fourth State *At Woodrising*, in etched letters in sky in R. upper corner.

E 10 RUSTIC ROAD WITH THATCHED BARN (Plate 55b) $2\frac{1}{4} \times 7\frac{1}{2}$

Rustic road winds towards L.; on L. is rising ground with old tree, to L. a post and rails; on R. of road large barn with thatched roof and open doorway, to R. of road large barn with thatched roof and open doorway, to R. of it thatched roof of another barn. This was middle of three etchings on one copper.

First State Before copper was cut into three separate plates, showing plate-mark only at sides. Doorway of large barn is not clearly defined.

Second State After copper was cut for Mrs Crome's publication, showing plate-mark on all four sides.

Third State Darkened throughout.

E 11 AT SCOUTTON $2\frac{3}{8} \times 7\frac{1}{2}$

Foreground a pool; on R. large tree trunks and bank beyond with smaller trees; distance on L. a church tower with sun setting behind it; on L. group of three trees on bank.
This was bottom of three etchings on one copper.

First State Before copper was cut, showing plate-mark only at bottom and sides.

Second State After copper was cut into three pieces for Mrs Crome's publication, showing plate-mark on all four sides. Church tower faintly seen and distance blurred, especially to L. of tower.

Third State *At Scoutton*, in etched letters at bottom in C. Church tower is now a mere outline without shading.

E 12 A COMPOSITION: MEN AND COWS $2\frac{9}{10} \times 3\frac{4}{5}$

Two men stand talking under tree. On their R. two standing cows; a third in front of them is lying down. In foreground broken ground. Plate appears only in one state. In late impressions it loses much of its charm. B.M; in these impressions it occurs printed on page with E 19.

E 13 AT BAWBURGH $5\frac{1}{2} \times 7$

On R. is pool, on L. bank a large willow. Foreground large-leaved plants. On L in distance, two tree stumps with scanty foliage, to R. of which stands a cow facing to L. Broken ground to L.

First State Before enclosing line drawn round four sides, and before Crome's name in upper R. corner. Under impression in Dawson Turner's collection has been written in ink: *The first impression.* B.M.

Second State Enclosing lines added. In upper R. corner: *J. Crome, fecit, 1813*, added in etched letters. In this state plate left by Crome, and published in Mrs Crome's set. B.M.

Third State *At Bawburgh*, added underneath in etched letters. Plate darkened throughout. In some of the latest impressions Crome's name has disappeared.

E 14 AT HACKFORD $6\frac{3}{4} \times 8\frac{3}{4}$

Open landscape. On L. foreground, a pool; immediately to R. of it two felled trunks of trees. Behind on L., two old tree stumps rise with scanty foliage. R. of trees a wooden paling with an opening through which are seen a pathway and fields. R. of paling two more tree stumps almost destitute of foliage, and behind them cottage with two trees to R. of it. Lane leads from R. foreground past cottage; to R. of lane, barn and another cottage with trees about it. On L. in water: *J. Crome, fct. 1812*, in etched letters.

First State Before sky. B.M.
Second State Delicate sky has been lightly etched in suggesting summer clouds. B.M.
Third State Lines added in sky between the two groups of trees on L.
Fourth State Series of heavy horizontal lines ruled in sky across plate at top. In this state plate left by Crome, and printed in Mrs Crome's set. In an impression in B.M. horizontal lines are black and heavy, but soon became faint.
Fifth State *At Hackford*, added in etched letters underneath. Plate not much altered. Reflections in water darkened and sky, as a rule, hardly visible.

E 15 LAKE AND BOAT ON IT, WICKERSWELL, SOMERLEYTON $8\frac{3}{4} \times 6\frac{3}{4}$
(BACK OF THE MILLS)

Water fills foreground, and on L takes sharp turn to R., where R. bank juts out into grassy promontory. In foreground on R. man sits by water's edge, facing L. On L. flat-bottomed boat fastened to ring fixed to post on bank. On R. withered trunk of tree; row of tall trees on L.

First State Tree stump on R. has scanty foliage, but main branches rise up bare and withered to sky. B.M.

Second State Dappled shading to trunk R., additional reeds to R. of seated figure, shading of sky C. darkened, shadow widened of reed reflection L. of C. B.M.

Third State Foliage delicately etched in behind and above tree stump R. In this state plate left by Crome, and printed in Mrs Crome's set. B.M.

Fourth State Rebitten by H. Ninham and engraved by W. C. Edwards. Lines in water beyond boat taken out, man's clothes etched over, foliage on R. darkened, plate generally black and unsatisfactory.

See D 34 for pencil drawing and D 35 for water-colour of this subject.

E 16 THE HALL MOOR ROAD NEAR HINGHAM $6\frac{3}{5} \times 8\frac{3}{5}$

Country road winds from R. foreground towards L., and is lost in wooded ground. On L. a cottage with a group of trees, on R. another cottage with withered trunks and a cow. L. foreground tall oak, and behind paling and stile. In L. top corner, *J. Crome, fecit, 1812*, in etched letters.

First State Principal branches of oak on L. stand out bare against sky; before horizontal lines were added in sky at top. Summer clouds lightly etched on R. B.M.

Second State Foliage has been added to tree on L. Blank space in sky to L. of tall tree. B.M.

Third State Similar to Fourth State but sky without ruled lines. B.M.

Fourth State Heavy horizontal lines added in sky at top of plate to R. of large tree. Blank space filled in with horizontal lines and foliage. In this state plate left by Crome, and printed in Mrs Crome's set. B.M.

Fifth State Much rebitten by Ninham. *Near Hingham*, added in etched letters beneath. Foliage of tree, which reached to top of plate, taken out.

E 17 A COMPOSITION (Plate 56a) $6\frac{1}{2} \times 6\frac{1}{10}$

Large tree on mound by side of road. R. in middle distance woman and child seated.

First State Before black lines round plate; paling on R. only indicated; no lines in sky above paling; L. of mound left white. Underneath impression from Dawson Turner's collection is written, 'First impression'.

Second State Black lines drawn round plate, lines added in sky R., work added on mound to L. In this state plate left by Crome, and published in Mrs Crome's set. Signed bottom L., *J. Crome Fecit*. B.M.

Third State *Composition* added in etched letters underneath.

E 18 ROAD SCENE, HETHERSETT $6\frac{1}{4} \times 5\frac{7}{8}$

Man is driving sheep up a track through woodland. Foreground on L. two felled tree stumps; tall trees beyond them. On R. another group of trees. Open hilly ground at back crossed by road on R.

First State As described. In this state plate left by Crome, and printed in Mrs Crome's set. B.M.

Second State Title added beneath in etched letters.

E 19 ROAD BY PARK PALINGS $4 \times 7\frac{15}{16}$

Road runs from L. to R. by park palings; in distance tower of church. Plate was not altered, and appears to have lasted well.

First State As above described. B.M.

Second State Distinct black burrs of dry point in grass bottom R. B.M. In this state occurs printed on page with E 12.

E 20 ROAD BY BLASTED OAK $5\frac{5}{8} \times 7$

Rustic road, over which stretch the branches of withered oak. Tree has its roots in mound of earth, which fills L. foreground and remains almost white, with scanty plants on its slope lightly indicated; in background row of leafy trees.

First State Peasant on R. standing by and leaning over donkey, his R. arm bent leaning on donkey's back. Donkey is very lightly etched in. Sky filled with heavy horizontal lines, which, in places at top of plate, have failed in biting, leaving blank spaces. *J. Crome, 1813*, very lightly etched in top L. corner. B.M.

Second State Donkey is erased by series of vertical lines. Blank spaces in sky remain. In this state plate left by Crome, and printed in Mrs Crome's set. B.M.

Third State Vertical lines are burnished out, leaving only portion of forearm of peasant. Space in front of him is blank, but there is suggestion that he is talking to some one and emphasising a point. Blank spaces in sky remains.

Fourth State R. forearm of man has been straightened, and he now holds spade, upon which he leans. Man in dark clothing is seated opposite him. This figure is badly drawn. It is very black and was put in with the graver. Blank spaces in sky have been made good. Signature is plainly visible.

Fifth State Seated figure has been burnished out and space left blank.

E 21 COMPOSITION: SANDY ROAD THROUGH WOODLAND (Plate 56b) $14\frac{3}{5} \times 10\frac{1}{2}$

Large upright plate. Bright sunny day. Rough country road runs through trees on either side; on L. ash-trees; on R. rising ground, on which stands in front trunk of old oak, gnarled and withered. Cart with two figures is driving away in distance. In middle distance two men—one standing with spade in hand, the other seated on bank with wallet on his back—are talking. In front of them a dog, lying down, looks up at its master. R. foreground is large-leaved plant. Beyond the trees is open country. Thick line surrounds plate on each side.

Undoubtedly sketch from nature but called a 'composition' because early collectors did not know what the scene represented.

First State Before lines in sky on R., before lines on lower half of large dock leaf to R., and before Crome's name. In B.M. are two impressions of this state, on one of which is writen in *faded ink* at top R. corner: *1st impression off this plate*: and on other in similar place: *2d impression off this plate.* Both are badly printed; ink has failed in first on R., and in second on L.

Second State Lines added in sky at top R. Lines added on lower half of dock leaf to R. At top R. corner: *J. Crome, 1813*, in etched letters with *3* reversed. In this state plate left by Crome, and printed in Mrs Crome's set. An impression on yellowed silk is in B.M. (1941–12–13–564).

Third State Plate worked over throughout. In particular white spot on dog's head is shaded and lines are added on coat of man seated on R. Foreground much darkened.

E 22 AT HEIGHAM $1\frac{15}{16} \times 6\frac{3}{4}$

Water in foreground; behind, on R., land with trees; on L. land recedes, and on extreme L. a church tower is dimly seen; on R. broad-bottomed boat, and behind an open shed. In C. land runs out into water and there is a cottage with tall elms, those on L. bowing down towards the water.

First State As described. Most delicate silvery etching, only fine in early impression, as delicate distance on L. soon went. In this state plate left by Crome, and printed in Mrs Crome's set.

Second State *At Heigham* in etched letters underneath.

E 23 FARM BUILDINGS BY A POOL 2×7

End of pool; on R. farmhouse and buildings, with barn near waterside. Trees fringe water's edge. On other side, opposite barn, are large trees, and near them path strikes away to L. Beyond this, undulating ground and sky with fleecy clouds.

First State In this state ground L. rises into a considerable hill. Branches of tree on L.

stretch out against sky with leafless ends. On R. white spot is left in sky. In this state plate left by Crome, and published in Mrs Crome's set. B.M.

Second State Hill on L. is lowered, leaving open undulating country; branches of tree on L. end in foliage, white spot in sky on R. filled in. B.M.

E 24 LANDSCAPE WITH A WOODEN BRIDGE (Plate 55a) $1\frac{3}{4} \times 6\frac{3}{4}$

R. wooden bridge leading to rising ground with trees L., and wind-blown bush R. Rising ground stretches away L., and is lightly etched with slim tree at point where it slopes downward. Man on horse rides away to L. L. top corner: *J. Crome* in etched letters.

One state only. In spite of its delicacy it lasted well and late impressions have considerable charm.

B.M.

E 25 COTTAGE AT EARLHAM 4×3

Road leads to cottage with high thatched roof; L. of road is bank with tree stump, from which foliage springs on R. Unpublished, probably unique. D.T.

Theobald notes that: *in the possession of Miss Geldart of Norwich* [*is*] *an interesting early oil painting by Crome of this cottage taken from a different point of view. The picture is known to be from a cottage at Earlham. The title for the etching has been taken from the picture.*

Soft-Ground Etchings

Of the nine etchings catalogued under this heading, eight only were published. There is no difference of state in the nine. They have suffered from wear and tear, but were left untouched by the desecrating hand of the improver, and sometimes late impressions are fairly good. Some have small local areas of hard ground.

(BUSHES AND TREE TRUNK)

E 26 (T. 27) Sketch of tree trunk. On L. bushes. $7 \times 5\frac{5}{8}$.

(WAGGON WHEELS)

E 27 (T. 28) On L. trunk of a tree, on R. beyond, row of trees dark against sky. In front of tree two heavy wheels leaning against each other. On R. of them upright beams with cross-bar supporting three heavy beams laid horizontally upon them. $7 \times 5\frac{1}{2}$.

(THE LANE)

E 28 (T. 29) Study of tree trunks on either side of lane. In front trunk leaning to R., with other trees behind. $8\frac{1}{4} \times 6$.

E 29 (T. 30) HOVETON ST. PETER $6\frac{2}{5} \times 9\frac{3}{10}$

End of wood. On R. tall trees, on L. fields and clouds roughly sketched in. In bottom R. corner J.C. in etched letters.

(TREES AND DOCKS)

E 30 (T. 31) Study of three trees close together; in front dock leaves. Pool to R. $8\frac{4}{5} \times 6\frac{4}{5}$. Dry point especially on grass bottom R.

E 31 (T. 32) COLNEY (Plate 54b) $6\frac{5}{8} \times 8\frac{1}{4}$

Cottage on R. with loose wheels leaning against paling. Posts and rails in foreground, against which man stands. Row of trees in background. Underneath,

in R. corner at bottom: *Crome, 1809*, with nine reversed. This is the earliest date to be found on an etching by Crome. Much work in dry point especially on fence and foreground figure.

E 32 (T. 33) BIXLEY (Plate 54a) $6\frac{1}{2} \times 9$

Study of trees by pool; old gnarled oak on R.; rail crosses water; on L. road and stile. Drawing for this etching is in B.M. (D 48). Local areas of dry point top C., clouds L. and foliage R.

(FELLED TREES)

E 33 (T. 34) Trees on bank by roadside. On L. of road are two felled trees ready for carting. To L of tree is notice-board. $6\frac{1}{2} \times 9\frac{1}{4}$. Not published before *c*. 1850.

(THREE TREE STUMPS)

E 34 (T. 36) Three tree stumps, two of them springing from one root; foliage higher; bushes to R.; a slender tree in background. $8\frac{1}{4} \times 5\frac{3}{4}$. Unpublished. B.M., Witt. Possibly not Crome.

Note to Etchings

E 1 Touched third state by J. B. Crome for H. Ninham's guidance at B.M. (1902–5–14–1130). According to Reeve, Ninham *quite exceeded the alterations in pencil and colour*. Subject matter of first two states similar to *By the Roadside* (D 53).

E 2 Second State very untidily touched is at B.M. (1914–5–12–102). The touching is possibly by Edwards.

Of Third State Theobald wrote *In addition to the piece cut off, about a quarter of an inch of the work on the right side was burnished out so as to leave a margin between the subject and the edge of the copper*. We know of no impression like this.

Unique impression from piece cut off copper (B.M. 1902–5–14–679) raises problems. The copper must have been reworked by Ninham. Bank beneath these trees R. of gate is now filled with small etched lines; distant hill behind is also darkened; head of boy is more finished and outline of palings strengthened. L. margin may be false if so this may be a fragment from an intermediate lost state between two and three. Touched third state by J. B. Crome for Ninham's guidance at B.M. (1902–5–14–1129).

E 4 Touched second state by J. B. Crome for Ninham's guidance at B.M. (1902–5–14–1138).

E 6 Touched second state by J. B. Crome for Ninham's guidance at B.M. (1902–5–14–1127).

E 7 According to J. B. Crome's inscription on B.M. (1902–5–14–1131), title was 'At Deepham, near Hingham'.

In fifth state we have not found water in R. bottom corner shaded.

E 8 In B.M. 'first stage' distant hills R. are there already. Touched first state by Crome in B.M. with ORD just visible bottom R.

Impression in Reeve Collection (Vol. 190 * a 9) inscribed faintly twice *Heigham* in pencil. This is corrected in pen by J. B. Crome to *Bridge at Cringleford*.

E 10 There seems to be only one barn.

E 15 According to Reeve's note (190 * a 9) also called *Back of the Mills*. State added to Theobald.

E 16 Touched third state for Ninham's guidance at B.M. (1902–5–14–1135). State added to Theobald.

E 17 Theobald did not note signature on second and third states. (See B.M. 1902–5–14–1126.)

E 19 State added to Theobald.

E 21 On first impression of first state extensive pencil alterations by Crome.

Some Oils based on the Etchings

Many more oils based on Crome's etchings exist than those here listed. Only two have any claim to be considered authentic (see under E 5 and 7). Most were based on the states in Mrs Crome or Dawson Turner's publication of the etchings (i.e. after 1832 or 1838). In the neighbourhood of Norwich there was probably a considerable demand. Some may be the work of those who were involved in reworking the plates for these editions: J. B. Crome, Henry Ninham and Edwards of Bungay. Others may have been honest reproductions by artists like W. P. B. Freeman, D. Hodgson and W. H. Crome; still others made in the 1870's or, 80s were clearly from the hand of a competent forger.

E 1 Canvas with donkey, formerly with Iden Gallery, Rye. Same picture (?) reappeared later in Witt without donkey. Canvas, 16 × 12 was with U.S. dealer and is now in Lady Mackintosh's Collection. Another 22 × 16½ at Philadelphia Museum. Cundall pl. XXII.

E 2 Canvas. 19 × 24. *Coll:* Victor Rienaecker. Accurately follows L. section of plate (as in state 3) but R. section is plunged in heavy shadow (photo in Witt).

E 3 Canvas. 15½ × 21. Formerly with P. M. Turner (photo in Witt). Similar picture additional mill R. was in Leverhulme Sale, February 1926. 14 × 23½ (photo in Witt).

 Both incorporated cottage from R. distance of E 16.

E 5 A favourite; apart from Dyson Perrins' picture (P. 65), which is authentic there is an upright in Mackintosh Coll. 18½ × 13½. Another probably by W. P. B. Freeman was with Lowndes Lodge. In a canvas 22¼ × 18 formerly in the Eldridge Coll., was a variant based on C. and L. of plate. It looked early and good. Further examples were in Mrs Blackwell's Collection 1921; in Steel Sale, Christies. 15 June 1951. (109) 28 × 35; and in Leverhulme Sale, Knight, Frank and Ruttley, June 1926. (53) 25½ × 21.

E 7 Tate oil (P 134) based on third state. A pastiche, probably by J. Paul, in D. Masters Coll. Reproduced, *Connoisseur*, December 1950, p. 190. Another by same hand, tree trunk L. broader, is photographed in Witt. A fourth in Witt under Constable.

E 8 30 × 23. An additional cottage tucked behind bridge L. sold Arnott and Calver, Woodbridge, December 6, 1967 (240).

E 14 On panel formerly with Fine Art Society. Photo in their files.

E 16 Panel(?) 10½ × 9. Forgery in reverse, sometime with tooth. 15½ × 21. With P. M. Turner (photo in Witt). Incorporates part of E 3.

 14 × 23½ in Leverhulme Sale, February 1926. Same as above with additional windmill R. incorporates part of E 3.

Canvas. $19\frac{1}{4} \times 25\frac{1}{2}$. In a private coll. Suffolk, repr. *Connoisseur*, December 1963, p. 214.

Another on canvas, partly based on *Poringland Oak* (P 87), at Sudley Manor, Liverpool. Cleaned Walker Art Gallery 1967.

E 21 Copy inscribed James Ward amongst Ward photographs in Witt.

E 22 Canvas. $9\frac{1}{4} \times 12$, in Montreal Museum (Learmont Coll.).

Paintings

P 1 THE COW TOWER, NORWICH (Plate 57)

Canvas. 18 × 24.

Coll.: N.C.M. (704–235–951).

Prov.: Mrs Wilson; J. J. Colman; R. J. Colman; by whom presented.
[A traditional, and probable, early history given by Baker suggests that it was in J. B. Crome's Sale of 1834 (100), that it passed to Mrs Wilson, whose father-in-law was a dealer and a friend of Crome.]

Exh.: Nor., 1921 (16) Crome Centenary.

Lit.: Dickes, p. 50.
Theobald, p. 27, No. 17.
Binyon, pp. 11 (repr.), 20.
Baker, pp. 25, 26, 30, 42, 131.
K. Smith, pp. 41, 71, 75, 106.
Mottram, pp. 57, 66, 178, 281.
Colman Cat. 704.
Illustrated Guide to the Colman Collection, 1951, p. 7.
The Mediaeval Cow Tower stands beside the River Wensum on Swanery Meadows, Norwich. Perhaps Crome's 'first sketch in oil', which may have been retained by the family for sentimental reasons. Thinly but broadly painted on a coarse unevenly stretched canvas in a palette predominantly of buff, grey, light green and pink. There is no ground for supposing this the picture Exh. Nor. Soc. 1806 (33), as believed by Theobald (p. 20). Before 1800, possibly much before.

P 2 NORWICH FROM MOUSEHOLD GRAVEL PITS (Plate 58a)
(COMPOSITION IN THE STYLE OF WILSON)

Canvas. 23 × 17½.

Coll.: Timothy Colman, Esq.

Prov.: Mr Bignold of Kirkley, Lowestoft until *c.* 1910; J. R. Nutman by 1920.

Exh. Nor. Crome Centenary, 1921 (47).
Agnews, 1958 (42).
Whitworth, Manchester, 1961 (2).

PAINTINGS

Lit.: Baker, pp. 31, 171, p. V.
K. Smith, pp. 79, 123, 141–142 (repr.).
Mottram, p. 68.
Barnard, p. 2, pl. 22.
Connoisseur, Dec. 1959, p. 233. pl. 5.

Condition: Yellowed by varnish, otherwise good.
Sandy foreground with white figures; middle distance brownish green. An Italianate composition deriving from Wilson. Dated by Baker, *c.* 1798.
Probably before 1800.

P 3 A VIEW ON THE WENSUM, NORWICH (Plate 58b)
(A NORFOLK KEEL ON THE WENSUM NEAR FOUNDRY BRIDGE)

Panel. 19½ × 16¼.
Coll.: N.C.M. (24–75–94).
Prov.: bt. in broker's shop in London by Michael Sharp Crome; given by him to J. B. Morgan who sold it to the East Anglian Society, by whom presented 1894.
Exh.: Nor. Crome Centenary, 1921 (9).
Stoke-on-Trent, 1953.
Kettering, 1952 (15).
Wisbech, 1960.
Lit.: Dickes, pp. 65, 66 (ill).
Theobald, p. 25, No. 13.
Cundall, p. 7, pl. III.
Baker, p. 169.
K. Smith, p. 175.
The Colman Collection Ill. Guide 1951, p. 7 where boat is described as a 'Norfolk Keel, the fore-runner of the Wherry'.
Condition: Three vertical cracks.
Translucently painted in a palette of rose, apple green, and tan. Simplicity of composition probably derives from Crome's painting of Inn Signs. Dated by Baker 1809, but more primitive than pictures of that date.
Before 1804, possibly before 1800.

P 4 SHEDS AND OLD HOUSES ON THE YARE (Plate 60b)

Canvas. 19 × 24¼.
Coll.: Constance, Viscountess Mackintosh of Halifax.
Inscribed: On verso *Sp . . . Mill by J. Crome; bought from his pupil Mr Stark.*

Prov.:	? James Stark.
	? W. Wilde. Anon Sale, [C. F. Huth] 30 June 1906, bt. Gooden. (£163)
	Sir Leicester Harmsworth in 1920;
	Tooth & Co. 1950, from whom bt. by 1st Viscount Mackintosh.
Exh.:	? Nor, 1860 (67) lent W. Wilde.
	Norwich Crome Centenary, 1921 (35).
Lit.:	Baker, pp. 30, 51 and 163, Pl. III.
	Mackintosh Coll., Mss Cat. p. 53 where it is identified as a site near Pull's Ferry on the basis of an oil by Robert Ladbrooke in Constance, Lady Mackintosh Collection.
Condition:	Good.

Colouring dark greys and tan browns, over-cast lighting, creamy highlights. Grandeur of design and occasional inadequacy of drawing relate to *Cow Tower* (P 1); the ducks are handled in much the same way as in *Cottage Gable in Ruins* (D 39); the poorly primed canvas points to an early date.

Dated by Baker: 1803. Inscription on back suggests an identification with *Sprowston Barn and Sheds* lent to Nor. 1860 (67) by W. Wilde.[1]

Probably before 1800, certainly before 1805.

P 5 RIVER LANDSCAPE WITH CHURCH
 (GORSEDALE SCAR, YORKSHIRE)

	Canvas. 29¾ × 24½.
Coll.:	Mr and Mrs Eric Hinde.
Prov.:	Found by P. M. Turner and offered by Gooden and Fox. to N.C.M. who declined purchase.
Inscribed:	Typed labels on verso *Gorsedale Scar, West Riding, Yorkshire 1769 John Crome 1821* and *Midland Railway, Nottingham.*
Condition:	Thinly painted, discoloured by varnish, but generally good.

Mountainous scene with high rocks L. At their base a river runs disappearing from sight C.R. In it are two rowing boats. Distance C. a church with a tower, R. Bank trees. Colours, grey, dark olive green and rich brown; rocks to L. yellow-cream and grey in high-lights. The boat in foreground flies the Red Ensign aft and has two uniformed oarsmen and a man wearing a tricorn hat as well as women passengers. The scene is not Gordale Scar but is probably on the Herefordshire Wye. Perhaps exhibited 1805 *A View of Persfield from the Wye* (169) although we have been unable so far to establish the existence of any such place on either the Herefordshire or the Derbyshire rivers of the name. Questioned, but in our opinion authentic. Similar in vision to *Rocky River Scene* (D 3) and *Castle in a Hilly Landscape.* (D 4).

Possibly later interpretation of earlier subject matter? *c.* 1804.

[1] An oil of *Sprowston Mill, Norwich* was bt. Lawrence in an Anon Sale, July 28 1909. Ex. Coll. W. Mitchell 1904 (see Baker pp. 115–6).

PAINTINGS

P 6 HORSE(S) WATERING (Plate 61a)

Millboard. 13½ × 10.
Coll.: N.C.M. (717–235–951).
Prov.: William Davey; Canon Davey of Lampeter; bt. by J. J. Colman 1895; R. J.
Colman, by whom bequeathed to N.C.M.
Exh.: Nor., 1921 (13) Crome Centenary.
Lit.: Theobald, p. 28 (No 18).
Baker, pp. 25, 26, 141.
The oast-cowl may be that at Harrison's Wharf, King Street, Norwich.
A brown monochrome. The free handling of paint and sombre tone might
suggest a very early date. Theobald described it as a *very early picture* and Baker
as *evidence of his student efforts* mentioning possible influence of Rembrandt
drawings. In palette, medium and technique similar to Mackintosh *Farmyard
Scene* (P. 7). Not necessarily *very* early.
Before 1805.

P 7 FARMYARD SCENE (Plate 60a)
 (STUDY OF AN OLD BARN)

Millboard. 16½ × 20¾.
Inscribed: Verso: *Study of a Farmyard. Old Crome.*
Coll.: Constance, Viscountess Mackintosh of Halifax.
Prov.: 'From Crome's Sale'; T. Woolner, R. A., his Sale 12 June 1875; E. J. Stansby,
Yelverton Hall, near Norwich; Leggatts, 1948. 1st Viscount Mackintosh of
Halifax.
Lit.: Mackintosh, Mss. Catalogue 39.
Baker, pp. 108, 135.
Baker seeks to identify it with *Farmyard, a sketch in oil* (67) Nor. Soc. 1805. This
is not impossible but if so it may have been painted considerably earlier. Ac-
cording to the owner a pendant did exist in the collection of the late Lord
Mackintosh which was sold *sometime ago*. We have been unable to trace it.
Palette golden brown with a grey-white cloud. In technique similar to *Horse
Watering* (P 6).
Before 1805.

P 8 (OLD) MILL ON THE YARE (Plate 59b)

Canvas. 25 × 29.
Coll.: Pennsylvania Museum, Philadelphia.
Prov.: Marquand Sale, American Art Assoc. N.Y. 24/31. Jan. 1903 No. 33 (repr.) bt.
Knoedler sold to George W. Elkin, by him pres. to Mus.

Lit.: Baker, pp. 147, 187, 192, 195.
Connoisseur, Nov. 1960, p. 214.
Not seen. Palette dark russet and whitish greys. Compare *Limekiln* (P 9) in the late Sir Stephen Courtauld's collection and similar in sky to *Cart Shed at Melton* (P 16).
c. 1804–6.

P 9 THE LIMEKILN (Plate 59a)

Canvas. 20 × 29½.

Coll.: The late Sir Stephen Courtauld, Rhodesia.
Prov.: Probably Thomas Churchyard, his Sale 28 March 1866 (43) bt. Roe; Mrs Temple-Silver; her Sale, 4 April 1912, bt. Agnew; Hon. Capt. C. Hanbury Williams in 1920.
Lit.: Dickes, p. 60.
Baker, pp. 26, 30, 42, 50, 145, Pl. IV.
Perhaps one of the two *Lime-Kilns* (P 51 and 98) exhibited in 1806 although probably painted considerably earlier. Not seen, the owner reports that its present condition is so dark that it is almost invisible. Influence of John Opie apparent. Compare *Mountain Scene, Wales* (P 14) and *Carrow Abbey* (P 15). We agree with Baker's dating.
Before 1806.

P 10 LIMEKILN NEAR NORWICH

Canvas. 15½ × 21¾.

Coll.: Dr Arnold Renshaw.
Prov.: H. A. E. Day.
Inscribed: On label verso: *No. 1 Limekiln near Norwich.*
Condition: Very poor, originally a thinly painted sombre toned picture that has been shamefully overpainted.
Track C. leading to a distant (?) limekiln L. banks and trees R. two figures, one standing, one seated by logs L.
Dr Goldberg in a letter to the owner (3 February 1965) identified this as *Blogg's Lime Kiln* that was Exh. Nor. Soc. 1806. This precise identification is hazardous.
c. 1804–6.

P 10x COTTAGE: SHEEP COMING THROUGH GATE

Canvas. 22½ × 30.
Coll.: J. R. Cozens Wiley, Esq.

Prov.:	Thomas Randal Wiley; his Sale 1827, bt. J. Wiley (£5-10-0); by descent to the present owner.
Inscribed:	On label verso: *This picture was bought in 1827 at Thomas Randal Wiley's auction, St. George's Norwich, and see the catalogue of Sale by Spelman where it is described as 'Landscape by the late Mr J. Crome, a very clever painter, in a rich frame, and was sold for £5-10-0. The original copy of which is in the . . . Law, Shalford Vicarage, Essex . . . of the late Mr J. Randal Wiley'.* The Law and Wiley families are related.
Exh.:	Nor. 1921 (56) Crome Memorial.
Lit.:	Baker, p. 129.
Condition:	Good.

Baker reports a copy, 22 × 28¼, in Anon Sale, Christies, 9 Nov. 1920 (67). This is an important document as it can be traced in undisturbed possession to within four years of Crome's death. (T. Randal Wiley died in 1825.) Although it cannot be identified as Baker suggests with No. 34 in the 1806 Exhibition as the quotation given with that exhibit is inappropriate, the likeness of the tree painting to P 10, the freedom of the brushwork which relates to *Gibraltar Watering Place* (P 17), and the subdued palette, all point to a date *c.* 1804–6.

P 11

EARLY DAWN (Plate 68)
(DAWN)

Panel. 13⅝ × 11¾.

Coll.:	N.C.M. (706–235–951).
Prov.:	Alderman William Davey of Norwich; Canon Davey of Lampeter; by whom sold to J. J. Colman in 1894; pres. by R. J. Colman.
Exh.:	Nor., 1921 (15) Crome Centenary.
Lit.:	Dickes, p. 132.
	Binyon, pp. 15, (repr.) 47.
	Baker, pp. 26, 30, 42, 51, 132.
	Mottram, pp. 68, 69, 93, 201.
	Theobald, p. 28, No. 18.
	K. Smith, pp. 79, 111, 106.

Smoke grey sky grading down to a clear primrose; grey black barn. Similar in simplified composition and limited palette to *The Windmill—Evening* (P 13) and Prof. Clarke's *Cottages* (P 25). The subject of this picture may not be *Dawn* but *Evening* and, if so, this may have been Exh. Nor. Soc. 1806 (39). Binyon, Mottram, Kaines Smith and Baker refer to its Rembrandt quality. In particular we see a resemblance to Rembrandt's early *Scholar in his study* at the National Gallery (3214).
c. 1804–6.

P 12

THE BELL INN (Plate 61b)

Canvas. 30½ × 23.

Coll.:	The late T. W. Bacon, Esq.

Prov.: bt. from Shepherd's Gallery, 1910 (£200).
Exh.: Loan to Birmingham City Art Gallery, 1950.
Condition: Relined, old relining refixed to new canvas. Paint surface excellent.
 We have been unable to identify the Inn. It may have been at King's Lynn. Inn building and foreground shades of fawn and chocolate brown; gateway R. with cream plaster walls, arch with pale brick red voussoirs; a dull mustard coloured sail L.; grey sky.
 Painted at the same time as *The Windmill—Evening* (P 13), Old Houses, Norwich (P 26) and *Carrow Abbey* (P 15). *c.* 1805–6.

P 13 THE WINDMILL—EVENING (Plate 69)

Canvas. $29\frac{3}{4} \times 24\frac{7}{10}$.
Coll.: Mr and Mrs D. P. Clifford.
Prov.: Anon Sale, Sotheby, 8 March 1967 (238), *Windmill on a Rise*.
Condition: Cleaned and restored 1967 by Mrs Hetherington.
 There is evidence that the development of this picture was extraordinary. X-ray photographs suggest that the Mill was originally light against a dark background. The foundation colour of the sky was a very dark, rather strong, blue; over this was painted another blue, considerably lighter but still stronger than usual with the later Crome; on top of this the greater part of the existing sky was imposed. To R. of the mill on the skyline was a dark green hedge ending in a tree which had two distinct positions; on the extreme L. the dark green branches of a tree stretched into the picture. So far, all was Crome's work, but it is not absolutely clear whether the first over-painting of the trees and hedges was done by him. We believe so. Certainly there was further overpainting later in a colour which was calculated to match the varnish-discoloured portions of the remainder. This was probably done to conceal *pentimenti* which may have begun to appear through Crome's final over-painting.
 Palette similar to *Early Dawn* (P 11). The indication of the building's texture seems paralleled in *Old Houses, Norwich* (P 26). This may be of the old post mill at Trowse (see Cot. & Haw. p. 30, pl. 2). Crome Exh. at Nor. Soc. 1806 (65) *The Windmill* and in 1807 (134) *Trowse Windmill*.
1804–7.

P 14 SCENE IN CUMBERLAND (Plate 66)
 (MOUNTAIN SCENE, WALES)

Canvas. $29\frac{5}{8} \times 23\frac{1}{4}$.
Coll.: National Gallery of Scotland, Edinburgh (944).

Prov.: ?D. Gurney, Anon. Sale (Rainger), Christies 28 February 1863 (28) (*Mountain Scenery, with figures and goats on the rocks.*) Shepherd Bros., 1907, bt. by Gallery.

Exh.: ? Nor. 1874. Loan Exh. of Norf. & Suff. Artists.

 Shepherd's Gallery, London, 1907.

Lit.: Edinburgh. Cat. p. 58.

 Baker, pp. 102, 168.

 The picture is *ascribed* to Crome in Edinburgh Cat: *If it is by Crome it seems more probable that it comes from the Lake District tour of 1802.* On the stretcher is a label, apparently cut from the cover of the Cat. of the Exh. of Aug. 1874 but that catalogue contains *no* entry for this picture.

 Accepted by Baker and dated *c.* 1803. There is no doubt that it is by Crome, and dates from about the same time as *Carrow Abbey* (P 15). The feral goats suggest the scene may be in Snowdonia perhaps on Tryfan. Is there a record of wild goats in Lakeland?

 c. 1803–6.

P 15 CARROW ABBEY, NORWICH (Plate 67)

 Canvas. 50 × 37½.

Coll.: N.C.M. (705–235–951).

Prov.: Philip Meadows Martineau of Bracondale, Norwich, principal surgeon at Norwich Hospital who is said to have received it as a gift from Crome; Miss Martineau at whose Sale *c.* 1877 bought by J. J. Colman (340 gns.); R. J. Colman by whom presented.

Exh.: Nor. Soc., 1805 (145)—marked as for sale.

 Nor., 1821 (55)—lent P. M. Martineau.

 Nor. and Suff. Inst., 1828 (54).

 Nor. Polytechnic Exh., 1840 (28).

 Nor., 1856 (305).

 R. A., 1862 (138) as *Sky by Opie*—lent Miss Martineau.

 R.A., 1878 (27).

 Newcastle, 1887.

 Norwich, 1921 (12).

 R.A., 1934.

Lit.: Dickes, pp. 47, 49 (ill).

 Theobald, p. 26.

 Binyon, pp. 9 (ill), 18.

 Baker, pp. 26, 27, 30, 42, 50, 59, 125.

 Mottram, pp. 100, 101, 102, 104, 107, 162, 178.

 Colman Coll. Ill. Guide 1951, p. 7.

 Cundall, p. 12.

 Repr. *The Portfolio*, April 1892.

 K. Smith, pp. 80, 106, 111, 127, 130, 141.

A *View from Carrow Abbey, after Crome* (228) was exhibited by J. Kirtle in Nor. Soc. 1808.

Condition: Rubbed. In *Eastern Daily Press* 31 January 1885 it was referred to as 'intact from the artist's easel' by which we take it to mean that it had not been over-worked for when Reeve (p. 23) saw it in 1877 it was 'much cracked, in bad condition and dark'.

The Abbey, now destroyed, was a Benedictine nunnery founded in the 12th century. Thinly but broadly painted. Palette, shades of grey with a paler luminous sky. There seems no evidence that Opie painted the sky, which was stated first in the 1862 Exh. A *View from Carrow Abbey, after Crome* (228) was exhibited by J. Kirtle in Nor. Soc. 1808.

1805 or before.

P 16 A (CART)SHED, AT MELTON, NORFOLK (Plate 63b)

Canvas. 28 × 39.

Coll.: Dr Arnold Renshaw.

Prov.: ? Madame de Rouillon; Squadron Leader Norman Hamson; H. A. E. Day. Anon Sale. 18 November 1966 (89) [repr.] bt. in.

Exh.: ? Nor. Soc., 1806 (46).

Inscribed: On the stretcher: *1805 Shed at Melton by J. Crome.*
 1820 de Rouillon.

Condition: 'L'-shaped tear top C., diagonal tear through centre skillfully repaired. Sky to R. retouched as also silhouette of horizon to R. Hard schematized edge to foliage R. is not autograph. Signs of *pentimenti* showing foliage to have extended over a larger area to R.

Thundery sky with white, grey green lights and a little blue. Foliage dark green, creamy impasto on wall of building with touches of pink. Compare *Gibraltar Watering Place* (P 17) and the *Slate Quarries* (P 18). Influence of Opie which began in 1798 leaves the date of this open to 1798–1806, probably *c.* 1804–5.

P 17 GIBRALTAR WATERING PLACE, NORWICH (Plate 64)

Canvas. 38½ × 55.

Coll.: Homeless.

Prov.: Anon. Sale (Rainger) 28 February 1863 (Lot 109) bt. Rainger; Lord Suffield, bt. Boswell; W. W. Lewis; possibly James Orrock; A. Sanderson Sale 3 July 1908 (57) bt. A. Smith a dealer in Knightsbridge, dead by 1921 (£105).

Exh.: Grosvenor Gallery, 1889 (51) lent W. W. Lewis.
Bradford, *late 19th century.*

Copy: By a contemporary Nor. hand, canvas, 38½ × 50, coll. of Mr and Mrs D. P. Clifford, bt. Sotheby 1966. Figure and boat to L. have been painted out but are still visible.

Lit.: *Art Journal*, 1897 (ill).

Dickes, pp. 102–3.

Baker, pp. 59n., 137.

Apollo, April 1966, ill in colour (advert).

Gibraltar Watering Place is beside the Gibraltar Inn at Norwich.

Broadly painted on a coarse canvas. Deep green water, creamy yellow impasto to palings R., thundery sky predominantly dark grey and pink. Building in distance L. with russet tiles. Produced under influence of Opie. Compare palette and handling of the *Slate Quarries* (P 18) and *Cart Shed at Melton* (P 16).

c. 1804–5.

P 18 SLATE QUARRIES (Colour Plate I)
(THE CUMBERLAND SKETCH; STONE QUARRIES)

 Canvas. $48\frac{3}{4} \times 62\frac{1}{2}$.

Coll.: Tate Gallery (1037).

Prov.: Dawson Turner; but not in his Sale; J. N. Sherrington Sale 1 May 1858 as *Stone Quarries* (30).[1] Fuller Maitland; Richard Charles Wheeler from whom bt. by Trustees of the Nat. Gall. 1878. (See also note 4 to Chapter 7 where an extensive correspondence is quoted.)

Exh.: B.I., 1864 (180) lent Fuller Maitland.

Leeds, 1868 (1072).

R.A. Old Masters, 1873 (47), lent Fuller Maitland.

Nor., 1921 *Crome Centenary* (2) repr.

Tate, 1959 (83).

Lit.: Dickes, pp. 37, 123.

Theobald, pp. 18, 19. No. 4.

Binyon, pp. 18–19.

Baker, pp. 28–29, 59n, 66, 164. Pl. VIII.

Wilenski, *English Painting* pp. 199, 201, Pl. 27b.

Mottram, pp. 93–94.

Barnard, p. 2.

K. Smith, pp. 10, 41, 42 (repr.), 106, 107, 126, 127, 128–9, 136, 142–3, 146.

Condition: Good, Theobald's description of its ruinous state should not, as Baker pointed out, be taken seriously. The blues are said to have gone. Cleaned by Walker.

Although the history must be considered unproved it seems probable that 'Dawson Turner; Sherrington; Fuller Maitland' is correct.

Dickes suggests the scene is in the neighbourhood of Borrodale and instances Green Crag, otherwise known as Castle Crag or Castle Rocks of St John with Saddleback beyond. If in Cumberland perhaps Exh. Nor. Soc. 1806 (145) with stanza from Collins. We are inclined to believe it a view of the slate quarries

[1] In Sherrington Sale described as: '*The Stone Quarry*'. *View over a grand and mountainous country. A fine composition and painted with great vigour and effect.* [150 guineas Bt. in.]

from Ffestiniog in North Wales with the semi-circular ridge of Snowdon visible
in L. distance. Compare also *Snowdon from Moel Hebog* by W. F. Varley (Hardie
Vol II, fig. 89).

If Borrodale, then based on the visit of 1802 or of 1806; if Wales, on the tour
of 1804. There is no reason to follow those who believe that an early sketch was
worked up for exhibition in 1818. Dated by Baker *c.* 1806 we see the style as
consistent with *c.* 1804.

P 19 DISTANT VIEW OF NORWICH (Plate 63a)
 (WINDMILL NEAR NORWICH)

Canvas. $25\frac{1}{4} \times 29\frac{1}{2}$.

Coll.: Museum of Fine Arts, Boston.

Prov.: Mrs Martin Brimmer, her bequest 1906.

Exh.: Boston, Fogg Art Mus., May 1930 (17).
 Toronto, 1935.
 Jacksonville, Nashville, New Orleans, 1967 (8). Repr.

Lit.: Baker *A Lay-in by Crome—Burlington Mag.* LXXIII (Dec. 1938) 429, p. 274,
 Pl. A.
 Connoisseur, Dec. 1960, pp. 216–17, fig. 7.
 Connoisseur Year Book 1962, p. 118, Pl. 3.
 Dr Goldberg in Jacksonville Cat. suggests a date *c.* 1814–16 whereas it had
 previously been dated 1812. Baker wrote '*It is most unlikely that Crome ever*
 exhibited this canvas which in his eyes would have been no more than an under-painting.'
 Not seen but apparently authentic. Composition derived from an engraving by
 Charles Catton jnr. of 1792 (Cot. & Haw. p. 30, pl. 1.). Brownish red ground to
 canvas, sky greenish grey with pink blush, curious light greens in foreground and
 ivory white on coarse canvas. Not seen but from description of palette appears to
 relate to the *Slate Quarries.* It is probably a finished work. Perhaps Exh. Nor. Soc.
 1806. (65) *The Windmill. c.* 1804–5.

P 20 TEMPLE OF VENUS, BAIAE (Plate 65)
 (RUINS ON THE BANKS OF A RIVER)

Canvas. $18 \times 28\frac{1}{2}$.

Coll.: N.C.M. (711–235–951).

Prov.: Anon Sale (Rainger), Feb. 28, 1863 (100) bt. in (£10) as *Ruins on the Banks of a*
 River. T. Woolner Sale 1875; passed to Sir Inglis Palgrave, bt. from him by J. R.
 Nutman; R. J. Colman by whom presented.

Exh.: Nor., 1921 (49) *Crome Centenary.*
 Tate, 1925 (66).

Lit.:	Dickes, p. 69.
	Baker, pp. 31, 165, Pl. II.
	K. Smith, pp. 47, 79.
	Mottram, pp. 68 and 117.
	Colman Coll. Ill. Guide 1951, p. 7.
	Constable, *Richard Wilson*, fig. 155c., p. 239.
	Barnard, p. 2, Pl. 21.
	Hawcroft, *Connoisseur*, December 1959, p. 233, fig. 4.
Copy:	Poor water-colour at N.C.M. (742–235–951). From Coll. of J. J. Nurse; P. M. Turner (1921); R. J. Colman 1933 (Turner exchanged it with Colman for a water-colour of Colchester Mill by Constable); passed to N.C.M. with Colman Coll.
	Oil acquired present title between 1863 sale and Woolner's sale in 1875. The ruins of the Temple of Venus looked very different. Compare Wilson drawing at V. & A. Mus. (Dyce 647) illustrated by Brinsley Ford, *Drawings of Richard Wilson* p. 57–8, Pl. 44. Said to be a reminiscence of a Richard Wilson which was in Dawson Turner's Collection. Not a copy of any known Wilson but a composition based on Wilsonian features. Best described as 'Wilson crossed with Opie'. There is no reason to suppose it the exhibit of 1811, as Baker did. Etched by Dawson Turner's daughter Mary Ann as No. 35 in a volume of prints after Wilson in B.M. (photo in Witt), 1804–5.

P 21 VIEW OF THORPE (Plate 62)

	Canvas. 26 × 19¼.
Coll.:	Dr and Mrs Norman L. Goldberg.
Prov.:	Colnaghi, 1884; H. Seligman, N.Y., 1884–1934, his Sale Amateur Art Assoc. 29 March 1934, (10); W. P. Chrysler jn. 1934–1950; Norton Gallery N.Y., 1950, Miss Nellie Bowen, 1950–59.
Condition:	Good, relined 1950.
	It is difficult to see this as a scene near Thorpe or, indeed, anywhere in the immediate vicinity of Norwich as the rocky river is quite uncharacteristic. It may be a scene on the Wye.
	Not seen; an unusual picture freely painted, thin in places. Feeling of paint like *A Cart Shed, at Melton* (P 16). Possibly Exh. 1807 (108).
	1805–6.

P 22 A COTTAGE–EVENING

	Canvas. 35½ × 27½.
Coll.:	Mrs M. St. J. Barne.
Condition:	Poor, rubbed thin, sky largely repainted.
	Gable of plaster cottage with three chimneys R., a track foreground disappears behind cottage C. Palings and trees L. Two squat figures on track C. Cottage

and foreground sombre shades of grey and brown, warm yellow sunlight silhouettes figures glancing on trees and palings. Pink and yellow sky washed with grey largely repainted. Painted after *Gibraltar Watering-Place* (P 17) and at about the same time as the Bacon *Bell Inn* (P 12), 1806. Possibly Exh. Nor. Soc. 1807 (164).

P 23 YARMOUTH JETTY (Plate 78)

Canvas. 39 × 49¾.
Coll.: Mr and Mrs Paul Mellon.
Prov.: Lord Hillingdon, Sevenoaks.
Exh.: R.A. 1903 (38) as *Sea Piece*.
 Agnew 1958 (45).
Lit.: Dickes p. 129.
 Baker p. 178.
Condition: Probably trimmed a little L. and R. sides and bottom. Relined. Through thin over-paint of foreground can be seen L. beached boat prow on, in front of it are standing two large fishermen seen from back view. They wear broad-brimmed hats. Sandy strip of beach can be seen through foreground boat R. Cleaned and restored 1967–8.
 Sombre colouring with a rich grey sky, silver yellow strip of sand; fine handling of straw baskets and kreel of fish L. foreground. The condition it is in makes one ask how Crome intended it to be left. In its original condition it must have looked like the Birkenhead version (see below). Dated by Baker *c.* 1809. We believe earlier, relating it in composition to B.M. *Yarmouth Jetty* (D 37). A variant of the figure bending forward in a cart is here repeated.
 c. 1804–6.
Version: (a)
 Canvas, 29 × 34½.
Coll.: Williamson Art Gallery, Birkenhead.
Prov.:

 Finished version, or record of, P 23. The composition is overcrowded and the foreground handling is particularly coarse. Doubtfully by Crome.

P 23x COTTAGE(S) AT HUNSTANTON, NORFOLK

Canvas. 30 × 25.
Coll.: Mr & Mrs D. P. Clifford.
Prov.: Rev. J. Homfray, Minister of Yarmouth (1768–1842); sometime before 1840 bt. from him by Dawson Turner (£14); his Sale 14 May 1852 (33); Knight, Frank and Rutley, 18 January, 1968 (4).

Inscribed: Label verso, written in faded brown ink; *An Old Cottage and Figures, Old Crome.* and in large letters *106 B.*

Exh.: Nor. Soc. 1807 (14).

Lit.: Turner. *Lithog.* p. 23 repr.

Copy: Pastiche probably based on *Lithog.* Canvas 30 × 25 in A. Gibbs Coll; with Leggatt 1911; Reid Sale, American Art Assoc. 1935 14–18 May Lot 11 69 (repr.). Possibly Exh. R.A. 1888 (3).

Condition: Poor, rubbed, particularly thin lower R. quarter of canvas, small scratches foreground. The *bare stem of an oak* mentioned by Turner has been cleaned off. Ruddy priming, palette as described in *Lithog.* Turner saw in it the influence of Gainsborough and Rembrandt. Very close in composition and handling to *Carrow Abbey* (P 15).

c. 1804–5.

P 24 THE CULVERT (Plate 71)

Canvas. 20½ × 25.

Coll.: Mr and Mrs D. P. Clifford.

Condition: Poor, rubbed, several small holes and a vertical tear to the R. repaired. Relined and cleaned 1966–7 by Mrs Hetherington.

Influence of Jacob van Ruysdael both in the sky and the oblique sunlight of the middle distance. Small glimpses of blue sky breaking through grey-white cumulus clouds; foreground generally chocolate brown and tan relieved with touches of dark green and russet. Grey-white impasto touched with salmon pink on R. wall of centre building. Terracotta brickwork showing through plaster and timber gable of cottage L.

c. 1804–6.

P 25 STORMY LANDSCAPE WITH GABLED COTTAGES (Plate 70b)

Millboard. 11 × 14½.

Coll.: Prof. J. Grahame D. Clark.

Prov.: ? in W. E. Gladstone Sale 1875, (*Gladstone Family,* inscribed in ink verso) Mrs Sackville Marten of Leigh (previously Miss Glynne) sold 1944; C. A. Jackson, Manchester (dealer) Oct. 1944; Anon. Sale, Christie, 2 December 1955 (37). Strong tone and fluent brushwork similar to *A Cart Shed, at Melton* (P 16) but closer in palette to *Early Dawn* (P 11). Study for untraced oil (P 26).

c. 1805–7.

P 26 OLD HOUSES, NORWICH (Plate 70a)

? millboard.

Coll.: Untraced; photo in Witt.

Not seen, but photographically convincing. An oil sketch for it is in Prof. Clark's collection (P 25).

c. 1805–7.

P 27 VIEW NEAR WEYMOUTH (Plate 72)
 (VIEW OF THE SOLENT)

Panel. 11 × 20¾.

Coll.: Institute of Arts, Detroit, U.S.A.

Prov.: W. Fuller Maitland in 1920; R. Langton Douglas; acquired by Detroit in 1928.

Exh.: ? Nor. Soc., 1806 (81).

Nor., 1921 (43) *Crome Centenary.*

Hartford, Conn., Wadsworth Atheneum.

Kansas City, M.O., Wm. Rockhill Nelson Gall., 1937.

Pittsburgh, P. A., Carnegie Inst., 1938.

Detroit, Mich., 1942, (62) repr.

Milwaukee, Wis., Milwaukee Art Inst., 1946.

Jacksonville, Nashville and New Orleans, 1966–7. (2) repr.

Lit.: Wodderspoon, p. 14.

Dickes, p. 56.

Baker, pp. 31, 76, 118, 164, Pl. VII.

J. Walther, *Bull. of the Detroit Inst. of Arts,* X, January 1929, p. 51, Pl. 4.

W. Heil, *Art in America* XIX 1930–31 p. 200ff.

Connoisseur, November 1960, p. 216, fig. 8.

Detroit Inst. of Arts. Cat., 1944, No. 17.

Dr Goldberg in the Catalogue of the Jacksonville Exhibition identified the scene as *of Weymouth Bay viewed from Wyke Regis on route to Portland in Dorsetshire* and states that it was painted in 1806 when staying with Thomas Buxton at Weymouth. That Crome *did* stay with Buxton is likely but not proved nor, if he did so, that it was in 1806; the preceding year is more probable. The scene is, however, almost certainly taken from the point Dr Goldberg described, the dark spot on the coast in C. being Sandsfoot Castle.

Not seen, colour reported to be *pale blue sky, brown field foreground, grey purple line of cliffs in distance.*

c. 1805–6 or later.

P 28 THE YARE AT THORPE (Plate 73)
 (A VIEW ON THE NORWICH RIVER, BY THE KING'S HEAD, THORPE)

Panel. 16 × 21½.

Coll.: N.C.M. (707–235–951).

<table>
<tr><td>*Prov.:*</td><td>Charles Norris, York Place, Norwich c. 1860; sold to Joseph Parrington of Bungay; his Sale 1866 (£10) passed to H. G. Barwell (£230) in 1888; Miss Barwell, by whom sold to Colman June 1906 thence to N.C.M. with Colman Collection.</td></tr>
</table>

Exh.: R.A., 1891 (29).
R.A. 1901.
Nor. *Crome Centenary*, 1921 (22).

Lit.: Dickes, p. 130 (ill.).
Portfolio, April 1892, etched by C. J. Watson.
Theobald, p. 33.
Binyon, pp. 31, 37 (repr.).
Baker, pp. 55, 175.
Mottram, p. 180.
Hawcroft, *Connoisseur*, December 1959, p. 236, fig. 13.

Drawing: Pencil study at B.M. (D 31) signed and inscribed: *View from King's Head Gardens at Thorp. July 3d 1806. J. Crome.* Letter from Charles Norris, Brixton Vicarage, 22 December 1886 is in Reeve Album—*A Picture of 'Cattermole's at Thorpe' I remember in my father's possession . . . I think it was given by him to his friend Robert Hansell, who now lives near the Whalebone at Catton. . . . The Old Crome was a view of Cattermole's Gardens at Thorpe with a fine old Willow in the left corner, taking in a little bit of the river, from the other side of which I should say it was painted . . . about two feet by 20 inches is my recollection of size.'* Note by Reeve—'the Norris picture is now (1901) in the possession of Miss Barwell, Surrey St., Norwich.' C. Norris had in memory reversed the picture.

Thinly painted, almost a grey monochrome. The date on the pencil drawing, reinforced by the indebtedness to Gainsborough, combine to date this c. 1806.

P 29 A SHEPHERD AND SHEEP BY A BARN

Panel. $11\frac{3}{10} \times 15\frac{9}{10}$.

Coll.: Mr and Mrs D. P. Clifford.

Prov.: Probably Anon (W. Rainger) Sale, 28 February 1863 (76), bt. Rippe (£12 5s); L. R. Nightingale; Rev. C. J. Sharp, his Sale, Sotheby, 5 October 1967 (207).

Condition: Poor. Panel cracked horizontally about three inches from bottom. Dark areas of paint broken up by bituminous cracking.

Thatched plaster barn or cottage R. seen from the back. Track C. on which is shepherd herding sheep; behind them a gate, trees background C. and L.

Brown priming, silver grey and green foliage. Light falls on C. group of shepherd and sheep illuming cream and fawn plaster wall of cottage.

Described in Rainger Sale as *Old Cottage at Bawburgh, near Norwich: a shepherd near a gate with a flock of sheep.* $15 \times 11\frac{1}{2}$.

Painted in a similar palette to the *Yare at Thorpe* (P 28), vision similar to

At Drayton (D 32), *Cottage: Sheep coming through Gate* (P 10x) and damaged *Woodland Scene* in Loyd Coll., Wantage. 1806–7.

Copy: Formerly with P. M. Turner. Photo in Witt. No measure given. A poor pastiche; the building R. made taller and slimmer, trees awkwardly painted with long slender branches.

P 30

THE RIVER YARE (Plate 74b)
(VIEW ON YARE: FARM AND BARN)

Canvas. 9 × 12½.
Coll.: Mrs W. Spooner.
Prov.: Agnew 1909; Lt. Col. J. B. Gaskell 1920.
Lit.: Baker, p. 175.
Described by Baker as in '*Early Wilsonian Manner*'.
? Before 1808.

P 31

ON THE DERWENT, DERBYSHIRE (Plate 74a)
(LANDSCAPE IN WALES, WELSH LANDSCAPE)

Canvas. 15 × 23½.
Coll.: Fitzwilliam Museum, Cambridge (P.D. 49–1949).
Prov.: ? Gillot Sale 1872 (305 gns.) [Dickes, p. 119 as *Gilbert* Sale] J. Heugh Sale 24 April (166) 1874 (210 gns.); Sir William G. Armstrong (by 1876); Agnews (129); Christies, bt. 1949 with Fairhaven Fund.
Exh.: R. A. Winter Exhibition 1876 (17).
Version: Drawing at N.C.M. from a slightly different angle (D 5).
Lit.: Baker, pp. 108, 167.
Constable, *Richard Wilson*, p. 143n.
The scene was identified as near Matlock Tor on the evidence of a landscape by Wright of Derby; see Charles E. Buckley *An English Landscape by Joseph Wright of Derby* in *Art Quarterly*, Autumn 1955, pp. 265–271; Shows influence of Richard Wilson both in composition and colour. Crome visited Matlock in 1802 and 1806. He exhibited a drawing of Matlock in 1811 (146). May not represent the High Tor itself but a similar crag a few hundred yards down the Derwent.
c. 1806–11.

P 32

RUINS, EVENING (Plate 76)
(RUINED BUILDINGS)

Canvas. 30 × 25.
Coll.: National Gallery of Canada (4273).

Prov.:	L. R. Nightingale; Sir Samuel Hoare; Palser Gallery, bt. by Gall. 1937.
Exh.:	? Nor. Soc., 1810 (17).
	Norwich, Paston House Gallery, 1936.
	Toronto Art Gallery, 1940 (60).
	Kingston, Ontario, Queens' University, 1962 (1).
	Victoria, B.C., Art Gallery, 1964 (1).
	Jacksonville, Nashville, and New Orleans, 1967 (4). repr.
Lit.:	*Norfolk Annual, 1936* repr. in colour on cover.
	Nat. Gal. of Canada Vol II, 1959, repr.

Not seen. Perhaps the ruined building is Carrow Abbey seen from a different direction than that in N.C.M.'s painting (P 15). Red-brown ground to a coarse canvas overlaid with translucent greens, creams and russets. Figure to R. of shed door is hardly visible. Compare *Old Houses, Norwich* (P 26) and *The Culvert* (P 24). There seems to be no evidence to suggest, as Dr Goldberg believes, that this is the *Ruins Evening* that was Exh. Nor. Soc. 1810 (17).

c. 1806–7.

P 33 RIVER LANDSCAPE WITH COTTAGES (Plate 75a)

Canvas. 21⅛ × 29¼.

Coll.:	H.R.H. The Duke of Kent.
Prov.:	Sir John Walsham; Lord Lee of Fareham.

Not seen. In store.

Perhaps 1806–7.

P 34 VIEW AT HELLESDON (Plate 75b)

Canvas. 14 × 20.

Coll.:	The Hon. Doris Harbord.
Prov.:	Bt. from Crome by Dawson Turner, his Sale, 14 May 1852 (42) bt. Rudder: ? C. H. Gurney; ? J. Baker, his Sale, 1873. By 1874 Lord Suffield, thence by descent.
Exh.:	R.A., 1870 (68), lent C. H. Gurney.
Lit.:	Turner *Lithog.* ill., p. 13.
	Baker, p. 140.
	K. Smith, p. 84.
Drawing:	Water-colour sketch for this picture is at N.C.M. (D 48).
Condition:	Poor, very rubbed. Said to have been damaged by fire. Cleaned and restored by Mrs Hetherington 1967.

Palette of muted greens and tan; sky dove grey with white impasto on cloud C. In a note Reeve (Nor. Soc.) p. 38 following, mentioned in a list of pictures *not* exhibited at St Andrew's Hall, 1874 as Coll. of Lord Suffield.

c. 1807.

PAINTINGS

P 35

LANDSCAPE WITH COTTAGE AND POND

Canvas. $10\frac{1}{2} \times 8\frac{1}{2}$.

Coll.: Mr and Mrs D. P. Clifford.

Prov.: A. H. Kirk (label verso); H. A. E. Day.

Inscribed: Verso Christies' stencil *763V*, a label *360 Old Crome* and Cut from a Sale Catalogue, *Crome | 141 A Landscape with Cottage and pond*, in red chalk numbered *02233*.

Condition: Relined, good, although a little thin.

Thatched cottage with chimney L. and trees, small haystack R. seen behind fence, pool in front. Grey sky, dark green trees turning russet L. Figure R. in scarlet blouse and grey skirt.

c. 1808–9, or later.

P 36

CATTON LANE SCENE (Plate 77)

(WOOD SCENE AT CATTON, NEAR NORWICH)

Canvas. $27\frac{1}{4} \times 23$.

Coll.: Untraced.

Prov.: (?) John Bracey by 1821;[1] J. N. Sherrington; Dawson Turner, by descent to Rev. J. Gunn (son-in-law of Dawson Turner); Mrs E. Gunn, her Sale 26 April 1912; bt. Agnew; Frank Gaskell by 1920; Sale 7 May 1954 (88); bt. Agnew, sold to H. A. Day.

Exh.: (?) Nor., 1821 (53) Memorial.
Nor., 1860 (40).
Nor., 1874 (19).
R.A., 1878 (49).
Nor., 1921 (31).
Agnews, 1958 (6).

Lit.: Binyon, p. 30.
Dickes, pp. 109, 121 (as two pictures).
Baker, p. 36, 126, repr. Pl. XXXVI.
Theobald, pp. 17, 36, No. 33.

Etched by R. Girling in reverse with title *Lane Scene at Catton From a Picture by Crome in the Possession of Dawson Turner Esqr.* (impressions at B.M. and N.C.M.).

Belonged to Sherrington and was exchanged by him with Dawson Turner for *Slate Quarries* (P 18). This was probably before the 1858 'Sherrington' sale but after the publication of Turner's *Outlines in Lithography* (1840) where *Lane Scene* did not feature. In the 1821 Memorial Exhibition Bracey dated the

[1] A picture of this title was offered for sale by the executors of J. Bracey in 1835 (*Norwich Mercury*, 10 June):
A charming upright Landscape—a Lane scene at Catton, painted with light facility of pencil by the same artist also for the late Mr Bracey.

196

picture 1816 which led Binyon to date it 1816 and Baker *c.* 1815. Bracey's dating may have been inaccurate. It is possible that he bought *Catton Lane* from Crome in 1816 although it had been painted earlier. The picture is rather primitive, notice especially the handling of the horse and cart and the naive-placing of the logs. Influence of early Gainsborough. Compare *Entrance to Earlham Park* (D 45), *River through Trees* (D 54). Not seen.
c. 1808–15.

P 37 BLACKSMITH'S SHOP NEAR HINGHAM, NORFOLK (Plate 86)

	Canvas. 58 × 45.
Coll.:	Philadelphia Museum of Art.
Prov.:	? F. Crome; J. B. Crome, his Sale 1834 (57); J. N. Sherrington, Sale May 1 1858 (46); Louis Huth; W. W. Pearce, his Sale 1872; bt. Myers; Agnew, 1896; John H. McFadden, his bequest.
Exh.:	R.A., 1808 (591).
	? Nor., 1821 (34) as *Blacksmith's Traverse at Hardingham* lent F. Crome.
	Nor. 1828, *Norf. & Suff. Inst.* lent J. B. Crome.
	Agnew, 1896 (20).
	Agnew, 1958 (46).
Drawings:	(*a*) Study at Doncaster (D 36).
	(*b*) Version at N.C.M. (D 44).
Lit.:	Dickes, p. 63.
	Binyon, pp. 20–21.
	Theobald, pp. 13–14.
	Cundall, p. 13–14, pl. XXII.
	Baker, pp. 59n, 106, 122.
	McFadden Coll. of pictures, pp. 13, 14 (repr.).
	Connoisseur, December 1959, p. 234, fig. 7.
	Connoisseur, November 1960, pp. 214, 215, repr. fig. 3.
	Note to Jacksonville Exh. Cat. 1967 (16).

In J. B. Crome Sale described as *The Blacksmith's Shop, one of his best pictures, in the Style of Gainsborough* (£6). The 1821 exhibit was attributed by F. Crome to 1814 but a picture of the same title was Exh. B.I. 1818 (75); this was much smaller than the Philadelphia picture (25 × 22 including the frame).

Influence of Gainsborough's *Cottage Door* which was in Coll. of Crome's patron, Thomas Harvey of Catton.
1807–8.

P 38 ON THE YARE (Plate 82a)
 (MARSHES OF YARE)

	Panel. 9 × 13.
Coll.:	Untraced.

Prov.: Fuller Maitland (1872–1920); formerly with P. M. Turner.
Lit.: Baker, p. 146.
R. H. Wilenski, *English Painting*, pp. 200, 205–6, 217, Pl. 110a.
Same area of ground but from a different angle as *Moonlight on Yare* (P 39) at Tate. Block-like form of clouds reminiscent of earlier *Farmyard scene* (P 7).
c. 1806–8.

P 39 MOONLIGHT ON THE YARE (Plate 82b)
 (MOONRISE ON THE MARSHES, ABBEY MILL ON THE YARE)

Canvas. 28 × 43¾.
Coll.: Tate Gallery (2645) transferred from National Gallery.
Prov.: bt. from Crome by Dawson Turner for £7; his Sale 14 May 1852 (56); bt. J. H. Anderdon; his Sale 30 May 1879 (122); bt. G. Salting (115 gns); Salting Bequest 1910.
Exh.: Amsterdam, 1936 (29).
Paris, 1938 (38).
Hamburg, Oslo, Stockholm, Copenhagen, 1949–50 (33).
Rotterdam, 1955 (28).
New York (Museum of Modern Art), St. Louis and San Francisco, 1956–7 (33).
Versions: Oil sketch showing same ground (P38).
Lit.: Turner, *Lithog* 1840, pp. 18, 19, 20 as *Old Draining Mill on the Yare* (repr.).
Dickes, p. 65.
Theobald, p. 36, No. 32.
Art Treasures of Gt. Britain, repr. (Dent).
Baker, pp. 26, 35, 38, 42, 55, 65, 69, 74, 149–150, Pl. X as *Moonrise on the Marshes of the Yare*.
Mottram, pp. 160, 175.
K. Smith, pp. 84, (repr.), 106, 108, 112.
Repr. on Cover of *Crome Centenary Exh. Cat.* 1921.
Hoyland *The Listener*, 10 June 1965, p. 867.
British School Cat. Nat. Gal., Martin Davis, pp. 29, 30.
British School Illustrations, 1936, p. 33.
Barnard, p. 2, pl. 26.
The location has been argued in Nat. Gal. *British School Cat.*, p. 29. Dawson Turner said that it was on the Yare near junction of Yare and Waveney under the Walls of Burgh Castle. A Mr G. N. Buffet suggested on the Bure at Runham —about 3 miles N.W. of Yarmouth.

 Crome's debt to Van der Neer is apparent. We agree with Baker that this may be *Moonlight scene on the River between Beccles and Yarmouth* (225) Exh. Nor. Soc. 1808. This also would tally with Dawson Turner's identification of the location.
c. 1807–8.

P 40

A COAST SCENE WITH JETTY

Paper or Canvas. 6¼ × 8¼.

Coll.: Untraced.

Prov.: Lady Lever Art Gallery No. 92; sale Christies, 6 June 1958 (102) repr. bt. Rust.[1]

Lit.: Tatlock. Catalogue No. 92, pl. 16 (as Calcott).

Not seen but photographically convincing as a work of *c.* 1808. When recently sold was attributed to Sir A. W. Calcott, R.A. Since then it has been attributed to Crome.

Beach foreground, low jetty stretching almost from L. edge of canvas to R. of C. Sailing boat out to sea R. Other boats drawn up beside jetty L. Two figures in conversation C. and figure by water's edge R. Cloudy sky.

c. 1807–8.

P 41

YARMOUTH JETTY (Plate 80a)

(YARMOUTH BEACH AND JETTY)

Canvas. 20½ × 33¼.

Coll.: Mr and Mrs Paul Mellon.

Prov.: Anon Sale (Rainger)[2] 28 February 1863 (99); bt. Cox £32; W. S. Fuller Maitland [not in 1879 Sale]; S. H. de Zoete;[3] Sale 8 May 1885 (167) bt. Agnew for George Salting; ? Lord Wimborne by 1923; P. M. Turner, Viscount Mackintosh of Halifax (until 1961).

Exh.: ? B.I., 1866 (144), lent Fuller-Maitland.

Virginia, 1963 (74).

R.A., 1964/5 (98).

Lit.: Dickes, p. 176.

Baker, p. 64, 176.

Catalogue of the Mellon Collection *Painting in England 1700–1850*, p. 64 (repr.). The composition is similar to P. 42 for which it may be a sketch.

c. 1807.

P 42

YARMOUTH JETTY (Plate 80b)

Canvas. 17⅝ × 23.

Coll.: N.C.M. (92–945).

Prov.: ? Mrs de Rouillon by 1821; Possibly Wynn Ellis, his Sale, May 6, 1876; S. H.

[1] Information supplied by Mr Fastnedge (letter dated 31 July 1967).

[2] Daniel Gurney prov. is unreliable. In Sotheby Cat. given as *D. Gurney of Hethel Hall.* The present Mr D. Gurney doubts if D. Gurney ever lived at Hethel. It was neither Exh. by him nor was it in his 1867 Sale. The Anon 1863 Sale was not Wimborne's as stated in Mellon Cat. Sir Ivor B. Guest was created first Baron in 1880.

[3] Dickes description of de Zoete picture in this Sale does not tally.

de Zoete by 1878; his Sale 8 May 1885, bt. Agnew; W. C. Quilter 1889; W. M. de Zoete by 1920; his Sale 5 April 1935 (65); sold by P. M. Turner to Sir Henry Holmes May 1936 bt. from Lady Holmes 1945.

Exh.: ? Nor. *Crome Memorial,* 1821 (30).
R.A., 1878 (28).
? Grosvenor Gallery, 1889 (97).
Nor, 1921 *Crome Centenary* (57).
B.F.A.C. 1929.
Wildenstein, 1937.
Harrogate, 1953 (29).
Worthing, 1957 (30).
Agnew, 1958 (15).
Whitworth, Manchester, 1961 (11).
Jacksonville, Nashville, and New Orleans, 1966–7 (6) (In Cat. with wrong photograph).

Lit.: Wodderspoon, p. 20.
Dickes, pp. 63, 64.
K. Smith, p. 132.
Baker, pp. 39, 59, 177–8, Pl. XII.
Colman Coll. Ill. Guide (1951), p. 7 Pl. 12b.
Barnard, Pl. 27.
Wilenski *English Painting,* pp. 200, 206, Pl. IIIa.
Distance R. and sky reminiscent of Watlington picture (P 51).

Wodderspoon, Dickes, and Baker date 1808–9; F. Hawcroft prefers a later date. Dr Goldberg suggests 1813. It connects with *Below Cliff—Cromer* (P 49) which is datable to 1808–9 quite apart from the fact that the Old Jetty, which is represented, was pulled down in 1808.
1808–9.

P 43 MOONLIGHT ON THE YARE (Plate 88)

Canvas. 39½ × 49½.
Coll.: The Hon. Sir Arthur Howard, K.B.E., C.V.O.
Prov.: Kirkman Hodgson; 1904; H. Darell Brown; his Sale 23 May 1924 (17) bt. Agnew (900 gns.).
Exh.: Franco-British, 1908 (73).
Rome, 1911 (19).
Agnew, 1919 (19).
Nor., 1921 (29).
R.A., 1934, (447), Cat. 332.
Agnew, 1958 (52).
Lit.: Dickes, p. 98 (ill.) (*not* in Humphrey Robert's Collection as stated).
Cundall, p. 13, Pl. VI.

PAINTINGS

Burlington, 1908 Vol. XIII, p. 197.
Baker, pp. 149, 184, 190, Pl. XXXV.
Souvenir, 50.

Condition: Rubbed in crown of tree L.; cleaned 1958.
Dated by Cundall 1814, Baker suggested 1816 relating it to the *Moon Rising* Exh: Nor. Soc., 1817 (14). We prefer to place it earlier, closer to the *Blacksmith's Shop* (P 37), *On the Skirts of the Forest* (P 53) and *Woodland Scene with Sheep* (P 55). *c.* 1808–15.

P 44 RIVER SCENE, EVENING (Plate 85)
 (WOOD SCENE—BOATS)

Canvas. 29½ × 24½.
Coll.: Royal Museum and Public Library, Canterbury (8733).
Prov.: S. H. de Zoete, his Sale, May 8 1885, bt. Colnaghi 20 gns. G. F. de Zoete by whom bequeathed.
Condition: Footbridge L. foreground paint largely perished otherwise despite a slight tendency to over-thinness, the condition is good.
Lit.: Baker, p. 110 note.
Consistently thinly painted in predominantly brown and gold on a coarse canvas. Trees L. feathered in a technique resembling late Gainsborough. Light on foliage is indicated in places by juicy specks of paint. A branch to R. of the tall trees (C. top) is outlined by pressure of (probably) the end of a brush. T. C. is inclined to doubt that this is by Crome. It is a little like an early Turner. *c.* 1808–15.

P 45 · YARMOUTH JETTY (Plate 81a)

Canvas. 11¾ × 15¾.
Coll.: Sir Edmund Bacon, Bart., K.B.E., T.D.
Prov.: Sir J. Staniforth Beckett; Sir Hickman Bacon, Bart.
Exh.: Agnew, 1958 (25) *Crome and Cotman.*
Nor., May–Aug. 1964 (16).
Condition: Sky poor, rubbed.
Water-colour study at Tate (D 50) with differences. Thinly painted. *c.* 1808–9.

Copy: (a) Millboard, 12 × 15⅜.
Coll.: Bury Public Library and Art Gallery.
Prov.: Thos. Wrigley Bequest 1897.
Inscribed: Verso *Great Yarmouth Beach, Norfolk* and a printed label: *IMPROVED FLEMISH GROUND PANEL BOARDS prepared for ROWNEY and FORSTER, artist's colourmen,* 51 *RATHBONE PLACE, LONDON.*
Lit.: K. Smith, p. 174.

P 46 YARMOUTH JETTY (Plate 81b)

Canvas. 17 × 22¼.

Coll.: N.C.M. (1-4-99).

Prov.: Miss F. Martineau, her Sale March 22 1877 bt. J. J. Colman (£300); his bequest 1898.

Exh.: ? Nor. Soc., 1817 (20).

Nor., 1874 (59).

R.A., 1878 (38).

Nor., 1921 *Crome Centenary* (8).

British Exh., 1925.

Oslo, Hamburg, Stockholm, Copenhagen, 1949/50 (32).

Paris, 1938 (39).

Leuwarden, Holland, 1948 (17).

British Council, 1949.

Harrogate, 1953 (28).

Art Exh. Bureau, 1953-4 (5).

Agnew, 1958 (11).

Derby and Notts., 1959 (27).

Cologne, Rome, Warsaw, Zurich, 1966.

Versions: (a) Oil (20 × 25½) was in Humphrey Roberts Coll. without anchor in foreground (Dickes, p. 129).

(b) According to a note on verso, Thomas Lound (1802-61), made a copy. This may be the same as (a).

Lit.: Binyon, pp. 35, 37 (ill.).

Cundall, p. 15, Pl. XXI.

Dickes, p. 128 (ill.).

Theobald, p. 24, No. 10.

K. Smith, p. 175.

Binyon suggests 1819, Baker *c.* 1812.

The most sophisticated composition of the *Yarmouth Jetty* series, showing influence of Cotman's pattern making. Relates to Sir Edmund Bacon's picture of the same subject (P 45). A large skiff lying on its side is seen, from the same angle, in the foreground of both. The palette in both is similar.

In the Agnew Catalogue Hawcroft implies a dating of *c.* 1816-7, Binyon suggested 1819 and Baker 1812.

c. 1808-9.

P 47 WHERRIES ON BREYDON (Plate 84a)
 (. . . . ON THE YARE; RIVER SCENE AND BOATS)

Canvas. 21⅓ × 30⅓.

Coll.: Tate Gallery (IIII) transferred from Nat. Gall. in 1949 as by John Sell Cotman.

Prov.: Wynn Ellis Sale, 6 May 1876 (43) *River Scene and Boats* as a Crome bt. Cox;

exhibited in Cox's Gallery 1878 (167) and 1882 (103) as by Cotman and bt. by Nat. Gall. out of Grant-in-aid, 1882.

Exh.: B.I., 1866 (182) lent by Wynn Ellis.
Tate, 1922 (33).
Agnew, 1958 (56) (as *by* Cotman).

Lit.: Binyon, p. 88.
Burlington, 1904 Vol. IV, p. 80.
Kitson, *Life of John Sell Cotman*, p. 116 (as *Wherries on the Yare*).
Isherwood Kay's dossier entry (Nat. Gal.).

Condition: A little thin, otherwise good.

The story that it was in Cotman's Sale at Norwich 12 September 1834 (127) as *Wherries on Breydon* and was there bt. by Thirtle and lent by Mrs Thirtle to the Nor. Poly. Exh., 1840 (140) is pure dealer's invention. There is no reason for identifying the Cotman painting with the present picture which is, in fact, unlike any known Cotman but entirely compatible with Crome.

Kitson unconvincingly defended the Cotman attribution: *Thirtle's widow tried at length to dispose of it without success, until at length it was worked upon and sold as a Crome. The additional paint has been cleaned off, and the original work has been drastically restored. Now it is merely a noble wreck, where the design is almost all that is left of Cotman's handiwork.*

It is comparable to Crome's *Moonlight on the Yare* (P 43), *Boatload* (D 46) and *Barge with a Wounded Soldier* (P 48).

If the scene has been correctly identified as Breydon then this may have been Exh. Nor. Soc., 1808 (154) *Scene near Breydon*.

c. 1808.

P 48 A BARGE WITH (A) WOUNDED SOLDIER (S) (Plate 84b)
(? FISHERMEN IN BOATS)

Canvas mounted on panel. $13\frac{1}{2} \times 20\frac{1}{4}$.

Coll.: Sir Martyn Beckett, Bart.

Prov.: W. Fuller Maitland, his Sale 10 May 1879 (bt. in, 160 gns); his Coll. 1921, bt. Sir Gervase Beckett, Bart.

Exh.: B.I., 1865 (159) lent Fuller Maitland.
Leeds, 1868 (1146).
R.A., 1876 (22).
Grosvenor Gall., 1888 (102).
Nor., 1921 (42).
Agnew, 1958 (32).
Jacksonville, Nashville, and New Orleans, 1966/7 (10) repr.

Lit.: Dickes, p. 125.
Baker, p. 120, Pl. XXIII.
K. Smith, p. 124.

There seems no justification for the present title. In the 1879 Fuller Maitland Sale the title was *Barge, with Fishermen*. The *Soldiers* are two fishermen wearing scarlet waistcoats, one in the boat and one on the shore. Fishermen wearing scarlet jerkins also occur in the *Yarmouth Jetty* series. Similar style to *Cromer Beach, below Cliff* (P 49) and *Boatload* (D 46). *Boatload* is not, as Dr Goldberg believes, neccessarily a study for this picture. There seems no evidence for the Baker-Goldberg dating of 1815–16. Perhaps Exh. 1808 (24) *Fishermen in Boats*. *c.* 1808.

P 49 CROMER BEACH, BELOW CLIFF (Plate 83b)

 Panel. $15\frac{1}{2} \times 22$.
Coll.: Private.
Exh.: ? Nor. Soc., 1809 (24).
Condition: Good save discoloured by varnish.
 Sand, shades of brown and yellow; L. fisherman standing wearing scarlet pom-pom hat and blue-black jerkin. Yellow-brown cliffs under a grey sky.
 Relates to *Barge with a Wounded Soldier* (P 48) and *Wherries on Breydon* (P 47). It is not unreasonable to believe it the picture of this title exhibited in 1809. *c.* 1808–9.

P 50 YARMOUTH BEACH AND MILL: LOOKING NORTH (Plate 83a)

 Canvas. 15 × 20.
Coll.: Lady Crathorne, O.B.E.
Prov.: ? Philip Barnes 1821; Wynn Ellis by 1866, his Sale 6 May 1876 (48); bt. Cox; C. Roundell by 1892; his Sale 10 June 1899 (58); bt. Agnew; sold to Sir Charles Tennant, Bart; Mrs Geoffrey Lubbock.
Exh.: ? Nor. Soc., 1819 (59) as *Yarmouth Beach, looking North—Morning*.
 ? Nor. Crome Memorial 1821 (57) as *Yarmouth Beach*; lent Barnes.
 B.I. 1866 (161) lent Wynn Ellis.
 R.A., 1892 (39) lent C. S. Roundell.
 Nor., 1921, (40) lent Mrs Geoffrey Lubbock.
 R.A., 1934 (602).
 Agnew, 1937 (64).
 Agnew, 1958 (20).
 Whitworth, Manchester, 1961 (12) repr.
 Jacksonville, Nashville and New Orleans, 1966–7 (12) repr.
Lit.: Dickes, p. 98.
 Baker, pp. 32, 39, 41, 109, 113, 176–7, Pl. L.
 K. Smith, p. 132.
 Country Life, 17 July 1958, p. 117, repr.

Connoisseur Year Book, 1962, p. 125, repr. 7.

Is there any reason to assume that this *is* Yarmouth Beach? No one has yet identified satisfactorily the three disjointed masses of masonry. Nor need this picture be as late as 1819. Compare *Squall off Yarmouth* (P 51) and Sir Edmund Bacon's *Yarmouth Jetty* (P 45). Type of figures and boats recur in a lost Paget drawing (D 42).

c. 1808–9.

P 51	SQUALL OFF YARMOUTH (Colour Plate V)

Canvas. 20¼ × 32½.

Coll.:	Hereward T. Watlington, Bermuda.
Prov.:	Sir Cuthbert Quilter, his Sale 9 July 1909, bt. Agnew; Sir W. Quilter; his Sale 26 June 1936 (23) bt. Gooden and Fox.
Lit.:	Baker, p. 164.

Connoisseur, November 1963, p. 199, fig. 9.

Not seen, but clearly very fine. Similar in handling to *Yarmouth Jetty* (P 45) and *Yarmouth Beach looking North* (P 50).

Copy:	On panel? Once with P. M. Turner (photo in Witt), later it was with two dealers, Bernard and Spiller and was offered to Lord Mackintosh. It has been suggested that it was by one of the Stannards.

c. 1808–9.

P 52	MOONLIGHT (Plate 90b)

Canvas. 10 × 12½.

Coll.:	Tate Gallery (2643) as by John Berney Crome.
Prov.:	?Anon (Rainger) Sale, 28 February 1863 (71), bt. in. 'Probably bt. as by John Crome by G. Salting'. Salting Bequest 1910; transferred to Tate 1919.
Exh.:	Leicester, 1956 (43).
Lit.:	Baker, p. 148 (in connection with Lewis Fry's *Moonlight*).
Condition:	Good.

Palette of dark greys and blacks overlaid with pale greenish grey, lemon white impasto centre. Crome exhibited *Moonlights* at the Nor. Soc. in 1805, 6, 8, 11, particularly in the types of foliage profiles, is similar to *Woodland Scene with Sheep* (P 55) and to *Skirts of the Forest* (P 53). *c.* 1809–11.

Copy:	Canvas 10¼ × 13⅜. Coll. Brigadier A. E. Matthews, Wolverhampton. Ex Gibson, Lewis Fry's Coll.; perhaps by J. B. Crome.

P 53	ON THE SKIRTS OF THE FOREST (Plate 87)

Canvas. 42 × 31.

Coll.:	Victoria and Albert Museum (236, 79).

Prov.: Anon. Sale (Rainger) 28 February 1863 (Lot 108) 'An upright landscape, on the skirts of a wood, with the Marlingford oak in the centre, and a shepherd and dog.' bt. Anderdon £53; his Sale 30 May 1879, bt. Groves for V. & A.

Exh.: ? B.I., 1863 (135) lent Anderdon.

R.A., 1872 (3).

Nor., 1921 (4) Cat. repr. Pl. III.

Lit.: Dickes, p. 77.

Theobald, p. 22.

Cundall, Pl. 14.

Art Journal, Ill.

Cassells *Famous Paintings*, 1912.

Baker, pp. 55, 164, Pl. XVI.

K. Smith, p. 82 (repr.), 174.

Studio, December 1948, p. 191, repr.

Condition: Excellent. *Pentimenti* show low C.L. foreground.

Dickes calls this *a matter of fact rather than an interesting picture . . . touch . . . carried almost to crudeness.* Theobald described it as *a fine picture, though not Crome at his best.* However in the 1921 Exh. the picture deservedly gained a kindlier press—*a splendid picture suggestive of the technique of Gainsborough, with thin, fluent and open quality of groundwork.*

Painted after *The Blacksmith's Shop* (P 37) but at the same time as the *Woodland Scene with Sheep* (P 55) and *Woodland Scene near Norwich* (P 54).

c. 1809–11.

P 54 WOODLAND SCENE NEAR NORWICH (Colour Plate II)
(THE MELTON OAK; WOODLAND LANDSCAPE; OAKS IN KIMBERLEY PARK)

Panel. 34½ × 51½.

Coll.: Mr and Mrs Paul Mellon.

Prov.: Anon. Sale (Rainger) February 28 1863 (Lot 106) bt. in; J. W. Fuller Maitland as *Melton Oak* (by 1872); H. F. Broadwood by 1892; James Orrock, R.A. by 1898; J. Pierpoint Morgan; Viscount Mackintosh of Halifax 1952–1961.

Exh.: (?) Norwich, 1860 (66) lent R. B. Scott.

New Gallery, 1898 (189).

Agnew, 1958 (1).

Richmond, 1963 (73).

R.A., 1964/65 (99).

Lit.: Dickes, p. 98, 131.

Binyon, p. 22.

Baker, p. 172.

Byron Webber, *James Orrock, R.I. Painter, Connoisseur, Collector.* Vol. 1, repr. p. 152.

Mellon Cat., p. 64. No. 73, Vol. II. Pl. 57.

c. 1808–9

V. Squall off Yarmouth

(P 51) $20\frac{1}{4} \times 32\frac{1}{2}$

H. T. Watlington Esq.

Panel primed in tan, golden light floods in from R. illumining a large oak, olive green foliage, sky overcast.

A figure with a dog to the right of the main oak has been removed since it was in the Orrock collection. Judging from a photograph these figures were not additions by another hand but were by Crome. Baker mistakenly supposed it to be *probably spurious*. In the Fitzwilliam Mus. are two early drawings by J. S. Cotman (formerly attributed to Crome) of *The Monarch of Kimberley* (D 187, 188). The form of this oak is rather similar. James Stark may have known this picture and based his *Forest Oak* upon it (*repr.* Dickes, p. 483). Compare *Woodland Scene with Sheep* (P 55), *On the Skirts of the Forest* (P 53) and soft ground etching *Bixley—Trees by a Pool* (E 32).

c. 1809–11.

P 55 WOODLAND SCENE WITH SHEEP (Plate 89)
 (CHAPEL FIELDS)

	Canvas. 24½ × 29.
Coll.:	Constance, Viscountess Mackintosh of Halifax.
Prov.:	Colnaghi 1927; Sir Jeremiah Colman, Bart; sold *c.* 1958 to Leggat from whom bt. by 1st Viscount Mackintosh of Halifax.
Exh.:	O. and P. Johnson, May 1965 (27).
Lit.:	Mackintosh Ms. Catalogue, p. 51 where it is suggested that it represents *Chapel Fields* in Norwich and is connected with the picture of that title in the Tate (P 125).
Condition:	A little thin in places, some retouching centre middle distance, generally good. Thinly painted in very fluid oil paint. In handling similar to *Skirts of the Forest* (P 53), *Woodland Scene near Norwich* (P 54), and *Moonlight on the Yare* (P 43). *c.* 1809–11.

P 56 THE BEATERS (Plate 91b)
 (WOOD SCENE WITH FIGURES)

	Panel. 21¼ × 33½.
?Signed:	*J. Crome* and dated *1810* in black print at an angle bottom L. of C.
Coll.:	Constance, Viscountess Mackintosh of Halifax.
Prov.:[1]	J. Bracey; from whom bt. 1835 by J. N. Sherrington through J. B. Crome;

[1] *Note to Provenance:*
In the *Norwich Mercury* for 10 June 1835 appears:
A splendid Landscape painted . . . expressly for Mr Bracey combining all the characteristic qualities of composition, colour and execution . . . The subject which is a Road leading into a Wood is treated with such fascinating simplicity and full flowing richness of pencil, that it may truly be termed a chef d'oeuvre of this Master. Size 2ft 10 in, by 1 ft 10 in. . . . For information and price apply to Mr Crome, Theatre Opening, Dunes, Yarmouth. This advertisement was on behalf of the executors of John Bracey.

his Sale 1 May 1858 (23) (£141. 5s. bt. White); H. S. de Zoete, his Sale 1 May 1885, bt. Permain (580 gns.); A. Andrews by 1886, his Sale 14 April 1888; bt. Merton or Lawrie (770 gns.); Sir Samuel Montague by 1894 became Lord Swaythling, his Sale 12 July 1946 (23); bt. Agnew and Leggatt; Sir Brian Mountain; Sir Edward Mountain, Bart; bt. from Leggatt 1950 by Viscount Mackintosh of Halifax.

Exh.: Edinburgh, 1886 (1450), lent A. Andrews.

Grosvenor Gallery, 1888 (53), lent A. Andrews.

R.A., 1894 (23), lent S. Montague.

R.A., 1907 (121), lent Sir S. Montague.

Nor. Crome Centenary, 1921 (55), lent by Rt. Hon. Lord Swaythling.

R.A., 1934 (580), Cat. 326.

Madrid, 1950.

Camberwell, 1951.

Leggatt, 1951.

Harrogate, 1953.

Nor., 1954 (30).

Leicester, 1956.

Agnew, 1958 (13) repr.

Whitworth, Manchester, 1961 (4) ill. p. 10 and cover.

Victoria and Albert Museum, 1962 (7) Cat. pl. 8.

O. and P. Johnson, 1963.

O. and P. Johnson, 1965 (repr. 21).

Lit.: Waagen, iii, p. 438.

Dickes, p. 103.

Theobald, p. 40.

Baker, pp. 26, 34, 37, 41, 43, 121, 122, Pl. XIV.

In the Sherrington Sale *The Beaters* is described

Lot 23. *A wood scene with figures: the entrance to a wood; in the centre three figures in conversation, and a dog. A most careful and beautiful specimen. Painted for T. [J.] Bracey Esq., and bought by Mr Sherrington of him.*

From this evidence *The Beaters* is likely to be the same as the picture described in the *Norwich Mercury*. However an element of doubt remains. The very obvious group of figures was not mentioned. A water-colour at N.C.M. (10–59–935), not by Crome, is inscribed *Original sketch by Old 'Crome' of Norwich called the Bracey Picture*. A much finer water-colour (16½ × 22½) of the same subject by J. N. Sherrington belongs to Mr C. E. R. Sherrington. Sherrington made copies of some at least of his finer Cromes; there is no copy of *The Beaters* although there is one of the '*Bracey Picture*'. The water-colour copies of the Bracey picture show it to have been in the same autumnal colouring as *The Beaters* and of a similar proportion. Elise Paget records that her father possessed an Autumn picture which may have been one of these.

Grey sky, leaves turning to russet, silver and grey lights on bark of trees, horizontal strip of golden light across distance. Seated figure L. wears a scarlet jacket, standing figure wears blue trousers. Compare handling of paint on banks and track to *A Sandy Bank* (P 57). Figures reminiscent of those in *Landscape near Blofield*. Influence of Jacob van Ruysdael evident. See note to *Hautbois Common* (P 126), 1810.

Country Life, July 17, 1958, p. 116.

Connoisseur, May 1963, ill. no. 615.

Condition: Horizontal crack through centre, slightly upper left to lower right. Signature and date have been discovered since 1921 (referred to as *signed and dated* by Swaythling Sale of 1946), and should be viewed with slight suspicion, the more so since the date corresponds with that given by Baker a dating which is, however, reinforced by that of the soft ground etchings.

Copy: (a) Detail of figure group: RABBITING WITH FERRETS

Panel, $13\frac{1}{2} \times 10\frac{1}{4}$.

Coll.: Untraced.

Prov.: J. Baker, his Sale, 15 March 1873, bt. J. P. Heseltine; in his Coll. 1920; Lord Swaythling by 1934.

Lit.: *Ten More Little Pictures in J. P. Heseltine Coll.* (repr.); Baker, p. 158. Accepted by Baker as autograph but of inferior quality and evidently produced after *The Beaters*.

P 57 A SANDY BANK (Plate 90a)

(GRAVEL PIT: LANDSCAPE—BANK WITH TREES)

Canvas. $15\frac{1}{4} \times 20\frac{1}{4}$.

Coll.: Fitzwilliam Museum, Cambridge (P.D.1—1966).

Prov.: C. Steward; Daniel Gurney (?); Lord Wimborne by 1881 and still in his collection 1920; his Sale 9 March 1923 (64); bequest to Museum by Guy Knowles with life interest to Lady Morrison.

Exh.: Possibly B.I., 1848 (142) as *Mulbarton Gravel Pit* lent by the Bishop of Ely.

Nor., 1860 (194) as *Sand bank.*

R.A., 1881 (3).

Lit.: Baker, p. 162.

? Dickes, p. 96 as *Gravel Pit—Evening* Exh.: Nor. Soc. 1814 (55).

Condition: Foreground ironed flat when relined, sky thin in places and retouched, otherwise good.

A Gravel Pit was in J. B. Crome's Sale 1834 as by Old Crome (46). It made 5*s.* 6*d.* Steward may have been the buyer; he also bought Lot 61.

Perhaps Exh. Nor. Soc., 1810 (99). Compare foreground handling and treatment of pollards with *The Beaters* (P 56).

c. 1810.

P 58 BRIDGE IN THE FOREST

Panel. $8\frac{3}{10} \times 11\frac{7}{10}$.

Coll.: Homeless.

Prov.: Paul and Dominic Colnaghi (label verso).

Condition: Excellent.

Pool extending from L. of C. to R. corner, crossed by a single rail footbridge. Three tree trunks L. of bridge. Thatched cottage on far side of pool R. screened from sky by trees. Middle distance fisherman seated in punt on pool.

Grey blue sky, cottage reddish brown, grey green and bottle green foliage relieved by patch of yellow green L. and by russet tree far R. Bundles of yellow, blue and white washing (?) L. of cottage door. Painted within a short time of *The Beaters* (P 56) and *Near Blofield* (P 59).

c. 1810.

P 59 LANDSCAPE NEAR BLOFIELD (Plate 91a)

Panel. 9 × 8¾.

Coll.: Constance, Viscountess Mackintosh of Halifax.

Prov.: Leggat, 1954.

Inscribed: Verso in ink, *Blofield, Norfolk. The Estate of—Burroughs Esq.; by John Crome of Norwich,* 1810.

Exh.: ? Nor. Soc., 1811 (27) as *Scene at Blofield.*
Agnew, 1958 (31).

Lit.: Mackintosh Mss. Cat., No. 38.

According to a letter from the then Vicar of Blofield to the late Lord Mackintosh (15 October 1958) this was probably Henry Negus Burroughs (fl. 1815–45) who owned land on the Northern extremity of the parish bordering on Woodbastick and Hemblington. Similar in handling to the *Willow* (P 92). The close up vision is found in Crome's soft ground etchings of 1809 (cf. E 28, 29), the *Composition* (E 17) and *Hedgerow with Grindstone and Stile* (D 67).

c. 1810.

P 59x DOG'S HEAD, JACK

Millboard. 13¾ × 18.

Coll.: Daniel Gurney, Esq.

Prov.: Painted by Crome for D. Gurney grandfather of present owner.

Inscribed: Label verso, *Dog's Head, Jack painted by J. Crome property of Daniel Gurney, Esq.*

Exh.: Nor. Soc. 1860, (5) lent D. Gurney.

Lit.: Baker, p. 132.

Condition: Good, *pentimenti* around outline of nose and on laps.

Collared head of sleek-coated dog with white markings on nose, throat and forehead. Resembles more a Spaniel than a Newfoundland. See p. 284.

c. 1810–18.

P 60 CORNER OF THE WOOD (Plate 92a)
 (AT EFFINGHAM)

Canvas. 17½ × 13½.
Coll.: Untraced.
Prov.: Probably J. N. Sherrington, Sale 1 May 1858 (34), bt. in or withdrawn; J.
 Staats Forbes; F. J. Nettlefold; bt. Agnew, C. C. Stillman, his Sale. American
 Art Assoc., N.Y., 3 February 1927, bt. Agnew; Mrs Sydney Martineau.
Exh.: Agnew, 1958 (30).
Lit.: Baker, p. 173.
 Date much the same as *The Beaters* (P 56). *c.* 1810–11. Perhaps in Whitehouse
 Sale, 29 March 1890, bt. Lawrie. Composition based on plate in Gainsborough's
 English Scenery, etched by J. Laporte, 1802.

P 61 VIEW OF ST. MARTIN'S GATE, NORWICH (Plate 101)
 (FULLER'S HOLE ON THE WENSUM)

Panel. 20 × 15.
Coll.: N.C.M. (170–955).
Prov.: ? Samuel Colman in 1821; Rev. H. J. Colman by 1878; G. N. Steven's Sale,
 14 June 1912 (78) bt. Agnew; Miss Faith Moore by 1921; Buchanan Sale
 (Moore Coll.) 26 June 1936 (67) bt. Gooden and Fox; by Ernest Cook; bequest
 through N.A.C.F., 1955.
Exh.: ? Nor. Crome Memorial, 1821 (66).
 R.A., 1878 (13).
 Nor., 1921 (45).
 Brussels, 1929 (54).
 R.A., 1934 (617) fig. 318.
 Brussels, 1935 (1104).
 Worthing, 1957 (26).
 Agnew, 1958 (22).
 Derby and Nottingham, 1959 (26).
 Whitworth, Manchester, 1961 (8).
 R.A., 1962 (183).
Lit.: Dickes, p. 60.
 Baker, pp. 24, 27, 41–2, 55, 161, 193, Pl. XIII.
 Burlington, May 1921, Vol. XXXVIII, ill., p. 254.
 Cot. and Haw., p. 120, Pl. 13.
Condition: Rubbed.
 The building is Fuller's Hall, Norwich (usually called 'Hole') which belonged to
 Henry Fuller, Sheriff in 1528 and Mayor in 1544. It was on the River Wensum
 in the parish of St Martins. Crome exhibited a number of pictures of this subject.
 If this is No. 66 in the 1821 Memorial Exhibition the date given by Colman
 was 1819. This may not be the same, or Colman may have been misinformed.

Baker observes *dates given in* 1821 *list not reliable . . . picture seems considerably earlier* [than 1819]. Similar branches and foliage in L. of *Norwich River: Afternoon* (P 95). Mood similar to *The Gate* (P 81). Probably painted before the journey to France.

Possibly *c.* 1812 or later.

Version: (a) ST. MARTIN'S RIVER AND GATE
 (BACK RIVER, NORWICH)

	Panel. 20 × 16½.
Coll.:	Hon. James Bruce.
Prov.:	Mrs T. Temple Silver, her Sale as *Back River*, 4 April 1912; bt. Agnew; passed through W. B. Paterson to Miss Coats; Sale, Christies 1954 (£6,300); Lord Glentanar.
Exh.:	R.A., 1878 (20) lent Mrs Temple Silver.
	Agnew, 1958 (27).
Lit.:	Dickes, p. 60.
	Baker, pp. 161, 162, Pl. XXI (as 1808–10).
	Cundall, Pl. XVI.
	Denys Sutton: *Christie's Since the War*, p. 52, pl. 80.
	Hawcroft, Note to Whitworth Exh. (1961), No. 8. Cat. p. 21.

Accepted by Baker who suggests that this is earlier than N.C.M. (P 61). Similar to that picture although many small differences; tall trees are omitted and a rowing boat is placed on river L. It is of slightly inferior quality. Compare texture of end wall of the main cottage, perspective of dormer window, recession of wall C., or less sensitive handling of distance.

c. 1810–13.

Copy: (a) ST. MARTIN'S RIVER (OR GATE)

	Panel. 20 × 15.
Coll.:	Philadelphia Museum and Art Gallery.
Prov.:	Mrs Steward, her Sale 8 December 1888 (131); bt. Agnew, Price Sale, 15 June 1895, bt. Agnew, sold to John G. Johnson, by whom bequeathed.
Lit.:	Dickes, p. 100.
	Baker, p. 161.

Although accepted by Baker this is surely *not* by Crome. It is an early simplified copy of the original at N.C.M.

(b)	Panel, 21 × 15¼. By a familiar Crome faker.
Coll.:	With Agnew, 1933.

P 62 FARM AND POND (Plate 92b)

Panel. 14 × 11.

Coll.: Untraced.

Prov.: Said to have been bt. from Crome by Rev. Richard Turner of Yarmouth; by
 descent to W. R. Fisher of Harrow (by 1876); Miss H. M. Fisher, Sevenoaks
 (by 1920).

Exh.: R.A., 1876 (16).
 Nor., 1921 (30) *Crome Centenary.*

Lit.: *Magazine of Art*, 1882, Vol. V, p. 221 (repr.).
 Dickes, pp. 70–71 (repr.).
 Theobald, p. 39, No. 40.
 Baker, pp. 35, 38, 43, 134, Pl. XXIX.
 Burlington, May 1921, Vol. XXXVIII, p. 254.

Copies: (*a*) oil formerly with H. A. E. Day (photo at N.C.M.).
 (*b*) in sepia wash, N.C.M. (13–59–935).
 Exh. Centenary, Nor., 1921 (89).
 (*c*) Canvas. 20 × 16. With Mandell's Gallery, Nor. 1967 with differences, as
 J. B. Crome.
 Described in 1921 Exh. Cat. as *A study of golden atmosphere with trees, buildings and
 water.* Dated by Dickes, 1811; Baker, *c.* 1814–16. Not seen.
 c. 1811–14.

P 63 MOUSEHOLD HEATH: MILL AND DONKEYS (Plate 93)
 (THE WINDMILL, A WINDMILL NEAR NORWICH)

Panel. 43 × 36.

Coll.: Tate Gallery (926).

Prov.: In Churchyard Coll. 1844, apparently not in his Sale 1866; J. Gillot Sale, 26
 April 1872; bt. Tennant; his Sale 1873, bt. in; probably Watts Russell 3 July
 1875 bt. for Nat. Gal. Transferred to Tate, 1951.

Exh.: Nor., 1921 *Crome Centenary.* (1) repr. Pl. VII.

Lit.: Dickes, p. 107 (ill), Pl. 19.
 Theobald, p. 17, No. 2.
 Binyon, pp. 12, 19 (ill).
 Mottram, pp. 157, 162–3, 175.
 Baker, pp. 40, 41, 151, Pl. XXXII.
 Times, 19 April 1921 (repr.).
 K. Smith, pp. 119, 123, 173.
 Barnard, pl. 24.

Condition: Three vertical splits, the centre one cutting through the pony and rider; cradled;
 at present dirty, discoloured, and a discredit to the Gallery. The panel appears
 to have been made up, top and bottom, with a horizontal strip 1½ in. wide.

Described by Bernard Barton when in Churchyard's Collection (Dickes).
Dated by Theobald 1816 relating it to the other *Mousehold Heath* at Tate (P 63).
This dating was followed by Baker and Mottram. We do not believe that this was
produced after the French journey. Closer in handling to the *Norwich from St
Augustine's Gate* (P 64). The composition and foliage treatment is Dutch.
c. 1810–13.

Copies: (*a*) Panel, N.C.M. (No. 131–949), very poor.

 (*b*) Water-colour, by Thomas Churchyard, $4\frac{3}{4} \times 3\frac{3}{4}$.
 Coll.: D. Thomas, Esq. (see Denis Thomas, *Thomas Churchyard of Wood-
 bridge* repr. Pl. 8).

 (*c*) Water-colour, by Churchyard. *Coll.:* Mrs M. Hurn, Drayton.

 (*d*) Oil, by Churchyard, with H. A. E. Day.

P 64 NORWICH FROM ST. AUGUSTINE'S GATE (Plate 94)

Panel. $20\frac{1}{2} \times 29\frac{1}{2}$.

Coll.: John Gurney, Esq.

Prov.: Said to have been painted for Samuel Gurney who bt. it from the artist for £10;[1]
 by descent to Sir Eustace Gurney.

Exh.: R.A., 1878 (48).
 R.A., 1908 (177).
 Nor., 1921 (32) Cat. repr. Pl. IV.
 Agnew, 1958 (44).

Lit.: Dickes, p. 110.
 Theobald, p. 33.
 Baker, p. 154, Pl. XIX.

Condition: Badly cracked; cleaned and restored by Holder 1968.
 Comparable style to *Mousehold Heath: Mill and Donkeys* (P 63) and *Pockthorpe
 Boat and Boathouse* (P 68). *c.* 1810–13.
 A similar composition with variations is at N.C.M. from Lord Rothermere's
 Collection. It is not by Crome.

P 65 NEW MILLS—MEN WADING

Panel. $11\frac{1}{4} \times 14$.

Coll.: Mrs C. W. Dyson Perrins.

Prov.: Possibly Samuel Paget; Archdeacon Hankinson by 1867; Mrs Hankinson, her
 Sale May 10, 1879 (63) bt. Agnew (£199. 10s).

 [1] The original receipt which is reported to have been on the back in an envelope has now
disappeared.

Exh.: Possibly Nor. Soc. 1812 (115).

Nor. 1821 (15) *Crome Memorial.*

Nor. 1867, *St Andrews Hall.*

R.A. 1934 (618) Cat. 329.

Nor. 1954 (22).

Jacksonville, Nashville and New Orleans 1967 (5) Repr. p. 15.

Lit.: Dickes, p. 74.

Theobald, p. 57–8.

Baker, pp. 57, 152, pl. XX.

Mottram, pp. 123, 149.

Burlington, December 1933, p. 265 Repr.

Connoisseur Year Book, 1962, p. 125, fig. 6.

Baker accepted and illustrated this picture not having seen it, stating that it was *said to have been etched by Crome.* When in Hankinson's Coll. Reeve knew it (pencil note in B.M. *Reeve Etchings* and Theobald op. cit.). It corresponds fairly precisely with the first state of *Front of the New Mills, Norwich* (E 5). That etching, dated 1813, seems to have been made after this oil. Similar date to Tate *Mill on Mousehold Heath* (P 63) and *Pockthorpe Boat and Boathouse* (P 68). See p. 176, E 5. 1812.

P 66 SCENE ON THE WENSUM, ABOVE NEW MILLS, NORWICH (Plate 122a)

Panel. $14\frac{1}{2} \times 19\frac{1}{2}$.

Coll.: N.C.M. (3–118–940).

Prov.: Sir Henry Holmes.

Exh.: Nor., 1932.

Arts Exh. Bureau, 1953–4 (4).

Harrogate, 1953 (27).

Kettering, 1952 (15).

Paris, 1953 (39).

Agnew, 1958 (23).

Derby and Nottingham, 1959 (24).

Lit.: Holmes Coll. Cat., 1932, No. 4, Pl. IV.

N.C.M. *Ill. Guide,* 1951, Pl. 3.

The finest of three versions. All three may be autograph. Crome treated the subject several times, in 1806, 1807 (pencil), 1814, 1815, 1816 and 1817.

The speckled foliage places this version close to the Dyson Perrins' *New Mills—Men Wading* (P 65). A *terminus ante quem* is probably provided by N.C.M. *Marlingford Grove* (P 86).

c. 1812–15.

Version (a) THE WENSUM, NORWICH (Plate 122b)
(A NORWICH BACKWATER)

Panel. 14½ × 19.
Coll.: Mr and Mrs Paul Mellon.
Prov.: Mrs W. C. Atkinson, her Sale, 19 April 1961 (83), bt. Colnaghi.
Exh.: V. & A., 1962 (6) Cat. Pl. V.
Richmond, 1963 (77).
R.A., 1964–65 (101).
Lit.: Baker, p. 57.
Mellon Coll. Cat., Vol. I, p. 66, ill. 77, Vol. II, Pl. 60.
Baker confuses this with an oil, based on an etching (E 5). Dr Goldberg has suggested that this version is by David Hodgson. Basil Taylor on stylistic grounds declines this attribution. The flecked juicy paint in foliage is unusual. In our view it is not by Hodgson but nor is it likely to be by Crome; compare *The Wensum at Thorpe: Boys Bathing* (P 91).
c. 1815–17.

Version (b) THE TANNING MILLS (Plate 120)
(OLD TANYARD, NORWICH, BACK OF NEW MILLS)

Panel. 10⅛ × 13¼.
Coll.: Ipswich Museum (1953–97).
Prov.: ? D. Gurney, *c.* 1867; A. Andrews; his Sale, 14 April 1888 (£105), bt. McLean; Shepherd's Gallery 1902 from whom bt. by Sir Edward Marsh; presented by N.A.C.F. June 1953.
Exh.: Grosvenor Gallery, 1888 (37), lent Andrews.
Nor., 1921 (44).
Lit.: Baker, p. 165.
If by Crome, which we do not feel to be certain, perhaps exh. Nor. Soc., 1806 (75), *View on the river at the back of the New Mills, Norwich—Evening*. The palette is not unlike *The Yare at Thorpe* (P 28).

P 67 ON THE YARE (Plate 121a)

Panel. 16 × 21¼.
Coll.: The Rt. Hon. Malcolm Macdonald, Nairobi.
Prov.: ? D. Gurney; Fisk, Sale March 24, 1888 bt. Agnew; W. D. Cruddas; bt. Tooths.
Exh.: ? Nor. 1860 (148). Manchester, Whitworth 1961 (6).

Lit.: Baker p. 175. Burlington, March 1961, p. 115, fig. 32.
Near Thorpe Church (view from opposite direction in Stark's *Rivers of Norfolk*, 1834). Probably painted in, or soon after, period of Crome's last etchings, not seen, *c.* 1812–14. Fine copy in Private Coll. canvas 13½ × 21 (*Exh.:* Agnew 1926, 1958 (18); Lowndes Lodge 1965 (18) repr.).

Copy (a) RIVER LANDSCAPE WITH BARGE (Plate 121b)
(A RIVER SCENE WITH BARGE)

Canvas. 17 × 25.
Coll.: Mr and Mrs Paul Mellon.
Prov.: Lady Hillingdon.
Exh.: Agnew, 1958 (38).
R.A., 1964–5 (101).
Lit.: Baker, p. 158, Pl. XI.
Condition: A vertical slip of about an inch has been added to both sides; cleaned Buttery, 1958. It has been suggested that it may have been Exh. Nor. Soc., 1810. Seems to be by the same false hand as *Hautbois Common* (P 126a) and *Washington Harling Gate* (P 81 note); perhaps by A. G. Stannard (1828–1885).

Copy (b) A VIEW ON THE RIVER AT THORPE

Panel. 21¾ × 31¼.
Coll.: Private.
Exh.: O. and P. Johnson, 1965 (25), repr.
A poor pastiche, most closely related to Mellon copy above.

P 68 POCKTHORPE: BOAT AND BOATHOUSE (Plate 95)
(RIVER SCENE WITH BOATHOUSE, VIEW NEAR POCKTHORPE)
The Bygrave Crome

Panel. 12¾ × 17¾.
Signed: Beneath man's R. knee *J.C.*
Coll.: The Hon. Keith Mason.
Prov.: R. Bygrave; Wynn Ellis; Thomas Churchyard; his Sale, 28 March 1866 (85); W. Fuller Maitland; Victor Rienaecker; Mrs M. E. Martineau. (Inscribed on back of panel: *View near Pockthorpe, by the late J. Crome: Mr. Bygrave and Wynn Ellis, Esq.*)

PAINTINGS

Exh.: ? Nor., *Crome Memorial*, 1821 (92); lent Bygrave.
R.A., 1873 (29).
Grosvenor Gallery, 1888 (12).
Nor., 1921 (41).
Agnew, 1958 (28).
Leggatt, 1963 (19) repr.
Jacksonville, Nashville, and New Orleans, 1967 (7) repr.

Lit.: Dickes, p. 109.
Baker, pp. 38, 43, 105, 156, Pl. XXXIV.

Copies: (a) Water-colour, 11 × 13. Inscribed lower R. *J. Crome.*
 Coll.: Dept. of Fine Arts, Mount Allison Univ., Sackville, N.B., Canada.
When exhibited in the 1921 Centenary called *River Scene with Boathouse—said to be a view at Pockthorpe, Norwich.* In style similar to *Mousehold Heath: Mill and Donkeys* (P 63). Dr Goldberg, following Baker, dates it *c.* 1816. We see a strong influence of Dutch painting and would not be satisfied with a dating much after the last dated etchings (1813).
c. 1810–14.

P 69 HARLING GATE (Plate 96a)

Canvas. 20½ × 16.
Coll.: Constance, Viscountess Mackintosh of Halifax.
Prov.: Leggatt, 1950; Major R. W. Cooper, M.C.; Viscount Mackintosh.
Exh.: Harrogate, 1953.
Agnew, 1958 (10).
Lit.: *Connoisseur*, November 1963, p. 196, fig. 4.
Copy: Canvas, 21 × 16¾. Baker (p. 138) and repr. as Pl. XXXIX in Lord Curzon's Collection 1920.[1] Of this he reported that inscribed on the back was: *it was painted for one of the Miss Gurneys; was given to Fulcher by Crome, and passed to Mr. Fison. In his Sale at Yarmouth 'thirty years ago'; this was written apparently c. 1874, when the picture was in a Sale at Deerbolt's Hall, Earl Stonham.* The owner perhaps was *C. W. Gray.* Nevertheless, it is tolerably clear from the photograph that Lord Curzon's picture was not by Crome and has the appearance of being a copy. Baker dated the Curzon copy *c.* 1817. Composition similar to the etchings.
? *c.* 1812–14.

[1] Exh. Norwich, 1921 (26), now in Sir Clavering Fison's Coll.

P 70 THE WAY THROUGH THE WOOD (Plate 96b)

Panel. 20 × 15⅞.
Coll.: Birmingham City Art Gallery (P. 10'50).
Prov.: Anon. Sale (Rainger), 28 February 1863 (92); bt. in; (? H. Graves bt. 1863);

T. J. Barret by 1898; his Sale, Christies, 11 May 1916 bt. Sir J. Beecham by 1902 his Sale 3 May 1917 bt. Smith; J. A. Mango 1920; Messrs. Gooden and Fox from whom acquired 1950.

Exh.: R.A., 1903 (19).

Paris, 1958 (41).

Rotterdam, 1955 (27).

Agnew, 1957 (43).

Tate Gallery, 1959 (85).

Lyon, 1966 (38).

Lit.: *Magazine of Art*, February 1898, p. 191 (Rpr.).

Dickes, pp. 120 (ill.), 121.

Baker, 2 p. 168, Pl. XVII.

City Art Gall.'s *Illustrations of 100 Oil Paintings* (1952), p. 10.

City Art Gall.'s *Catalogue of Paintings* (1960), p. 43.

Connoisseur, November 1963, p. 194.

Condition: Panel cradled, light network of bituminous cracks infilled: cleaned October 1966. Vision similar to *Norwich from St Augustine's Gate* (P 64) and *Mousehold Heath: Mill and Donkeys* (P 63). Dated by Baker *c.* 1812–14. This has some claim to be considered the *Boy Keeping Sheep—Morning* Exh.: Nor. Soc. 1812 (100) but see note to *Boy Keeping Sheep, Mousehold Heath* (P 75).

c. 1811–14.

Copy: Canvas, 23 × 17⅛ as *Mousehold Heath*. Philadelphia Mus. (Johnson Coll., 876) without figure and dog. Not seen, Baker, pp. 133–4.

P 71 OLD CASTLE ON SEA COAST

Panel. 11⅛ × 16⅞.

Coll.: Mr and Mrs D. P. Clifford.

Prov.: Probably Anon (Rainger) Sale 28 February 1863 (30) bt. Cox; 1885 Martin Colnaghi of the Guardi Gallery; L. R. Nightingale; Rev. C. J. Sharpe, Sale (Knight, Frank and Rutley), 14 December 1967 (35).

Inscribed: Label verso: Crome Sen.

 Born at Norwich 1769.

 Old Castle on the Sea Coast.

 Guardi Gallery.

 11⅛ × 16⅞ bt. June 11, 1885.

Condition: Poor; heavy bituminous cracking and paint loss in dark areas.

Sunset. Two Castle towers L. of C. behind them glimpses over sea or estuary; tree and distant tower R.

Foreground and towers shades of dark brown, tree with bottle green and yellow foliage. Pale blue sky changing to shades of yellow and pink.

A Wilsonian composition. Possibly based on Burgh Castle. In palette and subject matter reminiscent of *Cow Tower—Evening* (P 72). *c.* 1812–15.

In Rainger Sale described as *A Coast Scene with a Ruined Castle—Sunset* 10½ ×
17. *Ascribed* there to Crome.

P 72 COW TOWER: EVENING (Plate 97)
 (A WHERRY AND OTHER BOATS ON A RIVER)

	Canvas. 19½ × 24.
Coll.:	Mr and Mrs D. P. Clifford.
Prov.:	Colonel Stephenson Clarke, bt. through J. G. Millais; Colonel Sir Ralph S. Clarke, K.B.E., T.D., D.L., Sothebys 11 January 1967 (57).
Condition:	Relined, restored by Mr George Fenyö, 1967.

View looking East towards the spire of Norwich Cathedral. Pale blue sky, sun
setting L. behind dun-coloured tower illuming hay barge R. Probably painted
after *Way through the Wood* (P 70). Atmosphere and paint handling not far from
Mousehold Heath—Mill and Donkeys. (P 63).
c. 1812–17.

P 73 RETURN OF THE FLOCK (Plate 98)

	Canvas. 20 × 26.
Coll.:	Constance, Viscountess Mackintosh of Halifax.
Prov.:	Alexander Young in 1906; Mrs E. L. Raphael; Sir Gervase Beckett, Bart; Sir Martyn Beckett, Bart; Viscount Mackintosh of Halifax through Agnews.
Exh.:	? Nor. Soc., 1813 (97) as *Landscape with Sheep: Evening.*
	Fine Art Soc., 1903 (38).
	Agnew, 1906 (2).
	Nor., 1921 (49a).
	Nor., September 1956.
	Manchester, 1957 (214).
	Agnew, 1958 (17).
	Whitworth, Manchester, 1961 (7).
Lit.:	Cundall, Pl. V (colour).
	Baker, pp. 37, 43, 158.
	Mackintosh, Mss. Cat. 40.
Condition:	Bituminous cracking infilled.

Paint thickly applied in olive greens and browns but thin in places. The golden
glow of evening filters through trees L., spreading across the landscape and is
mirrored in a stream. According to Baker may have been exhibited in 1813. The

identification with the 1813 picture is guess-work. Similar in style to *Cow Tower—Evening* (P 72) and, to a lesser extent, *Road with Pollards* (P 74).

? 1810–13, or earlier, see note to P 75.

P 74 ROAD WITH POLLARDS (Plate 99)
 (HEATH SCENE)

	Canvas. 28 × 42.
Coll.:	N.C.M. (722–235–951).
Prov.:	J. N. Sherrington [not in 1858 Sale unless as written in Lot][1] W. H. Hunt of Yarmouth, his Sale bt. J. J. Colman; R. J. Colman, by whom presented.
Exh.:	Nor. Assoc., 1856 (225).
	International, 1862 (137).
	R.A., 1878 (39).
	Nor., 1921 (18, Cat. Pl. VI).
	Brussels 1929 (53).
Lit.:	Dickes, p. 135 (repr.).
	Baker, pp. 37, 39, 40, 55, 159, Pl. XXX.
	Theobald, pp. 26–7, No. 5.
	Cundall, Pl. XX.
	K. Smith, repr. frontispiece, pp. 113, 136.
	Mottram, pp. 180, 201.
	Colman Coll. Ill. Guide, 1951, p. 7, Pl. 12a (before cleaning).
	Barnard, p. 2, Pl. 28.

Condition: Judging from old photographs before cleaning the trees were more foliated (see particularly pollard to far L. and saplings centre). There was also a large area about 5 in. square of crude overpaint in the R. corner covering a ploughed field. From the copies, Mrs Thorneycroft's in particular, it is evident that the damage from overcleaning was slight and much less than has been alleged.

Scumbled drag of paint to suggest ground combined with an attempt to paint light reflected from weeds and dock leaves place this close to *Boy Keeping Sheep: Mousehold Heath* (P 75). The Hobbema vision particularly reminds one of the R. hand section of *The Beaters* (P 56). Dated by Baker *c.* 1815.

c. 1810–12 or earlier, see note to P 75.

Copies: (*a*) Fine full size oil. Said to be *by* J. N. Sherrington.
 Coll.: Mrs Thorneycroft (descendant of Sherrington).

 (*b*) Faithful water-colour *by* J. N. Sherrington, $14\frac{3}{4} \times 22\frac{1}{2}$.
 Coll.: C. E. R. Sherrington, Esq. (Sherrington's grandson).

 (*c*) Sepia, $9\frac{7}{8} \times 14\frac{3}{8}$, probably by W. H. Hunt.
 Coll.: N.C.M. (743–235–951).

(An inscription on the verso has been shamelessly obliterated but the following can be made out . . . *by* . . . *in the Collection of J. N. Sherrington.*)

Exh.: Nor., 1921 (85) Crome Centenary *as by Crome.*

[1] *Bequeathed* by Sherrington to Hunt, according to Theobald.

P 75 BOY KEEPING SHEEP, MOUSEHOLD HEATH (Plate 100b)
 (VIEW ON MOUSEHOLD HEATH, NORWICH)

Canvas. 21½ × 32.

Coll.: Victoria and Albert Museum (232'79).

Prov.: ? J. Bracey; Rev. E. T. Daniell, his Sale 1845; Anderdon in 1872, his Sale 30 May 1879, bt. Whitehead for V. & A.

Exh.: ? Nor. Soc., 1812 (100) as *Boy Keeping Sheep—Morning*.
 ? Nor. Memorial, 1821 (44) as *Boy and Sheep—Morning* (44) lent John Bracey, date given as 1815; R.A., 1872 (33) lent Anderdon.
 Nor., 1921 (5), repr. Cat. Pl. V.

Lit.: Dickes, pp. 74–6 (ill.), 100.
 Theobald, p. 20, No. 5.
 Binyon, p. 33.
 L'art et les Artistes, June 1913.
 Cundall, pp. 5, 14, Pl. IV.
 Baker, pp. 39, 40, 43, 151, Pl. XV.
 Mottram, pp. 122–3.
 K. Smith, pp. 26 (repr.), 123, 174.
 In L. G. Duke's Coll. is a small sketch which may connect (D 63). Composition based on plate in Gainsborough's *English Scenery* etched by W. F. Wells. *c.* 1803–4.

May not be either oil Exh. Nor. Soc. 1812 or Bracey picture with alleged date of 1815. Reason for this identification is title which could well apply to *Way through the Wood* (P 70). It might be argued that this is an earlier picture following on from the *Slate Quarries—Gibraltar Watering Place* family, *c.* 1807–8. If this were of that date it would effect the dating of P 73, 74 and possibly P 78. *c.* 1812–15, or earlier.

P 76 A RUINED CASTLE: MORNING
 (CASTLE IN RUINS)

Canvas. 12¼ × 13¾.

Coll.: N.C.M. (152–930).

Prov.: A note on the verso: *Sketch by Old Crome, given by him to Mrs George Pearson (née Sarah Stannard) of Norwich and purchased of her by J. H. Inglis Palgraves;* bt. J. R. Nutman 1906, bt. through N.A.C.F. 1930.

Exh.: Nor., 1921 (48).
 Tate, 1925 (69).
 Agnew, 1958 (33).

Lit.: Baker, pp. 31, 32, 125, 194, 195, 197.
 Palette of dark browns and greens with a luminous grey sky.

Despite the provenance this carries only moderate conviction; it is a modest

picture and, if right, is relatively late. Baker dated it *c.* 1803. In the Centenary Catalogue it was described as *an early picture in the Wilson style.*
c. 1808–12.

P 77 | KIRSTEAD CHURCH
(KERSTEAD, KIRKSTEAD)

Canvas. 9 × 12.
Coll.: N.C.M. (710–235–951).
Prov.: R. W. Burleigh Sale, Halesworth, 1883 bt. by J. J. Colman; R. J. Colman; by whom presented.
Exh.: Nor., 1921 (14) *Crome Centenary.*
Lit.: Dickes, pp. 77–8 (ill.).
Theobald, p. 30, No. 23.
Colman, Cat. 710.
Baker, p. 142.
Kirstead Green is South East of Norwich on the road between East Poringland and Woodton. Path foreground through churchyard. L. large house with tree in front, to R. east end of small church seen obliquely. Dated by Baker *c.* 1813. Compare handling of trees with *Return of the Flock* (P 73). The roof of the house to L. is disconcertingly out of perspective.
c. 1808–12.

P 78 | STUDY OF FLINTS (Plate 100a)
(FLINT STONES AND WEEDS)

Canvas. 8¼ × 12.
Coll.: N.C.M. (718–235–951).
? David Hodgson; Thomas Churchyard, his Sale 1866 (79), R. W. Burleigh, Halesworth; his Sale 1883, bt. J. J. Colman; R. J. Colman by whom presented.
Exh.: Nor., 1860 (74).
Lit.: Dickes, p. 93 (ill.).
Baker, p. 135.
Barnard, p. 2, Pl. 29.
Theobald, p. 29, No. 22.
Colman, Cat. 718.
Colman Coll. Ill. Guide, 1951, p. 2, Pl. 14b, where incorrectly described as *Dock Leaves, Flints.*
The old N.C.M. prov. is probably incorrect. It reads *said to have been painted for W. Stone*; T. Brightwell, his Sale 1860, 6 gns. In 1820 a *Study of Flint Stone* was Exh. Nor. Soc. (76) as by G. D. Stone. Reeve noted of a picture Exh. Nor. 1860 (74) *Sold at Mr Brightwell's Sale for £6 6s od., afterwards sent to London—said to have*

been painted by Stone. This was presumably the *Flint*, 9 × 12, in T. Woolner's Coll., Exh. Grosvenor Gallery, 1888 (331).

Dated by Baker *c.* 1811, probably painted at same time as *Study of a Burdock* (P 80).

c. 1811–13 or earlier. See P 75 note.



P 79

A THISTLE



(?) Canvas 26¼ × 20¼.

Coll.: Untraced.

Prov.: Thomas Churchyard, his Sale 28 March 1866 (44) bt. Loder; Fuller Maitland by 1875, his Sale 10 May 1879 bt. A. Levy; Leonard, F. Harrison by 1929.

Exh.: ? Nor. Soc. 1810 (18).

B.F.A. *c.* 1929.

Not seen. Photo in Witt. This has been attributed to David Cox. That the present picture was the one in Churchyard's Collection is demonstrated by the water-colour by him in Mr L. G. Duke's Collection. (See Denis Thomas. *Thos. Churchyard of Woodbridge.* pl. 25.) Similar to *The Burdock* (P 80) and *Study of Flints* (P 78).

c. 1810–13.



P 80

STUDY OF A BURDOCK (Plate 102)



Panel. 21½ × 16½.

Coll.: N.C.M. (4–4–99).

Prov.: John Middleton, bt. by R. P. Burcham of Norwich 1856; after whose death bt. by J. J. Colman 1894, by whom bequeathed 1899.

Exh.: Possibly Nor. Soc., 1813 (47).

Nor. B.M.A., 1874 (5).

R.A., 1878 (23) (label on verso).

Norfolk and Norwich Hospital, 1883 lent Burcham.

Nor., *Crome Centenary*, 1921 (7) Cat. repr. Pl. X.

R.A., 1934 (611).

Arts Council, 1954 (39).

Agnew, 1958 (37).

Derby and Nottingham, 1959 (28).

Manchester, Whitworth, 1961 (3).

Lit.: Nor. Mus. Cat., ill. No. 17.

Dickes, p. 91 (ill.).

Theobald, p. 24, No. 11.

Baker, p. 124, Pl. XLIV.

Mottram, pp. 132, 201.
Colman Coll. Ill. Guide, 1951, p. 7.
K. Smith, pp. 134, 175.
Studio, August 1947, p. 27, repr.
Cundall, p. 14.
Hawcroft, *Country Life*, 15 July 1954, p. 205, fig. 3.
Connoisseur, December 1959, pp. 236–237, Pl. 15.

Condition: Two vertical splits, *pentimenti* top R. corner.
Plant studies occur in foreground of the Tate's *Mousehold Heath* (P 90) and *Marlingford Grove* (P 86). Compare *Study of Flints* (P 78).
Possibly *c.* 1813.

P 81 THE GATE (Plate 103)
(THE NORGATE CROME)

Canvas. 27¼ × 24¼.
Coll.: Timothy Colman, Esq.
Prov.: ? sold by J. B. Crome shortly after his father's death; Jonathan Norgate 1860, his Sale 1873; passed to Staats Forbes; Sir H. S. Theobald by 1906; bt. R. J. Colman 1910.
Exh.: Nor., 1860, lent Norgate.
Grafton Gallery, 1905 (288) lent Staat Forbes.
Leicester Gallery, 1906, lent Theobald.
Nor., 1921 (24).
Lit.: Theobald, p. 35.
Burlington, Vol. VII, p. 325.
Cundall, Pl. X (colour).
Connoisseur, November 1963, p. 195, fig. 3.
Baker, p. 136.
Condition: In a Mss. note to 1860 Exh. written: *sky said to have been painted by old Ladbrooke.* There seems to be no justification for this comment.
Version: Baker (loc. cit.) records a little version, *with one donkey and no figures, in part perhaps by Crome, was in Messrs. Brown & Phillips possession,* 1920. It came from the Woolner and Coventry Patmore Colls.
This has been a fruitful source of spurious compositions of which the most notorious is *Harling Gate, Near Norwich* (Widener Collection) which disfigures the walls of the National Gallery in Washington.
 This has some claim to be considered *Solitude* (97) in the Nor. Soc. 1816 Exh. of which David Hodgson wrote in a Mss. in the Reeve Album (p 16): *his Solitude painted in 1816 (apart from other considerations) was remarkable for high poetic feeling.*
c. 1811–16.

P 82 BRUGES RIVER—OSTEND IN THE DISTANCE—MOONLIGHT (Plate 104)
 (BRUGES RIVER, MOONLIGHT)

	Canvas. $25\frac{1}{4} \times 31\frac{1}{4}$.
Coll.:	N.C.M. (3–4–99).
Prov.:	F. Crome in 1821; W. Freeman by 1829; Anon. (Rainger) Sale 28 February 1863 (97), bt. Whitehouse; T. Churchyard of Woodbridge; his Sale 28 March 1866 (41), bt. Allen; T. Woolner by 1873; his Sale 12 June 1875, bt. Myers; W. Angerstein of Weeting Hall by 1881; Hermann de Zoete; his Sale 8 May 1885 (168), bt. Clowes for J. J. Colman; by whom bequeathed 1898.
Exh.:	? Nor. Soc., 1816 (49).
	Nor., Crome Memorial, 1821 (60), lent F. Crome, as *c.* 1818.
	Nor. 1829, lent Freeman.
	R.A. 1873 (96), lent Woolner.
	? R.A. 1881, lent W. Angerstein.
	Newcastle, 1887 (728), lent Colman.
	Nor., 1921 (6).
	Arts Council, 1947 (8).
	Agnew, 1958 (48).
	Derby and Nottingham, 1959 (29).
Lit.:	Dickes, pp. 96, 105, 122–3, 170 (ill.).
	Theobald, pp. 23–24, No. 9.
	Binyon, pp. 33–34.
	Cundall, p. 13, Pl. XVII.
	Baker, pp. 19, 124.
	Mottram, pp. 93, 153, 160, 201.
	K. Smith, pp. 54, 112, 129, 160, 175.
	Colman. Coll. Ill. Guide, 1951, p. 7.
Condition:	Rubbed, trees to L. especially.

There is some doubt if this picture is correctly identified. The Girling Etching bears only a pencilled title in a later hand. (? Reeve.) The picture looks as though it could be considerably earlier than 1814–15 and may not have acquired its distinctive title until *c.* 1860–70. In pencil on the mount of the third state at the B.M. is: *Copies of the original picture are said to have been made by J. B. Crome and others—subject somewhat altered—Picture in the possession of T. J. Angerstein.* The well-known T. J. Angerstein died in 1823. Dawson Turner (*Lithog.* No. 19) wrote: *Mr. Sherrington of Yarmouth . . . has . . . one [Crome] that might really be mistaken for a Vander Neer. Of it there is a spirited and characteristic etching by Mr. Richard Girling . . .*

Versions and
Copies: (*a*) Etched by R. Girling in reverse. (Impression in B.M. Print Room.)

(*b*) Water-colour perhaps by Girling was on the market 1965.

(*c*) Canvas, old photograph with Agnew.

(*d*) Panel, $7\frac{1}{2} \times 9\frac{3}{4}$. *Not by Crome.*

Coll.: Ashmolean Museum (A. 892).
Prov.: Jonathan Norgate, his Sale 13 December 1873; J. P. Heseltine (*c.* 1878–1920);
 P. M. Turner, his bequest 1957.
Exh.: R.A., 1878 (54).
Lit.: Dickes, p. 105 as sketch for P 72.
 Heseltine, *Norfolk and Suffolk Artists*, 1914, ill. 15.
 Baker, p. 124 (accepted).
 Ashmolean Cat., 1962, p. 45.

P 83 VIEW IN PARIS—ITALIAN BOULEVARD (Colour Plate III)
 (BOULEVARD DES ITALIENS, PARIS)

 Canvas. $21\frac{3}{8} \times 34\frac{1}{4}$.
Coll.: Quintin Gurney, Esq. (on loan to N.C.M. since 1935).
Prov.: Hudson Gurney; by descent, J. H. Gurney.
Exh.: Nor. Soc., 1815 (98).
 Nor. Crome Memorial, 1821 (79), lent H. Gurney, M.P.
 Nor., 1874 (55).
 R.A., 1878 (18).
 Nor. Crome Centenary, 1921 (34).
 Amsterdam, 1936 (32).
 Paris, 1948.
 Bristol, 1953 (34).
 Paris, 1953 (42) ill. p. 14.
 Agnew, 1958 (39). repr.
 Whitworth, Manchester, 1961 (10).
 Cologne, Rome, Warsaw, Zurich, 1967 (Nos. 14, 50).
Lit.: Dickes, pp. 96, 99–100 (ill. frontispiece).
 Binyon, pp. 29–30.
 Theobald, pp. 34–5.
 Gazette des Beaux Arts, October 1912 (ill.).
 Cundall, p. 3, Pl. XIX.
 Baker, pp. 19, 21, 41, 55, 61, 123, Pl. XXXI.
 K. Smith, pp. 53–4, 90, 124, 128–9, 143.
 Mottram, 149, 153–4, 160, 165, 178.
 Apollo, October 1948, p. 91.
 Barnard, p. 2.
 T. S. R. Boase, *English Art*, 1800–1870, Pl. 24a.
 Connoisseur, November 1963, p. 199–200. Figs. 10 and 11.
 Etched by Edwin Edwards 1878.
 Painted from a sketch made in Paris. The type derives from Van der Heyden.
 1814–15.

PAINTINGS

P 84 BACK OF THE NEW MILLS, NORWICH (Plate 108b)
 (ON THE WENSUM)

 Canvas. $16\frac{1}{4} \times 21\frac{1}{4}$.

Coll.: N.C.M. (2–4–99).

Prov.: William Davey; Canon Davey of Lampeter; from whom bt. by J. J. Colman 1895; by whom bequeathed 1899.

Exh.: Arts Council, 1947 (7).
 Leeuwarden, 1948 (16).
 Madrid, 1949 (11).
 Cape Town, 1952 (10).
 Kettering, 1952 (18).
 Stoke on Trent, 1958.
 Rotterdam, 1955 (29)
 Leicester, 1956 (27).
 Agnew, 1958 (21).
 Derby and Nottingham, 1959 (25).
 Moscow, Leningrad, 1960 (46).
 Whitworth, Manchester, 1961 (9).

Lit.: Binyon, pp. 43 (repr.), 48.
 Dickes, pp. 97, 102 (ill).
 Theobald, p. 25, No. 12.
 Cundall, Pl. XI.
 Baker, p. 152.
 Mottram, pp. 116, 125, 162, 201.
 K. Smith, p. 175.
 Cot and Haw, p. 28, Pl. 27.
 Wilenski, *English Painting*, pp. 200, 203, 205, repr.
 Barnard, p. 2, Pl. 31.
 Colman Coll., Ill. Guide, 1951 p. 7, Pl. 14a.

Condition: Good, Baker's comment that the *sky has suffered* is unjustified.

The New Mills, according to Cotman and Hawcroft (loc. cit.), belonged to the Norwich corporation and water was piped from here into the city. The name *New Mills* dates from the reign of Elizabeth I.

 Pale blue sky with vaporous white clouds, buildings soft shades of grey and pink, green foliage. Compare Mellon's *Old Houses at Norwich* (P 85) and the Michaelis *Norwich River Afternoon* (P 95). Painting of foliage and figures similar to *Bury Road Scene* (P 97). These features combine in the *Italian Boulevard* (P 83) and *Fishmarket, Boulogne* (P 98). This type of picture must have influenced Henry Ninham (1793–1874).
 c. 1815–18.

P 85 OLD HOUSES AT NORWICH (Plate 105)

Canvas. 21¾ × 16¾.
Coll.: Mr and Mrs Paul Mellon.
Inscribed: *Old Houses at Norwich Crome presented to Mr French by the Artist.*
Prov.: Mr French; *the organist at Windsor*; Thomas Churchyard, his Sale 1866 (86);
 Captain P. Beaumont, Sale 6 July 1962 (156).
Ex.: Virginia, 1963 (76) Cat. Pl. 61.
 R.A., 1964/65 (97).
Lit.: *Country Life*, 24 December 1964. repr.
 According to Mr Alec Cotman the scene is at the back of Elm Hill. Although
 composition is similar to *Ruined Houses* (D 47), handling of paint close to *Back of
 the New Mills* at N.C.M. (P 84).
 c. 1812–16.

P 86 MARLINGFORD GROVE (Plate 106)
 (SCENE IN A LANE NEAR NORWICH)

Canvas. 32 × 27.
Coll.: N.C.M. (1–118–940).
Prov.: Probably Samuel Paget 1815; J. N. Sherrington, Sale 1 May 1858 (36) bt. in
 (76 gns.); Lord Northbrook (the Baring Family); with Colnaghi 1930; Sir
 Henry Holmes; who unaccountably derived the provenance from Rev. E.
 Valpy, Headmaster of Norwich Grammar School in 1811.
Exh.: Nor., 1931 & 1932.
 Paris, 1953 (40).
 Nor., 1954 (21).
Lit.: *Cat. of H. N. Holmes Coll.* (1932) p. 11, Pl. I (frontispiece).
 N.C.M. *Illustrated Guide* (1951) p. 2, Pl. 4.
 Barnard, Pl. 25.
Etching: By Richard Girling in reverse (an impression in B.M. Print Room bears pencil
 note *from a picture by Old Crome*, and on a first state a note in Reeve's hand: *from
 a sepia drawing by R. Girling*).
Condition: Bituminous cracking in-filled; gate taken out; *pentimenti* around figure. Restored
 by Moritt 1946–7.
 There is little evidence to identify this landscape as of Marlingford Grove. It is
 very like the etching (E 21) in reverse, which has no title but has been referred
 to as *Composition—Sandy Road through Woodland*.
 This picture is first described in the Sherrington (Huth) Sale, 1858:
 36 AN UPRIGHT LANDSCAPE: Scene in a lane near Norwich; to the left a
 fine beech tree; a peasant passing over c. small wooden bridge; a peep through
 the centre discloses fields and distant hills. *A very wonderful specimen of this great
 master, admirable for power and subject.*

This picture has been suspected and is now hung in the Reserve Collection at N.C.M. It has not formerly been noted that it was in the Sherrington Sale and was engraved by Girling. Elise Paget in 1888 identified the Lever 'version' below as that belonging to her mother. She wrote that at home it was always described as *the green picture*. We are not satisfied that the Lever picture is, in fact, by Crome. At a distance of fifty years, and without the N.C.M. picture before her, Elise may well have confused the two. It is important to notice that Girling did not engrave the Lever version but did the N.C.M. version. Girling, like Samuel Paget, was a Yarmouth man.

Painted at about the same time as *Poringland Oak* (P 87). *c.* 1815–17.

Version: MARLINGFORD GROVE (Plate 117)
(LANDSCAPE AND FIGURES)

Canvas. 53¾ × 39¼.

Coll.: Lady Lever Art Gallery, Port Sunlight.

Prov.: J. N. Sherrington, not in Sale 1858; said to have been sold privately to Louis Huth by 1862, his Sale 20 May 1905 (44) repr. bt. Agnew; Sir Joseph Beecham Bart, his Sale 3 May 1917 (25) repr.; bt. Smith (5, 300 gns.). J. A. Mango; Mrs J. A. Mango; Graham, his Sale 11 May 1923 (118) repr. bt. Thomas for Lord Leverhulme.

Exh.: ? B.I., 1862 (179) as *Landscape*, lent Huth.
R.A., 1871 (35) as *Landscape and Figures*, lent Huth.
Burlington F.A.C., 1871 (44) *Landscape with Figures: Marlingford*, lent Huth.
Grosvenor Gallery, 1888 (152).
Agnew, 1958 (40).
B.F.A.C., F.A.C., 1912 (31) as *Landscape*.
R.A., 1962 (302).

Lit.: Waagen iii, p. 438.
Dickes, p. 101 (repr.).
Binyon, p. 30.
Magazine of Art, April 1882, ill. p. 225.
Art Journal (?).
Burlington, vol. VII, 1905, 324.
Cundall, p. 14, Pl. VIII.
Baker, pp. 42, 59b. 146, Pl. XXXIII.
Lever Gallery Guide, p. 22. Pl. 16.

Copy: (*a*) Water-colour, 22½ × 16 by J. N. Sherrington; Coll.: C. E. R. Sherrington, Esq.
(*b*) Canvas. Coll.: S. E. Gurney, Esq., Heggatt Hall.

In favour of the authenticity of this version is the existence of the water-colour copy of it by J. N. Sherrington. This, however, only proves that the Lever picture *was* in Sherrington's collection which is not doubted. Nor is there any question but that this is a picture Sherrington sold to Huth. This does not

make it by Crome. It is probable that when Paget sold P 86 to Sherrington it was already disfigured by the deep cracks and fissures which can still be seen beneath the restored surface, and that he employed his friend, John Berney Crome, to make a fine copy of it. The adjustments to the composition are very much of the same sort that Berney Crome had already made to his father's sketch of the *Yarmouth Water Frolic* (P 99). Baker wrote of the Lever version: *it is unaccountably doubted by the Norwich purists* (ie. by Reeve?). But in our view the doubt is easily accounted for by the placing of the distant horseman, by the over-lighting of the right foreground, the failure to understand the significance of the marks on the tree-trunks to the right and the reduction of Crome's genuinely observed and comprehended trees to a much slighter, and more easily painted form. Nor is the sky, which Baker praised, of the remarkable airy quality which authentic Cromes usually are. In our view this is an example of the way in which a true Crome was 'strengthened' and made more interesting to satisfy the taste of the eighteen-thirties.

P 87	PORINGLAND OAK (Plate 107)
	(A STUDY FROM NATURE; PORINGLAND, NORFOLK)

Canvas. 49¼ × 39½.

Coll.: Tate Gallery (2674).

Prov.: Bt. at auction by W. Freeman senior (No. 136 in Freeman Mss. in Nat. Gall) on the back of frame is the label of *Jeremiah and William Freeman, 2 London Lane* (Norwich); W. P. B. Freeman, by whom sold to a dealer named Colls; Rev. George Leathes of Shropham Hall and/or J. F. Leathes of Herringfleet; bt. by Captain Charles Steward of Blundeston (*c.* 1830), Rev. Charles John Steward, Somerleyton; from whose exors. bought by Temple West Fund 1910.

Exh.: ? Nor. Crome Memorial, 1821 (59).
B.I., 1824 (36).
Nor., 1860 (153).
R.A., 1875 (116).
Nor., 1878 (143).
Newcastle, 1887 (782).
R.A., 1891 (39).
R.A., 1908 (170).

Lit.: Dickes, p. 123 (ill).
Theobald, pp. 30–31, No. 24.
Binyon, pp. 33, 34, 45, 48 (ill. as frontispiece).
Baker, pp. 33, 35, 38, 41, 43, 44, 52, 54, 55, 69, 156, Pl. XLI.
Mottram, pp. 41, 160, 172–3, 175, 178.
K. Smith, pp. 113, 114 (repr.), 119, 130, 146.
Reeve, pp. 25, 64, 69.
Freeman, Mss in Nat. Gall.
Graves, *A Century of Loan Exhs.* Vol. V, 2nd Addenda.

Nat. Gal. Catalogue British School, Martin Davies, pp. 30–31.
Illustrations *British School* 1936, p. 34.
Barnard, Pl. 23.
Francis Holyland, *The Listener*, 10 June 1965, p. 867.
Goldberg, *Connoisseur*, November 1963, p. 194, fig. 1.
The figures were said by Charles Steward to be by Michael Sharp; they have, however, no appearance of being by anyone but Crome. According to tradition the boys are the sons of Crome and Mr Aldous the Mail driver. The smallest child is said to be Michael Sharp Crome (born 1813) (see note 1 to Chapter 7).
c. 1815–16.

Copies: (*a*) by J. Paul hanging in reserve Coll. at N.C.M. The Bathing figures omitted and replaced by seated fisherman and girl standing holding a jug.
(*b*) a pastiche at Sudley Manor, Liverpool, distance to L. incorporates a cottage (in reverse) from near Hingham (E 16).
(*c*) Canvas, $50\frac{1}{2} \times 40\frac{1}{2}$. Untraced.
Prov.: G. J. Gould, N.Y.; Jones' Sale Park Bernet, N.Y., December 1941 (26).
(*d*) Canvas, $19\frac{1}{4} \times 25\frac{1}{2}$. R. T. Gardner. Incorporating part of E 16.

P 88 STORMY HEATH SCENE WITH MILL (Plate 108a)

Canvas. 14×20.
Coll.: Mr and Mrs D. P. Clifford.
Prov.: Sotheby. 8 March, 1967 (165) as *T. Gainsborough, R.A.*
Condition: Thin, badly rubbed. Cleaned by Mrs Heatherington 1967.
The subject suggests that it may be *Heath Scene—Sun After a Storm* (No. 25) Exh. Nor. Soc. 1819. An untraced *Heath Scene and Mill* was in the T. Woolner Sale, 12 June 1875.
 Foreground, trees and mill are tan. Golden light streams across horizon from R. Above, purple grey clouds lifting to reveal a grey-blue sky.
c. 1816–19.

P 89 HEATH SCENE WITH A GIPSY ENCAMPMENT

Canvas. $29\frac{1}{2} \times 45$.
Coll.: Untraced.
Prov.: Colnaghi, Exh. 1959 (1); bt. Leggatt.
Lit.: F. Davis. *Illustrated London News*, April 11, 1959, p. 620.
Probably of Mousehold Heath. Baker records 23 appearances of pictures of Mousehold and others could probably be discovered; most are spurious.
 Not seen but photographically convincing, in composition reminiscent of *Mousehold Heath* (E 3).
c. 1812–17.

P 90 MOUSEHOLD HEATH, NORWICH (Plate 111)

Canvas. 43 × 71.

Coll.: Tate Gallery (689).

Prov.: J. B. Crome's Sale 1834 (rolled up as a 'sundry lot'); ? bt. J. Stannard (£1) (in two pieces, said to have been used as studio blinds); ? French of Windsor, a dealer; W. P. B. Freeman (who rejoined the pieces), by whom sold to William Yetts of Yarmouth (£25); bt. by Trustees of Nat. Gall. 1862 (£400); [*but in Freeman Ms. (in Nat. Gall.)—'sold by Mrs Crome for £12 to pay her rent. Later with J. B. Ladbrooke. Bt. by Freeman for £25 4s. od.; in 1840 sold to Colld. for £20 or less; figures by Bristow then taken out*].

Exh.: Nor. Polytechnic, 1840 (72) lent Yetts as *Landscape*.
Nor. Fine Arts Assoc., 1856 (198).
Internat., 1862 (157) lent Yetts.

Lit.: Freeman Mss. (in Nat. Gall.).
Dickes, p. 106 (ill).
Theobald, pp. 15, 16, No. 1.
Binyon, pp. 12, 13, 30, 33, 47–8, repr. opp. p. 28.
Old English Masters engraved by T. Cole (1902).
Mottram, pp. 130, 157, 162, 172, 173, 175.
Baker, pp. 36, 37, 38, 39, 41, 43, 44, 55, 59n, 65–6, 70, 72, 33, 74, 150, Pl. XL.
K. Smith, pp. 114, 178.
Cundall, pp. 5, 14–15.

Condition: For details of the pictures division and rejoining see: Chapter 7.
Handling of foreground close to *Poringland Oak* (P 87). Buildings on horizon L. treated in the same way as those in *Fishmarket at Boulogne* (P 98). Binyon and Cundall suggests 1816, Baker suggests 1818–20. We prefer the earlier dating. 1816, or perhaps as early as 1814.

Copy: Water-colour, 12 × 17½; by W. P. B. Freeman (1813–97).

Coll.: Major Jonathan Alford, R.E.,

Prov.: Orwell Park, Ipswich; Appleby, 1965.

P 91 THE WENSUM AT THORPE: BOYS BATHING (Colour Plate IV)
(BATHING SCENE)

Panel. 18½ × 13½.

Coll.: J. P. Stephenson Clarke, Esq.

Prov.: Painted for Dawson Turner, he paid £5; his Sale 14 May 1852 (58); bt. Smart (£5); J. E. Fordham; his Sale 9 Apl. 1910 (£472 10s.); bt. Agnew; H. Darell Brown (by 1921); Charles Clarke.

Exh.: Probably Nor. Soc., 1817 as *Bathing Scene* (44).
Burlington F.A.C., 1910 (11).
Nor., 1921 (28).

R.A., 1934 (613).

Agnew, 1958 (19).

Lit.: Turner, *Lithog.*, pp. 24, 25 (repr.).

Dickes, p. 116.

Cundall, Pl. XV.

Baker, 38, 41, 169, Pl. XXXVIII.

Dawson Turner wrote: *As the picture last described was one of Crome's earliest productions, so in the present we have one of his latest. He painted it for me but a year or two before his death, immediately on his return from his Midsummer journey to London, with his whole soul full of admiration at the effects of light and shade, and brilliant colour, and poetical feeling, and grandeur of conception, displayed in Turner's landscapes in the Exhibition. His object in this small piece was to embody upon the canvas [sic] a portion of what was impressed upon his mind; and the result has been the producing of a very pleasing picture, though nothing resembling Turner.*

1817.

P 92 THE WILLOW TREE (Plate 109)
(HORSEMAN AND WOMAN ON A ROAD, THE WILLOWS)

Canvas. 51 × 41.

Coll.: Castle Museum and Art Gallery, Nottingham ('55–53).

Prov.: Rev. Wilson of Kirby Cane; at his Sale bt. by auctioneer Baker of Bungay for £8; J. N. Sherrington; his Sale 1 May 1858 (25) bt. Rev. J. Holmes for £105; to his brother G. Holmes of Brooke Hall; acquired by Sulley and Wertheimer (*c.* 1898) and sold to M. C. Borden, U.S.A. (? £2,000); his Sale 13–14 February 1913, (33) bt. G. K. G. Billings of California for $55,500; 1920 James Hardy, his Sale American Art Assoc., 8 January, 1926; 1927, Ernest Cook, his bequest through N.A.C.F. 1955.

Exh.: Nor. 1860 (164).

Nor. 1874 (36).

R.A., 1876 (280).

R.A., 1891 (33).

Knoedler, 1912.

Independent Gallery, 1926.

Lit.: Waagen, iii, p. 438.

Binyon, pp. 36–37.

Theobald, pp. 40, 41 (No. 43).

Dickes, p. 126.

Baker, pp. 59n, 170, 183, 190, 197, 200, Pl. XLVII.

Mottram, pp. 160, 173-4, 175, 207.

Cundall, p. 1.

Studio, March, 1926, p. 199.

Ernest Cook Collection. 1957 (repr.).

Rather paler in colour than usual; the foliage R. very free and formless. Pale

blue sky, vaporous white clouds, sandy bank L. pale green foliage. A review in a
Norwich paper of the 1860 Exh. gave this picture third place after the *Poringland
Oak* (P 87) and another oak. A resemblance to Gainsborough was noted.
According to a note by Reeve to B.M.A. Loan Exh. 1874 the horse is taken from
a Hobbema. This figure group may have been put in after Crome's death.
1810–17.

P 93 POSTWICK GROVE (Plate 112)
(A WOOD SCENE)

Mill-board. 18¾ × 15½.
Coll.: N.C.M. (728, 235–951).
Prov.: Miss Mack in 1878; by will to Miss Ewing of All Saints Green, Norwich; her
Sale April 1895 bt. J. J. Colman; presented by R. J. Colman.
Exh.: St Andrew's Hall, Norwich 1878 (177).
Nor., 1921 (17) Cat. Pl. IX.
Louvre, 1938 (41).
Lit.: Dickes, pp. 109, 116.
Theobald, p. 29 (No. 21).
Baker, pp. 37, 41, 157, Pl. XLVI.
Guide to Colman Collection, 1951, p. 7. ill., Pl. 13.
Colman Cat., 728.
Bernard, Pl. 30.
K. Smith, pp. 124, 145, 146.
Holyland, *Postwick Grove* in *The Listener* 10 June 1965, pp. 866–7 (repr.).
Palette of bright green and ochre on a grey ground.
There are no firm grounds for identifying this with *View in Postwick Grove* (32)
in the 1821 Memorial Exh. lent by Mrs de Rouillon and there dated to 1816 as
does Baker who, notwithstanding, dated it *c.* 1820. In J. B. Crome Sale 1834
Lot 101, by *the late Mr Crome* was *Postwick Grove, sketch*. The relationship pointed
out (verbally) by Dr Rajnai of the tree-painting to the foundation painting of
the trees in *Italian Boulevard* suggests *c.* 1814–16.

P 94 YARMOUTH HARBOUR (Colour Plate VI)
(VIEW FROM YARMOUTH BRIDGE—EVENING—LOOKING DOWN THE RIVER)

Canvas. 16 × 26.
Coll.: Tate Gallery (5361).
Prov.: Wynn Ellis (as *by J. M. W. Turner*); his Sale, 6 May 1876 (48) bt. Agnew
(400 gns.); Edwin H. Lawrence; his Sale 6 May 1892 (344) bt. Maclean (£472);
George Salting, 1893; Romer Williams, 1909; H. Darrell-Brown; his Sale 23
May 1924 (18) bt. Agnew; Sir Arthur Peto 1926 (his Bequest 1942).

Exh.:	B.I., 1864 (132).
	R.A., 1878 (40).
	R.A., 1892 (42).
	Agnew, 1902 (2).
	Manchester, 1909 (3).
	Nor., 1921 (27).
	R.A., 1934 (610).
	Canterbury, 1937 (52).
	Agnew, 1958 (24).
	Jacksonville, Nashville, and New Orleans, 1966/67 (11) repr.
Lit.:	Dickes, p. 117.
	Cundall, p. 15, Pl. XVIII.
	Baker, pp. 28, 177, Pl. XVIII.
	K. Smith, pp. 91, 132.
	Connoisseur, May 1921.
	Nat. Gall. Cat., British School, Martin Davies, pp. 31–2.
Condition:	Paint surface broken up by a network of cracks and infilled.

Saffron yellow sunset, stone grey shops and sails foiled by a Cuyp-like sky. Baker seeks to identify it with No 25 in the Nor. Soc. Exh. of 1812. Dickes and Goldberg agree on 1817. We favour the later dating.

c. 1817.

P 95 NORWICH RIVER—AFTERNOON (Plate 113)
(ON THE YARE, NORWICH, ABOVE NEW MILLS)

	Canvas. 27½ × 39.
Coll.:	Lady Michaelis.
Prov.:	Said to have been bought by Alderman Hankes at *the Sale of Crome's effects* [or *from the artist*—Theobald] but no works by Crome were in either of his sales; ? J. N. Sherrington; C. F. Huth; his sale 19 March 1904 (46) bt. Colnaghi; Sir Max Michaelis.
Exh.:	Agnew, 1958 (47).
Lit.:	Dickes, p. 125.
	Theobald, p. 32. No. 25.
	Art Journal, 1904, ill.
	Burlington, VII, p. 325.
	Baker, pp. 41, 43, 154, Pl. XLIII.
	Country Life, July 17, 1958, p. 117 (repr.).
	Connoisseur, November 1963, p. 197, fig. 8.
Condition:	Apparently good; cleaned Holder, 1958.

Baker records: *Not seen owing to insuperable difficulties* and quotes *Cold colour; dark green and red; more positive in colour than usual.* Oddly, we have been equally unlucky.

VI. Yarmouth Harbour: Evening

(P 94) 16 × 26

c. 1817

Similar to *Back of the New Mills* (P 84), *Old Houses* (P 85) and *Bury Road Scene* (P 97). Baker suggests 1819.

c. 1816–19.

P 96	LANE SCENE

	Panel. 19 × 14.
Coll.:	H. Birkbeck, Esq.
Prov.:	Jeremiah and William Freeman; H. Birkbeck by 1894 thence by descent.
Condition:	Bituminous cracking in foreground which has been infilled. Paint flaked and rubbed off upper C. and restored. Note on back *Restored 1875 Oct. by Wm. Freeman. H. Birbeck. 29.3.94.*
Exh.:	Nor. 1921 (97). Crome Centenary.

Tall trees C. view L. down small village street with cottages and church with a tower. Group of figures foreground. Chocolate brown foreground, laurel green and gold foliage with touches of scarlet and grey in buildings.

Although most of Freeman's retouching has recently been removed the picture is in too poor condition to be certain of its date.

? *c.* 1815.

P 97	BURY ROAD SCENE (Plate 115)
	(A ROAD NEAR BURY)

	Panel. 15 × 19¼.
Coll.:	Mrs I. Ashcroft.
Prov.:	? W. Crome; ? J. S. Muskett; C. W. Unthank; Col. Unthank's Sale, Robinson and Fisher, 28 May 1897 (169) bt. Colnaghi; sold to Fleischmann 1898, Ashcroft by 1920.
Exh.:	? Nor., 1860 (177) lent Muskett.
	R.A., 1878 (1) lent Unthank.
	Norwich, 1921 (10).
	Agnew, 1958 (12).
Lit.:	Dickes, p. 73.
	Baker, pp. 34, 35, 38, 41, 43, 55, 113, 125, Pl. XLII.

Silvery toned, green and grey foliage, touches of soft brick red on house tiles. Possibly *Road Scene and Cottages near Bury* (9) Exh. Norwich, 1821. Memorial lent by W. Crome and attributed to 1818; certainly very near to this in date. Baker suggested Exh. Nor. Soc., 1819 (161) *A Lane Scene.* Mr F. G. McAlpine has an oil, *Cottage with Boy on Stile* (19½ × 15½) which from a photograph seems close to this in style.

c. 1815–19.

P 98 THE FISHMARKET AT BOULOGNE (Plate 114)

Canvas. 20⅝ × 33⅞.

Coll.: Quintin Gurney, Esq. (since 1935 on loan to N.C.M.).
Prov.: W. Freeman; Hudson Gurney; J. H. Gurney; by descent.
Exh.: Nor. Soc., 1820 (36); but see note to Appendix A.
 Nor., 1821 (87).
 Nor., 1874 (65).
 R.A., 1878 (14).
 Nor., 1921 (33), Cat. Pl. VIII.
 Brussels, 1929 (51).
 R.A., 1934 (146).
 Nor., 1954 (34).
 Agnew, 1958 (41).
 Jacksonville, Nashville & New Orleans, 1966/67 (13) (repr.).
Lit.: Binyon, pp. 29, 30.
 Dickes, pp. 95, 132 (repr.).
 Theobald, p. 34, No. 28.
 Cundall, p. 13, Pl. XXIV.
 Baker, pp. 19, 21, 38, 61, 135, Pl. XLV.
 Smith, pp. 53, 54, 90, 124, 129.
 Mottram, pp. 149, 160, 165, 177–8, repr., 176.
 Burlington, July/Aug. 1959, p. 29, Fig. 48.
 Barnard, p. 2.
 Etched by Edwin Edwards 1878.

From a sketch made on the spot in 1814. Mottram identified it *as the sandy spit
near the modern Casino, the view westward across the harbour mouth (there were no piers
in that day).* Goldberg draws attention to its Cuypish quality, connecting it with
Crome's ownership of Cuyp's *Fishmarket at Scheveningen.* See D 78 for what was
presumably a study for this picture.
Probably 1820.

P 99 YARMOUTH WATER FROLIC (Plate 110)
 (YARMOUTH REGATTA; WROXHAM WATER-FROLIC)

Canvas. 16½ × 30.

Coll.: Lt. Col. M. St. J. Barne.
Prov.: W. Cox; Rev. W. H. Stokes; Langton Douglas in 1937.
Exh.: R.A., 1878 (44), lent Rev. W. Stokes.
 Swaffham, 1882.
 Nor., 1954 (35).
 Agnew, 1958 (14).
 Whitworth, Manchester, 1961 (13).

Jacksonville, Nashville and New Orleans, 1967 (14) repr. in colour.

Lit.: Dickes, pp. 138, 156.

Baker, pp. 178, 198.

K. Smith, pp. 56, 124.

Burlington, August 1954, p. 265, fig. 29.

Burlington, July/August 1959, pp. 288–291, fig. 47.

Connoisseur Year Book, 1962, p. 125, ill. 10.

Connoisseur, February, 1966, detail in colour on cover.

The Yarmouth Water-Frolic was a festive occasion, revived in 1816, which closed with a rowing match in the evening.

A sketch upon which the finished picture at Kenwood was based. There seems no reason to connect this with the water-colour (D 100). Baker believed this to be by J. B. Crome, and was surely wrong, as Hawcroft pointed out. Hawcroft relates it to J. M. W. Turner's *Dort: the Dort Packet Boat from Rotterdam Becalmed* at Farnley Hall, Exh. R.A., 1818. He also sees a resemblance here to Cuyp. A study for Crome's unfinished last work (99a).

c. 1820–21.

P 99a YARMOUTH WATER FROLIC (Plate 119)
 (WROXHAM WATER FROLIC)

Canvas. 41 × 68.

Coll.: Iveagh Bequest, Kenwood.

Prov.: ? J. B. Crome Sale 1834 (192) or (193) as *Wroxham Water Frolic*; Dr Turton, Bishop of Ely, his Sale 1864 (as by Crome); Canon Selwyn; by descent to Captain Selwyn, his Sale 16 June 1894 (£2,730), bt. Agnew; Lord Iveagh.

Exh.: Nor. Soc., 1821 *by J. B. Crome.*

R.A., 1873 (42) lent Canon Selwyn.

R.A., 1910 (136) lent Lord Iveagh.

Lit.: Dickes, pp. 136, 138, 156.

Baker, pp. 21, 178 as by J. B. Crome.

Reeve; where correspondence with Canon Selwyn is preserved.

Binyon, p. 41.

Cundall, pp. 6, 16.

Mottram, p. 112, 181.

Burlington, July/August 1959, pp. 288–291, fig. 46.

Cat. of Jacksonville, Exh. No. 41.

Apart from the design, which is in principle Crome's, and a small passage in the lower and upper R. corner which may be a remnant of his father's sketch, this is by the hand of John Berney Crome. Many similar features are in J. B. Crome's *Rouen* at N.C.M. (Beecheno Bequest).

c. 1821.

Condition: Sky rubbed and scratched especially L., cleaned and restored Buttery.

P 100 WOOD SCENE: POOL IN FRONT (Plate 116)
 (LANE SCENE)

 Panel. 20 × 16.

Coll.: Dr and Mrs Norman L. Goldberg.

Prov.: Possibly J. B. Crome; Anon (Rainger) Sale. 28 February 1863 (93), 50 gns. bt. in. William T. Carrington; Denis Peterkin.

Exh.: ? Nor. Soc., 1821 (90) as *Lane Scene*.

 ? Nor., 1821 (111) as *Wood Scene*.

 Jacksonville, Nashville and New Orleans, February/June 1967 (15) repr.

Copy: (*a*) With slight variations, at Nat. Gall. of Victoria, Melbourne, Australia. Ex. Coll.: Viscount Traprain. Dr Goldberg considers this to be earlier version than his own. Judging from photographs only, the Melbourne picture appears to be a copy.

 (*b*) Canvas, 21⅛ × 17½. Coll.: F. L. Wilder, Esq.

Lit.: *Norfolk Chronicle*, 18 August 1821.

 Wodderspoon, pp. 14, 20.

 Dickes, p. 138.

 Baker, p. 172, 186, 195.

 Connoisseur, November 1960, p. 216, fig. 9.

Condition: Said to be good, cleaned 1961.

 The notice in the *Norfolk Chronicle* 18 August 1821 is not decisive evidence: *Lane Scene, No. 90—This and the Wood Scene near it are pleasing specimens of the late artist's best manner. There are a spirit, a finish and effect, about the handling which are admirable. In painting old trees and woodland scenery where . . .*

 . . . The mossgrown root peeps out, Mr Crome is in his element. The drawing in both these subjects is strikingly correct. The colouring is vivid without glare. There is a marked vigour but no hardness no carelessness, in the pencilling. Every part is finished with the delicacy of a miniature. The trunks and branches of the trees are beautifully designed and the foliage struck out, with equal precision, richness of taste, and harmonious contrast of light and shade.

 The argument that this is a late work bears considerable weight and it may well be Memorial Exh. 1821 (90), described as *Wood Scene, the last picture painted by the late Mr Crome in April.*

SOME PAINTINGS BY OR PROBABLY BY JOHN CROME, BUT WHICH ARE AT PRESENT UNTRACED. (See also Appendix G.)

P 101 HOLY-OAKS

Coll.: Dawson Turner, bt. from Crome for £13.

Lit.: Dawson Turner MS. Memoranda in possession of Mr Geoffrey Palgrave Barker. D.C. suggests this may be *Hollyhocks* (9 × 6⅝) attributed to Constable in Mellon Coll. (*Painting in England 1700–1850* 1964–5. ill. p. 12.)

PAINTINGS

P 102

OVAL MOONLIGHT

Coll.: Dawson Turner, bt. from Crome for £7.

P 103

VIEW NEAR NORWICH

Panel. 10 × 8.
Coll.: Dawson Turner.
Lit.: Turner, *Lithog*, p. 21 (repr.).
See D 161.

P 104

COTTAGE NEAR NORWICH

Millboard. 11½ × 8½.
Coll.: Dawson Turner, his Sale, 1852 (39).
Lit.: Turner, *Lithog*, p. 15.
This and P 105 were brought from the Rev. J. Homfray for £7. They hung in
Turner's bedroom in Yarmouth.

P 105

CLAY COTTAGE

Millboard. 11½ × 8½.
Coll.: Dawson Turner, his Sale, 1852 (40). See P 104.

P 106

WOODY LANDSCAPE (? RINGLAND MILL).

Panel. 23½ × 29½.
Coll.: Sometime with Arpad, Washington; formerly Knoedler. From bad photograph
in Witt looks authentic.
c. 1806–7.

P 107

KIRBY BEDON COTTAGE

Canvas. 30 × 24.
Coll.: John Wright of Buxton near Aylesham.
Exh.: ? Nor., Crome Memorial 1821.
? Nor., 1860 (106), called *Evening*.

241

Lit.: Turner, *Lithog*, note to P 95.
Dickes, p. 57.
Baker, pp. 130, 200.
A pendant to *Cottage at Hunstanton* (P 106). There is a drawing after this picture in the Thomas Harvey Album at the B.M.

P 108 WILLOW TREE NEAR MR WESTON'S HOUSE

Etched by George Vincent (Baker Pl. XXXVII). A painting attributed to Vincent is in the Mappin Art Gallery, Sheffield, which is after the engraving and may not be by Vincent but is not by Crome.
Lit.: Baker, p. 170, Pl. XXXVII.

P 109 ST. MARTIN'S: OLD HOUSES

Etched by S. D. Colkett (Baker, p. 161, Pl. XXXVII), a copy, possibly by David Hodgson, is in Lord Mancroft's Collection; other copies are recorded.
Prov.: J. Prior of Cambridge; C. A. Barton; his Sale, 1902; bt. Mr Falke, 1150 gns.
Lit.: Possibly Dickes, p. 92. *A Norfolk Landscape*, 23 × 18½.

P 110 BACK OF NEW MILLS, NORWICH

Etched by R. Girling *after Crome* (B.M.).

P 111 COTTAGE BEHIND TREES

Etched by R. Girling. Inscribed: *J. Crome fecit—R.G* (B.M.).

P 112 COW AT A POND

Etched by R. Girling *after Crome* (B.M.).

P 113

COTTAGE AND TREES

Etched by Edmund Girling. Inscribed *J. Crome pt.—E. Girling fecit* (B.M.).
Lit.: Dickes, p. 169 (repr.).
Baker, p. 130.

P 114

PORTRAIT OF MRS GURNEY

Canvas. 23⅜ × 19½.
Coll.: Untraced.
Prov.: With Prof. A. E. Richardson, A.R.A., 1937.
Exh.: London, *Country Life.* 1937 (369) repr.
Not seen. Mrs Gurney, head and shoulders three quarters to R. wears a bonnet and shawl and holds a pair of spectacles in her R. hand. Possibly by M. Sharp. *c.* 1815–21.

P 115

THE BRIDGE AT BURY

The well-known Picture of the Bridge at Bury, Crome Snr., painted to the express order of E. Browne, Esq., to be sold on 22, 23 November 1842: an advertisement by Spelman in the *Norfolk Chronicle*, November 19 1842.

P 116

THE GLADE COTTAGE

Canvas. 44 × 36.
Coll.: Said to be in a private collection in New York; also said to have been destroyed in the *Titanic*, 1913.
Prov.: Bernard Barton; J. E. Fordham; C. Flower (Lord Battersea) sold to Boswell; J. Pierpont Morgan to his daughter. Mrs H. L. Satterlee; Satterlee Sale 22 April 1948 (48).
Exh.: Nor. 1860 (27).
R.A. 1880 (23).
A. Cunningham. *Cabinet Gallery.* 1834, II, p. 23–8. repr.
Lit.: Dickes, p. 131.
Theobald, p. 39.
Cundall, Pl. IX.
Baker, p. 137.
Connoisseur, November, 1963, p. 198, fig. 7.
Dr Goldberg in Jacksonville Cat., 1967. p. 74. No. 20, note.

Baker saw it in 1930 in Mrs Satterlee's N.Y. apartment and said so in a letter to Goldberg (October 1 1958). Seen by Goldberg in 1960 and 1961.

The drawing in Lady Mackintosh's collection (D 209) is after the oil. It was said to be a *green* painting. Compare *Marlingford Grove* (P 86) and *Poringland Oak* (P 87). Not seen.

c. 1815–17.

P 117 HETHELL HALL

Farmhouse surrounded by trees, figures passing along road. A picture in his best manner. Upright.

Prov.: H. Gurney (1821); J. H. Gurney, M.P. (1860); in Overend, Gurney & Co. Sale, 13 March 1867 (274).

Exh.: Nor. Soc., 1817.
Nor., Crome Memorial, 1821 (90).
Nor. Loan, 1860 (50).
In 1860 described as a 'green' picture like P 116.

Lit.: Baker, p. 140.
Dickes, p. 116.
? *c.* 1817.

P 118 SCENE IN WALES

Exh.: Nor., 1860 (58), lent Mr Roe of Cambridge.
Exceeding elegance and masterly treatment of rocks, castillated buildings, water, and a fair breadth of single sky.
See D 4.

NOT BY CROME, OR POSSIBLY, OR IN PART BY CROME

(This list does not pretend to include all Cromes in public collections, nor any in private collections which have not already received wide publicity as being genuine.)

P 119 THISTLE AND WATER VOLE
 (OPIUM POPPY AND MOLE)

Canvas. $28\frac{3}{4} \times 24$.
Coll.: Mr and Mrs Paul Mellon.

Prov.: Wilson of Hellesdon; Boswell; A. M. Samuel; Lord Mancroft.

Exh.: Japan, 1910 (27).

Nor., Crome Centenary, 1921 (52).

R.A., 1934 (630).

Nor., 1954 (37).

Agnew, 1958 (49).

O. and P. Johnson, 1965 (19).

Lit.: Theobald, p. 37.

Baker, p. 165.

We are reluctant to take the credit for this beautiful picture from Crome, but it really is extraordinary that it should ever have been thought to be his; one can only suppose that Crome students, blinded by its merits, were unable to view it critically. It is based upon Thomas Bewick's wood-engravings; possibly by George Stubbs (1724–1806). See *Bay Arab in a Coastal Landscape* (1779). (Mellon Coll. Cat. 1963, Pl. 179, text p. 168.)

P 120 RIVER SCENE IN WELSH HILLS

Oil on canvas. $24\frac{1}{2} \times 29\frac{1}{2}$.

Coll.: N.C.M. (721–235–951).

Prov.: Sir George Holford; his Sale Christies, 17–18 May 1928 (122) as Richard Wilson; bt. Gooden and Fox; R. J. Colman, by whom presented.

Stamp: On verso with Custom's duty mark that was not instituted until 1784 (Wilson died in 1782).

Lit.: Holford Coll. Cat. 1927. II No. 173 as Wilson (repr.).

W. G. Constable. *Richard Wilson*, p. 143n, 235, fig. 140a.

Probably by Thomas Barker of Bath (1769–1847), showing influence of Gainsborough's *Bath* landscapes.

P 121 BREATHY BRIDGE, WESTMORELAND
(*Brathy* or *Brethey, Cumberland*)

Canvas. $18\frac{1}{2} \times 25\frac{1}{4}$.

Coll.: Tate Gallery (1831).

Prov.: Henry Vaughan by 1862, bequeathed to the National Gallery, 1901.

Exh.: ? Nor. Soc., 1806 (156).

? B.I., 1862 (180).

R.A., Old Masters, 1871 (45).

B.F.A.C., 1871 (25).

Nor., 1921 (3).

Lit.: Dickes, pp. 56, 61.
Theobald, pp. 19, 20.
Mottram, pp. 93, 112.
Baker, p. 123.
K. Smith, p. 173.
Doubted by Theobald; dated by Baker, *c.* 1814–15. The style is, however, largely inconsistent with pictures connected with one or other of the Cumberland visits of 1802 or 1806. The tree treatment is of an unusual type; foliage to L. being self-consciously Italianate. It may be a picture of *c.* 1812 based on a much earlier sketch. In a letter from a Mr F. Yates to Tate (from Ambleside, January 1908) it is stated that the bridge is Skelwith seen from the west and not Breathy.

P 122 COPY OF REMBRANDT'S MILL

Panel. 32 × 39.
Coll.: N.C.M. (728A–235–951).
Prov.: Bt. by R. J. Colman from P. M. Turner.
Lit.: Barnard, Pl. 2.
Rembrandt's *Mill* now in Nat. Gal. Washington (Widener Coll. 658) reached England with the Orleans Collection in 1792 and was exhibited for sale in Pall Mall in the following year; it was bought by William Smith, M.P. for Norwich; was on public view in 1798; and was yet again available for copying at the B.I. in 1815. This copy has no history. According to a letter from P. M. Turner at Norwich the attribution to Crome was confirmed by Binyon, Baker, and Holmes. It is, in our view, very probably by Crome but since many artists copied this famous picture[1] and as there is no history of Crome doing so there must remain an element of doubt. [In N.C.M. (18–4–944) there is a chalk drawing on blue paper $3\frac{3}{10} \times 5\frac{3}{10}$ by J. B. Crome, datable *c.* 1814–16 (on the basis of watermarks on other drawings), which is, perhaps, a record of this, his father's, copy.]
? *c.* 1805–7.

P 123 VIEW AT BLOFIELD, NORFOLK

Canvas. 30 × 24½.
Coll.: Birmingham City Art Gallery (73'47).
Prov.: Said to have been painted for Samuel Paget in 1811; thence by descent to Mrs Gaddow of Great Shelford, Cambridge, Paget's great granddaughter; Tabor Sale, Christies, 2 August 1928 (164), bt. Permain (£525); F. J. Nettlefold by whom presented in 1947.

[1] An oil based on the Rembrandt is signed and dated *James Ward* 1806 (photo in Witt.).

Exh.: Aberystwyth, 1956 (22).

Lit.: Dickes, p. 69 or 89.

Baker, p. 123.

Nettlefold Cat., 1938 I repr. p. 78.

Dickes, pp. 69 and/or 89.

Connoisseur Magazine, 1948 (Vol. CXXI), p. 83.

City Art Gal. Cat. (1961), p. 43.

Condition: Good, dead branch to L. of cottage possibly painted in by restorer.

Blofield is about seven miles East of Norwich on the Yarmouth Road. The trees with small forked branches are mechanically painted. In 1811 Crome exh. at Nor. Soc. *Scene at Blofield* (27) and at R.A. in same year *View in Blofield, near Norwich* (465). *Scene at Blofield* was exh. at Nor. Soc. 1813 (10) and in the 1821 Memorial Exh., S. Paget lent *Lane Scene at Blofield* (46) which he attributed to 1813.

Foreground colouring like that in Barber Institute's *Near Harwich* (P 124). Monotonous handling of foliage with mechanical repetition of forked branches, shaky drawing of handrail to steps, lack of vitality in brushwork point to a dubious authenticity.

P 124 NEAR HARWICH

Canvas. $44\frac{3}{4} \times 37\frac{1}{2}$.

Coll.: Barber Institute, Birmingham.

Prov.: J. B. Crome; from whom bought by Edward (? Evans) Lombe (? Loombe) of Melton Hall, Norfolk; T. Wells of Bracondale, Norwich by 1848; sold by Miss Wells 1915 to Messrs Sulley and Boswell with Knoedler of New York 1921; A. J. Sulley Sale, Christies, 1 June 1934 (5); bt. by Barber Institute from W. Boswell and Son, Norwich, 1939.

Exh.: Nor. Fine Arts Association, 1860 (35), there catalogued as *Old Crome and J. B. Crome.*

Nor. Medic. Assoc., 1871 (1).

Nor., 1874 (as by J. and J. B. Crome).

Nor., 1878 (as by J. Crome).

Nor., 1883 (as by J. Crome).

Nor., 1894 (as by J. Crome).

Nor., April 1902 (155), *St. Andrews Hall.*

Toronto, 1924 (2).

Lit.: Baker, pp. 58, 87, 138–139, 191, 192, 200.

A. C. Sewter in *Burlington* LXXVIII, 1941, pp. 10–13, ill., Pl. 1b.

Apollo, XXX, 1939, p. 160.

Illustrated London News, 29 July 1939, repr.

Eastern Daily Press, Nov. correspondence 23–24 February 1926; in the Barber archives is a letter from Holmes and Baker in 1925 saying that in their view it was by Crome with additions by J. B. Crome fifteen or twenty years later.

On the back of a picture which is now at Norwich Castle (repr. Cundall LXII) is a label in Reeve's hand: NEAR BURY ST. EDMUNDS *painted by John Berney Crome 1832 as a companion to his father's Harwich for Edward Lombe Esqre.; of Melton Hall, Norfolk. The sum of fifty guineas was the amount paid by Mr Lombe to J. B. Crome for the picture.*

All that is now on the surface by Crome is the foreground and building to L. Trees L. are nearly entirely overpainted in J. B. Crome's typical manner, as are also the sky and the silhouette of distant hills. Sewter dated it *c.* 1813 seeing in it a relationship, which we do not see, to Turner's *Frosty Morning*. Fundamentally a fine Crome of *c.* 1805–7, but marred by J. B. Crome's alterations.

P 125 A VIEW OF CHAPEL FIELDS, NORWICH (Plate 118)
 (AVENUE AT CHAPEL FIELDS)

Canvas. 29 × 41.
Coll.: Tate Gallery (897).
Prov.: William Spratt, Norwich; by descent to A. W. Spratt, St Catherine's Coll. Cambridge; H. F. Chorley; his bequest 1872.
Exh.: ? Nor. Soc., 1820.
Lit.: Dickes, p. 133.
 Theobald, pp. 17–18, No. 3.
 Binyon, p. 47.
 Baker, pp. 126, 184, 193, 197.
 K. Smith, p. 73.
 Mottram, p. 179.
 Wilenski, *English Painting*, pp. 201–2, 217, 230, 254–5.
 Etched by R. S. Chattock; impressions reproduced in *Standard*, 21 December 1885.
 Said to have reached A. W. Spratt *unfinished*, cattle added by William Shayer (1788–1879). This is an admirable example of what the mid-nineteenth century found lacking in Crome. The picture, was, of course, finished by Crome but was later worked up to meet contemporary taste by Shayer. Some foreground grass has been repainted; the palings to the right have been partially repainted and possibly extended by four inches, top-right of wall on left has been added; cattle and horseman by Shayer, seated figure probably Crome. Generally dated 1820. We prefer a much earlier date. Painted before the *Skirts of the Forest* (P 53). ? *c.* 1807–9. Possibly at about the time of D 43.

P 126 HAUTBOIS COMMON, NORFOLK

Panel transferred to canvas. 22 × 35.
Coll.: Metropolitan Museum, N.Y. (89-15-14).
Prov.: ? F. Stone, his Sale, *The Shrubbery*, Newmarket Road, 28 October 1835 (106),

bt. A. Stannard for Mr Stacey (£16. 5s. 6d.); said to have belonged to J. N. Sherrington, *not in his Sale*; Mrs Ellison by 1862, her Sale 16 May 1874, bt. Agnew;

[*Confusion follows:*]

A. Levy, Sale 14 August 1864 ;A. Levy, Sale 16 April 1876 (288) (£404. 5s., bt. in); Levy Exors Sale 3 May 1884 (£435. 15s.), bt. Lesser; passed to Sedelmyer; Henry G. Marquand 1888; his gift 1889.

Exh.:	? Nor. Soc., 1810 (27).
	? Nor., 1821 (37), *Crome Memorial*, lent F. Stone.
	? Nor., 1860 (179), lent J. Brightwell as *Hautbois, View*.
	? International, 1862 (125), lent Mrs Ellison as *A Clump of Trees, Hautbois Common*.
Lit.:	Dickes, pp. 67, 68.
	Burlington, XXII, p. 270 (repr.).
	Baker, pp. 37, 43, 139.
	Connoisseur, November 1960, p. 215, fig. 5.
Condition:	Transferred from panel in 1914.

A *Scene at Hautbois Common, near Coltishall, in Norfolk* was exh. Nor. Soc., 1810. Mr F. Stone lent a *Hautbois Common, Norfolk* to the Memorial Exh. 1821 giving the date for its execution as 1810.

The composition in reverse is similar to *The Beaters* with a road winding through trees and a distant flat landscape to one side. Both are lit from the Left. It has a similar measure and, like *The Beaters* was originally on panel. *The Beaters* is signed and dated 1810.

The Metropolitan picture has not been seen by either of us for sometime. T.C. considers it a copy of a lost original. He is unable to parallel the thready handling of the distance, unusual foliage technique or failure of the artist to convince one that the trees grow out of the ground.

D.C. accepts it, but places it later than 1810, allowing inconsistencies of paint handling to its present condition.

Copies: (a)	Canvas, 24½ × 36, by a familiar Crome forger.
Coll.:	Mr and Mrs Paul Mellon.
Prov.:	A. P. Forrester Paton; Lord Glenconnor.
Exh.:	Glasgow, 1901 (59) as *The Road to the Farm*.
Inscribed:	*J. Crome*, bottom centre L.
(b)	Sepia. ? by W. H. Hunt, or R. Girling.
Coll.:	N.C.M. (12–59–935). (D 111).
Exh.:	Nor., 1921 (84) *as by Crome*.

P 127	A MILL NEAR LAKENHAM
P 128	A COTTAGE NEAR LAKENHAM

Canvas. 11½ × 13½.

Coll.: The Rt Hon. Lord Mancroft, K.B.E.

Prov.: Sir Arthur Samuel, Bart.

Exh.: Japan, 1910 (26) and (27).

Nor., Crome Centenary, 1921 (53) and (54).

Agnew, 1958 (26) and (29).

Lit.: Cundall, Pl. XIII, Pl. XII.

Baker, p. 142.

Burlington, 1921, Vol. XXXVIII, p. 254.

Condition: Poor, paint surface probably singed and flattened when relined. Recently well restored by Bull.

These deservedly well-known pictures, both of immense charm, have really very little of the essential characteristics of Crome. P. M. Turner suggested that they might be by Ninham. It is far more probable that they are by an artist strongly influenced by J. M. W. Turner, *c.* 1809 and Sir Augustus Wall Collcott is suggested.

P 129


COTTAGES ON THE WENSUM

(OLD BUILDINGS ON THE WENSUM)



Panel. $11\frac{3}{4} \times 16$.

Coll.: Mr and Mrs Paul Mellon.

Prov.: Dr J. S. Cotman, grandson of the artist, 1952.

Viscount Mackintosh of Halifax until 1961.

Exh.: Agnew, 1958 (35).

Virginia, 1963 (75) repr.

R.A., 1964–5 (96).

Lit.: Mellon Cat., Vol. I, p. 65, No. 75, Vol. II, Pl. 59.

Copy: Water-colour in Cotman basement of N.C.M. called *Old Granary and Staithe* by Henry Ninham.

Not by Crome; we endorse the view already put forward that this is probably by John Sell Cotman, but not impossibly by Ninham.

P 130


WHERRIES ON THE YARE

(WHERRIES ON YARE: GOING THROUGH THE BROADS)



Canvas. $18\frac{1}{2} \times 23$.

Coll.: Leeds City Art Gallery (1164).

Prov.: Said by Baker to be ex-Sherrington; A. Andrews; his Sale, 14 April 1888, bt. Lawrie; W. M. de Zoete; his Sale, 5 April 1935 (64); Samuel Smith; by whom presented, 1935.

Exh.: Grosvenor Gallery, 1888 (295).

Hamburg, Oslo, Stockholm, and Copenhagen, 1949–50 (34).

Agnew, 1958 (43).

Whitworth, Manchester, 1961 (5).

Lit.: Baker, pp. 42, 169.
Apollo, February 1942, p. 38, Pl. XLVII.
Baker suggests 1817–18 and says that 'it revives the steely, blackish, greens of 1818'. We can see no sign of Crome's hand in any part. The distance is hard and the contrasts over-emphatic; paint is laid on in places in an un-Cromelike way; the tree-stump to the right is modelled with dull sealing-wax red. The construction is attractive but the handling suggests a good J. B. Crome; if it has a Sherrington provenance, J. B. Crome is its probable author.

Compare distance in *Moonlight Scene* by J. B. C. at N.C.M. (Miss Geldart Bequest).

P 131 VIEW NEAR NORWICH—HARVESTERS

Panel. 15 × 21.
Coll.: City Art Gallery, Manchester (105).
Prov.: bt. Agnew.
Lit.: Baker, p. 154, 192.
K. Smith, p. 175.
City Art Gallery Cat. (repr.).
Accepted by Baker who had not seen it. The subject matter, composition and foliage treatment are all untypical. There are features in it reminiscent of Crome. *c.* 1810–15 but nothing that is persuasive.

P 132 TREES ON A KNOLL
Panel. 11$\frac{11}{16}$ × 15.
Coll.: Walker Art Gallery, Liverpool (No. 2947).
Prov.: Owen Owen Ltd., 1951 by whom presented.
Condition: Good.
Palette of grey, grey-green, and pink-green, light falling centre; yellowy-fawn. A difficult picture, perhaps not unconected with P 131; not to be paralleled in undoubted works.

P 133 GROVE SCENE (Plate 123b)

Canvas. 18$\frac{1}{2}$ × 25$\frac{1}{2}$.
Coll.: N.C.M. (727–235–951).
Prov.: On verso a label in ink: *Grove Scene—painted by old John Crome. I purchased this painting 'The Grove Scene' of the Widow of the Elder John Crome, about-Two Months*

251

after his Decease in the Year 1821—And for which I gave her Thirty Pounds. Joseph Geldart.[1]

bt. by J. J. Colman in 1890 from Robert Geldart; R. J. Colman by whom presented.

Exh.: ? Nor. Soc., 1820.

? Nor., Crome Memorial, 1821 (76), lent J. Geldart, Jnr.

R.A., 1891 (9).

Nor., 1921 (21).

Copy: Canvas, 19¾ × 26½ in Coll. of Mrs T. H. Porter of Lowestoft.

Lit.: Dickes, p. 134 (ill.).

Theobald, p. 27.

Binyon, p. 37, 39 (ill.).

K. Smith, p. 66, 113.

Cundall, Pl. VII.

Mottram, pp. 180, 201.

Baker, pp. 34, 42, 53, 43–4, 137–8, 188.

The Sphere, 30 April 1921 (detail repr.).

Hawcroft, *Connoisseur*, December 1959, p. 235, fig. 11.

Baker wrote that in this picture *Crome comes perilously near the quality of John Berney Crome,* and in another place remarks that it is *famous for having pleased Mrs. Crome because of its likeness to a Hobbema.* In our view the label on the back is (1) a forgery, or (2) it applied to a different picture, or (3) the picture has been almost totally over-painted. What cannot be true is that this picture was painted by Crome.

Comments: *Grove Scene . . . in which one is tempted to feel that this attachment to the Dutch model almost amounts to a setback, and that the painter is loosing, rather than gaining in freshness and truth by reason of it.*

—K. Smith.

Beautiful . . . it is the very best manner, an example of his main line.

—Mottram.

Surprising . . . One can certainly believe that he painted it to please someone, not himself. [He notes its resemblance to Stark] *. . . a fine Stark; for Stark, who was Crome's pupil, is far more faithful to Hobbema than Crome was. The picture is a vagary, and lies outside the line of Crome's individual development. But it is interesting, and, from the lateness of its date extremely remarkable.*

—Binyon.

P 134 NEAR HINGHAM, NORFOLK (Plate 123a)

Canvas. 24¼ × 32¼.

Coll.: Tate Gallery (1504).

[1] Joseph Geldart (c. 1778–1851), the artist's father was a wine merchant and not a solicitor. His father also was Joseph Geldart (d. 1823). A third Joseph Geldart was the artist (1808–82). Robert Geldart was the artist's brother. [Information kindly supplied by Dr Rajnai.]

Prov.: Baker (pp. 140, 141) gives: '*Perhaps Exhib. Norwich Soc. 1812. Crome Memorial Ex. 1821 (39) lent S. Paget. Perhaps exhib. Suffolk St. 1834, lent J. Stark. Said to have been found by one Gooden. Passed to J. Gillott. Apparently in his Sale 26 April 1872,* "LAND-SCAPE, RICHLY WOODED". *Said to have gone to America.*[1] *Passed to Mrs Bischoffs-heim; bt. by Sir H. Tate*'. The earlier history is sheer fabrication, but truth, perhaps, enters with *said to have been found by one Gooden*. Presented by Sir H. Tate, 1894.

Exh.: Guildhall, 1894 (81).
 Loaned in 1960 to Nat. Gallery of Canada.

Lit.: Dickes, pp. 89, 90 (ill.), 119.
 K. Smith, p. 173.
 Goldberg, *Connoisseur*, November 1960, pp. 214, 215 (ill.).
 Baker, pp. 140, 141, 183, 188, 193, 194, 198.
 Brand. *MS. at Tate.*
 Theobald, pp. 59–60—*The picture was no doubt painted to deceive. It is not without cleverness or it would not be where it is . . . none of these things can make it genuine . . . Mr Reeve considers that it is by A. G. Stannard (1828–1885), of whom his father Alfred Stannard, used to boast that he painted at least 300 Cromes.*

Condition: Good, relined 1936. Cleaned and hole repaired.

Allied works: (*a*) Etching in Five States (E 7), *Deepham, Near Hingham.*
 (*b*) Canvas, $8\frac{3}{4} \times 11\frac{7}{8}$, by Paul. *Coll.:* D. Masters. *Lit.: Connoisseur.* December 1950, p. 191.
 (*c*) Similar to the above, also by Paul. There are slight differences; does not extended so far to R. Photo in Witt. This may have been in Mr C. E. Brand's Coll., 1946.
 Baker, pp. 140–141. *In the main Crome's work; the trees and most of the sky are his. The palings probably not, nor the distant hill: c, the ground has been re-touched.*

 Engraved in mezzotint by Sir Frank Short.

 The case against this picture rests in part upon the fact that it is a copy of an etching made by Crome in 1813 (E 7) *Deepham, near Hingham*, nor is it a copy of an early but a fairly accurate representation of the Fourth State as left by Crome and later published. The title *At Hingham* was added to the Fifth State. An article in *Connoisseur*, December 1950, purporting to prove that another copy of the etching was by Crome has no relevance. Although it is not impossible that Crome should have copied his own etching in its Fourth State it is improbable. Baker's solution that bits are by Crome is not tenable. The picture is painted by the same hand throughout and in our opinion it is a thorough-going forgery of great merit. Isolated features are indistinguishable from the work of Crome's hand but the total effect is quite unlike Crome. This is precisely the way in which a brilliant forger would be likely to succeed . . . and to fail. Although this is possibly by J. B. Crome we are inclined to date it *c.* 1860–70 when it was *found by one Gooden.*

[1] According to Reeve bt. at Gillot's Sale for U.S. Government *Broadway* Coll. for 600 gns. (See B.M. 190* a 9 opposite E 7.)

P 135 WOODY LANDSCAPE (Plate 124)

Panel. 19¼ × 15¼.

Coll.: Victoria and Albert Museum (64).

Prov.: Sheepshanks gift, 1857.

Versions: (*a*) Water-colour in Mr Cyril Fry's Collection, which is not by Crome.

 (*b*) Pencil drawing at B.M. by George Vincent signed and dated 1823.

 (*c*) An etching, without children and without logs L. foreground, by George Vincent, initially G-V and dated 1827. (Impression in Author's Coll.)

Lit.: Dickes, p. 73 (repr.).

 Theobald, p. 21.

 Baker, p. 36, 43, 54, 56n, 174, Pl. XLIX.

 Painted by George Vincent, *c.* 1823-7.

P 136 A VIEW OF NORWICH WITH THE CASTLE AND CATHEDRAL

Canvas. 28½ × 38½.

Coll.: Mr and Mrs Paul Mellon.

Prov.: Said to have been painted for Sir D. Gooch of Benacre, Suffolk. Apparently passed to G. F. Williams; J. Beausire, 1898, his Coll., 1920; Tooth by 1958.

Exh.: Port Sunlight, 1902.

Lit.: Baker, p. 154 (as 1812).

 Dickes, p. 110 (as 1816).

 Connoisseur, October 1958, p. xxxi (repr.).

This cannot be by Crome for the Shirehall which appears at the bottom of the Castle Mound was built in 1822–3; nor does it look like one and that it was ever accepted shows the extent to which Crome has been misunderstood. (See Cot. and Haw., pp. 61–63, Pl. 4 and 5.) It is probably by Robert Ladbrooke— compare his *Foundry Bridge* at N.C.M. (repr. in Cat. of Loan Exh. of Nor. School Paintings, 1927, Norwich, No. 58, p. 26.)

 ? *c.* 1835.

P 137 EARLHAM HALL GARDENS

Panel. 21¼ × 30.

Coll.: John Gurney, Esq.

Prov.: Family descent.

Exh.: Nor. 1921 (99). *Crome Centenary.*

Lit.: Baker, p. 132.

Single-storey room R. opening out onto a garden. Path C.R. disappearing into

distance. C. Large trees on lawn L. Gardener with spade R. Foliage of trees green yellow and brown; sandy yellow path, lettuce green grass, building with red brick walls and slate roof. Painted by the Misses Gurney and Crome their instructor. Trees L. and sky seem to be entirely Crome's work. Lawn, path, flowers and some of the building by the Gurney girls.

c. 1809–10.

LOCATIONS OF PAINTINGS AND DRAWINGS
ILLUSTRATED

The Trustees of the Tate Gallery—I, VI, 35a, 82b, 84a, 90b, 93, 107, 111, 118, 123a; H. Watlington, Esq.—V, the Trustees of Norwich Castle Museum—1, 2, 3, 4, 6b, 9a, 10, 15, 18b, 22, 24, 25, 26a, 26b, 28, 29, 31, 38, 52a, 52b, 53b, 57, 58b, 61a, 65, 67, 73, 80b, 81b, 99, 100a, 101, 102, 104, 106, 108b, 112, 122a, 123b, 125a, 125b; from the Collection of Mr and Mrs Paul Mellon—II, 36a, 39, 78, 80a, 105, 121b, 122b; Quintin Gurney, Esq.—III, 114, 127a, 127b; John P. S. Clarke, Esq.—IV; whereabouts at present unknown—5, 7, 21b, 35b, 70a, 77, 82a, 92a, 92b, 108b; Norman Baker, Esq.—6a, 8a, 8b, 12b; L. G. Duke, Esq.—9b, 33a, 33b; Sir Edmund Bacon, Bart., C.B.E., T.D.—19b, 41, 47, 51, 81a; the Trustees of the British Museum —12a, 14, 17, 18a, 19a, 20, 27, 32, 34a, 34b, 50; Mr and Mrs Derek Clifford—11, 16, 21a, 23, 36b, 69, 71, 97, 108a; E. P. Hansell, Esq.—13; the late Sir Stephen Courtauld—30, 59a; the Trustees of the Museum and Art Gallery, Doncaster—37; the Trustees of the Victoria and Albert Museum—40, 46, 48, 87, 100b, 124; the Trustees of the Whitworth Art Gallery, Manchester—42, 43, 44; the Trustees of the City Art Gallery, Manchester—45; the Trustees of Ipswich Museum—49a, 49b, 53a, 120; Timothy Colman, Esq.—58a, 103; Pennsylvania Museum of Art, Philadelphia—59b, 86; from the Collection of Constance, Viscountess Mackintosh—60a, 60b, 89, 91a, 91b, 96a, 98; the late T. W. Bacon Esq.—61b; Dr and Mrs Norman Goldberg—62, 116; Dr Arnold Renshaw—63b; Homeless—64; the Trustees of the Museum of Art, Boston—63a; the Trustees of the National Gallery, Edinburgh—66; Professor T. Grahame Clark—70a; The Institute of Art, Detroit—72; the Syndics of the Fitzwilliam Museum, Cambridge—74a, 90a; Mrs W. S. Spooner—74b; His Royal Highness the Duke of Kent—75a; The Hon. Doris Harbord—75b; the Trustees of the National Gallery of Canada, Ottawa—76; the Trustees of the Williamson Art Gallery, Birkenhead—79; Lady Crathorne—83a; Anonymous—83b; Sir Martyn Beckett, Bt.—84b; the Trustees of the Royal Museum and Art Gallery, Canterbury—85; the Hon. Sir Arthur Howard, K.B.E., C.V.O.— 88; John Gurney, Esq.—94; the Hon. Keith Mason—95; the Trustees of the Birmingham City Art Gallery—96b; the Trustees of Nottingham Castle Museum and Art Gallery—109; Lt.-Col. M. St. J. Barne—110; Lady Michaelis—113; Mrs I. Ashcroft—115; the Trustees of the Lady Lever Art Gallery, Port Sunlight—117; the Trustees of the Iveagh Bequest, Kenwood —119; the Rt. Hon. Malcolm Macdonald—121a; J. G. Firth, Esq.—126a, 126b; Miss U. P. Terry—128.

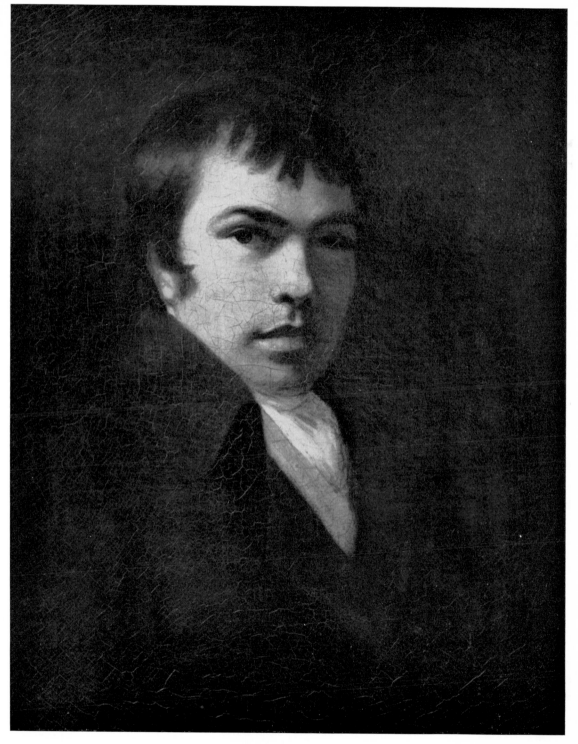

1. John Crome by John Opie

Norwich Castle Museum

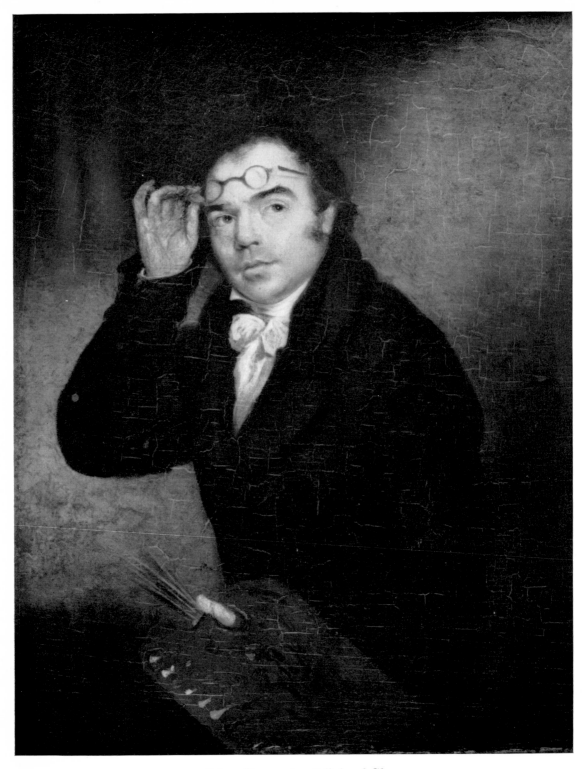

2. John Crome by Michael Sharp

c. 1818

Norwich Castle Museum

Pray let me know how you are going on giving
best respects to all friends I believe the
English may boast of having the start of
these foreigners in many things but a happier
race of people there cannot be shall make this
journey happyready. I shall
be very cautiousout my money
I have seen somehold they
Ask treble what they will take so you
may suppose [what a] they give
I shall see David to Morrow and the
rest of the Artist. when I can find time
I write this before I know what I am
going about at y as the post
compels me —

I am &c

Mrs Coppin will Yours till death
 John Crome
give you our address
If you have any thing
to write but if not let
her say in here how
you all are

3. Holograph by John Crome

1814 *Norwich Castle Museum*

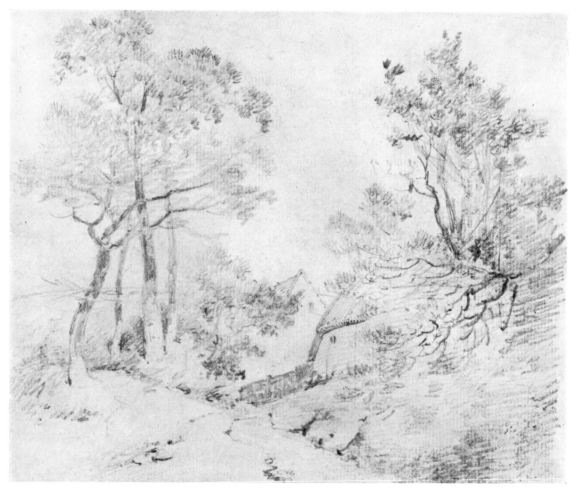

4. Landscape at Hethersett

1794–1802 (D 1) $6\frac{2}{5} \times 7\frac{9}{10}$ *Norwich Castle Museum*

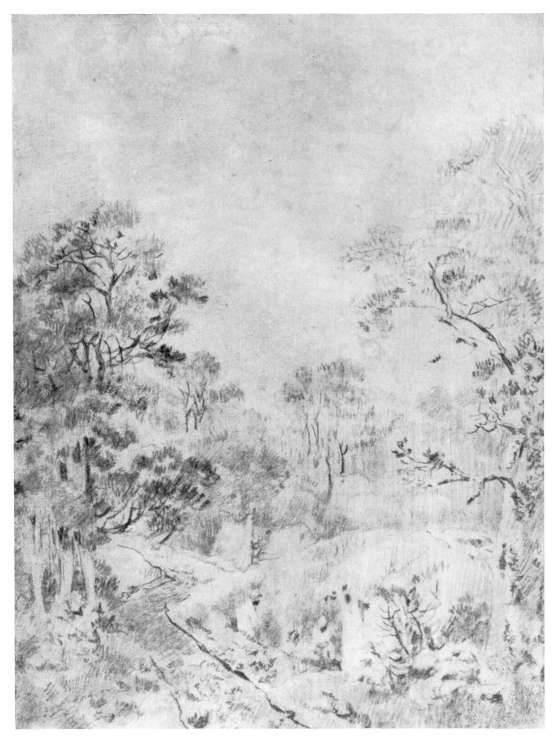

5. Wooded Landscape

1794–1802 (D 2) 10 × 7½ *Untraced*

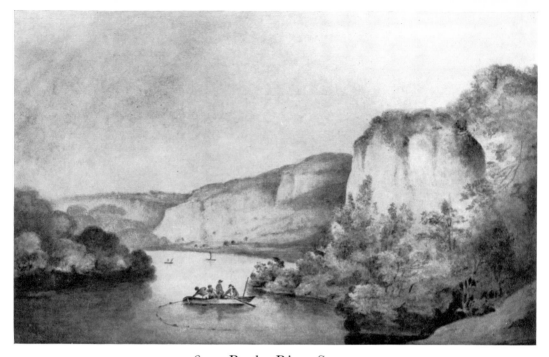

6a.　Rocky River Scene

1797-1804　　　　　　　　　(D 3) $15\frac{3}{10} \times 24\frac{1}{5}$　　　　　　　*Norman Baker Esq.*

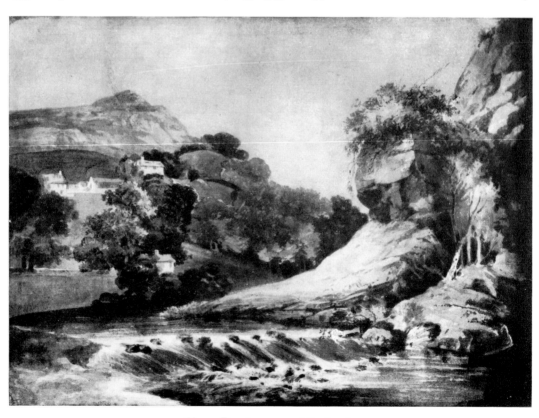

6b.　Rocks near Matlock

1802-6　　　　　　　　　(D 5) $15\frac{7}{8} \times 22\frac{3}{8}$　　　　　　　*Norwich Castle Museum*

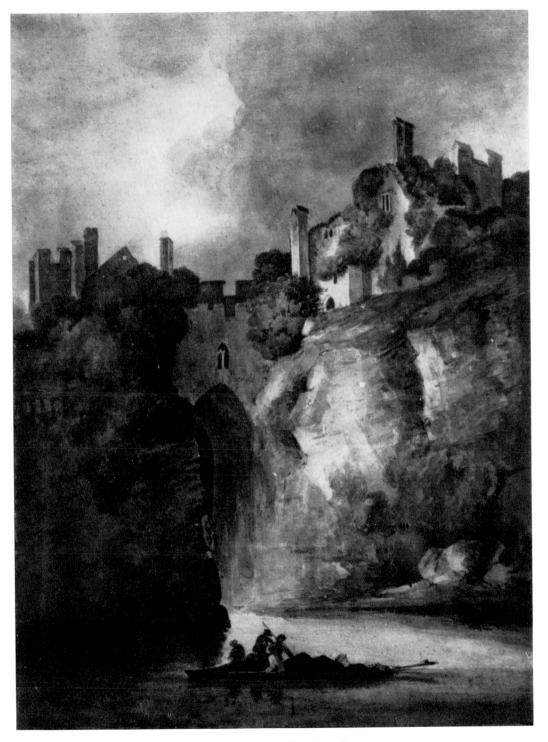

7. Castle in a Hilly Landscape

1803–5 (D 4) $16\frac{3}{4} \times 12$ *Untraced*

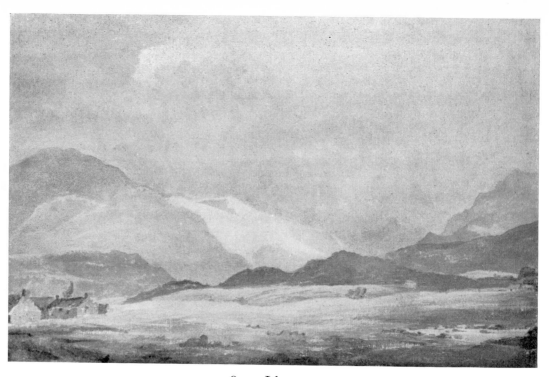

8a. Llanrug

1804 (D 7) $11\frac{1}{2} \times 18\frac{1}{5}$ *Norman Baker Esq.*

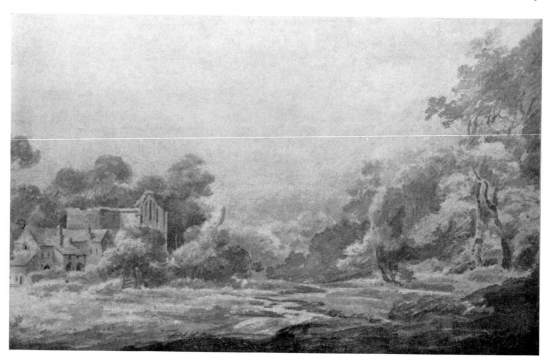

8b. Valle Crucis

1804 (D 6) $11\frac{1}{5} \times 18\frac{1}{2}$ *Norman Baker Esq.*

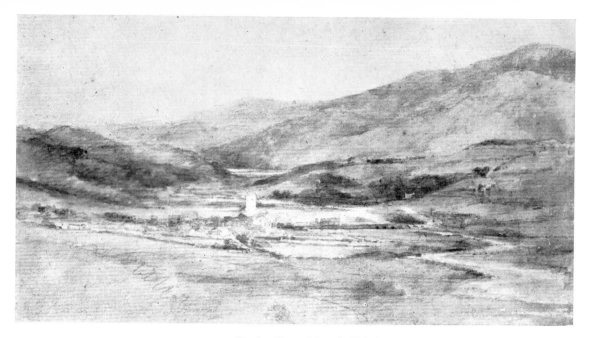

9a. Dolgelley, North Wales

c. 1804 (D 9) $6\frac{7}{8} \times 12\frac{1}{4}$ *Norwich Castle Museum*

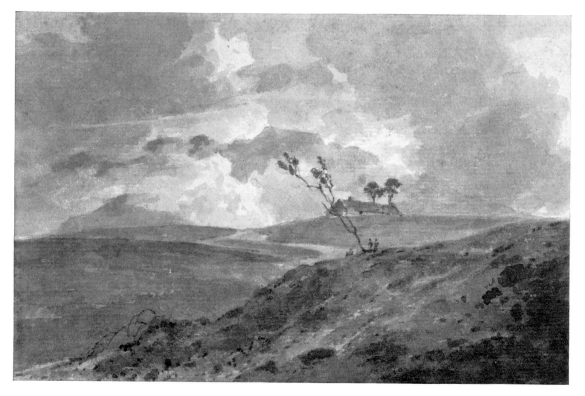

9b. Mountainous Landscape

c. 1804 (D 8) $6\frac{15}{16} \times 10\frac{15}{16}$ *L. G. Duke Esq.*

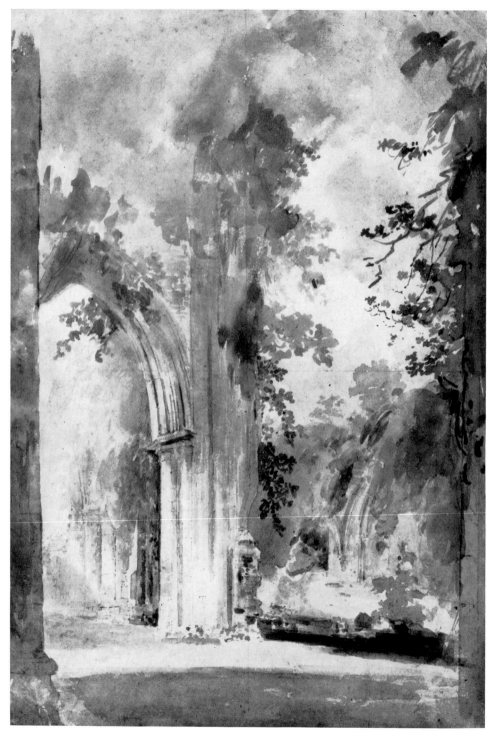

10. Tintern Abbey

1805–7 (D 42) $13\frac{1}{5} \times 9\frac{1}{10}$ *Norwich Castle Museum*

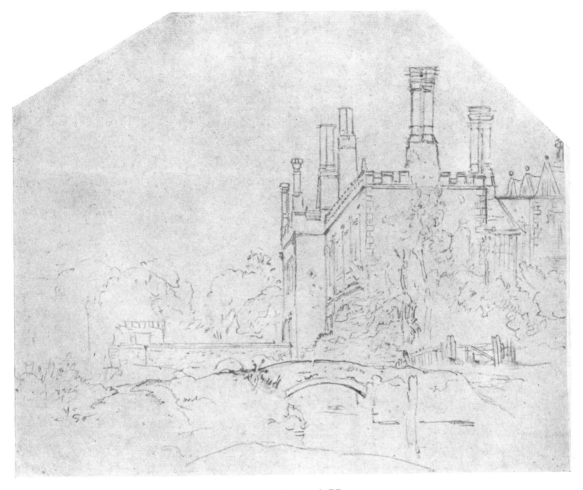

11. A Moated House

c. 1802–7 (D 41) $9\frac{3}{5} \times 12$ *Mr and Mrs Derek Clifford*

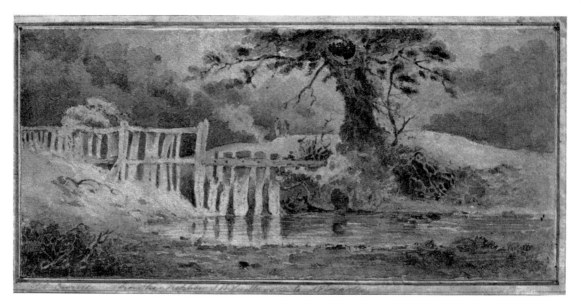

12a. Palings and Trees by a Pond

c. 1803–4 (D 13) $4\frac{3}{4} \times 10\frac{7}{8}$ *British Museum*

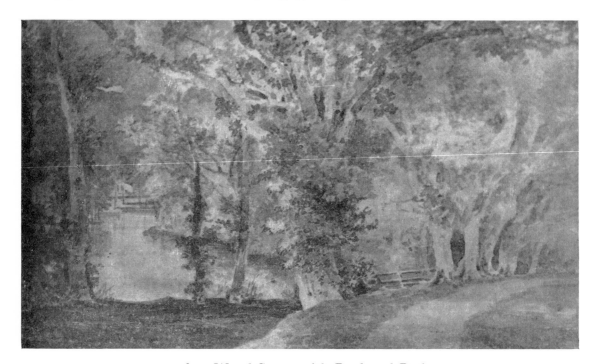

12b. Wood Scene with Pool and Path

1804 (D 10) $7\frac{1}{10} \times 12\frac{1}{5}$ *Norman Baker Esq.*

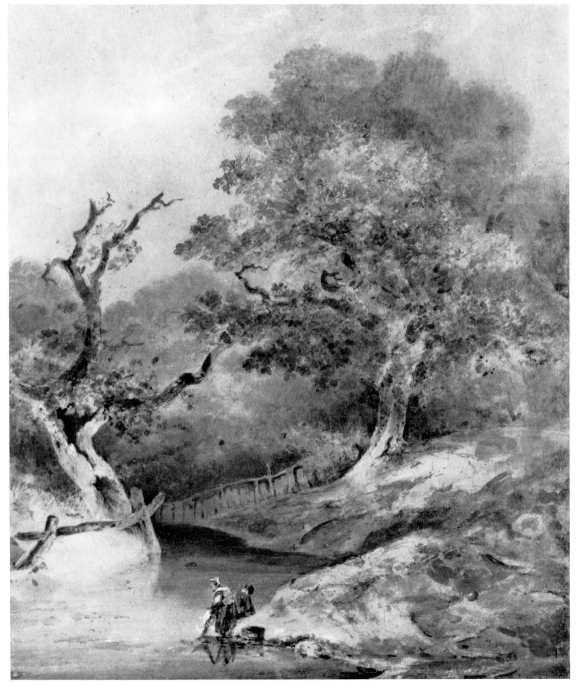

13. Glade Scene

1803-4 (D 14) $20\frac{7}{8} \times 17\frac{7}{8}$ *E. P. Hansell Esq.*

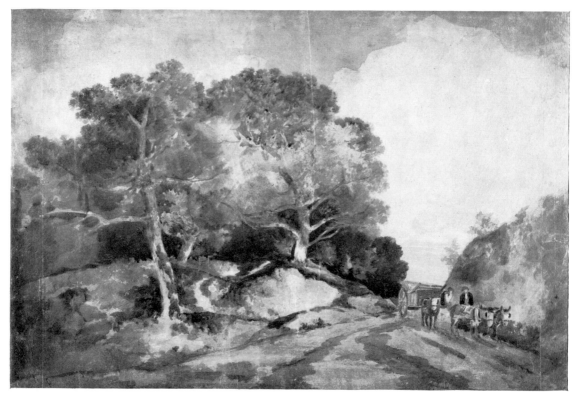

14. The Hollow Road

c. 1804–5 (D 15) 16¼ × 24¼ *British Museum*

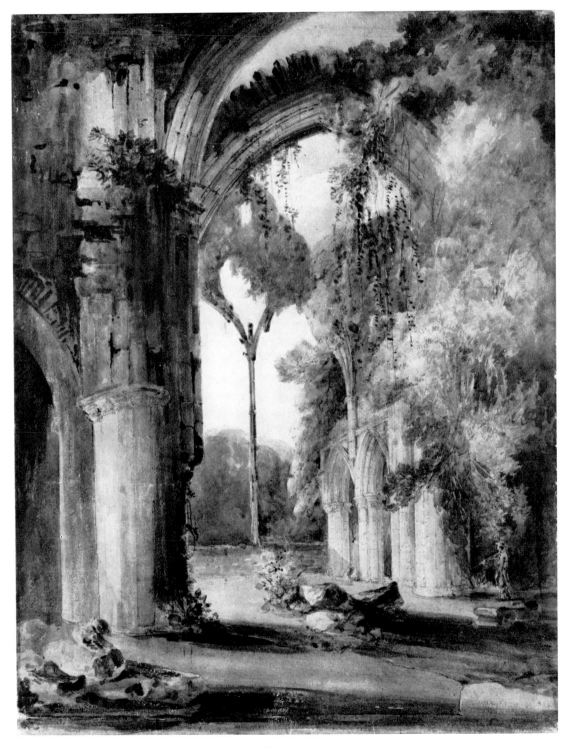

15. Tintern Abbey

1804–5 (D 12) 21⅛ × 16⅜ *Norwich Castle Museum*

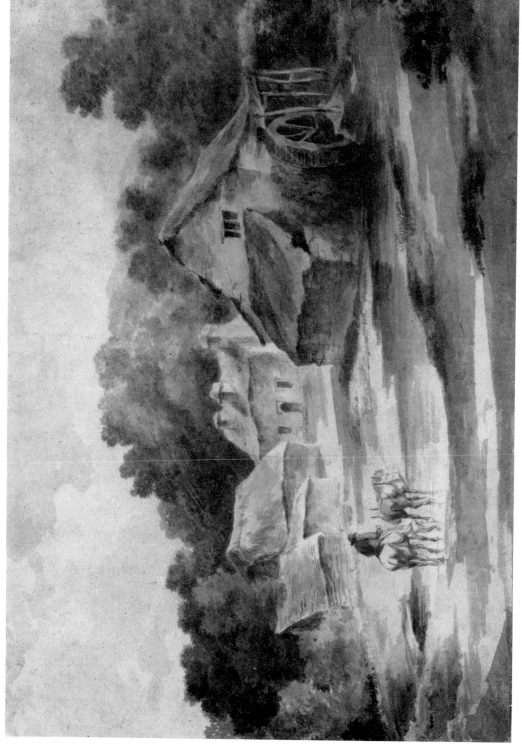

16. The Mill Wheel

(D 16) $11\frac{1}{2} \times 16\frac{1}{4}$

Mr and Mrs Derek Clifford

1805–6

17. Trees on a Bank

(D 19) $11\frac{1}{5} \times 16\frac{3}{5}$

c. 1806

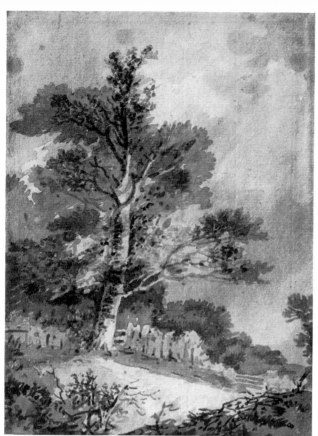

18a. Trees and Palings

c. 1805–6 (D 21) 9 × 6½ *British Museum*

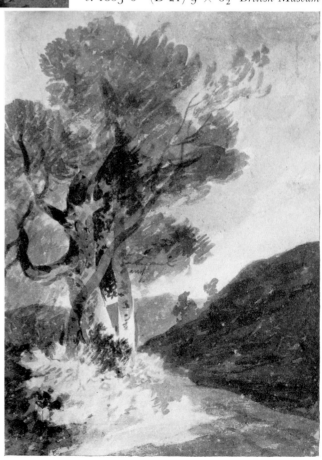

18b. The Glade

c. 1805–6 (D 20) 12⅛ × 8 9/16
Norwich Castle Museum

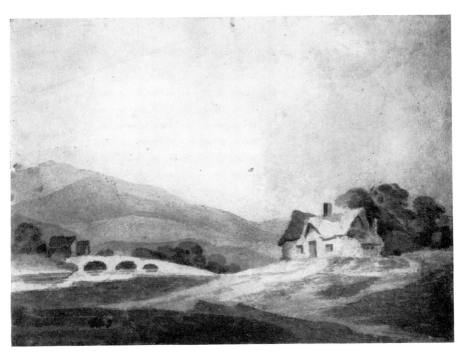

19a. Mountain Scene

c. 1804–6 (D 22) $5\frac{3}{4} \times 8\frac{1}{2}$ *British Museum*

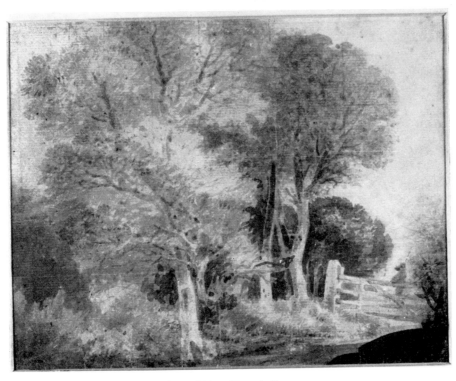

19b. Woodland Scene

c. 1804–6 (D 24) $6\frac{1}{2} \times 8\frac{3}{4}$ *Sir Edmund Bacon Bart*

20. Barn and Cart

(D 23) 7 × 8⅘

c. 1805–6

21b. Entrance to a Castle

(D 18) $11\frac{1}{8} \times 9\frac{5}{6}$ *Untraced*

c. 1804

21a. Trees in a Rocky Landscape

(D 17) $9\frac{1}{5} \times 7$ *Mr and Mrs Derek Clifford*

? *c.* 1805–6

22. Old House beside a River with Overshot Mill

(D 26) $11\frac{1}{2} \times 18$

Norwich Castle Museum

1806

23. Old Building at Ambleside

(D 27) 12 × $17\frac{1}{2}$

Mr and Mrs Derek Clifford

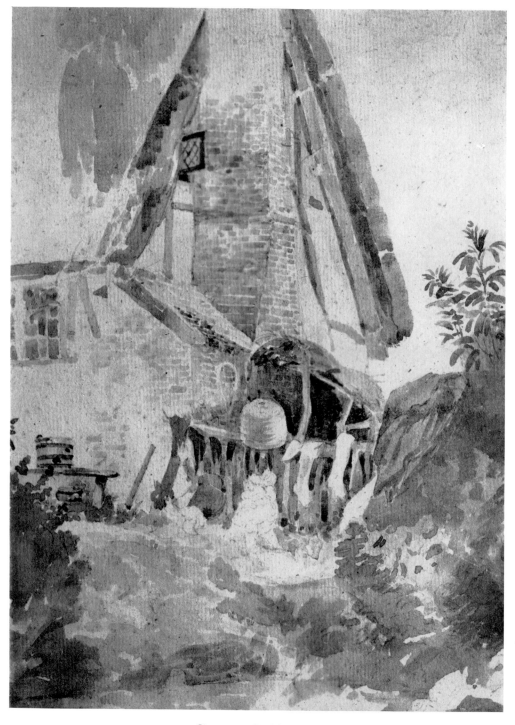

24. Cottage Gable in Ruins

c. 1805–6 (D 39) $9\frac{9}{10} \times 8\frac{1}{4}$ *Norwich Castle Museum*

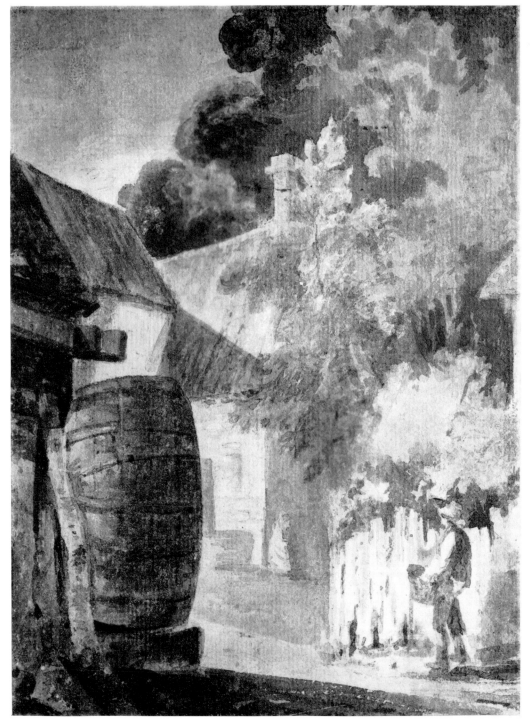

25. Farm Buildings

1804–6 (D 25) $7\frac{3}{4} \times 6$ *Norwich Castle Museum*

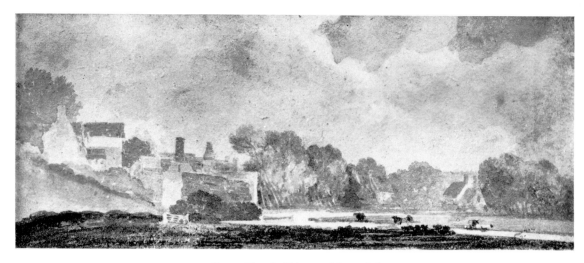

26a. Back River, Norwich

1807–8 (D 48) $4\frac{5}{8} \times 10\frac{5}{8}$ *Norwich Castle Museum*

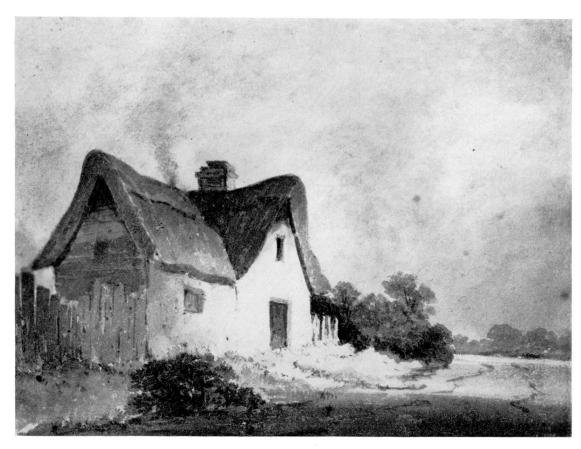

26b. Thatched Cottage

c. 1806–8 (D 49) $6\frac{1}{2} \times 8\frac{1}{4}$ *Norwich Castle Museum*

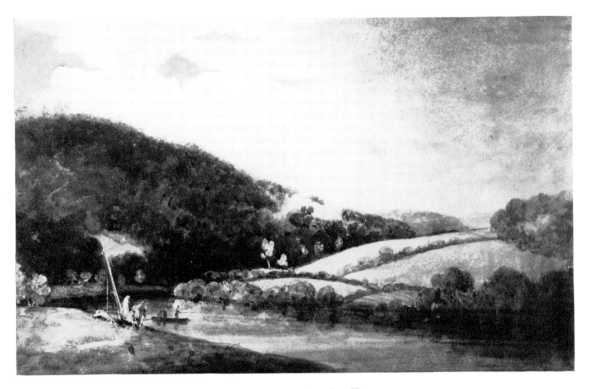

27. Waiting for the Ferry

? *c.* 1806–7 (D 30) $7\frac{3}{4} \times 12\frac{3}{4}$ *British Museum*

28. Maltings on the Wensum

(D 28) $10\frac{3}{5} \times 17\frac{3}{5}$

c. 1805–6

Norwich Castle Museum

29. Whitlingham

(D 29) $10\frac{7}{8} \times 17\frac{1}{2}$

c. 1805–6

Norwich Castle Museum

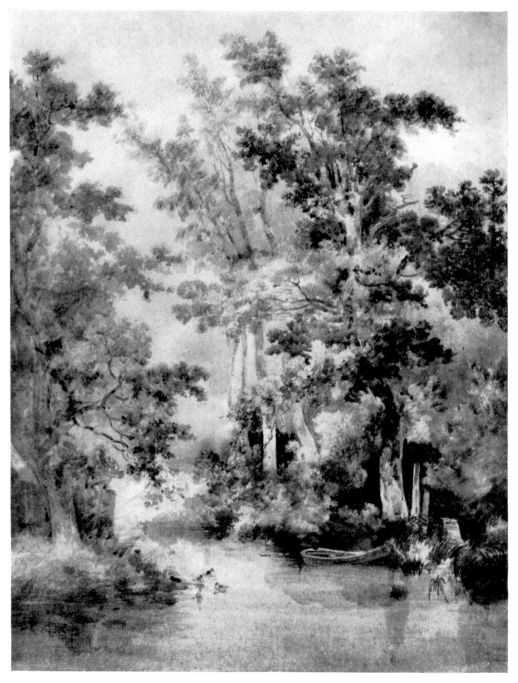

30. River Scene

c. 1806–13 (D 35) 20 × 15½ *The late Sir Stephen Courtould*

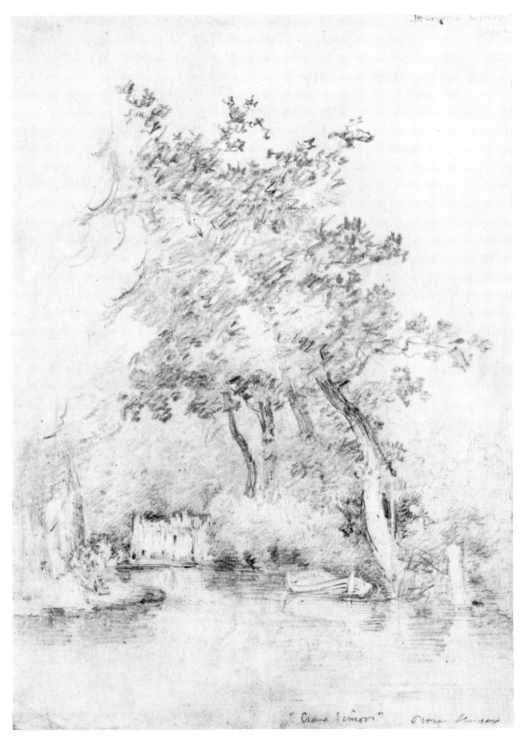

31. Trees over a Stream

1806 (D 34) $10\frac{3}{4} \times 8$ *Norwich Castle Museum*

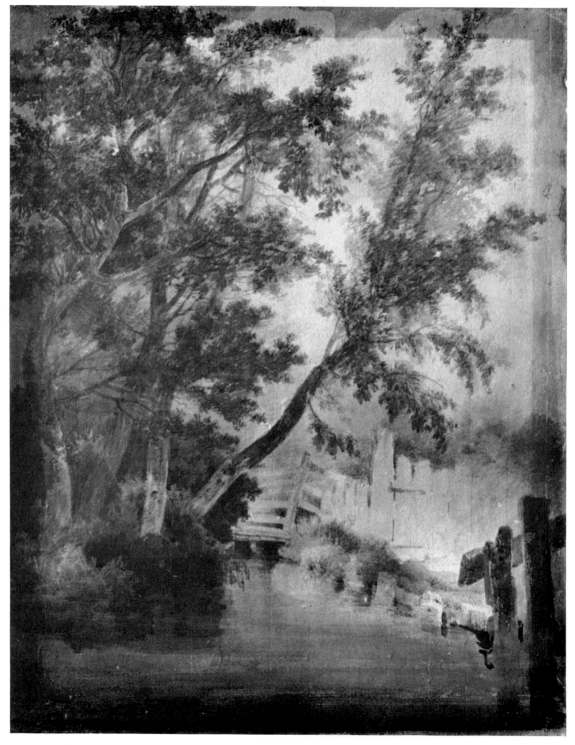

32. Near Caister

c. 1806–7 (D 43) 20½ × 16½ *British Museum*

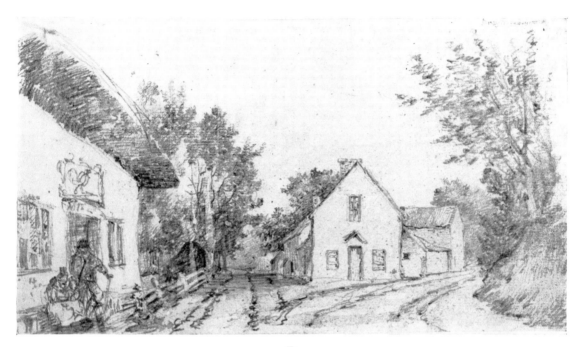

33a. Drayton

1806 (D 32) $6\frac{7}{10} \times 12\frac{1}{2}$ *L. G. Duke Esq.*

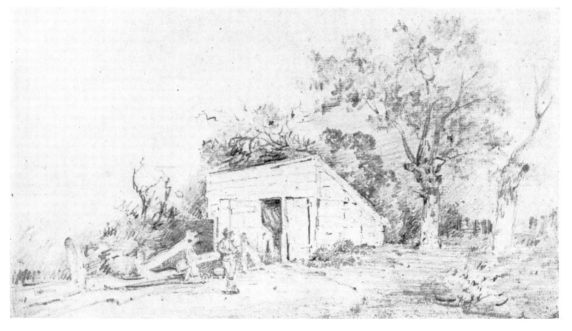

33b. Landscape with Shed

1806 (D 33) $6\frac{7}{10} \times 12\frac{1}{2}$ *L. G. Duke Esq.*

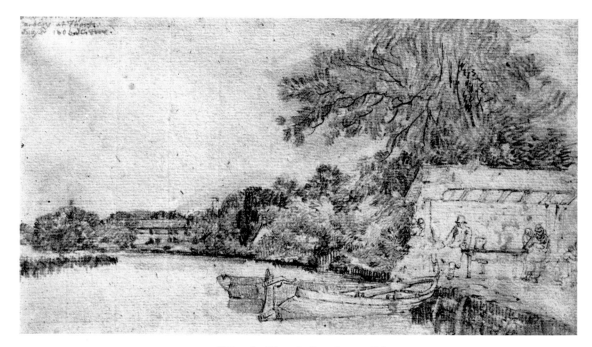

34a. King's Head Gardens, Thorpe

1806 (D 31) $6\frac{5}{8} \times 12$ *British Museum*

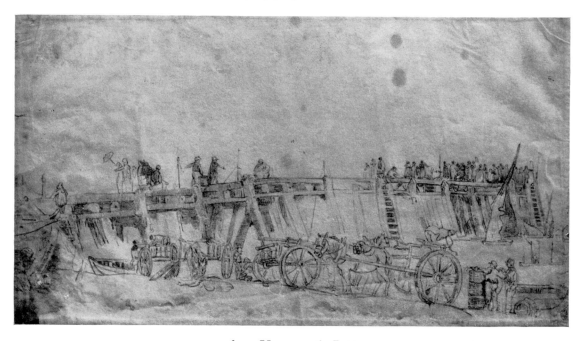

34b. Yarmouth Jetty

c. 1806–7 (D 37) $9 \times 16\frac{7}{10}$ *British Museum*

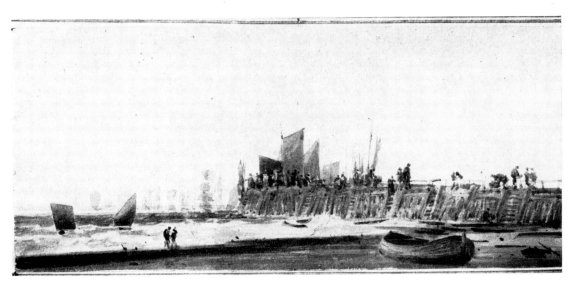

35a. Yarmouth Jetty

c. 1808–9 (D 50) $3\frac{1}{2} \times 8\frac{1}{4}$

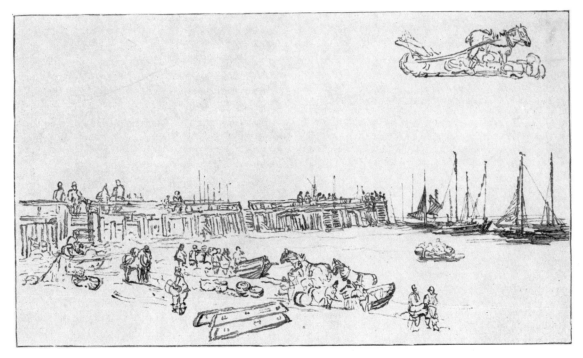

35b. Old Jetty, Norfolk

c. 1806–8 (D 38) $9\frac{1}{2} \times 15$

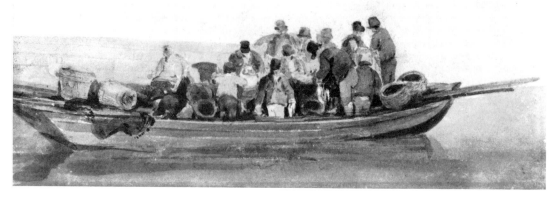

36a. A Boatload

c. 1808
(D 46) $4\frac{7}{8} \times 9\frac{1}{8}$
Mr and Mrs Paul Mellow

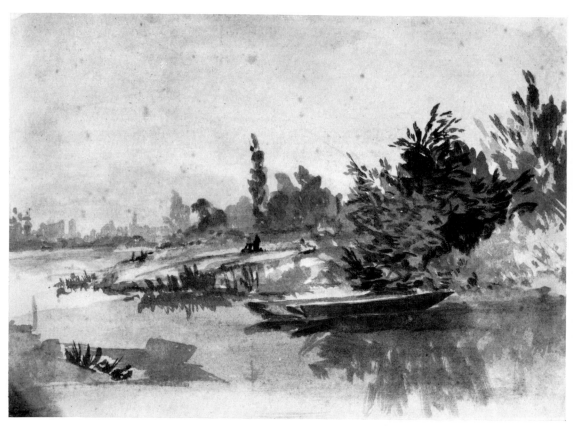

36b. Boat by River Bank, Evening

c. 1805–10
(D 40) $8\frac{3}{5} \times 12\frac{1}{2}$
Mr and Mrs Derek Clifford

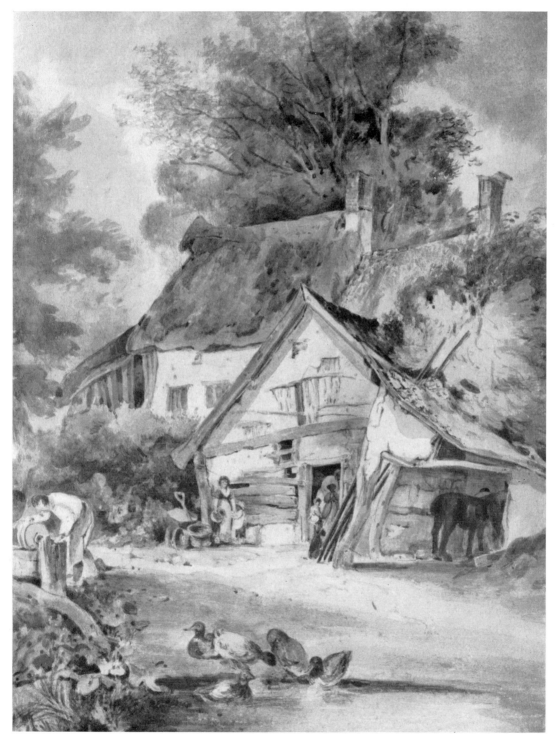

37. Hingham, Blacksmith's Shop

c. 1806–7 (D 36) 16 × 12 *Doncaster Museum and Art Gallery*

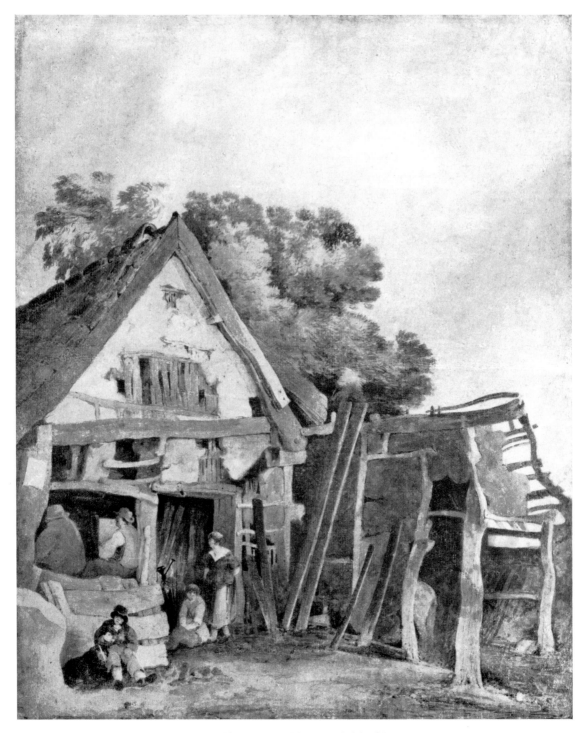

38. Hingham, Blacksmith's Shop

(D 44) 21¼ × 17¼

Norwich Castle Museum

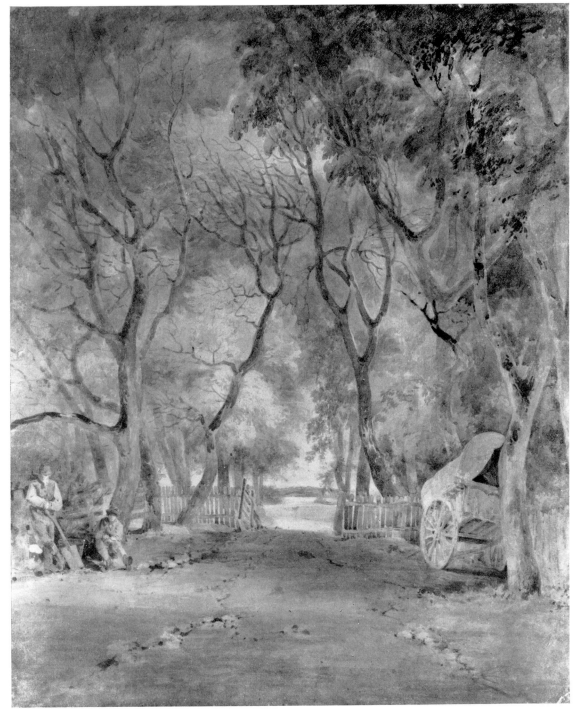

39. An Entrance to Earlham Park

c. 1807–8 (D 45) $22\frac{1}{4} \times 18\frac{1}{8}$ *Mr and Mrs Paul Mellow*

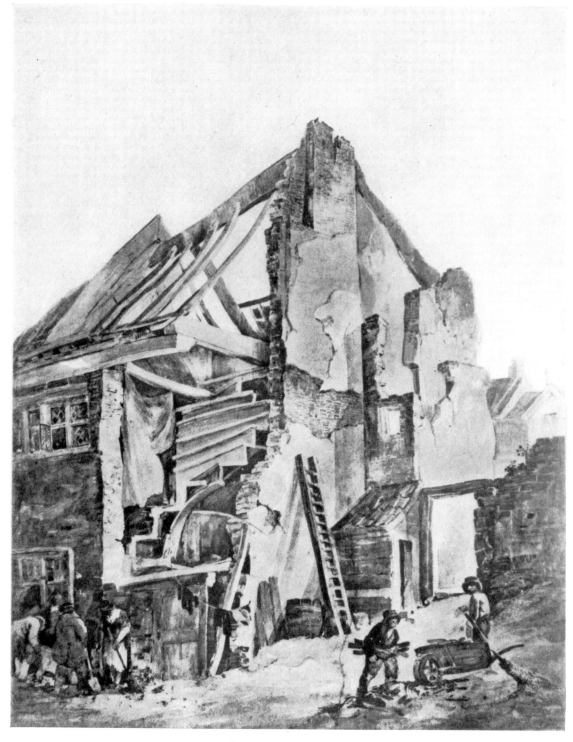

40. Old Houses at Norwich

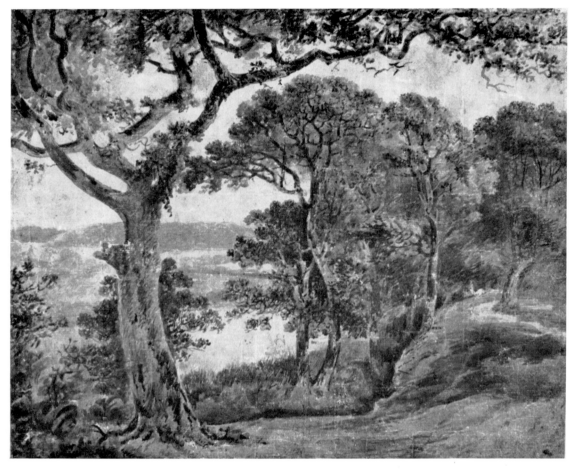

41. River through Trees

1807–8 (D 54) $13\frac{7}{8} \times 18$ *Sir Edmund Bacon Bart*

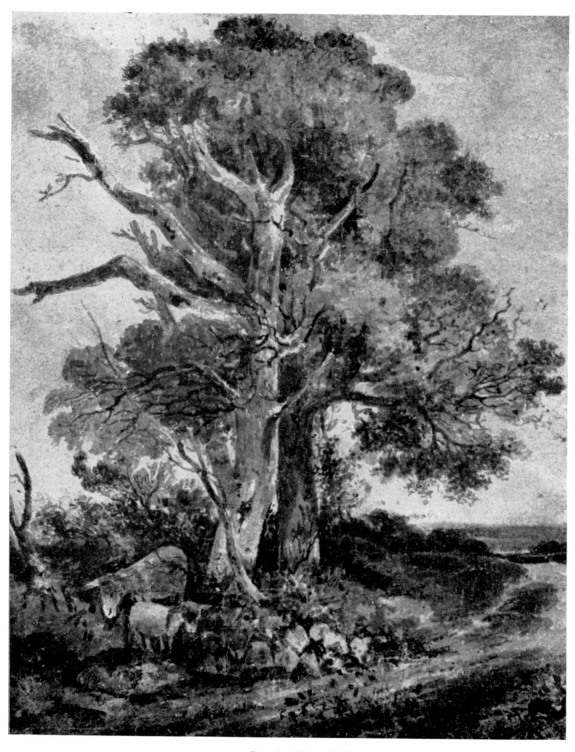

42. By the Roadside

c. 1808–10 (D 53) $10\frac{1}{4} \times 8\frac{1}{4}$ *Whitworth Art Gallery, University of Manchester*

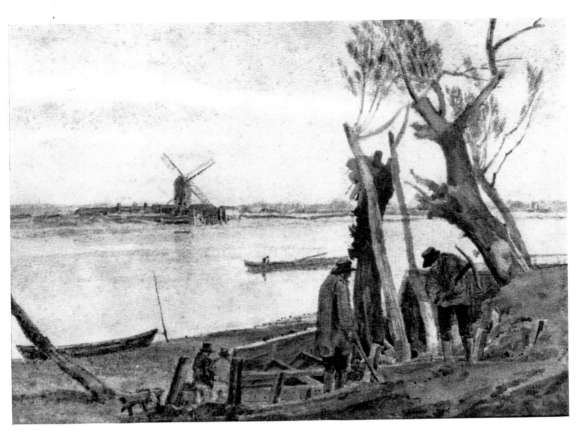

43.　View of Thames at Battersea

c. 1807–10　　　　　(D 56) $8\frac{1}{8} \times 11\frac{3}{8}$　　　*Whitworth Art Gallery, University of Manchester*

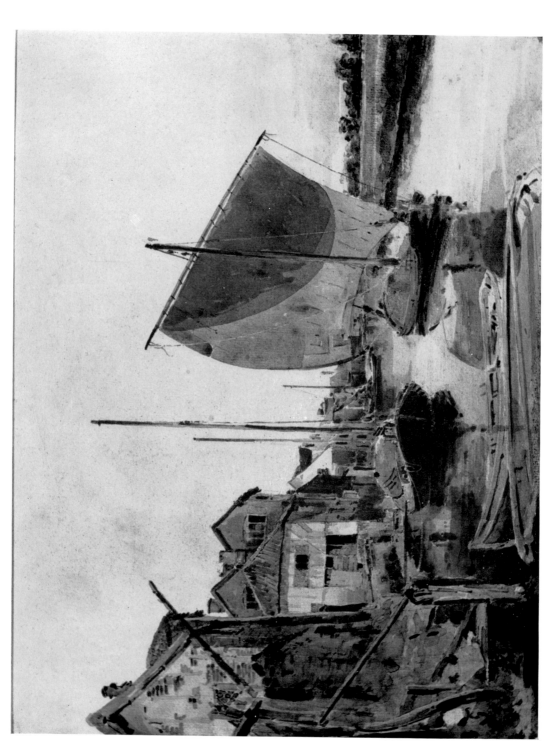

44. Houses and Wherries on the Wensum

(D 51) $11\frac{3}{4} \times 15\frac{5}{8}$ *Whitworth Art Gallery, University of Manchester*

c. 1808–9

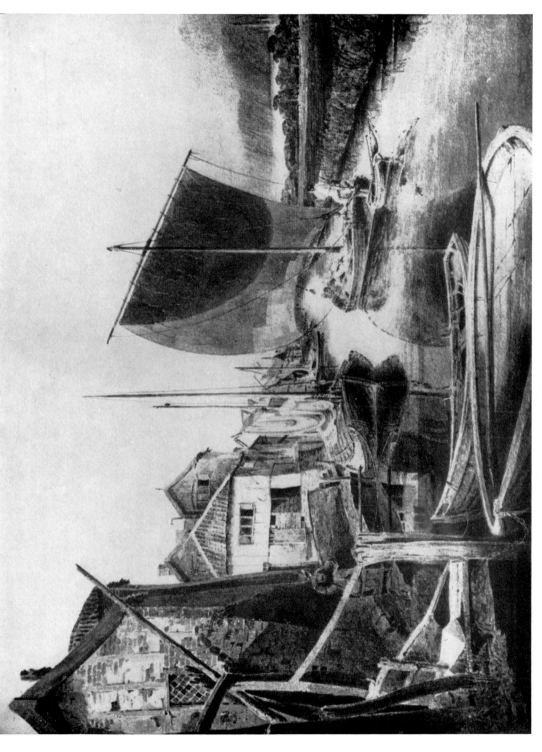

45. Houses and Wherries on the Wensum

(D 52) $16\frac{1}{2} \times 22$

c. 1808–9

City Art Gallery, Manchester

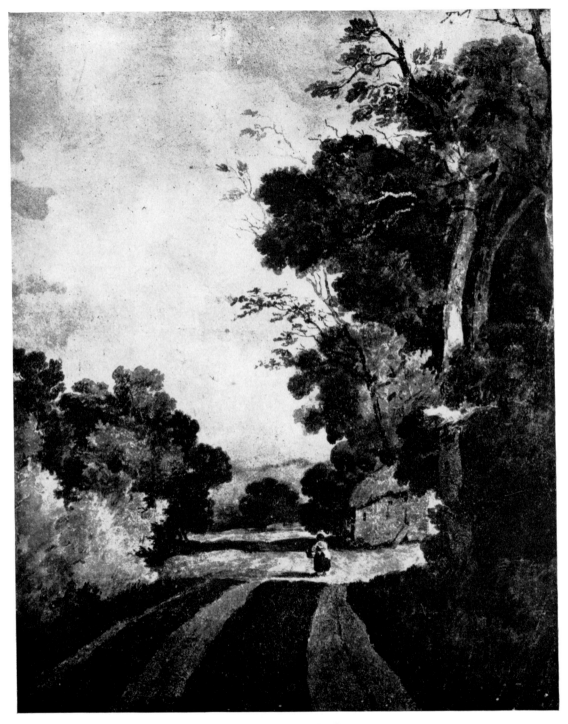

46. Landscape with Cottages

c. 1808–10 (D 55) 20½ × 16¾ *Victoria and Albert Museum*

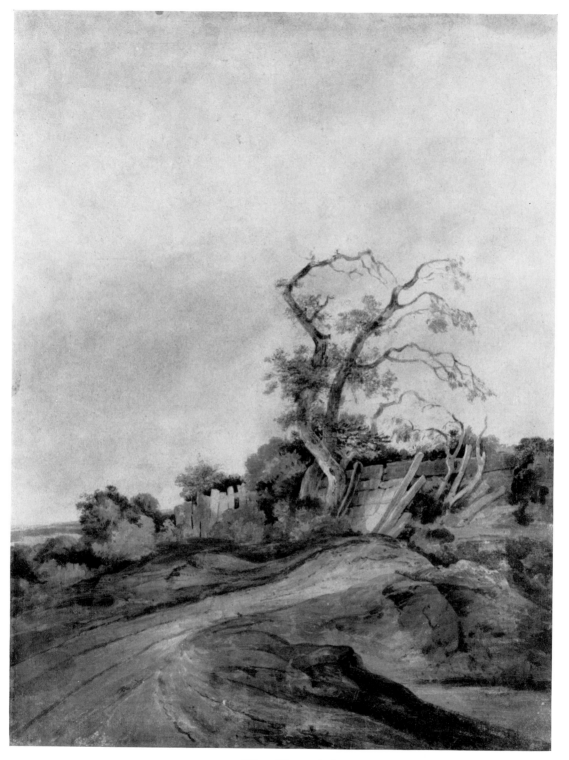

47. The Blasted Oak

c. 1808–9 (D 57) 23 × 17¼ *Sir Edmund Bacon Bart*

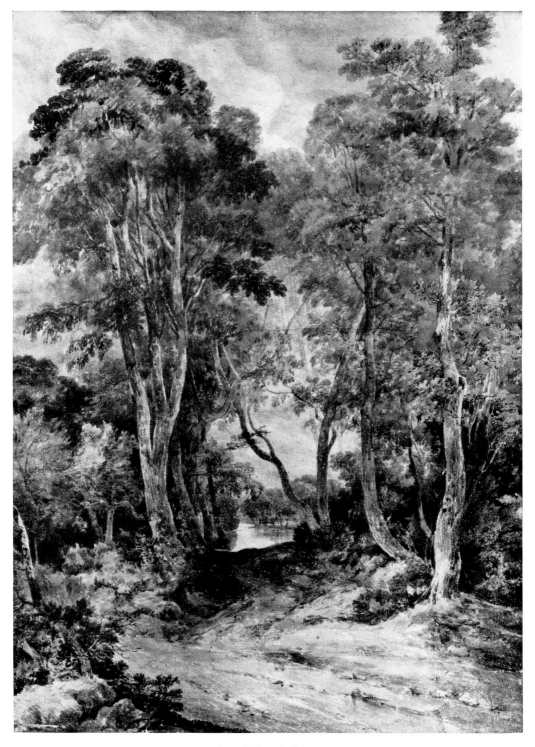

48. Wood Scene

c. 1809–10 (D 58) 22¼ × 16¼ *Victoria and Albert Museum*

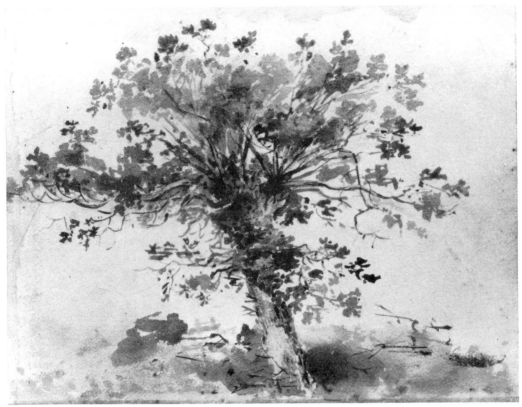

49a. Pollard—Tree Study

post 1810 (D 68) $9\frac{1}{5} \times 12\frac{1}{10}$ *The Ipswich Museums*

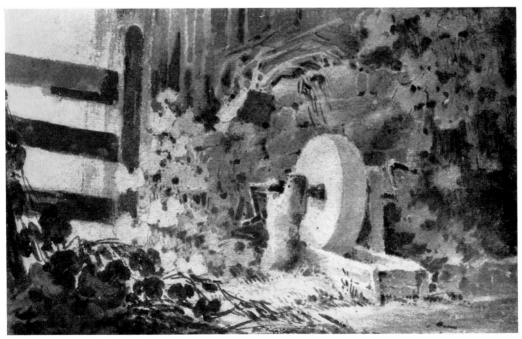

49b. Hedgerow with Grindstone and Stile

c. 1809–10 (D 67) $8\frac{2}{5} \times 13$ *The Ipswich Museums*

50. Bixley—Trees on a Stream

(D 65) $6\frac{1}{8} \times 8\frac{7}{8}$

c. 1809

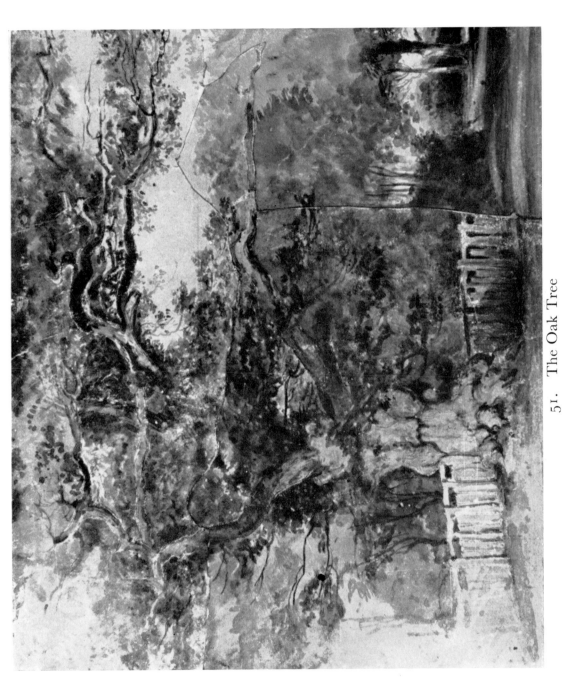

51. The Oak Tree

(D 69) $11\frac{7}{8} \times 14$

c. 1809–13

Sir Edmund Bacon, Bart

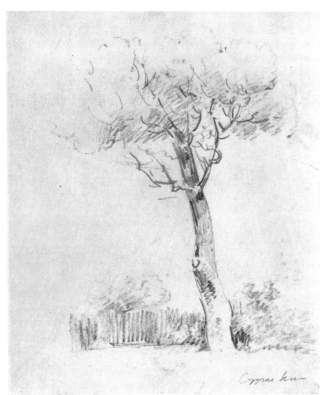

Cromer Kin.

52a. Trees and Bushes

?1810–17 (D 72) $7\frac{1}{5} \times 6\frac{2}{5}$

Norwich Castle Museum

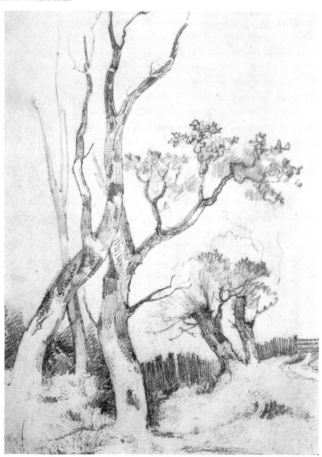

52b. Pollards and Oaks

c. 1809–10 (D 66) $6\frac{3}{4} \times 5\frac{3}{8}$

Norwich Castle Museum

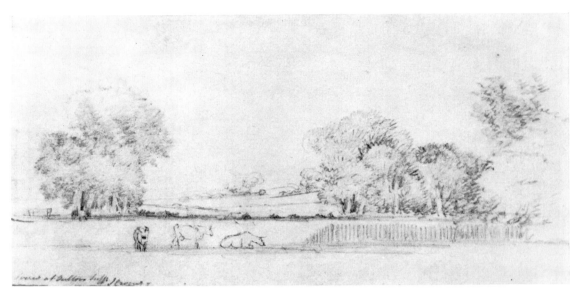

53a. A View at Oulton, Suffolk

post 1810 (D 70) $5\frac{1}{2} \times 11\frac{1}{4}$ *The Ipswich Museums*

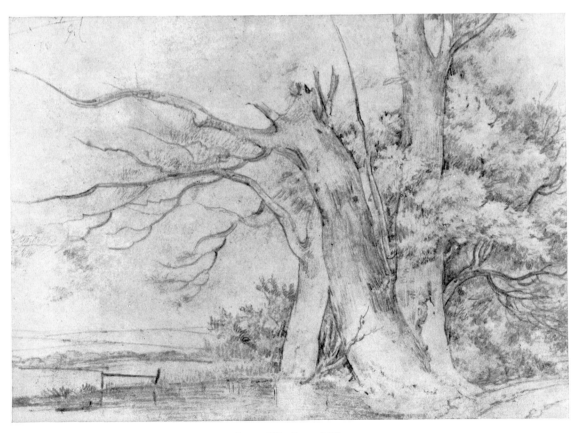

53b. Glade of Trees

c. 1810–21 (D 71) $8\frac{1}{2} \times 12\frac{2}{5}$ *Norwich Castle Museum*

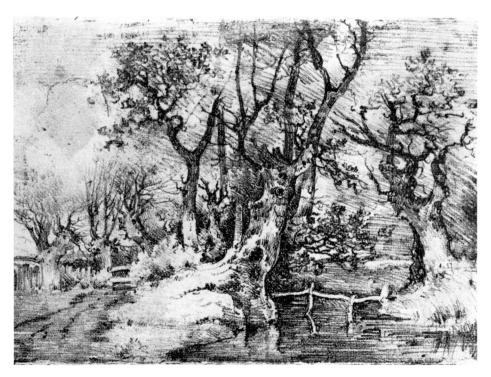

54a. Bixley

(E 32) $6\frac{1}{2} \times 9$

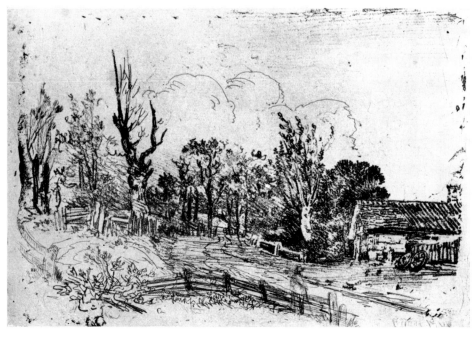

54b. Colney

(E 31) $6\frac{5}{8} \times 8\frac{1}{4}$

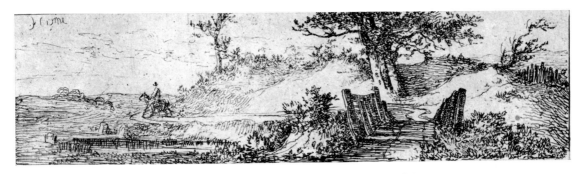

55a. Landscape with a Wooden Bridge

1809–13 (E 24) $1\frac{3}{4} \times 6\frac{3}{4}$

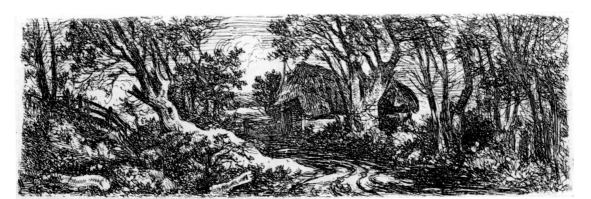

55b. Rustic Road with Thatched Barn

1809–13 2nd state (E 10) $2\frac{1}{4} \times 7\frac{1}{2}$

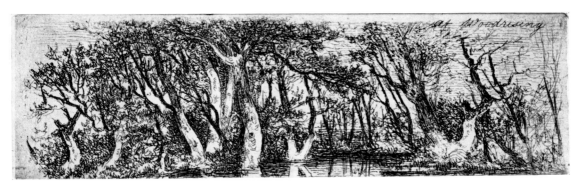

55c. At Woodrising

1809–13 4th state (E 9) $2\frac{1}{4} \times 7\frac{1}{2}$

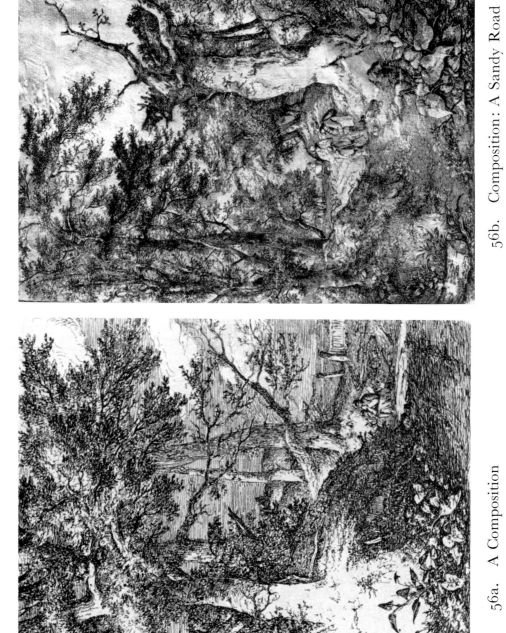

56b. Composition: A Sandy Road

(E 21) $14\frac{3}{5} \times 10\frac{1}{2}$

1809–13

56a. A Composition

(E 17) $6\frac{1}{2} \times 6\frac{1}{10}$

1809–13 2nd state

Norwich Castle Museum

57. The Cow Tower, Norwich

(P 1) 18 × 24

? 1790–1800

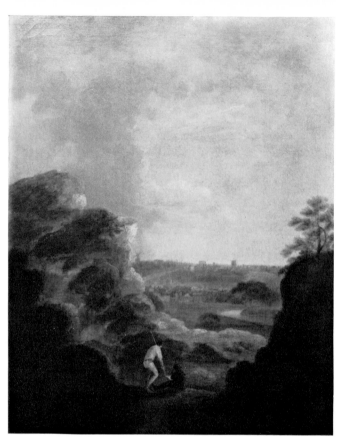

58a. Norwich from Mousehold
 Gravel Pits

? 1798–1800 (P 2) 23 × 17½ *T. Colman Esq.*

58b. A View on the Wensum

? before 1800 (P 3) 19½ × 16¼

Norwich Castle Museum

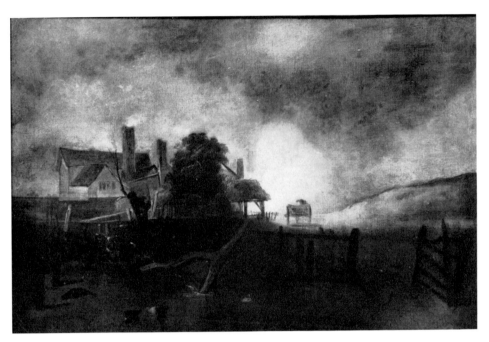

59a. The Limekiln

before 1806 (P 9) 20 × 29½ *The late Sir Stephen Courtould*

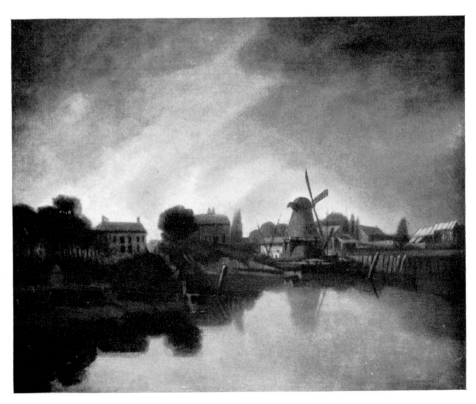

59b. Mill on the Yare

1804–6 (P 8) 25 × 29 *Philadelphia Museum of Art*

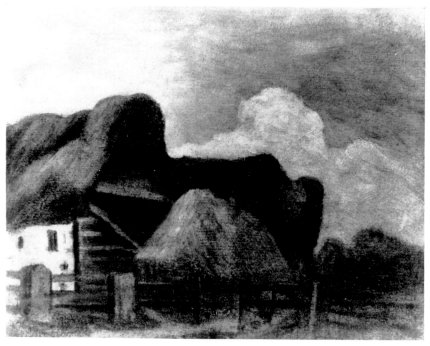

60a. Farmyard Scene

before 1805 (P 7) 16½ × 20¾ *Constance, Viscountess Mackintosh*

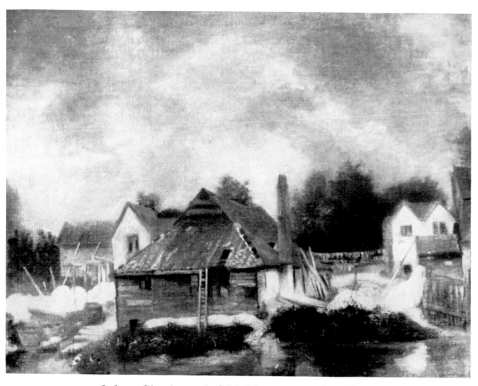

60b. Sheds and Old Houses on the Yare

? before 1800 (P 4) 19 × 24½ *Constance, Viscountess Mackintosh*

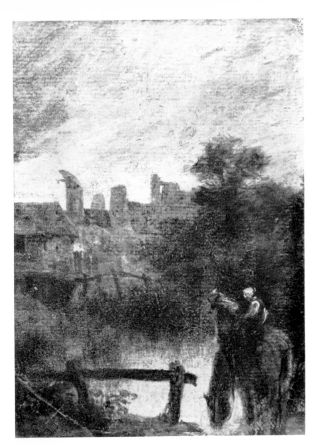

61a. Horses Watering

before 1805 (P 6) $13\frac{1}{2} \times 10$
Norwich Castle Museum

61b. The Bell Inn

c. 1805 (P 12) $30\frac{1}{2} \times 23$ *The late T. W. Bacon*

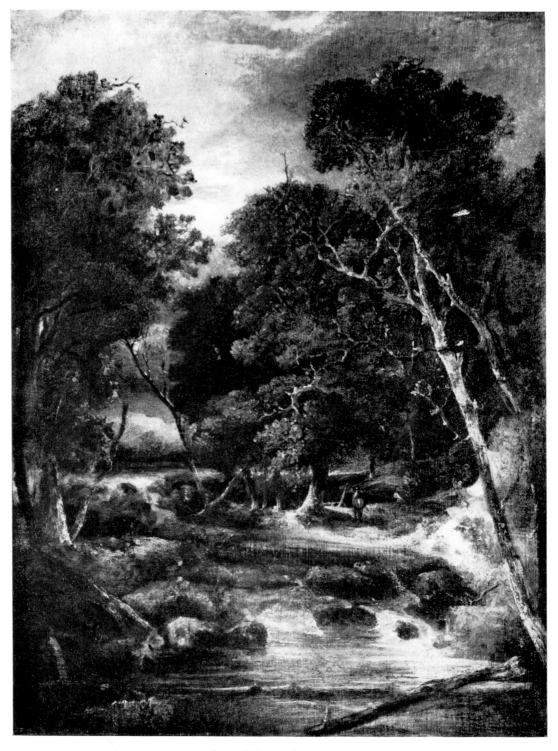

62. View of Thorpe

c. 1805–6 (P 21) 26 × 19¼ *Dr and Mrs Norman Goldberg*

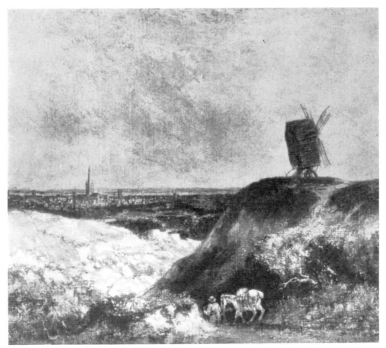

63a. Distant View of Norwich

c. 1804–5 (P 19) $25\frac{1}{4} \times 29\frac{1}{2}$ *Museum of Fine Arts, Boston*

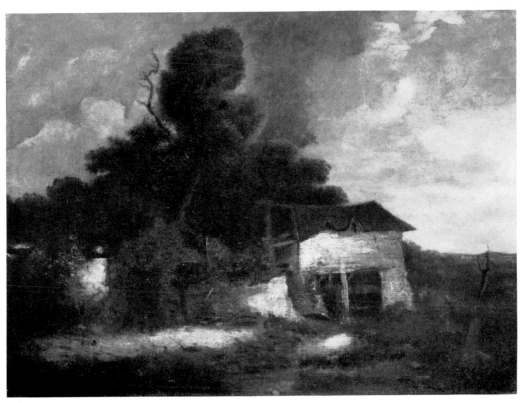

63b. A Shed at Melton, Norfolk

c. 1804 (P 16) 28×39 *Dr Arnold Renshaw*

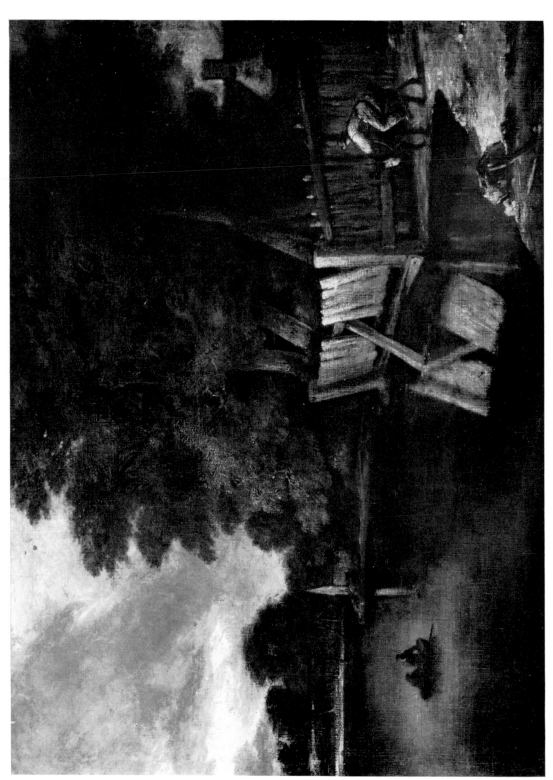

Homeless

64. Gibraltar Watering Place

(P 17) $38\frac{1}{2} \times 55$

c. 1804–5

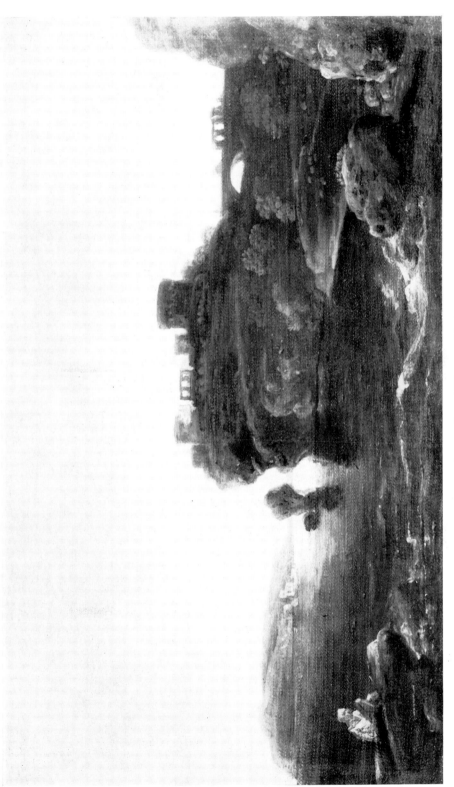

1804-5

65. Temple of Venus, Baiae

(P 20) 18 × 28½

Norwich Castle Museum

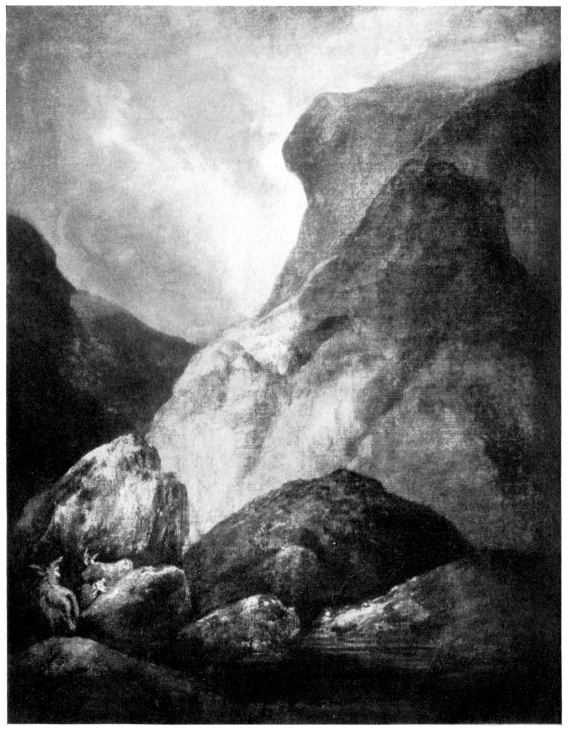

66. Scene in Cumberland

1803–6 (P 14) $29\frac{5}{8} \times 23\frac{1}{4}$ *National Gallery of Scotland*

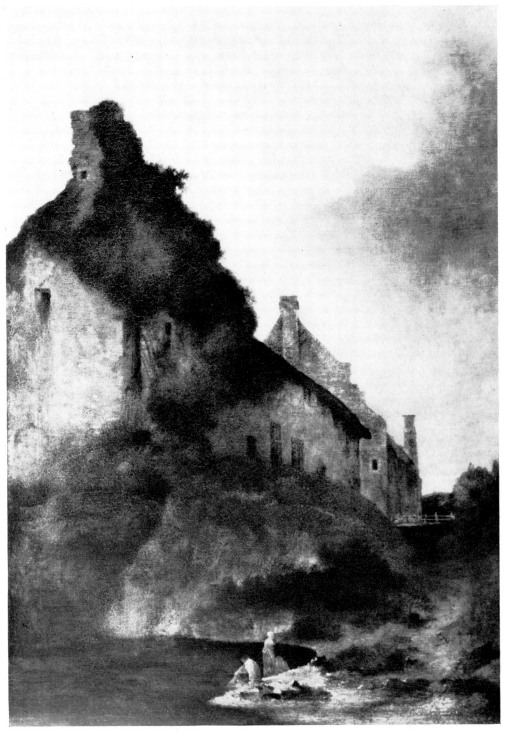

67. Carrow Abbey

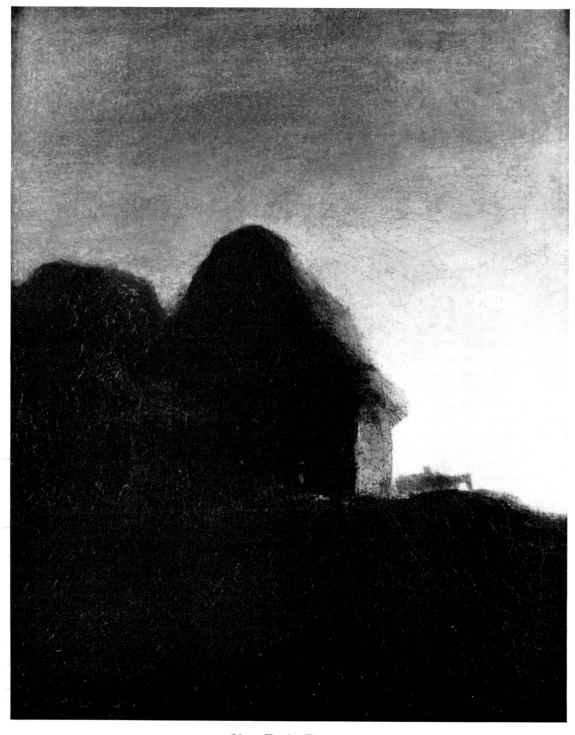

68. Early Dawn

c. 1804–6 (P 11) 13⅝ × 11¾ *Norwich Castle Museum*

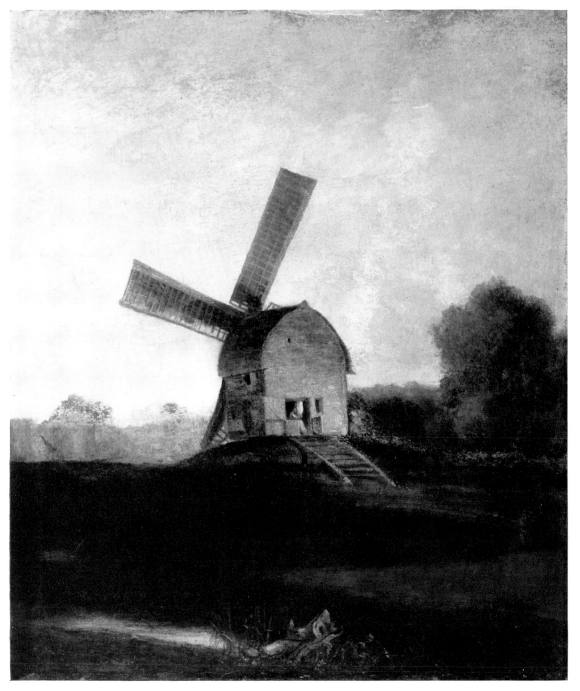

69. The Windmill: Evening

c. 1804-7 (P 13) $29\frac{3}{4} \times 24\frac{7}{10}$ *Mr and Mrs Derek Clifford*

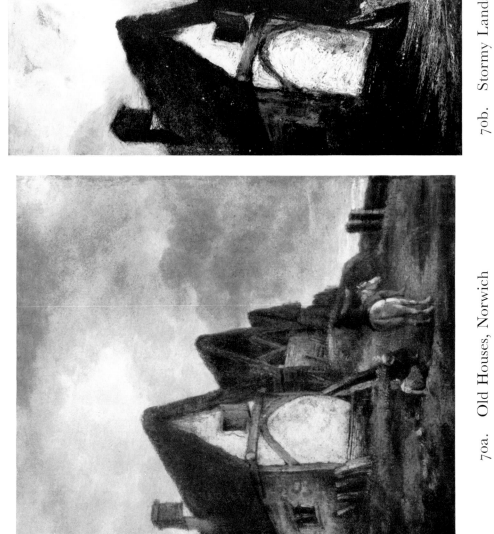

70a. Old Houses, Norwich

(P 26) ?

1806–8

70b. Stormy Landscape with Gabled Cottages *Professor J. Grahame Clark*

c. 1805–7 (P 25) 11 × 14½

Untraced

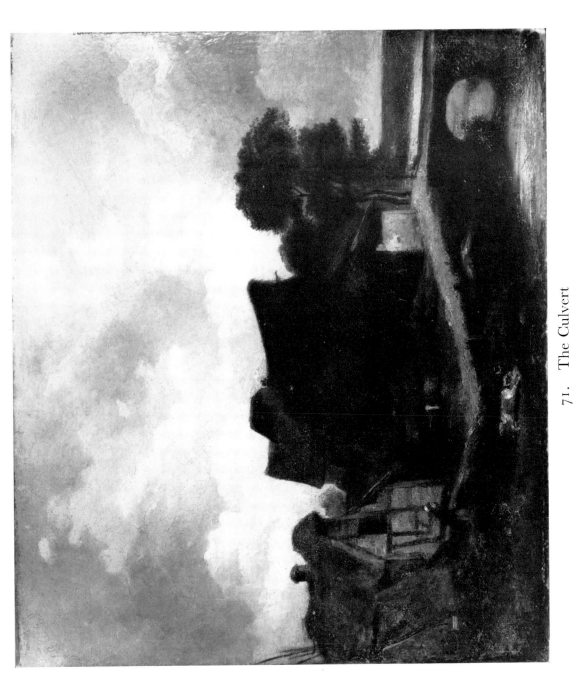

71. The Culvert

(P 24) $20\frac{1}{2} \times 25$

Mr and Mrs Derek Clifford

c. 1804–6

72. View near Weymouth

(P 27) 11 × 20¾

Institute of Art, Detroit

? 1805–6

c. 1806

73. The Yare at Thorpe

(P 28) 16 × 21½

Norwich Castle Museum

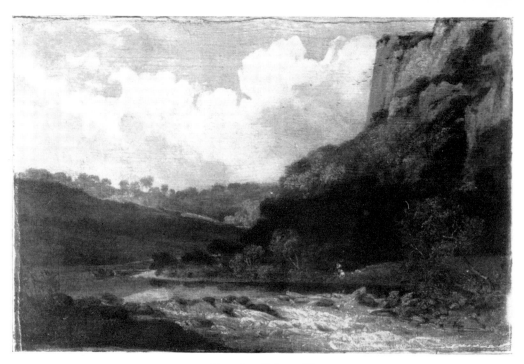

74a. On the River Derwent

1806–11 (P 31) 15 × 23½ *Fitzwilliam Museum, Cambridge*

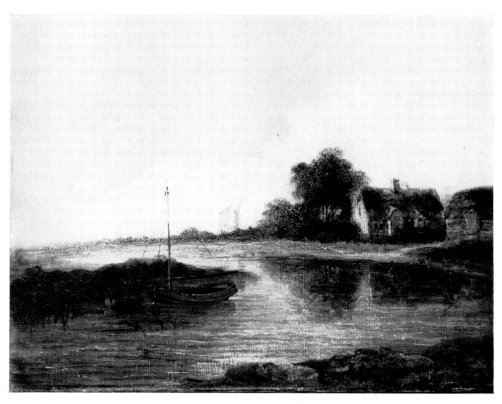

74b. The River Yare

? before 1808 (P 30) 9 × 12½ *Mrs W. Spooner*

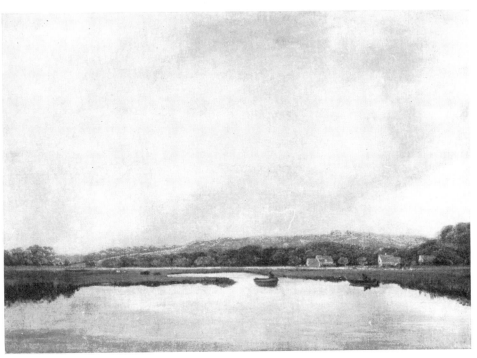

75a. River Landscape with Cottages

? 1806–7 (P 33) 21⅛ × 29¼ *H.R.H. The Duke of Kent*

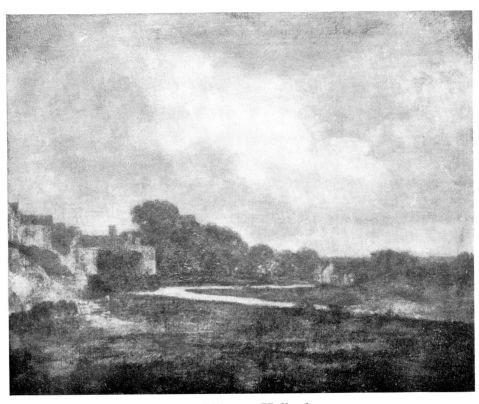

75b. View at Hellesdon

c. 1807 (P 34) 14 × 20 *The Hon. Doris Harbord*

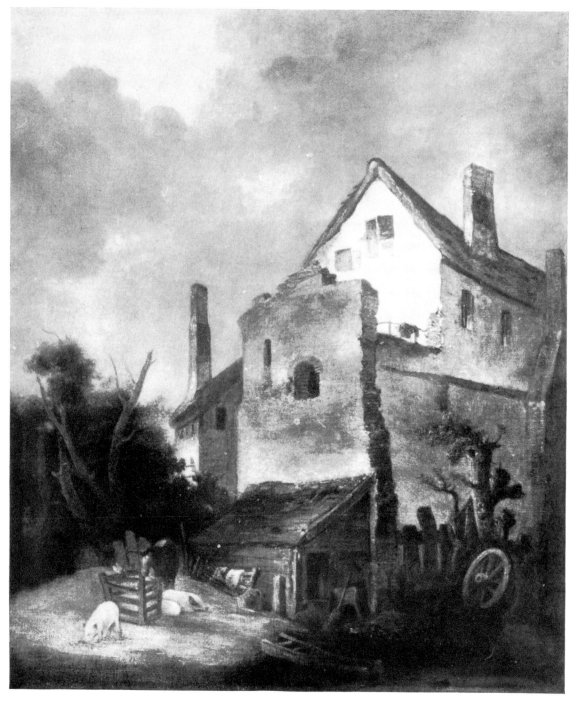

76. Ruins: Evening

c. 1806–7 (P 32) 30 × 25 *National Gallery of Canada*

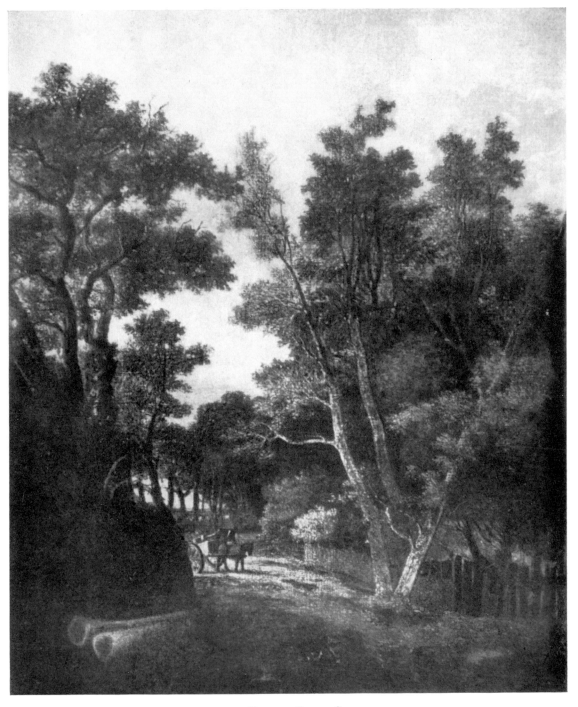

77. Catton Lane Scene

c. 1808–15 (P 36) 27¼ × 23 *Untraced*

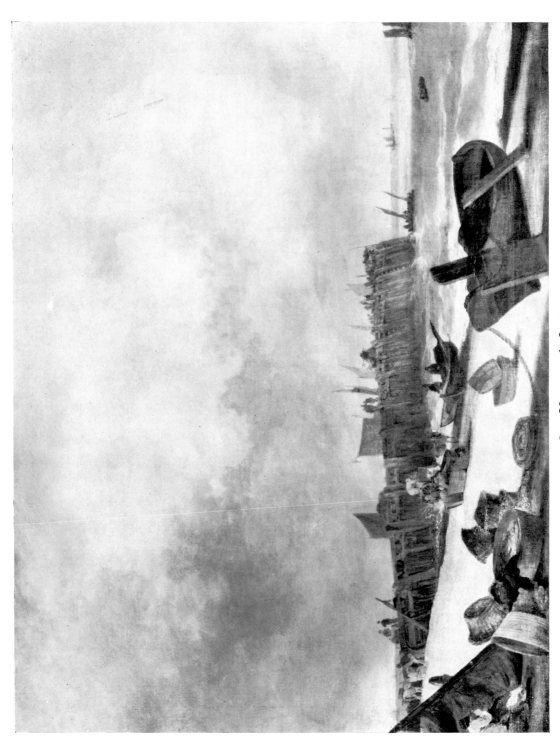

c. 1804–6

78. Yarmouth Jetty

(P 23) 39 × 49¾

Mr and Mrs Paul Mellon

79. Yarmouth Jetty

(P 23a) 29 × 34½

Williamson Art Gallery, Birkenhead

c. 1804–6

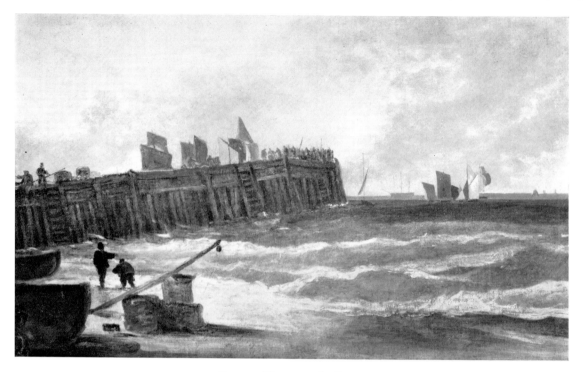

80a. Yarmouth Jetty

c. 1807 (P 41) $20\frac{1}{2} \times 33\frac{1}{4}$ *Mr and Mrs Paul Mellon*

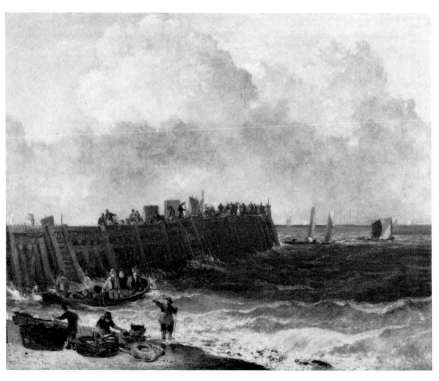

80b. Yarmouth Jetty

c. 1808–9 (P 42) $17\frac{5}{8} \times 23$ *Norwich Castle Museum*

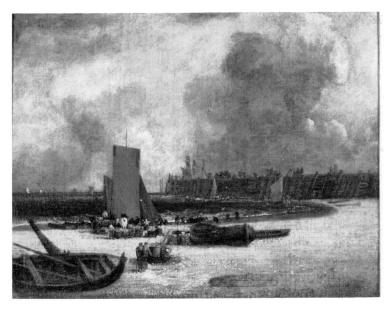

81a. Yarmouth Jetty

c. 1808–9 (P 45) $11\frac{3}{4} \times 15\frac{3}{4}$ *Sir Edmund Bacon, Bart*

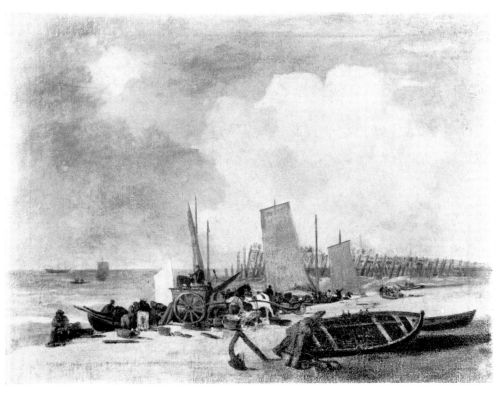

81b. Yarmouth Jetty

c. 1808–9 (P 46) $17\frac{1}{2} \times 22\frac{1}{4}$ *Norwich Castle Museum*

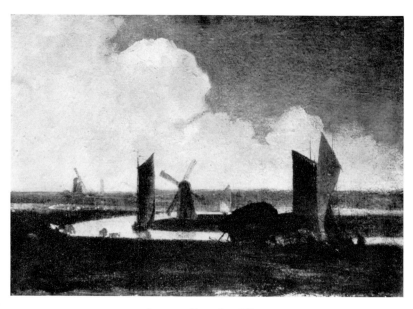

82a. On the Yare

c. 1806–8 (P 38) 9 × 13 *Untraced*

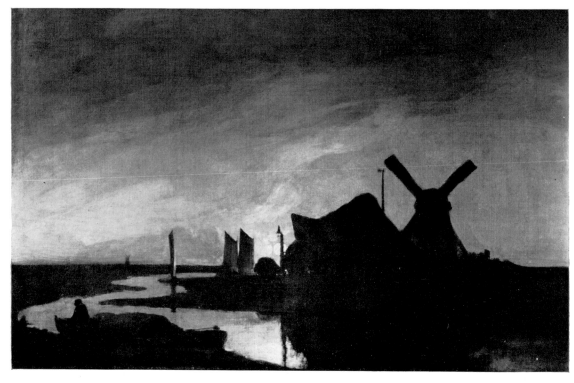

82b. Moonlight on the Yare

c. 1808 (P 39) 28 × 43¾ *Tate Gallery*

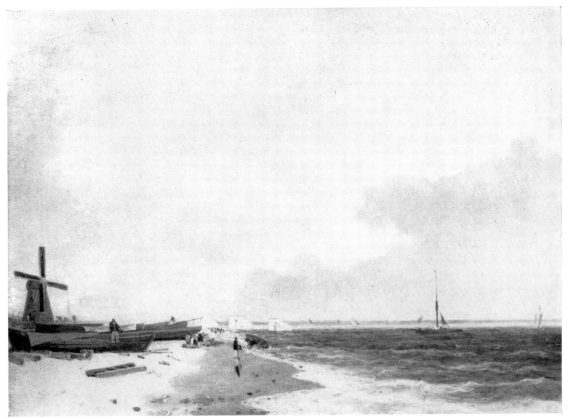

83a. Yarmouth Beach and Mill: looking North

c. 1808–9 (P 50) 15 × 20 *Lady Crathorne*

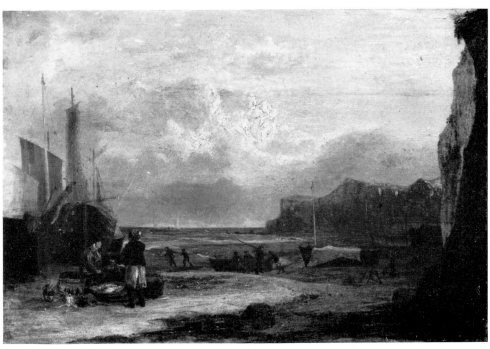

83b. Cromer Beach, below Cliff

c. 1808–9 (P 49) 15½ × 22 *Private collection*

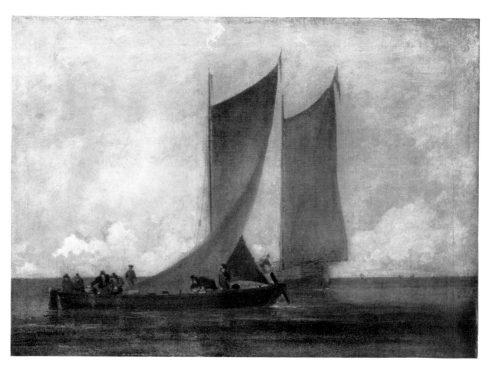

84a. Wherries on Breydon

c. 1808 (P 47) $21\frac{1}{3} \times 30\frac{1}{3}$ *Tate Gallery*

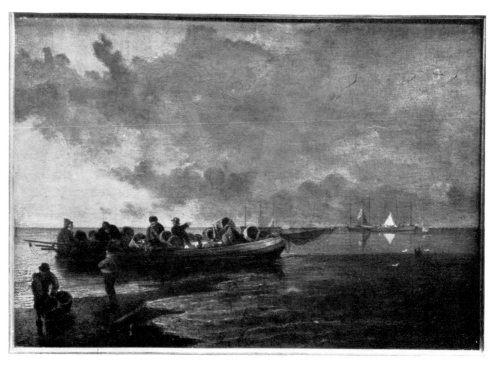

84b. Barge with a Wounded Soldier

c. 1808 (P 48) $13\frac{1}{2} \times 20\frac{1}{4}$ *Sir Martyn Beckett Bart*

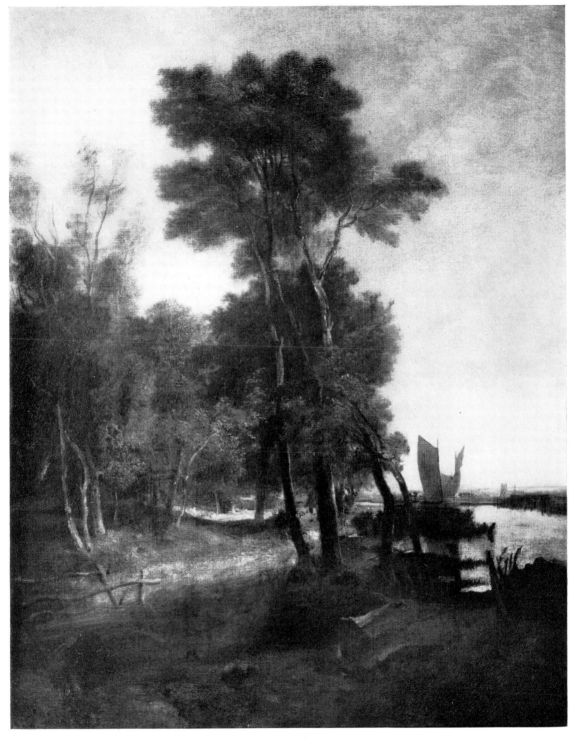

85. River Scene: Evening

c. 1808–15 (P 44) 29½ × 24½ *Royal Museum, Canterbury*

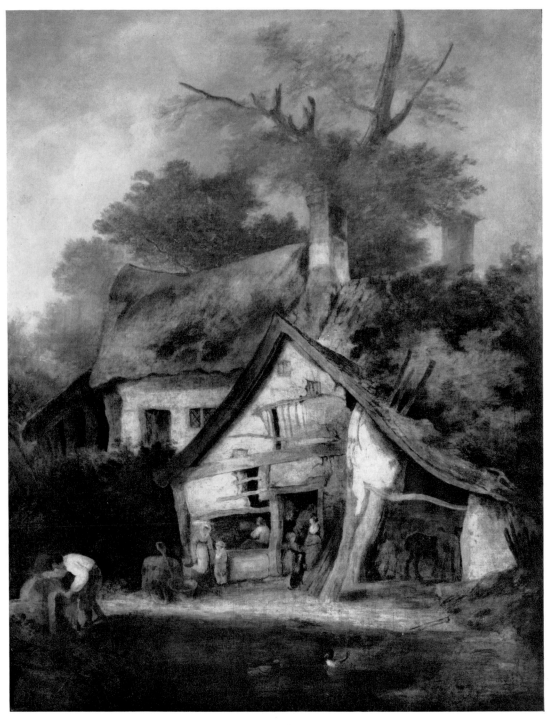

86. Blacksmith's Shop, Hingham

1807–8 (P 37) 58 × 45 *Philadelphia Museum of Art*

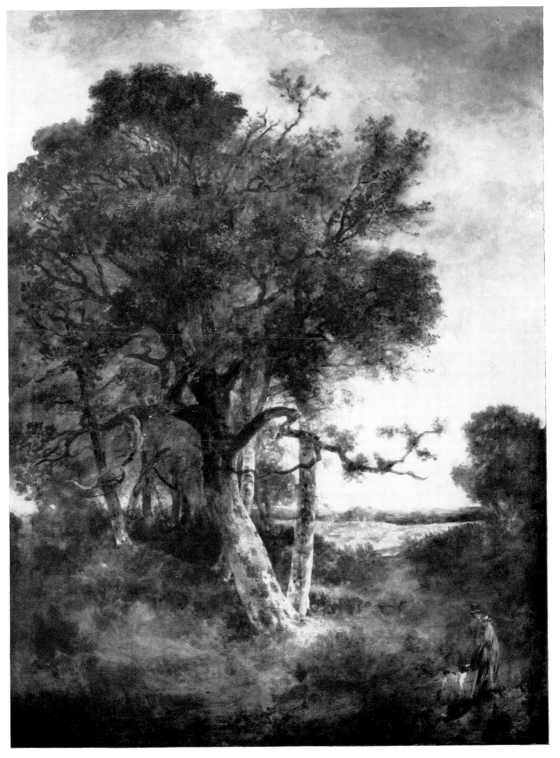

87. On the Skirts of the Forest

c. 1809–11 (P 53) 42 × 31 *Victoria & Albert Museum*

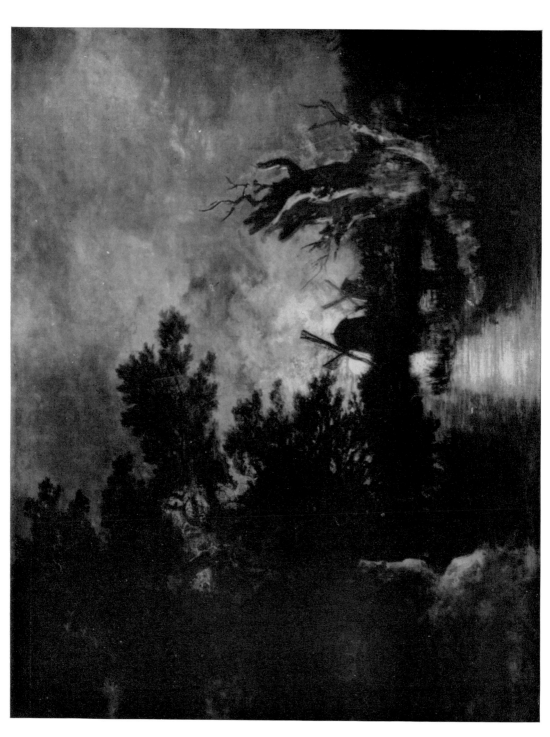

88. Moonlight on the Yare

(P 43) $39\frac{1}{2} \times 49\frac{1}{2}$

The Hon. Sir Arthur Howard

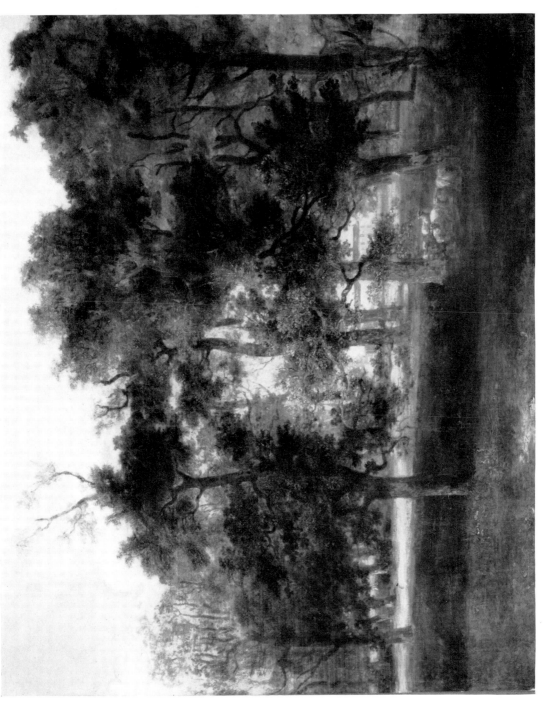

89. Woodland Scene with Sheep

(P 55) $24\frac{1}{2} \times 29$

c. 1809–11

Constance, Viscountess Mackintosh

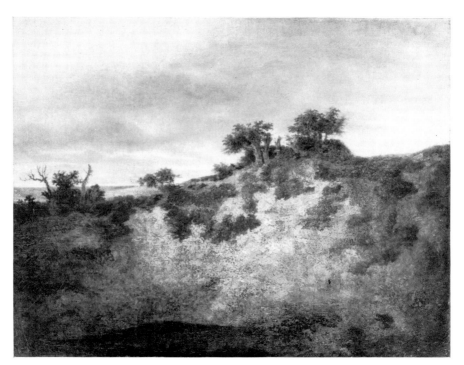

90a. A Sandy Bank

c. 1810 (P 57) $15\frac{1}{4} \times 20\frac{1}{4}$ *Fitzwilliam Museum, Cambridge*

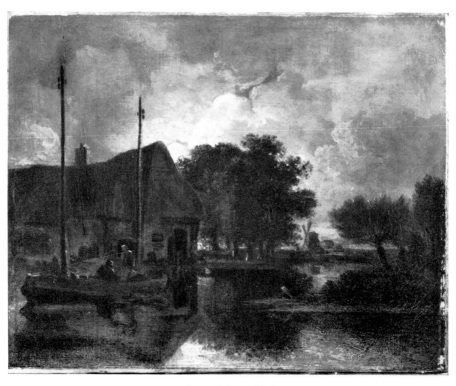

90b. Moonlight

c. 1809–11 (P 52) $10 \times 12\frac{1}{2}$ *Tate Gallery*

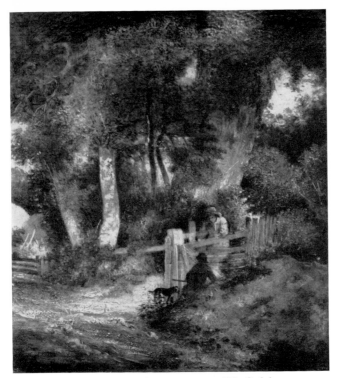

91a. Landscape near Blofield

c. 1810 (P 59) 9 × 8¾ *Constance, Viscountess Mackintosh*

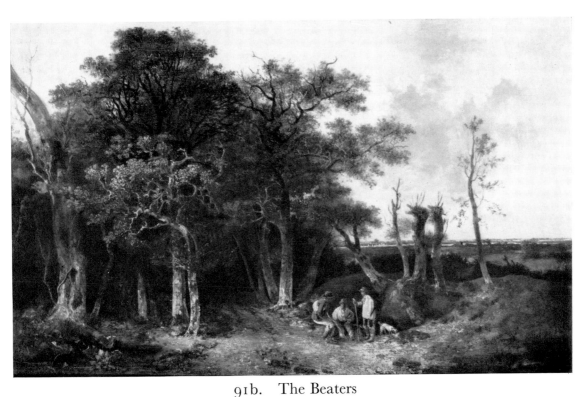

91b. The Beaters

(P 56) 21¼ × 33½

Constance, Viscountess Mackintosh

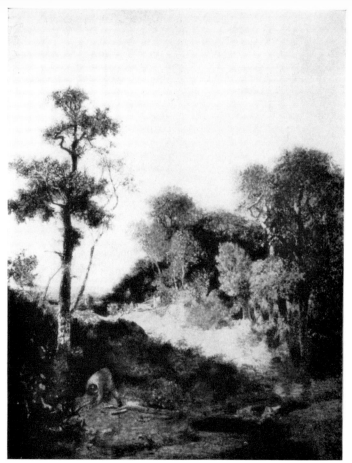

92a. Corner of the Wood

c. 1810 (P 60) 17½ × 13½ *Untraced*

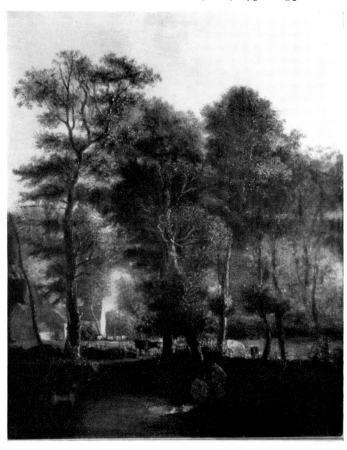

92b. Farm and Pond

c. 1811–14 (P 62) 14 × 11 *Untraced*

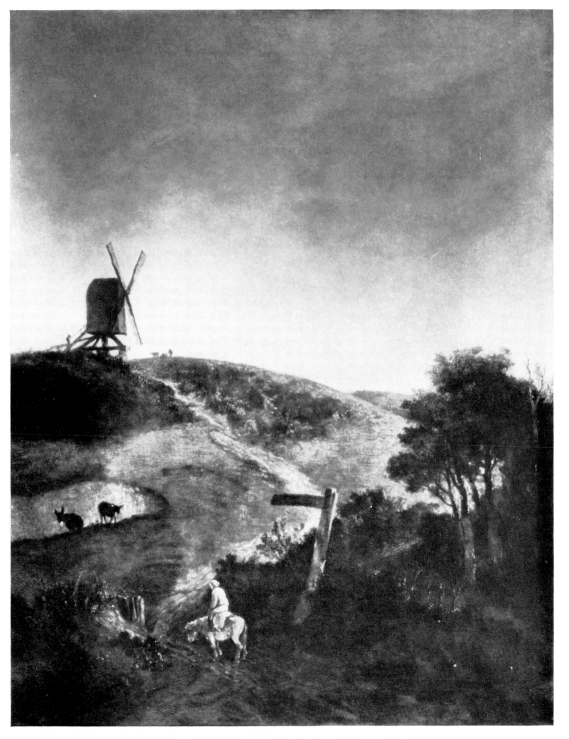

93. Mousehold Heath; Mill and Donkeys

c. 1810–13 (P 63) 43 × 36 *Tate Gallery*

94. Norwich from St Augustine's Gate

(P 64) $20\frac{1}{2} \times 29\frac{1}{2}$

c. 1810–13

c. 1810–14

95. Pockthorpe: Boat and Boathouse

(P 68) 12¾ × 17¾

The Hon. Keith Mason

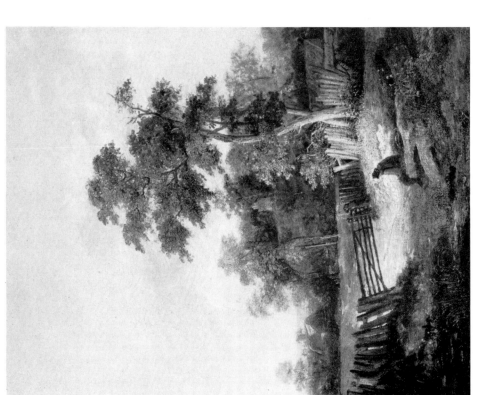

96a. Harling Gate

? c. 1812–14 (P 69) 20½ × 16 Constance, Lady Mackintosh

96b. The Way through the Wood

c. 1811–14 (P 70) 20 × 15⅞ Birmingham City Art Gallery

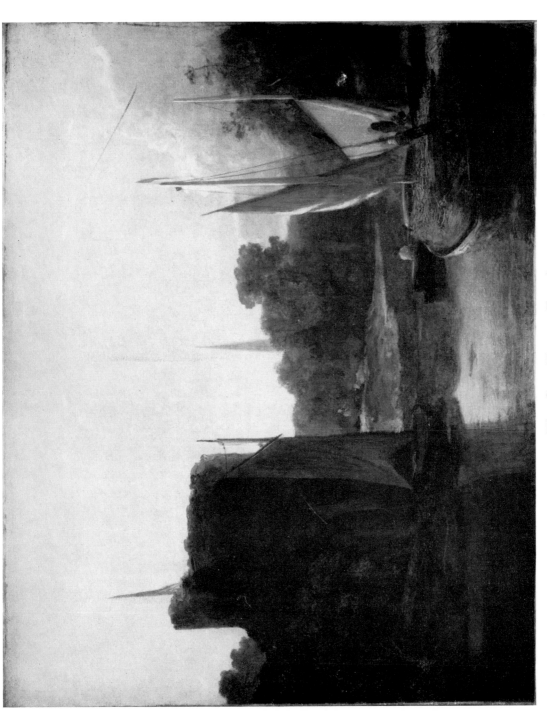

c. 1812–17 97. The Cow Tower: Evening

(P 72) 19¼ × 24

Mr and Mrs Derek Clifford

98. Return of the Flock

(P 73) 20 × 26

c. 1810–13

Constance, Viscountess Mackintosh

? c. 1810–12

99. Road with Pollards

(P 74) 28 × 42

Norwich Castle Museum

100a. Study of Flints

c. 1811–13 (P 78) 8¼ × 12 *Norwich Castle Museum*

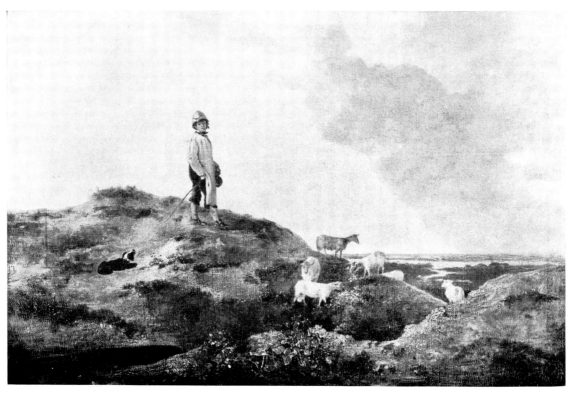

100b. Boy keeping Sheep, Mousehold Heath

c. 1812–15 (P 75) 21½ × 32 *Victoria & Albert Museum*

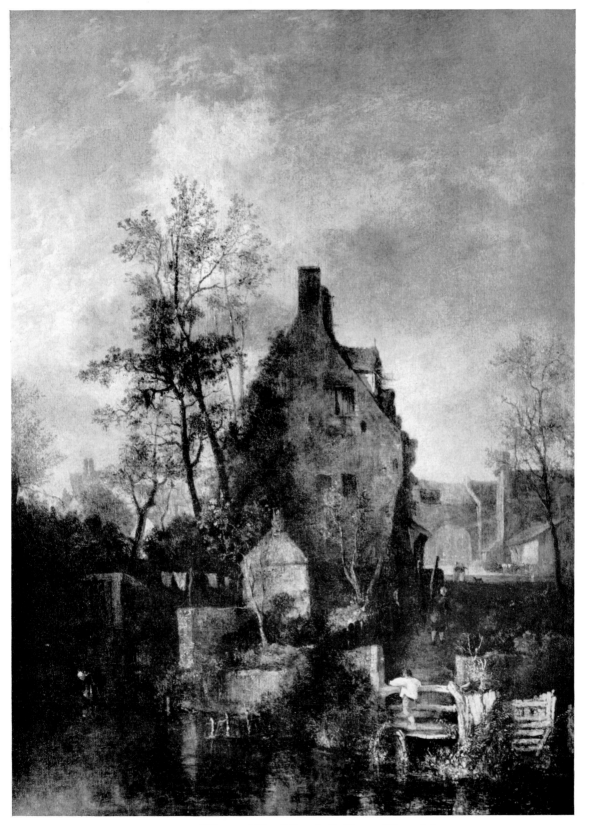

101. View of St. Martin's Gate, Norwich

c. 1812 (P 61) 20 × 15 *Norwich Castle Museum*

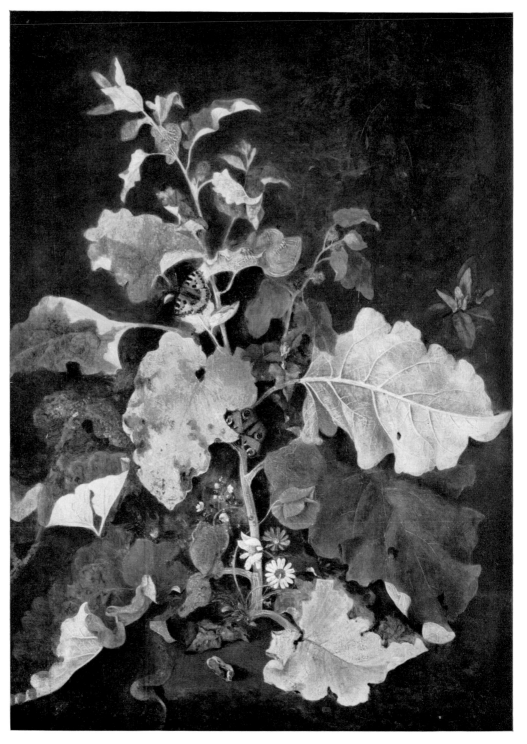

102. Study of a Burdock

? 1813 (P 80) $21\frac{1}{2} \times 16\frac{1}{2}$ *Norwich Castle Museum*

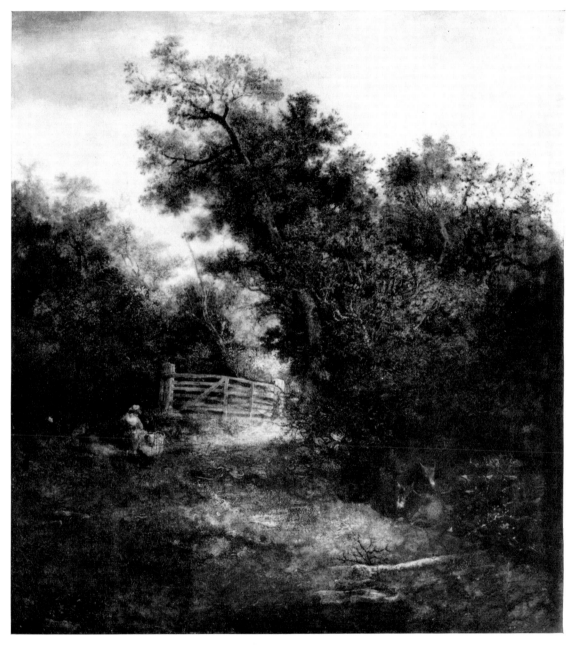

103. The Gate

c. 1811–16 (P 81) 27¼ × 24¼ *Timothy Colman Esq.*

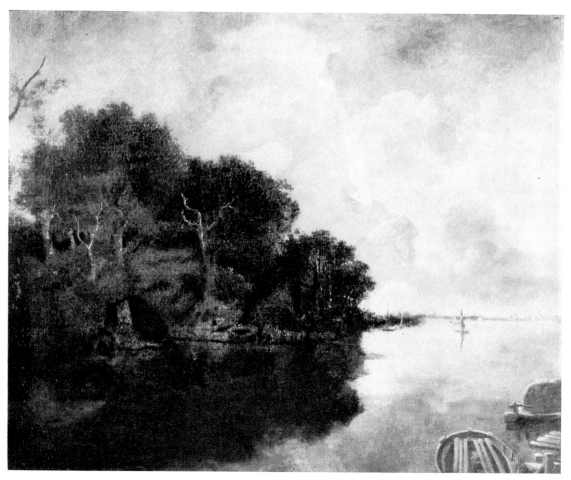

104. Bruges River, Ostend in the Distance

1815 (P 82) $25\frac{1}{4} \times 31\frac{1}{4}$ *Norwich Castle Museum*

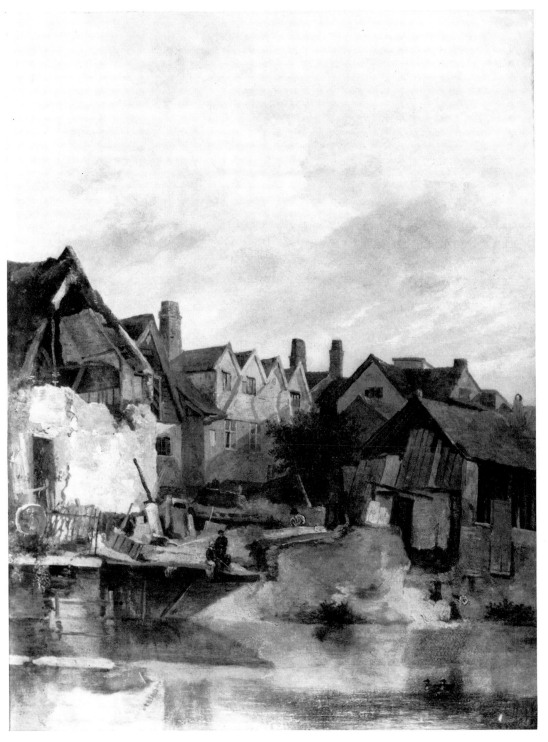

105. Old Houses at Norwich

c. 1812–16 (P 85) 21¾ × 16¾ *Mr and Mrs Paul Mellon*

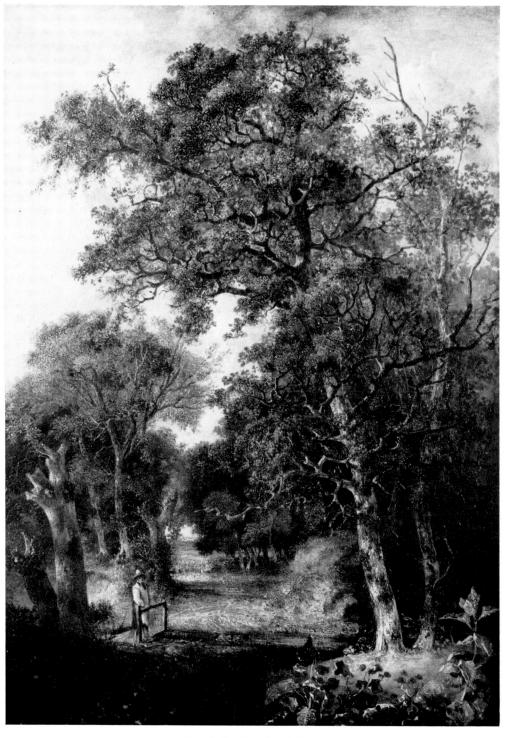

106. Marlingford Grove

c. 1815–17 (P 86) 37 × 27 *Norwich Castle Museum*

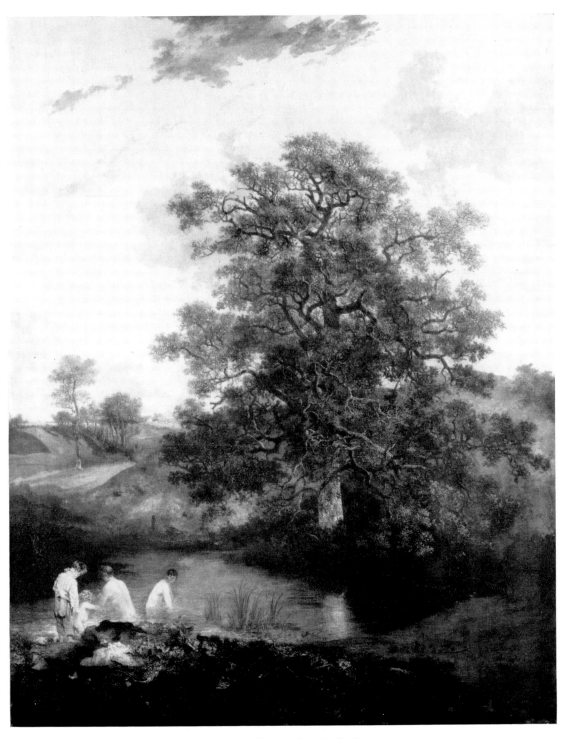

107. Poringland Oak

c. 1815–16 (P 87) 49¼ × 39½ *Tate Gallery*

108a. Stormy Heath Scene

c. 1816–19 (P 88) 14 × 20 *Mr and Mrs Derek Clifford*

108b. Back of the New Mills, Norwich

c. 1815–18 (P 84) 16¼ × 21¼ *Norwich Castle Museum*

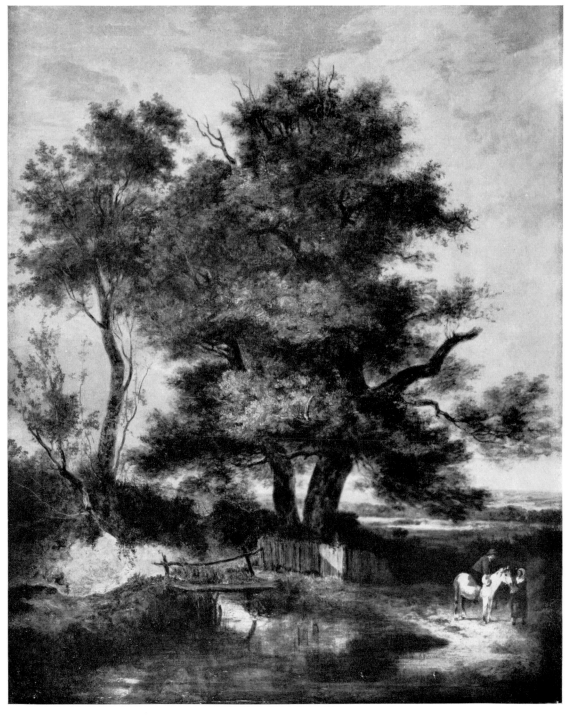

109. The Willow Tree

1810–17 (P 92) 51 × 41 *Castle Museum, Nottingham*

110. Yarmouth Water Frolic

(P99) $16\frac{1}{2} \times 30$

Lt.-Col. M. St J. Barne

c. 1820–21

111. Mousehold Heath, Norwich

(P 90) 43 × 71

c. 1814–16

Tate Gallery

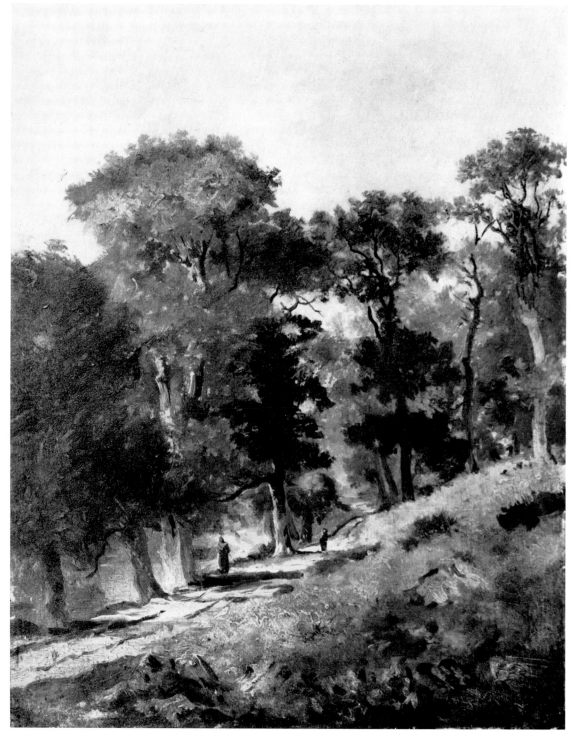

112. Postwick Grove

(P 93) 18¾ × 15½ *Norwich Castle Museum*

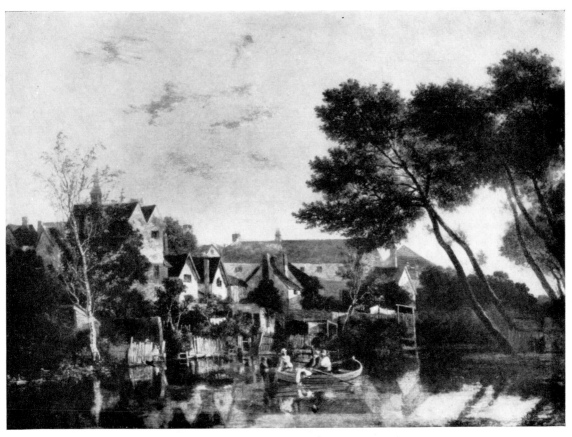

113. Norwich River: Afternoon

c. 1816–19 (P 95) 27½ × 39 *Lady Michaelis*

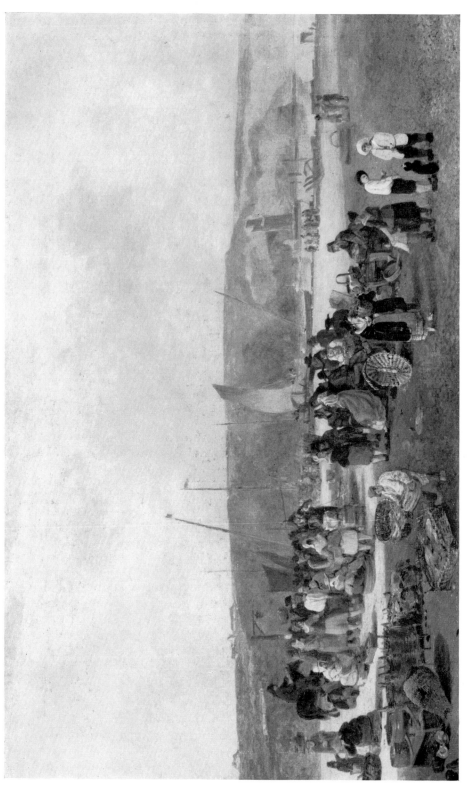

? 1820

114. The Fishmarket at Boulogne

(P 98) $20\frac{5}{8} \times 33\frac{7}{8}$

Quintin Gurney Esq.

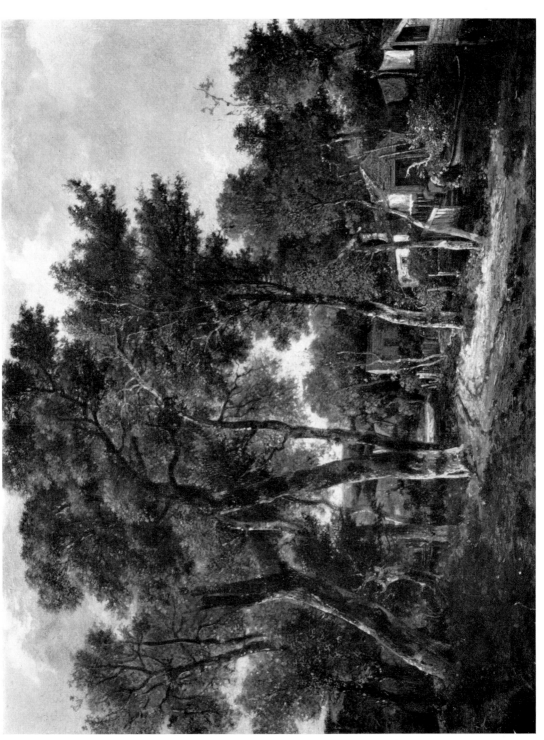

c. 1815–19 115. Bury Road Scene *Mrs I. Ashcroft*

(P 97) 15 × 19¼

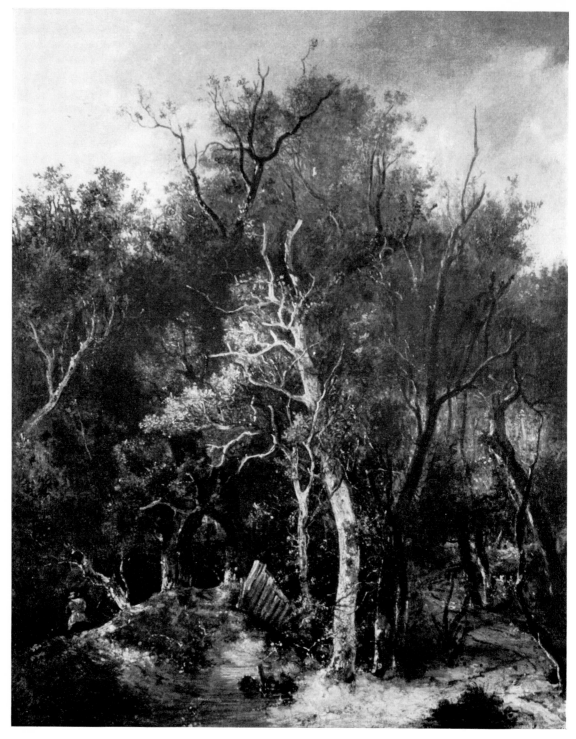

116. Wood Scene with Pool in Front

? 1821 (P 100) 20 × 16 *Dr and Mrs Norman Goldberg*

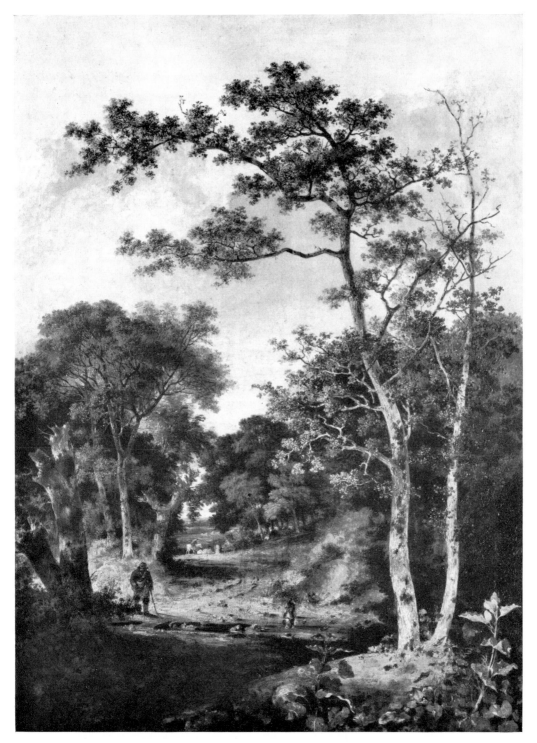

117. Marlingford Grove, probably by John Berney Crome

(P 86a) $53\frac{3}{4} \times 39\frac{1}{4}$ *Lady Lever Art Gallery, Port Sunlight*

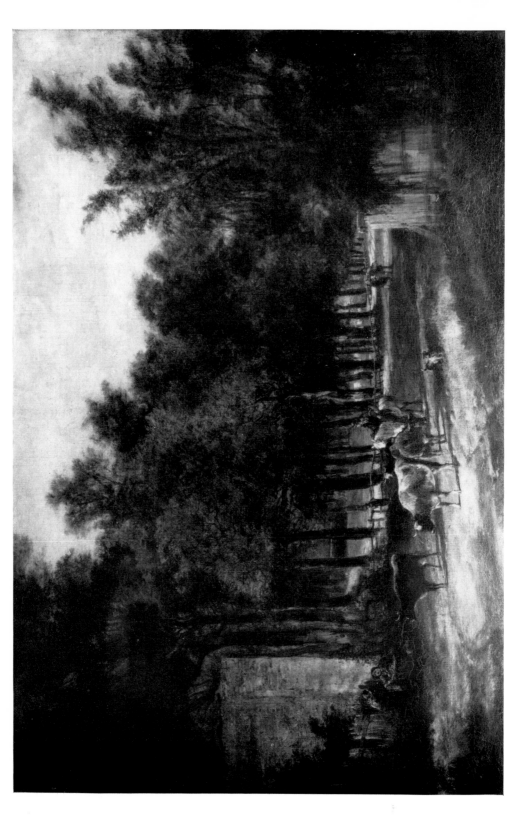

118. A View of Chapel Fields, Norwich, by John Crome and William Shayer

(P 125) 29 × 41

c. 1802–9

119. Yarmouth Water Frolic, by John Berney Crome

(P 99a) 41 × 68

Iveagh Bequest, Kenwood

1821

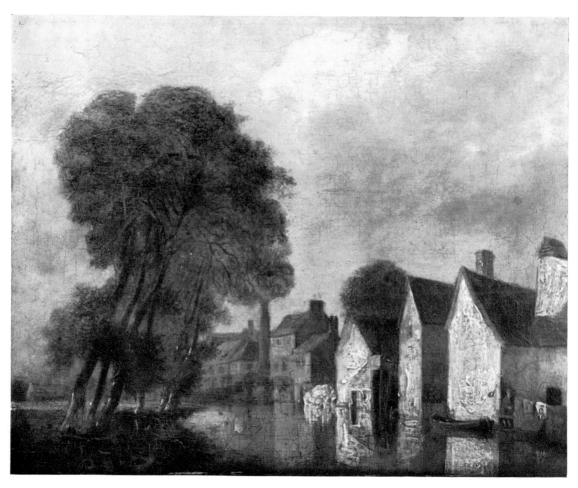

120. The Tanning Mills, possibly by Crome

? c. 1806 (P 66b) $10\frac{1}{8} \times 13\frac{1}{4}$ *The Ipswich Museums*

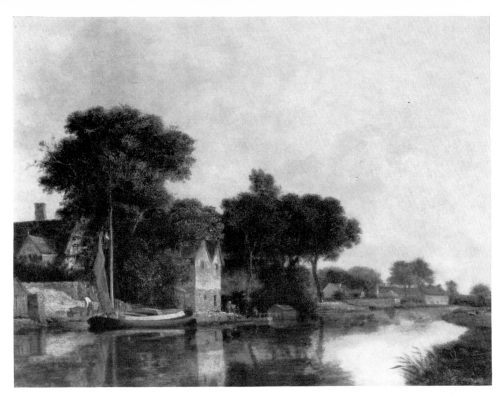

121a. View on the Yare

c. 1812–14 (P 67) 16 × 21¼ *The Rt Hon. Malcolm Macdonald*

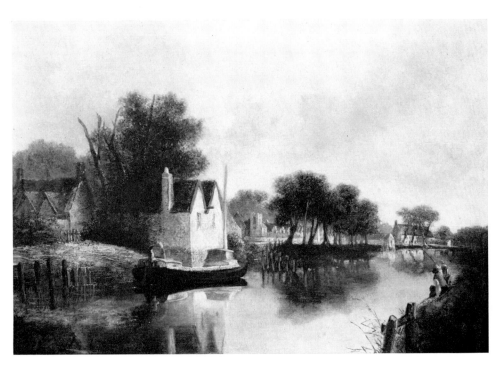

121b. River Landscape with Barge, probably not by Crome

? *c.* 1850 (P 67a) 17 × 25 *Mr & Mrs Paul Mellon*

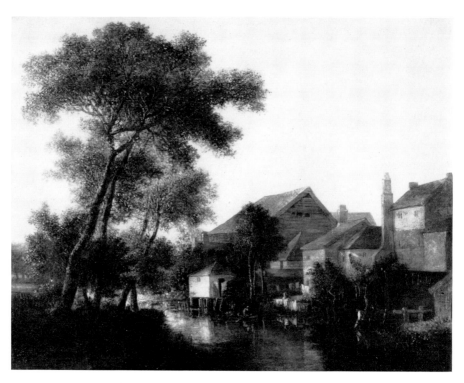

122a. Scene on the Wensum, possibly by Crome

c. 1812–15 (P 66) 14½ × 19½ *Norwich Castle Museum*

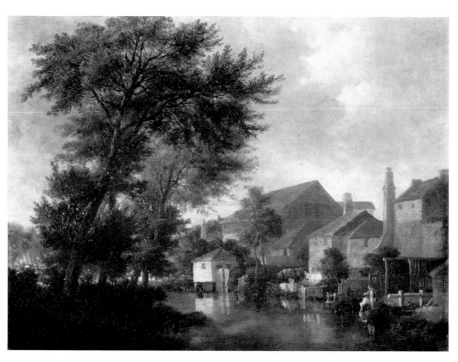

122b. The Wensum, Norwich, possibly by Crome

c. 1815–17 (P 66a) 14½ × 19 *Mr and Mrs Paul Mellon*

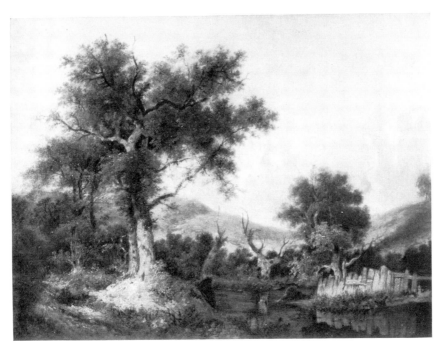

123a. Near Hingham, Norfolk, by a Crome Forger

c. 1860–70 (P 134) $24\frac{1}{4} \times 32\frac{1}{4}$ *Tate Gallery*

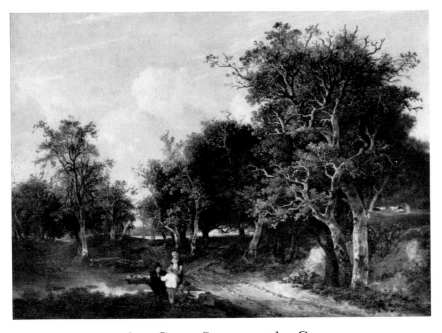

123b. Grove Scene, not by Crome

c. 1812 (P 133) $18\frac{1}{2} \times 25\frac{1}{2}$ *Norwich Castle Museum*

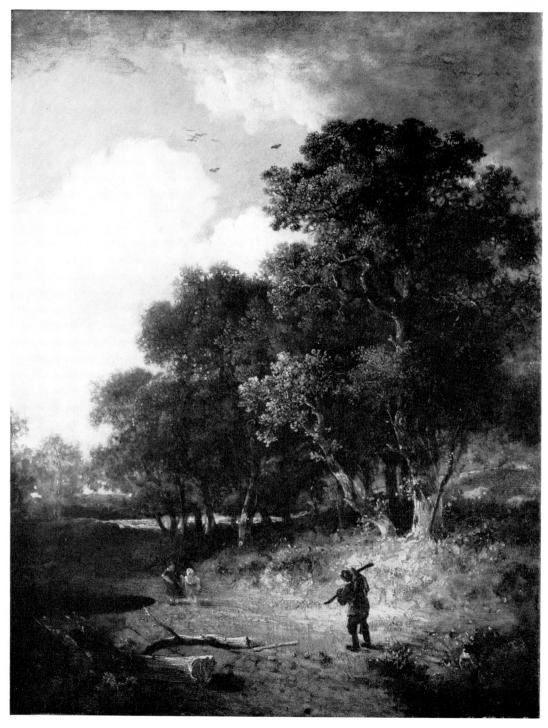

124. Woody Landscape, by George Vincent

c. 1823–27 (P 135) 19¼ × 15¼ *Victoria & Albert Museum*

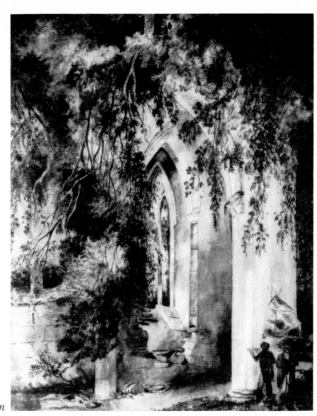

125a. Tintern Abbey,
by a Gurney girl

1805–7 (D 99a) 19 × 14¾
Norwich Castle Museum

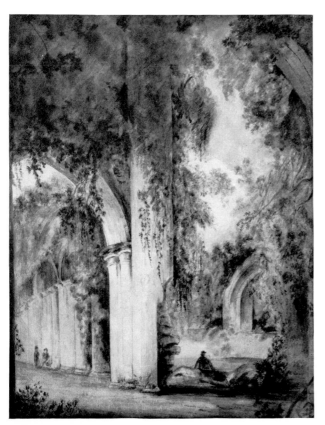

125b. Tintern Abbey,
by a Gurney girl

1805–7 (D 42a) 19¼ × 15
Norwich Castle Museum

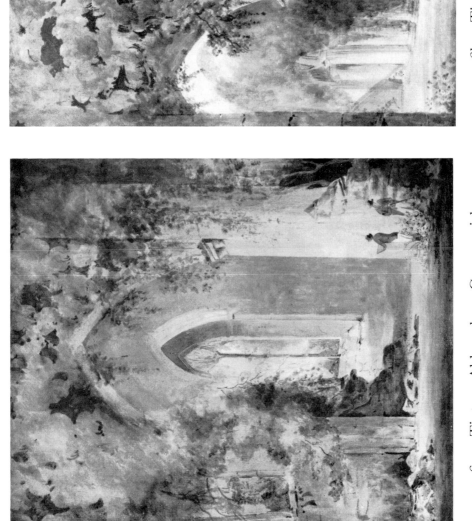

126a. Tintern Abbey, by a Gurney girl

(D 99b) 20 × 15

1805–7

John Firth Esq.

126b. Tintern Abbey, by a Gurney girl

(D 42b) 20 × 15

1805–7

John Firth Esq.

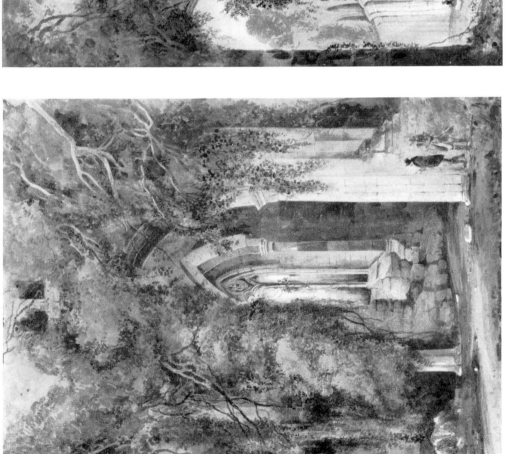

127a. Tintern Abbey, probably by Richenda Gurney

(D 99c) $21\frac{1}{2} \times 15\frac{3}{4}$ *Quintin Gurney Esq.*

1805–7

127b. Tintern Abbey, probably by Richenda Gurney

(D 42c) $20\frac{3}{4} \times 15\frac{3}{4}$ *Quintin Gurney Esq.*

1805–7

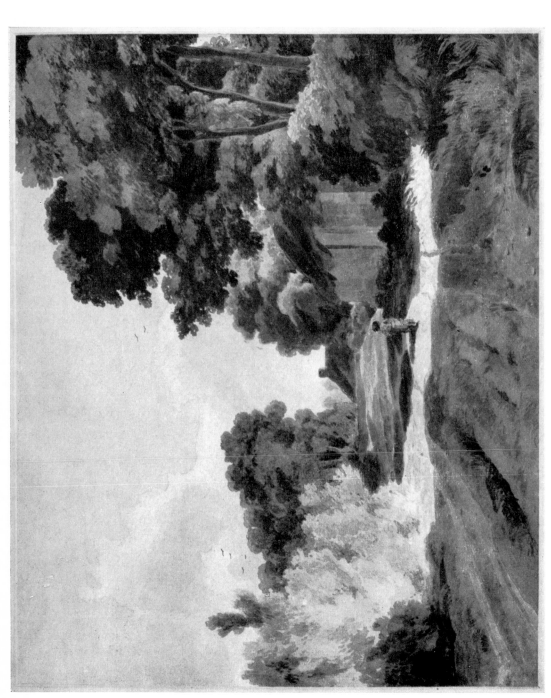

128. The Shadowed Road, possibly by Robert Dixon

(D 55a) 15 × 17¼

c. 1808–10

APPENDIX A

Works by John Crome exhibited with the Norwich Society. An asterisk was from time to time used to denote works for sale.

1805

13 Moon light, a sketch in oil
20 A cottage scene
34 Pigs, a sketch
50 A sketch in Patterdale, India ink
60 View on Barford common, near Norwich
67 Farm yard, a sketch in oil
73 A cottage near Harleston, Norfolk
89 A view near Yarmouth
93 Scene in Patterdale, Cumberland, a sketch
98 Bishop-gate bridge, Norwich
111 A marle pit
114 Part of the chapel in Chepstow castle, from the Wye
118 The great west tower from the inner bellgium, Goodrich castle
139 Part of Chepstow castle from the Wye
*145 View of Carrow abbey, near Norwich
151 Oulton church, Suffolk
159 An interior view of Tintern abbey
163 The entrance to Goodrich castle, from the inner bellgium
169 A view of Persfield, from the Wye
174 Figures, a sketch in oil
177 A view of the Fellmongers, near Sandling's ferry, Norwich, since taken down
209 Waterfall at St Michael's Le Fleming's, Westmorland, coloured on the spot
210 An interior of Tintern Abbey
223 Lowther woods

1806

19 View on the Thorpe road

24 Trees, a study
26 Rocks and water-fall
27 A wood-scene and moat, at Hunstanton, Norfolk
 'Solemn and slow the shadows blacker fall,
 And all is awful, list'ning gloom around'
 Thomson
28 The entrance of Goodrich castle, morning
33 Cow-tower, on the Swanery-meadow, Norwich
34 Grove scene, with sheep
 'Nor undelightful is the ceaseless hum
 To him who muses thro' the woods at noon,
 Or drowsy shepherd as he lies reclined'
 Thomson
35 Part of Goodrich Castle, evening
39 Evening
41 Moonlight
46 A cart-shed, at Melton, Norfolk
47 Blogg's lime-kiln
57 Sketches on the spot, pig-sties
58 The milk-pot
65 The windmill
66 Moonlight, Sprowston
67 A brook in Lord Roseberry's grounds
70 Rocks
75 View on the river at the back of the New Mills, Norwich, evening
81 View near Weymouth
87 Lime-kiln, out of St Giles' gates

89 View in the forest in Hampshire

93 View on Thorpe river

96 Sketch in oil, view on Thorpe river

145 A view on lakes in Cumberland
'Cliffs to heaven upheld,
Of rude access, of prospect wild,
Where, tangled round the jealous steep,
Strange shades o'erbrow the valleys deep'
Collins

156 Breathy bridge, Westmorland

210 Street scene, St George's Colegate, near Green's Lane

221 Sketch, from nature, in the style of Gainsborough

229 Oak tree in Lord Wodehouse's park, lead pencil

1807

5 Landscape and cattle

8 Scene from nature

13 Tintern abbey

14 Cottage near Hunstanton, Norwich

17 Caister castle

19 Blacksmith's shop, from nature

33 Sketch at Starston, Norfolk

39 Old building at Ambleside

55 Landscape from nature near Morton in Norfolk

65 Drawing

75 View near Bishopgate

81 Blacksmith's shop, Hardingham

90 Drawing on the spot

100 Blacksmith's shop, from nature

108 Scene on the river Wye

125 Yarmouth beach and jetty

134 Trowse windmill

135 Caister castle

138 Wood scene

155 Caister castle, coloured on the spot

163 Pencil-sketch on the river, St Martin's at Oak

164 Cottage at Hingham

166 View in Norwich

167 Pencil-sketch, back of the New Mills, Norwich

170 Pencil-sketch, view in St Martin's at Oak

171 View in Goberry Park, Cumberland, seat of the Duke of Norfolk

176 Sketch in oil, from Nature

180 An old house, Ambleside, Westmoreland

181 Yarmouth, beach and jetty, drawn on the spot

182 Scene from nature

185 Broken ground, back of the barracks, Norwich

1808

10 Yarmouth, Beach and Jetty

24 Fishermen in Boats

43 Sketch from Nature

44 Sketch from Nature

62 Sketch in Water Colours

63 Old Stables, Sketch in Oil on the Spot

73 Landscape

112 Landscape

114 Painting in Oil; Evening

126 Wood's End, Bramerton

154 Scene near Braydon

167 Scene at Yarmouth; Boats and Figures

171 Cottage at Hingham, painted on the spot

197 Walnut Grove

200 View near St Martin's at Oak, looking down the River

225 Moon-light Scene on the River between Beccles and Yarmouth

1809

14 Landscape, Barford Common

16 A Scene on Yarmouth Quay

19 Landscape, water-colours

24 Cromer Beach, below Cliff

29 Old Buildings in Norwich

47 A View in Cumberland looking down from King of Patterdales, in the distance Ullswater

48 Drawing in Water Colours, Grove Scene

59 Yarmouth, Beach and Jetty, oils
60 Old Cottages, painted on the spot
66 Landscape
84 An Old House in St Clements', Norwich
203 Chepstow, on the Wye

1810

15 View from Herringfleet
17 Ruins, *evening*
18 A thistle painted on the spot
24 View taken from the telegraph lane, looking towards Gen. Money's—painted on the spot
27 Scene on Hautbois common, near Coltishall, in Norfolk
29 View on St Martin's river, Norwich
30 Patterdale church
34 View on St Martin's river, Norwich
36 Cottage, in oils
79 Upright landscape scene of Colney
89 View, looking over Heigham Marshes to Costessey
95 Trees, from nature
99 Gravel pit
104 Cottage and road scene, near Blundeston after rain
190 Evening
193 Landscape

1811

*2 Windmill at Trouse—evening
*9 Broken Ground, back of the Horse Barracks
18 View, looking towards Mr Cozen's House, near Norwich
*25 Sketch in oils—evening; looking up the river from R. Alderson's Esq.
*26 Broken Ground, near Norwich
*27 Scene at Blofield
*34 View in Blundenstone Lane
*35 Trowse Bridge
*36 A Woody Scene, with Public House
*38 A Lane leading to Mr Unthank's
*43 A Waterfall and Rock
*83 The Outside of a Blacksmith's Shop

*86 Public House on a Heath
90 Scene near Bawburgh Mill
*94 Moonlight
97 Scene of St Martin's River—afternoon
*99 Landscape
*102 Rocks and Waterfall
*103 Cottage on a Common
104 Road scene near Heigham
*108 Study of Trees
*146 Drawing of Rocks near Matlock
*167 Water-colour Drawing
*171 Mulbarton Green
*183 Cottage at Hingham
*186 Temple of Venus, after a sketch of Wilson's
224 River Scene

1812

2 Grove scene—painted from Nature
7 View on the Norwich River, looking towards White Friars Bridge
15 Cottage Scene
23 Cattle crossing a River
24 Scene at St Martin's at Oak River, Norwich
25 Evening, looking down the River from Yarmouth Bridge
27 Lane Scene, Hingham
45 A Cottage Scene, from Nature
100 Boy keeping Sheep—Morning
103 A Landscape
104 The Blind Pensioner
105 View without St Augustine's Gates
114 Scene on Heigham River
115 Creek scene, near the New Mills, Norwich
123 Landscape Scene at Bawburgh
126 Dutch Boats
196 Cottages in Hingham
197 Study of Pollards—Water-colours
199 Water-colour Drawing from Nature—Sheds
205 Cottage Scene

1813

7 Foot-bridge, Keswick

259

10 Scene at Blofield
19 Lane Scene—Lord Roseberry, Bixley
27 Landscape
28 Scene in Heigham
37 Sketch, in oils
44 Sketch at Marlingford
47 Docks
56 Landscape at Hackford
57 Cottage at Deepham
73 Boat-builder's Yard, near the Cow Tower
78 Scene near Lord Wodehouse's Park
94 Scene on St Martin's River, near Morse and Adam's Brewery
97 Landscape, with Sheep—Evening
190 Lane scene, near Cromer

1814
20 Heath Scene
29 Cottage and Trees
37 Yarmouth Quay
52 Scene, from Nature
55 Gravel-pit—Evening
60 View on the Norwich River
67 Study, from Nature
87 Creek Scene
88 Scene, from Nature—for a large Picture
111 Village Scene

1815
34 Composition
40 Landscape
48 View of Norwich
56 Landscape
58 Landscape
88 Scene on Mousehold Heath
90 Lane Scene
96 Village Scene
98 View in Paris—Italian Boulevard
106 Scene in St Martin's at Oak
112 Cottage Scene

1816
24 Scene from nature
26 Character of an Oak
28 Landscape

29 Landscape—a sketch on the spot
40 Sketch in oil
41 Scene from nature
43 Scene on St Martin's River
45 Landscape
49 Bruges River—Ostend in the distance—moonlight
51 Cottage Scene
57 Cottage—Haddiscoe
62 A Lane Scene, near Norwich
65 River Scene
70 Landscape—autumn
75 Cottages at Cromer
90 Landscape—composition
97 Solitude
101 Landscape—composition
110 Scene on Heigham River

1817
14 Moon Rising
20 Yarmouth Jetty
28 Scene on Mr Blake's Bleaching Ground, Heigham
44 Bathing Scene
51 Mackerel Shore Boat going off—morning
65 Landscape
66 Landscape
75 Landscape and Cattle
79 Raven Craig
80 Lane Scene
87 Scene at Bawburgh
88 Hethel Hall, the seat of Sir T. Beevor, Bart.
92 Landscape
97 Sketch, from nature
143 Scene on the Norwich River
177 Sketch, in oil
179 Landscape

1818
30 Twilight
46 Sketch, in Oil
47 Landscape
51 Ruins
59 Scene on the Norwich River

Appendix A

67 Moonlight
73 Landscape
77 Yarmouth Beach, from the Pier
97 Landscape
152 Dog's Heads

1819

1 Moonlight
9 Landscape
14 Landscape and Cattle
25 Heath Scene—sun breaking out after a Storm
40 Landscape—Mid-day
48 A Scene on the Norwich River—Afternoon
52 Yarmouth Beach, the Jetty in the distance—Evening
54 Landscape
59 Yarmouth Beach, looking North—Morning
62 Sketch in Oil
156 The Moon Rising
161 A Lane Scene
207 The Thorn Tree, in Hethel Churchyard; considered an antiquity in the reign of King John

1820

14 Composition
15 River Scene
19 Sketch near Bishop Bridge
21 Cottage Scene
23 Group of Trees—A Sketch
36 The Fish-Market at Boulogne, from sketches made on the spot in 1814[1]
46 Cottage and Trees
53 Grove Scene
55 Sketch in Oil
68 Moonlight Sketch
69 Landscape
71 Cottages at Heigham
78 A Sequestered Wood Scene
80 Scene in Chapel Field, Norwich
81 Cottage and Wood Scene
86 Evening
92 Cottage on the River Wensum

1821 (J. Crome deceased)

40 View, looking from the New Mills towards St Michael's Bridge
73 Landscape—Evening
90 Lane scene—the last Picture
91 Wood Scene

[1] Note to No. 36 in the 1820 Catalogue of the Norwich Society.
The 1820 Catalogue in the British Museum Print Room has added to it a press-cutting from the *Norfolk Chronicle* of 29 July 1820. The passages referring to Crome may reveal a general attitude of his patrons at this time: 'Mr. Crome has furnished us this year in (No. 36) "the Fish-market of Boulogne", with conclusive evidence that the scope of his ingenuity can embrace with effect not only the department of rural landscape to which he has hitherto devoted himself with so much success, but the equally skilful and still more interesting delineation of national character and costume. The production, however, to which we are now attending is of such unequal execution, that the artist loses "half the praise he would have got" had he but discreetly bestowed a little more pains upon the finishing of it. In consequence of an adequate degree of forcibleness and animation not having (as we conceive) been given to the foreground, and the principal groups being placed in the half-distance, this little picture, which has considerable merit in its details, produces only the impression of a sketch. But, as it were, to make ample amends for all deficiences of this kind, Mr. Crome presents for inspection two pictures, in his usual free and unconstrained manner, and with more than the degree of labour which he ordinarily finds time to bestow on his works.—53 "Grove Scene", exhibits the touch of a vigorous pencil, great truth of perspective, and an agreeable effect of light and shade. 71 "Cottage on the River Wensum", is a production of which we cannot speak in terms of "faint praise". The composition is good, the tone of colouring soft and delicate, the tints harmoniously blended, and the light and shade adjusted and proportioned in a manner the most

suitable and the most pleasing. On a second inspection of the picture we were glad to see the word "sold" ticketed at the corner. In a landscape (by the same artist) in which is a bridge with men angling from it, the form of the trees, and touching of the foliage, are excellent, the waters are pencilled with a free and lively hand, and it is altogether a very agreeable picture. Mr. Crome has several other productions in the room, but these particularly attracted our notice.' [71 is 'Cottages at Heigham'; 'Cottage on the River Wensum' is 92.]

APPENDIX B

Royal Academy Exhibits

1806

260 A landscape

285 A landscape

1807

527 A cottage from Nature, near Lynn, in Norfolk

1808

591 Blacksmith's shop, near Hingham, Norfolk

1809

36 A sketch from Nature

235 Old buildings in Norwich[1]

1811[2]

465 View in Blofield, near Norwich

1812

11 Landscape

84 Landscape

132 Landscape

384 Landscape

1816

8 View near Norwich

1818

218 View near Norwich

[1] The critic of *The Beau Monde* wrote 'Mr J. Crome has No. 36 and No. 235. The latter represents old buildings at Norwich. There is a pleasing effect of partial sunlight on the buildings' (Whitley, 1800–20, p. 146).

[2] In Anderdon's grangerized collection of Royal Academy Catalogues in the British Museum Print Room at this entry is the following note: 'At Dawson Turner's Sale I fell in with 2 of this artist's pictures knowing previously nothing of his great merit. I was struck the moment I entered Christie's room by a Rag. I may say a rag of canvas hanging loose on the stretcher it came to me for 29 gns.'

APPENDIX C

The British Institution Exhibits

(Measure of frames included)

1818

 75 A Blacksmith's Traverse, 25 × 22

1820[1]

 254 Scene at Wittingham, near Norwich, 60 × 54

1821

 40 Heath scene near Norwich, 29 × 38
 231 A Scene near Norwich, 23 × 38[2]

1824

 36 A Study from Nature; Poringland, Norfolk, 66 × 57

[1] Collins Baker gives No. 82 as *View on the Norwich River* but the copy of the British Institution Catalogue in the British Museum reads *View in Rotterdam* and is by J. B. Crome.

[2] Bought by Sir John Swinburne for £31 10s. The unframed measure of this picture when shown at the R.A. in 1888 was 17½ × 26. It was subsequently sold at auction to Leggatts from whom it passed to Whitelaw Reid, U.S.A.

APPENDIX D

Crome Memorial Exhibition, 1821

No.	Title	Year when painted	Owner
1	Sketch—his first in oil	1790	Mr F. Crome
2	Composition, in the style of Wilson	1796	Mr W. Spratt
3	Scene in Cumberland	1817	
4	Study of Broken Ground, near St Augustine's Gates, Norwich	1815	
5	Study near Bishop's Gate, painted on the spot	1820	
6	View on the Thames	1808	
7	Moonlight scene on King-street Meadows	1817	
8	Composition, in the style of Wilson	1798	C. Higgin, Esq.
9	Road Scene and Cottages near Bury	1818	Mr W. Crowe (sic)
10	Landscape Composition	1819	
11	View at the back of the New Mills, Norwich	1814	Mrs Paget
12	Grove scene near Marlingford	1815	Samuel Paget, Esq.
13	Study at the Duke's Palace, the site of the New Bridge	1817	
14	Study of Ruins	1817	
15	View of the back of New Mills near the Manufactory of C. Higgin Esq.	1817	
16	View in the Park of Lord Lowther	1807	Mr W. Spratt
17	Study of Trees near Earlham	1820	
18	Trees and Broken Ground	1815	
19	View on the River Wensum	1818	J. Brightwen, Esq.
20	Wood and Water Scene near Bawburgh	1821	Miss Burroughes
21	Lane scene near Hingham	1815	Rev. E. Valpy
22	Landscape	1818	Mr E. Sparshall
23	Landscape and Cattle	1806	S. Martin, Esq.
24	Scene at the Back of the New Mills	1814	
25	View near Yarmouth Bridge	1815	Rev. E. Valpy
26	Landscape and Cattle	1816	Mr Wm Stark
27	Cottage and Wood Scene	1820	
28	Scene near Dickleborough	1820	
29	Scene at Mulbarton	1817	Mrs de Rouillon
30	Yarmouth Jetty	1808	

31	Moonlight	1818	
32	View in Postwick Grove	1816	
33	Beach scene—Morning—Mackarel boat going off	1818	
34	Blacksmith's Traverse at Hardingham	1814	Mr F. Crome
35	Scene at Wood Rising, painted on the spot	1811	
36	Scene at Bawburgh	1816	
37	Hautbois Common, Norfolk	1810	Mr F. Stone
38	View, looking from Pier Head towards Yarmouth Jetty	1817	
39	Lane scene near Hingham	1812	Samuel Paget, Esq.
¹40	Lane scene near Witlingham	1820	Mr Charles Turner
41	Yarmouth Jetty	1811	
42	Scene near Hardingham	1816	
43	Lane scene	1817	John Bracey, Esq.
44	Boy and Sheep—morning	1815	
45	View on Mousehold Heath	1816	Mr Wilson
46	Lane Scene at Blofield	1813	Samuel Paget, Esq.
47	Scene at Heigham	1819	Rev. J. Homfray
48	Scene at Blundeston	1816	Mr G. Stacey
49	View at Back of the Mills	1815	Rev. J. Homfray
50	Lane Scene near Beccles	1814	Mr Freeman
51	Scene in Cumberland	1818	Mr D. B. Murphy
52	Cottages at Barford	1813	
53	Lane scene at Catton	1816	John Bracey, Esq.
54	Scene at Marlingford	1808	Rev. J. H. Browne
55	Carrow Abbey	1805	P. M. Martineau, Esq.
56	Road scene at Blundeston	1810	T. Brightwell, Esq.
57	Yarmouth Beach	1819	Mr P. Barnes
58	Portrait of the late Mr Crome painted by J. J. Wodehouse, Esq. M. D. in 1813		
59	Scene at Poringland	1818	
60	Scene between Bruges and Ostend	1818	Mr F. Crome
61	Blacksmith's Shop	1808	
62	Yarmouth Jetty	1819	Mr P. Barnes
63	View at the Back of the New Mills	1816	Rev. E. Valpy
64	Scene near Lakenham	1820	Mr Wilson
65	Cottage and Wood Scene	1820	M. Bland, Esq.
66	View on the River Wensum	1819	Mr Samuel Colman
67	View on Mousehold Heath	1816	Mr James Stark
68	Mill—Twilight	1813	Samuel Paget, Esq.
69	Cottage Scene near Drayton	1815	Mr F. Crome
70	Cottages at Witlingham	1814	Miss Cameron Innes
71	Landscape—Evening	1821	Mr Crome
72	Sketch of an Oak in Kimberley Park	1813	
73	Study of Trees at Colney	1814	Mr F. Crome

74	Moonlight	1819	Mr G. Stacey
75	Composition in the style of Wilson	1809	
76	Grove Scene	1820	J. Geldart, jun., Esq.
77	View near Scoulton	1815	Mr F. Crome
78	View on the River Yare, painted on the spot	1814	
79	View of the Italian Boulevards at Paris	1815	H. Gurney, Esq., M.P.
80	View at North Elmham	1814	Mr F. Stone
81	View, looking from the New Mills, towards St Michael's Bridge	1820	Mr R. de Carle, jun.
82	View on the River Wensum	1820	Mr I. H. Wright
83	Scene near Hackford	1813	
84	Lane scene at Witlingham	1817	Mr F. Crome
85	Group of Trees near Melton	1820	Mr B. Steel
86	Scene near Wood Rising	1816	Mr W. Freeman
87	Fishmarket at Boulogne	1820	
88	View on the River Yare	1819	
89	Scene at North Elmham	1814	Mr F. Stone
90	Hethell Hall, the seat of Sir T. Beevor, Bart	1819	
91	Scene near Keswick	1820	(3) Mr F. Stone
92	View on the River Yare	1814	R. Bygrave, Esq.
93	Study of an old Thorn Tree standing in Hethel Church-yard	1819	
94	Study of Plants, painted on the spot	1814	Mr Crome
95	View near Wickerwell	1819	Mr E. Girling, jun.
96	Sketch of Norwich, painted on the spot	1815	
97	View at Fritton	1814	Mr F. Crome
98	Sketch at Marlingford	1812	
99	Study of Trees and Broken Ground at ditto	1815	J. D. Palmer, Esq.
100	Lane scene at Mulbarton	1813	Mr E. Girling, jun.
101	View near Hellesdon	1819	Lady Jerningham
102	View near Honingham	1813	
103	Hackford Church	1817	
104	Study at Wood Rising	1815	Miss Paget
105	View at Bawburgh	1818	Mr F. Crome
106	Cottages at Haddiscoe		
107	View at Heigham	1815	Miss Paget
108	Cottage scene near Dereham	1817	
109	Moonlight Sketch	1819	
110	View at the back of New Mills	1806	
111	Wood scene, the last picture painted by the late Mr Crome, in April	1821	Mr Crome

[1] MS note by Reeve in the B.M. copy of this catalogue: 'The Revd. Charles Turner informs me that Mr Crome painted this picture for his father and that he paid him £30 for it.'

APPENDIX E

As far as it is possible to tell from the catalogues no works by Crome were included in his Sale at Yarmouth (Lugt, *Repertoires des Catalogues*, 8238—B.M. Print Room), nor in the Sale at Norwich after his death in 1821 (Lugt, 10113—B.M. Print Room; V. and A. typed copy; W. Roberts; Norwich City Library). One entry in the Yarmouth Sale of a picture offered on the third day *may* have been by Crome. It was *Evening—after Wilson*, but it may equally have been by Harvey or one other of the Norwich Wilson enthusiasts. In John Berney Crome's Bankruptcy Sale Catalogue of 1834 (Lugt, 13758—B.M. Print Room) there are, however, a number of entries 'by the late Mr Crome'.—

No.	Title	Price Realized £ s. d.	No.	Title
			97	Sketch in oil
			99	Fellmonger's yard
36	Sketch on the spot	10 6	100	Cow's Tower
38	Study of boy and dog	14 6	101	Postwick Grove, sketch
41	The direction post	5 6	102	Pair of sketches in oil
46	Gravel pit	7 6	103	Dutch boats, sketch
55	Study of trees	1 6 0	104	Circular picture (*It is not clear that this was by Crome*)
57	The blacksmith's shop, one of his best pictures in the style of Gainsborough	6 0 0	106	Picture and two sketches
			107	Sketch on pannel, Marlingford
61	Boat house at Blundeston	3 6 0	109	Three sketches in oil
62	Ditto, companion	3 9 0	111	Sketch in oil
70	Sketch in oil	17 0	112	Ditto
72	Steam packet	10 6	192	Wroxham water frolic
93	Sketch in oil		203	Study
94	Splendid sketch in oil, equal to Gainsborough		215	One sketch by late Mr Crome, and two by J. B. Crome

APPENDIX F

Among the many hundreds of false 'Cromes' we have seen few give the appearance of having been painted to deceive. By far the greater number are honest copies by one of the many East Anglian artists, amateur for the most part, who directly or indirectly derived from the Norwich School. Once beyond the reach of the hand that made them such pictures lose their identity, the greater number of them quietly acquire an attribution to Crome and eventually emerge on the market under his name. Few of them survive a first critical scrutiny and it is to be presumed that they return to brood in privacy until, some of them at least, take another hopeful airing decades later. Others, however, and not necessarily the best of them, fall into the hands of the disreputable and acquire wonderfully convincing provenances and wonderfully unconvincing signatures. It is astonishing in what reputable and plushy company these maltreated waifs sometimes appear. But not all false Cromes are bad pictures. The level of amateur painting in East Anglia was often very high and such men as Thomas Lound, James Sherrington and Thomas Churchyard were better than some who earned their living by it; all three are a possible source of doubtful Cromes.

More serious are the works of competent professionals such as George Vincent, James Stark, Charles and David Hodgson, John and Henry Ninham, John Berney Crome, and Robert Dixon, men who are unlikely to have painted to deceive but whose manner was modelled on Crome's. When faced with this type of pseudo-Crome it is an advantage to be familiar with the hands of these lesser artists; after all, if one knows a picture is by Vincent one does not have to take long to decide that it is not by Crome. In fact, late Vincent and late Stark do not usually give much difficulty, but we suspect that John Berney Crome, Robert Ladbrooke, David Hodgson, Henry Ninham, and Dixon, are all occasionally the source of confusion. Ladbrooke was a professional copyist and may well have been given the job of painting Crome replicas; if these were of the pre-1815 group it might be difficult to disentangle them. Ladbrooke's own work has generally less colour and is more crowded than Crome's of the same period.

Hodgson is known to most as a rather ham-handed painter of buildings whose pigment is uncomfortably fat and greasy, but this is not all the story, he worked for a long time and some pencil-drawings and water-colours, as well as some few of the recognized oils, suggest that he may have attained a more acceptable level of sensibility. In any case where have all the Hodgson *River Scenes* gone to? He exhibited more than Crome did, but we see rather less. Even more difficult is Ninham, he was a sensitive, slightly meticulous artist whose oils have generally a delicacy and charm on the small scale in which he is usually found, but his style was not unchanging through a long working life and at least two 'Cromes' in famous collections we believe to be by him. Dixon is a special case, little is known of his oils, but it is possible that the splendid *Mill* at Norwich is by him, and several water-colours lie in disputed ground. As he died in 1815 the field of confusion is limited to the earlier and less often copied Cromes. Other professionals such as W. H. Hunt of Yarmouth and W. P. B. Freeman are rarely good enough to deceive nor probably, did they ever intend to, although others have intended that they should.

The allegations that the Paul family ran a faking factory are probably well based, but Joseph Paul's protest that his pictures were his own and intended to be his is certainly true in part. Most Pauls are so clearly in his distinctive hand that it is difficult to believe that they were ever painted to deceive and it is a little unfair that such merit as they sometimes have is denied them. A. G. Stannard is another matter. His abilities were greater. Although born after Crome's death his father, Alfred Stannard, was steeped in the Norwich tradition and when in 1845 A. G. Stannard married David Hodgson's daughter he allied himself to one of Crome's near contemporaries and almost his greatest admirer. If it is true that A. G. Stannard claimed to have painted over 300 Cromes some at least should be looked for among those doubtful little cottage scenes which from time to time confuse even the wary. Whether he was responsible for the really splendid forgeries is not certain. J. B. Ladbrooke also seems to have been something of a rascal. It is possible that to some extent he succeeded in suppressing his own third-rate mannerisms when copying Crome but his authentic work scarcely suggests sufficient talent for really able forgery. John Joseph Cotman is another whom it is not difficult to believe may have painted to deceive, but his own personality in paint is so strong that it is better to regard the charge as not proven.

Students of Norwich pictures are sometimes inclined to assume that one or other of the many Norwich School artists are responsible, either inadvertently or intentionally, for all the pseudo-Cromes which appear on the market. This is far from the truth for some of the best work that goes under Crome's name

was painted by men who have little or no claim to the Norwich label. John Varley's brother-in-law, William Mulready, in his earlier work is readily mistakable, the impasto of his buildings and sandy banks is very close to Crome as well as to the first period of Cotman's oils. In seascapes, and possibly in landscapes as well, both in oil and water-colour, Samuel Austin must be regarded as a hazard; and for the later and smaller and more popular type of Crome that rather elusive character Bristowe, who is known on more than one occasion to have worked on Crome's canvases, is a potential source of trouble; nor does one feel sure that he would not have intentionally painted to deceive. More generally important is, perhaps, Sir Augustus Wall Callcott who did exhibit at Norwich although he was in no sense a Norwich man. His work, which is of a high professional standard, is often of considerable charm, and appears in a variety of styles. Usually thought of as a distant follower of J. M. W. Turner this in itself points to his common ground with Crome. Callcott was also a friend of Mulready and thus connects through John Varley with Cotman and Crome at the very time when Cotman and Crome had most in common. It is not improbable that he was responsible for the *View near Norwich* (P 131) at Manchester as well, maybe, as for the delightful pair P 127 and P 128, illustrated by Cundell.

Among the very many painters whose work can and has been confused with Crome it is worth mentioning as examples two amateur artists and collectors, William Roberts (1788–1867) who was a friend of Cox and Müller as well as of many Norwich artists, and who is known to have owned at least two Cromes; and the Rev. Thomas Judkin (1788–1877), a friend of Constable. Work by either of these amateurs can have something of Crome's breadth of conception as well as an engaging coarseness of execution.

The French landscapist Georges Michel is hardly likely to be the source of fake Cromes, although his work has points of similarity. Michel, born in 1763, was five years Crome's senior and although he may, through Nägler and Cunningham, have heard of Crome towards the end of his life (he died in 1843) he is unlikely to have been influenced by him. The similarity—as Bryan put it 'his style may be compared at a respectful distance, to the work of Old Crome' —derives rather from a common source in Ruysdael. For some time Michel was the painting companion of Lazare Bruandet (1755–1803) who imitated Ruysdael and who, with Michel, painted the countryside around Paris as Crome did that around Norwich. Michel should be a sufficient reminder that with a common artistic ancestry, contemporaries may arrive at a not dissimilar destination without helping each other on the way. *All* English painters whose work looks somewhat like Crome's were not necessarily influenced by him.

Although Crome was much copied there are no grounds for supposing that he was fraudulently copied until after 1862; nor is it likely that any but innocent mistakes were made much before that date. Pictures are attributed wrongly to an artist if his name is well-known and his work is valuable. There would have been no incentive to pass off as genuine Crome's pictures which were not by him until his prices drew attention to a possible source of profit. Why fake a Crome when *The Blacksmith's Shop* (Plate 86) could be bought at auction for £6? (Appendix E). Why fake a Crome when *The Poringland Oak* (Plate 107) and *Mousehold Heath* (Plate 111) were lying unsold and unsaleable at £25 a piece in Freeman's shop in Norwich? Or when a fine collection of authentic Crome's was virtually rejected as unfit for auction by Christies? The first clear sign of a rise in prices occurred in the so-called Sherrington Sale of 1858.[2] In this the *Willow Tree* (Plate 109) was sold at 100 guineas; but the *Blacksmith's Shop* was bought in at 84 guineas, the *Slate Quarries* (Colour Plate I) at 150 guineas, and two unidentified landscapes at 120 and 78 guineas respectively. Better though these prices are they hardly suggest a seller's market.

In 1860 the underground interest in Crome was publicly confirmed by the appearance of forty-six exhibits after his name in an Exhibition of Deceased Local Artists in Norwich. The real break in Crome prices occurred two years later in 1862 when the National Gallery paid £420 for *Mousehold Heath* (Plate 111) which had been shown in the International Exhibition of that year. This Exhibition had contained seven Cromes. It is not difficult to see in this purchase the hand of Lady Eastlake, the wife of the Gallery's Director. Lady Eastlake was a Norwich girl, the daughter of Crome's first employer, Dr Rigby,[3] and in her guidance of her husband's buying policy it is not surprising that she should have directed him to the work of her father's old errand boy. The next few years saw a flurry of activity in the Crome picture market but it is revealing to see in what direction the interest lay. In 1864 £294 was paid for *The Yarmouth Regatta* (Plate 119) which in material respects is the work of J. B. Crome, and in 1867 £1,100 was paid for *Coast Scene near Yarmouth* which has also been thought to be by J. B. Crome rather than by his father.*

It would have been reasonable to guess, given this sudden rise in value, that spurious purchasers could even make their appearance. The success with which they did so is shown by the sale of a *Road Scene* for £1,575 in 1875, a picture which was swiftly repudiated as 'not by Crome'. By this date 'not by Crome' was probably the rule with high-priced 'Cromes' rather than the exception.

It follows from this brief history of Crome's prices that any picture of his

* This fine picture, now in the collection of the Rt. Hon. Lord Butler, is by neither. Baker (p. 127) wrote: 'somewhat like an early Turner sea-piece'. This is what it may be.

which can be traced to collections made before 1862 is unlikely to be spurious. The exceptions may be such innocent copies made by his pupils as the two loaned by the Rev. J. Paget in 1860, or the bizarre instance of J. B. Ladbrooke's loan to the same exhibition of a picture which he had himself painted. This absurdity can best be explained as the gesture of one who shared in the annoyance of his family at the publicity being given to Crome.[4]

[1] Canvas 39 × 49. P. M. Turner gift. (N.C.M. 130–949.)

[2] There was an isolated 100 guinea bid recorded in 1852 for *Sea Coast, Norfolk*.

[3] She was also Cotman's favourite pupil.

[4] There is a note in the Reeve Album of Crome's Etchings at the British Museum which draws attention to the fact that the press-cuttings he includes were mounted by J. B. Ladbrooke, but that Ladbrooke had purposely *not* mounted other references to Crome which had failed to mention the Ladbrooke family. He was, Reeve wrote, jealous of Crome. Recently a painting appeared at Sotheby's with a letter from J. B. Ladbrooke on the back guaranteeing that it was 'certainly the work of his uncle, John Crome'. It certainly was not.

APPENDIX G

There were the considerable collections formed before 1863 which between them contained sixty-two paintings by Crome. The first and best-known of these was the so-called 'Sherrington' Collection. In his *Outlines in Lithography* Dawson Turner wrote: 'Mr. Sherrington of Yarmouth, who has judiciously confined his collection of paintings to those by Crome . . . has had the good fortune to become the possessor of some of his best.' In the study of the provenances of Crome's pictures, Sherrington's Collection occupies a pivotal position. There is no evidence that he bought in Crome's lifetime, but it is certain that by 1835 with the assistance of his friend, Crome's eldest son John Berney Crome, he was buying heavily from those who had commissioned paintings directly from the artist. Pictures that had belonged to John Bracey, to Samuel Paget, to Dawson Turner, as well as some which had been inherited by John Berney Crome himself, found their way to Sherrington. Naturally a Sherrington provenance has been sought after and regarded, generally, as good.

A hint of a different point of view occurs in Collins Baker: 'It has been alleged, with what base of truth we cannot now decide, that Joseph Sherrington, whose sale was in 1858, co-operated with J. B. Crome in producing unauthentic Cromes. Against this, we feel bound to put in that from all accounts J. B. Crome was an honourable and filial painter, unlikely to prostitute his father's reputation . . . As for the allegation that Joseph Sherrington was responsible for the frauds we can only use such evidence as exists. The identified pictures in his sale in 1858 are all genuine and fine.' (Sherrington's name was, in fact, James and not Joseph.) Collins Baker was probably repeating something he had heard from Reeve who was familiar with an enormous amount of local gossip and legend. If we turn from legend to fact we find that the Sale of 1 May 1858 contained the following *'Pictures by Old Crome from the celebrated Sherrington Collection'*.

23. *A WOOD SCENE with figures: the entrance to a wood; in the centre three figures in conversation, and a dog. A most careful and beautiful specimen. Painted for T. Bracey Esq. and bought by Mr.*

Sherrington of him. (Here we have indisputable evidence that *The Beaters* (Plate 91b), or a picture with similar features, was in the Sherrington Collection from before 1835 until 1859.)

24. *A LANE SCENE: a thickly wooded landscape; to right hand, an outlet enlivened by a gleam of sunshine, in foreground, to left a white cow browsing and a peasant on horseback. Rich and powerful in tone, and excellent in composition—on panel.* (This, which was bought in at 120 gns. and was clearly one of the most important pictures in the Sale has not since been recognized.)

25. *THE WILLOW TREE: in the centre, a finely formed willow tree, near to which is a bank bounded by water and rustic bridge; to left hand, a peasant on horseback, in conversation with a woman. Worthy of Gainsborough—on canvas 105 gns. Rev. J. Holmes.* (This is Plate 109 now at Nottingham Castle. It should be noticed that Christie's catalogue compiler at the time reads right and left from behind the picture looking out of it, and not as is now more commonly done.)

26. *THE BLACKSMITH'S SHOP: Scene in a valley, with rustic cottages; to right hand, a man at a grindstone, numerous other figures variously engaged; to left, a stable and horse in it. Painted with great force, and rich in tone—on canvas.* (This is the Philadelphia picture Plate 86 and was bought in at 84 gns. Baker says *Perhaps in Sherrington Sale.*)

27. *A LANDSCAPE; Study from nature, a saw mill, cart wheels, etc.* (Bought for 7½ gns. by the Rev. J. Holmes who lent it to the Norwich Exhibition of 1860 (166). Since lost sight of.)

28. *A CLASSICAL LANDSCAPE: an old castle on the summit of a rock; at its base, a river and figures in a boat, buildings, etc. in distance.* (This was bought in at 22 gns. and appears to be the picture exhibited at The Fine Arts Society in March 1903 as No. 11, see also D 4 and P 107.)

29. *A SMALL LANDSCAPE—Entrance to a village—panel.* (15 gns.—not identifiable.)

30. *THE STONE QUARRY: View over a grand and mountainous country. A fine composition and painted with great vigour and effect.* (This can be no other than *The Slate Quarries* (Colour Plate I); it was bought in for 150 gns. Baker writes *said to have been bt. by Sherrington from Dawson Turner.* See p. 103 note 4.)

31. *Portrait of John Crome, by J. T. Wodehouse.* (This was exhibited in the 1821 Memorial Exhibition. It fetched £31 10s 0d.) Now property of City of Norwich.

32. *Study of Docks.* (This, which fetched £2 8s. 0d. cannot be Plate 102 *Study of a Burdock* if the provenance given for that picture is correct.)

33. *Shipping. The Passage Boat. Painted with great breadth and effect.* (Possibly this is *Steam Packet* (72) in John Berney Crome's bankruptcy Sale of 1834 as his father's work. It fetched 10s. 6d. then and £30 19s. 6d. now. Not known. But may this not be the picture illustrated by Dickes as by John Berney Crome? Its present whereabouts is unknown but from the photograph it could well be the father's work.)

34. *A small upright landscape: in the foreground, a stream; to right a man gathering sticks. Exquisite in colour.* (This had been struck through and was presumably withdrawn. The description fits Plate 92a, *Corner of the Wood.*)

35. *A SEA PIECE: VIEW OF YARMOUTH JETTY FISHERMEN, etc.—canvas. A grand work worthy of Turner.* (Bought in at 55 gns. It may have gone to Holmes after the Sale. Possibly Plate 78 in the Mellon Collection? Bt. by Sherrington originally for £70—Reeve.)

36. *AN UPRIGHT LANDSCAPE: Scene in a lane near Norwich; to the left a fine beech tree, a peasant passing over a small wooden bridge; a peep through the centre discloses fields and distant hills.*

A very wonderful specimen of this great master, admirable for power and effect. (Bought in at 76 gns; a price which curiously justifies Christies' report to Samuel Paget's son over twenty years before that it would not make £100. This is the true *Marlingford Grove* (Plate 106), that which hangs in Norwich Castle and which has never before been accorded a Sherrington provenance because its place had been taken by a changeling, Plate 117.

37. *A homestead. A beautiful cabinet specimen.*

37a. *A Crome landscape.* (A written-in lot which, being bought in at 78 gns. was probably a major picture admitted to the Sale in place of Lot 34. Was this the 'Bracey picture' of which two water-colour copies exist? (see note to P 56).)

It would appear then that May 1858 was not the end of the Sherrington Collection for seven pictures were bought in and one withdrawn out of the fourteen catalogued. In February 1908 when the collection of Sherrington's widow, Mrs Caleb Rose, who had died in the previous year, was offered at Christies, a list of her property was compiled by her son, Sir Charles Sherrington, for guidance to the cataloguers—a guidance which in the case of the drawings in material respects they characteristically ignored. It opens with a *Note:*

Mr Sherrington was a personal friend and patron of John Berney Crome, David Cox, Robert Carrick, Henry Bright, Thomas Lound, Richard and Edward Girling, and other artists. He befriended the widow of John Berney Crome who gave him many articles formerly belonging to Old Crome, including his palette, and Indentures of Apprenticeship to the Coachpainter, and many of his pencil sketches and etchings including an unpublished copper-plate, still in the possession of Mrs Rose's representatives. Besides the pictures and drawings now to be sold Mr Sherrington had in his collection a number of the most important of Old Crome's pictures. Of these, fourteen larger ones were sold by his Widow privately more than 45 years ago to Louis Huth, Esq. They included the 'Grove Scene, Marlingford' (sold 1904—C. F. Huth Sale) 'The Yare above the New Mills' and 'On the Yare, Moonlight' (sold 1904—C. F. Huth Sale) and 10 others which were soon afterwards sold by Messrs. Christie and Manson. See advertisement in the 'Times';—

10 Capital Pictures by Old Crome, from the famous Sherrington Collection . . . Ten capital landscapes by Old Crome from the celebrated Sherrington Collection comprising a Wood Scene with figures, a Lane Scene, The Willow Tree, The Blacksmith's Shop, The Stone Quarry and other works painted with that force and richness of tone which are so characteristic of the Master.

The Blacksmith's Shop (exhib. Messrs. Agnew—1896) is at Liverpool (Mr. McFadden).

(The following are the items in the Sherrington typescript which relate to Crome. There are no Lot or page numbers.)

Woodland Landscape, Norfolk 21 × 16½. On panel:
> One of the Sherrington collection (*see note at beginning of this list*). *Purchased privately by Mr. Sherrington on 6 July 1847 from Saml. Paget of Yarmouth, for whom the artist painted it, and in the possession of Mr. Sherrington's widow, the deceased Owner, ever since 1847. (See the accompanying receipt from Mr. Paget, on sale of this, and of two larger pictures afterward bought by Mr. Huth.)* (This became Lot 51 *A Forest Scene, Norfolk* with a peasant on a path by a pool: and a receipt from Mr Paget in the subsequent catalogue.)

River Scene near Hingham 7 × 8½. On panel: One of the Sherrington Collection. (This became Lot 52, *A River Scene near Hingham, with boats.*)

These were the only paintings by Old Crome; there followed four by John Berney Crome, bought from the artist, one of them in April 1837. The drawings, which were also listed in the Sherrington typescript, appeared earlier in the Caleb Rose Sale.

Of the fourteen pictures offered by Christies in 1858 ten only are described as 'capital', and they, presumably, are those in capital letters in the catalogue although the written-in Lot 37a would seem to have been in the same class. According to a strict reading of the typescript, which is slightly ambiguous, the fourteen large Cromes were sold to Huth circa 1862, but since ten of these are said to have been sold 'soon afterwards' in 1858 we must take it that the Huth purchase was shortly before that. The 'Sherrington Sale' of 1858 was then, in fact, a Huth Sale and the operation begins to take on the air of a speculation and, if later there were any sharp practice, it is probable that Huth and not the Sherrington family was responsible.

Of other pictures attributed to Crome which Louis Huth at one time possessed we know of the following:

1. Landscape; rustic bridge (16 × 20½) (Dickes p. 101).
2. Landscape (14½ × 20½) (Grosvenor Gallery, 1889).
3. Marlingford Grove Scene (53¼ × 38½) (Huth Sale 20 May 1905. bt. Agnew) (P 86 version).
4. View of Norwich (13½ × 18) (R.A. 1876 (30); Huth Sale bt. Rothschild).
5. View on Yare: a tower (8½ × 18½) (Huth Sale bt. Agnew).

Whereas C. F. Huth (who may be thought to have obtained his pictures from or through Louis) owned:

6. Moonlight on the Yare (26½ × 40) (Huth Sale 1904. bt. Barton).
7. Norwich River: afternoon (27½ × 39) (Huth Sale 1904. bt. Colnaghi) (P 95).

8. River Scene: old buildings (18 × 23) (Huth Sale 1905. bt. Laurie)
(P 85).

What of these eight? Only one appears at first glance to have been among those bought in at the 'Sherrington Sale' and then only at first glance, for No. 3, *Marlingford Grove* with its closely traced provenance from Huth to its present resting place at Port Sunlight, is *not* Lot 36 in the 'Sherrington' Sale but a larger and more elaborate and inferior replica of it. If then, Huth purchased his *Marlingford Grove* from Sherrington's widow (and we know that his version was in Sherrington's collection because of the Sherrington watercolour copy of it) then he attempted to sell in 1858 the genuine *Marlingford Grove* and failed to do so, but retained until his Sale in 1905 the substitute. Of this latter Collins Baker wrote: *perhaps in Anon Sale 28 Feb 1863 bt by Rainger and sold to Sherrington* (who was dead), and claimed that it appeared in Sherrington's Sale five years before, according to him, he had bought it. Of the remaining seven, No. 4 *View of Norwich* is now in Norwich Castle and, though Baker accepted it as a true Crome, we do not believe that any serious Crome student now would; No. 6 *Moonlight on the Yare*, which we have not seen, has been attributed to John Berney Crome, and *Norwich River: afternoon* (No. 7) has not always been free from suspicion. These two last are said to have been bought at the *Sale of Crome's effects by Mr. Hanks*. There were no pictures by Crome in the *Sale of his effects* either in 1812 or in 1821. Of the *Norwich River: afternoon* which Baker was unable to see he records someone else's comment: *Cold colour; dark green and red, more positive in colour than usual.* The remaining five have passed from view. As the *ten capital pictures* of 1858 and their five less capital companions included none of these eight Huth Cromes it follows either that the Huths acquired other Cromes than the fourteen said to have been bought from Mrs Sherrington (really fifteen), or that amongst the twenty-three were pictures not painted by Crome—although quite possibly acquired from the Sherringtons.*

We are inclined to believe that what happened was that certain genuine Cromes in the Sherrington Collection, being in poor condition, were copied (with improvements) by John Berney Crome, perhaps also by Robert Ladbrooke and Bristowe, and that these pictures were sold, probably in good faith as 'versions by other hands' to such as Huth who were less scrupulous to make clear that the goods they passed on were not autograph. This, after all, is

* The Sale of Miss Elizabeth Sherrington, the brother of James, took place on 11 March 1892 and included two significant entries: Lot 150—*Postwick Grove on the River Yare with cattle and boats, upright* 24 × 30; Lot 151—*The companion picture* 24 × 30. Both were catalogued as 'in the manner of Old Crome'.

very much the sort of thing that led to John Berney Crome's *Yarmouth Water-frolic* (Plate 119), now in Kenwood, being sold as by John Crome and, had it not been for the insistence of Reeve, *by John Crome* it would probably be still—as it regrettably was in Christie's bi-centenary celebrations of 1966.

We have the evidence of Dawson Turner (*Lithog.* 15) that Sherrington at one time owned the moonlight known as *Bruges River: Ostend in the Distance* (Plate 104) which appeared in an Anon Sale in 1863 having, presumably, been in Huth's possession in the interval; and Baker also gives as a Sherrington picture *Wherries on the Yare: going through the Broads* (P 130), although his grounds for doing so are unknown. In any case this last picture is not in our view by Crome. *Hautbois Common* (in the Metropolitan Museum, New York) is also said by Baker to have been Sherrington picture, but we know of no evidence that it was.*

It should surely have been possible in the life-time of Mrs Caleb Rose to obtain very detailed information about the negotiations which built up the Sherrington Collection. The same idea seems to have occurred to the indefatigable James Reeve. In his album there is a letter from Caleb Rose dated 1 March 1883:

'Dear Mr. Reeve,
'I am not disposed to part with the documents your letter refers to, and I do not exactly understand what good purpose it would serve to make facsimiles of them. . . .'

And on 19 October of the same year he wrote again:

'. . . I am sorry not to be able to comply with your request as to the 'Crome Memorials, the why and the wherefore are too long for a letter and would not interest you, the result being that, as I said before, I am not able to send them for your exhibition. . . .'

Does one have to have a very suspicious nature to consider it probable that Dr Caleb Rose was perfectly well aware that a number of pictures that had been in the Sherrington Collection were now sailing under false colours?

In any case what happens now to Collins Baker's assertion that Sherrington's pictures are *all genuine and fine*? Probably they were. But who knows which pictures were Sherrington's? Certainly not all those which are claimed to be.

The second collection, of equal and in some ways of greater importance

* Sherrington also at one time owned *Road with Pollards* which he gave to W. H. Hunt and *Catton Lane Scene* which he exchanged with Dawson Turner for the *Slate Quarries*.

than the Sherrington, was that of William Rainger. Rainger's Collection was sold anonymously at Christies on 28 February 1863 which may account for the neglect with which it has been treated. It is, in fact, an estimable provenance. Nothing has been discovered about Rainger except that he was resident in the Queen's Hotel, Hastings, at the time of the Sale, and that he was said to be 'of the Carlton Club'. Dickes wrote of him as 'Secretary of the Carlton Club'* and a friend of Crome's to whom Crome left a picture. There were twenty-four paintings by Crome amongst other, chiefly Norwich School, pictures in his Sale.

21. A Peasant with sheep and a cart before a cottage	11 × 16	bt. Cox	£10–5–0
22. Fish	12 × 18	bt. Cox	£2–6–0
24. The Outskirts of a Wood, with a pool of water	16¼ × 20	bt. in	£7–10–0
28. Mountain Scenery, with figures and goats on the rocks	30 × 40	bt. in	£11–5–0
29. A Landscape, with old cottages	16 × 24	bt. Pennell	£5–0–0
36. A Woman standing at the Door of a cottage, under a cluster of trees: a broken cart in the foreground	19 × 15	bt. in	£7–7–0
56. An Exterior, with figures standing at a door; near a shed is a donkey; several figures in front	12 × 9¼	bt. Pennell	£7–5–0
61. A CLUSTER OF TREES NEAR A POOL OF WATER; felled oaks in the foreground	18 × 14	bt. Whitehouse	£25–4–0
63. A Landscape, near Burfield Hall: donkeys in the foreground	15 × 12	bt. Smith of Bond St.	£7–5–0
64. An Italian Lake Scene, with two figures in the foreground: on the right, a rock with ruins on the top; on the left trees	17½ × 15	bt. Whitehouse	£6–5–0
71. A River View by Moonlight, on the right, a cottage: on the left, a cluster of trees, through which the moon is breaking	13 × 10	bt. in	£10–0–0
76. An Old Cottage at Bawburgh, near Norwich: a shepherd near a gate with a flock of sheep	15 × 11½	bt. Rippe	£12–5–0
87. A Shepherd and Sheep, reposing under the shade of a large oak tree	?4 × 17½	bt. Radclyffe	£4–15–0
88. A Boat at Anchor near a Jetty, with three figures in the foreground	18½ × 15½	bt. Cox	£7–5–0

* Unfortunately the Carlton Club records were destroyed in 1940.

92. SUNSET ON THE OUTSKIRTS OF A WOOD: in the foreground a felled tree, on which is a dog, a shepherd behind him and several sheep near (A very fine example)	20 × 16	bt. in	£52–10–0
93. A WOODY SCENE, with a pool of water in front—the companion (His last picture. A very fine example)	20 × 16	bt. in (sold after Sale to T. Markin)	£52–10–0
97. A River View near Bruges: Moonlight (A very fine example)	21 × 25	bt. Whitehouse	£52–10–0
99. YARMOUTH OLD JETTY, with figures on the sands, and vessels in the offing	33 × 20½	bt. Cox	£32–0–0
100. Ruins on the Banks of a River, with a figure on a rock in the foreground	27½ × 17	bt. in	£10–0–0
106. THE MELTON OAK: a woody scene, with a woodman and dog	35 × 53	bt. in	£58–16–0
107. A Woody Scene, with a reclining figure near the Kimberley Oak	48 × 36	bt. in	£30–9–0
108. AN UPRIGHT LANDSCAPE, on the skirts of a wood, with the Marlingford oak in the centre, and a shepherd and dog	40 × 30	bt. Anderdon	£53–0–0
109. A GROUP OF TREES, on the banks of a river, with palings: two figures in a boat in the centre, a donkey, and a man posing before them. (A very fine example)	53 × 38	bt. in	£63–0–0
112. A written in Lot which may be read as Lot 112 a—Crome Senior—bt. in £1 112 b—Vincent, a landscape—bt. in £15			

There were four further lots ascribed simply to 'Crome'.

4. Yarmouth Beach, with boats and figures	9 × 6½		
5. An old cottage on the Norwich River, with a boat and figures	13½ × 11		
26. An upright View, with ruins and sheep	29 × 26	bt. Cox	£1–8–0
30. A Coast Scene with a ruined castle—sunset	10½ × 17	bt. Cox	£5–5–0

The following lots from this Sale have been identified:

28. P 14

36. Possibly with the Earl of Normanton;
 photograph in the Witt Library
71. P 52
76. P 29
92. P 70
93. Perhaps P 100
97. P 82
99. P 41
100. P 20
106. P 54
107. Possibly the picture *The Oak* now in
 Nat. Gallery, Canada (No. 2920)
109. P 17
 4. ?D. 50x
 26. Possibly the untraced picture (with P. M.
 Turner) of which a photograph is in the
 Witt Library: a copy with Heinneman of
 Munich, 1912
 30. P 71

The third collection of this group was formed by Thomas Churchyard, the solicitor and amateur artist of Woodbridge. He seems to have had no major Cromes at the time of his Sale (28 March 1866) save *Bruges River, Antwerp in the Distance* (Plate 104), but one other, *Mousehold Heath, Windmill and Man on Donkey* (Plate 93), had been disposed of previously. There is little doubt that the majority, if not all, of Churchyard's Cromes were genuine, although the suggested identification of Lot 84 is a questionable picture.

41. The celebrated *Moonlight Picture*, with a view of Bruges in the distance (This picture was later the property of Mr Rainger of the Carlton Club and was purchased by him off the son of the artist) — 31 × 25 — bt. for Mr Pearce — 155 gns.
42. *Landscape with Cottage and Figures* (Very fine) — 29 × 24 — 50 gns.
43. *The Lime Kiln* (In the manner of Rembrandt) — 30 × 20 — bt. Mr Silver for Owen (?) — 83 gns.
44. *Study of a Thistle* — 26 × 20 — bt. J. Soden — 11 gns.
45. *Landscape, with boy leaning over Bridge* — 14 × 12 — 20 gns.
59. *Norwich from Mousehold Heath, with the castle and church.* (A magnificent picture) — 27 × 18 — bt. for Mr Parrington's Friend (?) — 68 gns.
60. *View at Marlingford* (Painted for the late Revd. Mr Brown of the Hingham Grammar School) — 18 × 13 — 56 gns.

61. *Lakenham Old Mills*	11 × 9	21 gns.
62. *A Ruined Cottage and Landscape*	11 × 8	27 gns.
(Lately in possession of Dawson Turner, Esq., of Gt. Yarmouth)		
63. *Cottage and Landscape*	12 × 6	26 gns.
(Late the property of Josiah* French, organist, of Windsor 'Are you the man that rings the bass, etc.')		
76. *Horsted Marl Pit*	12 × 6	£20
(Painted for the Revd. Thomas Image of Whipstead, pupil of Mr Crome, and given to him by the artist)		
78. *Cottage and Landscape*	7 × 5	£10
79. *Study of Flint Stones and Weeds*	12 × 8	£9–10–0
(For many years the property of the late Mr Hodgson of Norwich)		
80. *Pair—Cottages*	5 × 4	£16–0–0
(Painted for the late Mr. Enger of Norwich)		
81. *Blacksmith's Shop and Avenue of Trees at Whitlingham*	11 × 9	15 gns.
82. *Cottages at Heigham* (very fine.)	13 × 12	32 gns.
(This picture belonged to the Bishop of Ely and was sold at his Sale after Crome's death)		
83. *Norwich Cathedral—Early Morning*	18 × 14	26 gns.
84. *Woody Landscape*	24 × 19	29 gns.
85. *View near Pockthorpe*	18 × 11	50 gns.
(Formerly in the possession of Mr Bygrave. A picture of the very highest quality)		
86. *Buildings and River Scenery on the Yare*	20 × 17	82 gns.
(Another beautiful specimen of the master)		
87. *Farmyard and Buildings and Landscape*	18 × 8	25 gns.
115–123 (inclusive)		
Drawings, very fine, mounted and glazed		

The lots in this Sale are identified at present as follows:—

41. P 82
43. P 9
44. P 79
62. Turner Lithog.
79. P 78

* French remained a friend of the Crome family after Crome's death. See letter from J. B. Crome to Mr French, Chapel Royal, Windsor in 1838. (Reeve p. 53.)

84. possibly Victor Rienaecker's *Woodland
 Scene with Track and Gate*, canvas, 19 × 24;
 photo in Witt; not seen but suspect, based
 on E 2
85. P 68
86. P 67 (?)

Of the drawings one, D 68, at Ipswich may well have been from this Sale. There was a subsequent Sale of Crome's water-colours from Churchyard's Collection at Forsters, 4 December 1867 (D 90, 91, 92).

A fourth Collection, which may have had an importance little less than the other three, was that of Daniel Gurney which was sold at Robinson and Hetley's, 21 Old Bond Street on 13 March 1867. Although Collins Baker quoted this Sale we have been unable to trace a catalogue. Baker lists only twelve pictures without measurement or price. There may have been more, for Baker's transcriptions are almost always incomplete and inaccurate. In a brief description of his property written in 1850 Daniel Gurney mentions four pictures by Crome: *The House and River at Thorpe*; *The Same Subject but a different View*; *Landscape, Moonlight*; *The Head of my old Dog, Jack*. The last of these may be connected with 152 in the 1818 Exhibition and must certainly be No. 5 *Dog's Head: Jack* in the Norwich Exhibition of Deceased Local Artists of 1860. It is at present in the possession of Mr Daniel Gurney, grandson of the dog's owner (P 59x).

BIBLIOGRAPHY OF JOHN CROME

Abbreviations

Armstrong	ARMSTRONG, Sir Walter	Dec. 1883
	Some Forgotten Etchers in *English Illustrated Magazine*	
Baker	BAKER, C. H. Collins	1921
	John Crome, introduction by C. J. Holmes	
	BAKER, C. H. Collins	1932
	An Unpublished Crome in *Burlington*, Vol. LX, pp. 223-4	
	BAKER, C. H. Collins	Dec. 1938
	A 'Lay-in' By Crome in *Burlington*, Vol. LXXIII, pp. 274-5	
	BARNARD, G. V. Miss	N.D.
	Paintings of the Norwich School	
Binyon	BINYON, Laurence	1897
	John Crome and John Sell Cotman in *The Portfolio of Artistic Monographs*	
	BINYON, Laurence	2nd edition
	English Water-Colours	1946
	BINYON, Laurence	1953
	Drawings of the Norwich School in the British Museum in *Burlington*, Vol. VI 1953	
	BOLINGBROOKE, L. G.	
	John Crome and the Norwich School of Artists in *Norfolk and Norwich Notes and Queries First Series* pp. 351-4	1899
	BRIGHTWELL, Miss	?
	Life of Amelia Opie	
	BURNET, John	?
	Progress of a Painter	
Bury	BURY, Adrian	Oct. 1958
	Crome and Cotman in *Connoisseur*, Vol. (CXLII), pp. 113-14	
	CASTLE, Egerton	?
	The Jerningham Letters	
Clifford	CLIFFORD, Derek	1965
	Water-Colours of the Norwich School	
	CLIFFORD, Derek	1966
	The Norwich School of Water-Colourists in *Old Water-Colour Society's Club*, Vol. XLI	
	CONSTABLE, W. G.	1953
	Richard Wilson	

| Cot. & Haw. | COTMAN, Alec and HAWCROFT, Francis W. | 1961 |

Old Norwich, A Collection of Paintings, Prints and Drawings of an Ancient City

| Cund. | CUNDALL, H. M. | 1920 |

The Norwich School

CUNNINGHAM, Allan 1834
Cabinet Gallery of Pictures

DAVIS, Frank 1959
Wind on the Heath in *Illustrated London News*, April 11, 1959, p. 620

| Dickes | DICKES, William Frederick |

The Norwich School of Painting 1905

EARLAND, Ada 1911
John Opie and His Circle

| Farington | FARINGTON, Joseph R. A. | 1922 |

The Farington Diary edited by James Greig

FLOWER, Robin Dec. 1934
A Famous Letter of John 'Old' Crome in *BM Quarterly IX*, pp. 39–40

GOLDBERG, Norman L., M.D. 1960
Old Crome in America in *Connoisseur*, Nov. 1960, pp. 214–17, Vol. CXLVI

GOLDBERG, Norman L., M.D. 1962
John Crome and the Norwich Cathedral: An Enigma. Connoisseur Year Book, p. 118–25, 1962

GOLDBERG, Norman L., M.D. 1963
On John Crome and Connoisseurship; the present day problem in *Connoisseur*, Nov. 1963, pp. 194–200, Vol. CLIV

GOLDBERG, Norman L., M.D. 1966
America Honours the Norwich School in *The Connoisseur*, Feb. 1966

GOLDBERG, Norman L., M.D.
Catalogue of *Landscapes of the Norwich School*, an Exhibition in Jacksonville, Nashville and New Orleans 1967

GRANT, Colonel M. H. 2nd edition
Old English Landscape Painters, Vol. V, pp. 399–406 1959

HARDIE, Martin 1967
Water-Colour Painting in Britain, Vol. II

| Hare | HARE, Augustus J. C. | 1895 |

The Gurneys of Earlham

HAWCROFT, F. W.
John Crome and The Yarmouth Water-Frolic in *Burlington Magazine*, July/August 1959, pp. 288–91

HAWCROFT, F. W. 1954
East Anglia's Debt to Holland in *Country Life*, July 15, 1954, p. 205

HAWCROFT, F. W. 1959
Crome and His Patron; Thomas Harvey of Catton in *Connoisseur*, Dec. 1959, pp. 232–7, Vol. CXLIV

HAWCROFT, Francis W.
Review of Derek Clifford's *Water-Colours of the Norwich School* in
Burlington Magazine, Vol. CVIII, No. 758, May 1966, pp. 268–9

HEATON, Charles W. ? or Mary W. 1879
John Crome in *Portfolio*, X, pp. 33–48

HIND, A. M. 1934
A drawing by John Crome in *BM Quarterly VII*, p. 139

HODGSON, David 1856
*Reverie, or Thoughts suggested by a visit to the Gallery of the Works of
Deceased Artists of Norfolk and Norwich*

HOYLAND, Francis 1965
Postwick Grove by Crome as *Painting of the Month* in *The Listener*,
June 10, 1965

HUGHES, C. E. 1913
Early English Water-Colours 3rd ed. 1950

JACOB, G. L. (Miss)
The Raja of Sarawak an account of Sir James Brooke, K.C.B., LL.D.

KAINES SMITH, S. C. 1923 and 1926
Crome, introduction by C. H. Collins Baker

KITSON, Sidney D. 1942
Catalogue of the Colman Collection

KITSON, Sidney D. 1932/33
Notes on a Collection of Drawings formed by Dawson Turner in Wal-
pole Society, Vol. XXI

LADBROOKE, Henry 1882
Dottings in *Eastern Daily Press*, April 1921

MACKINTOSH, VISCOUNT of HALIFAX May 1949
A Landscape for Identification in *Country Life*, Vol. CV, p. 1064

MARENDAS, D. M. K. Oct. 1948
John Crome: his paintings and posterity in *Apollo*, Vol. XLVIII,
pp. 91–92

MASTERS, David Dec. 1950
A John Crome Discovery in *Connoisseur*, Vol. CXXVI, pp. 190–2

MONKHOUSE, Cosmo 1887
John Crome in *Dictionary of National Biography*

MONKHOUSE, Cosmo 1890
The Earlier English Water-Colour Painters

Mottram MOTTRAM, R. H. (London Bodley Head) 1931
John Crome of Norwich

MUTHER, R.
History of Art

NAGLER 1835
Neues Allgemeines Künstler-Lexicon, Vol. III

NATIONAL GALLERY London 1959
The British School, Catalogue of Paintings, Martin Davies, pp. 28–30

NORWICH CASTLE MUSEUM 1903
Catalogue of the Loan Collection of Drawings in the New Picture
Gallery in the Norwich Castle Museum
OPIE, John 1809
Lectures on Painting
PAGET, Elise April 1882
John Crome paper in *The Magazine of Art V*, p. 221
REDGRAVE, R. and S. 1866
A Century of British Painters Phaidon reprint. 1947

Reeve REEVE, James
 Crome Family Biographical Sketches, notices of work, etc. collected
 by James Reeve. 167 c. 8. B.M. Print Room

Reeve, Cat. *Catalogue of Drawings and Etchings by Norfolk and Norwich Artists*
 in Collection of James Reeve. 167 c. 4. B.M. Print Room

Nor. Soc. *Norwich Society of Artists, 1805–25. Cuttings from Norwich Mercury*
 Reeve *and Norwich Chronicle.* 167 c. 5. B.M. Print Room

Reeve *Bound volume of touched proofs of Crome's Etchings.* 190 a. 9, in B.M.
 Etchings Print Room

 REYNOLDS, Graham 1950
 An Introduction to English Water-Colour Painting
 ROBERTS, William 1907
 The Life of Sir William Beechey
 ROGERS, J. J. 1878
 Opie and His works
 ROGET, John Lewes 1891
 A History of the 'Old Water-Colour' Society
 SEWTER, A. C. Jan. 1941
 Four English Landscapes in *Burlington*, Vol. LXXVIII, pp. 9–15
 SEWTER, A. C. April 1942
 An Unknown Work by Crome in *Burlington*, Vol. LXXX, pp. 82–85
 STEPHEN, Geo. A. 1915
 Norfolk Artists: an anotated catalogue of the books, pamphlets and
 articles relating to deceased Norwich artists in the Norwich Public
 Library
 SUTTON, Denys July 1938
 The Origins of the Norwich School in *Country Life*, Vol. CXXIV,
 pp. 116–17
 THEOBALD, Sir Henry Studdy, M.A. 1906
 Crome's Etchings—A Catalogue and an Appreciation with some
 Account of His Paintings
 TURNER, P. M. 1921
 The Crome Centenary in *Burlington*, Vol. XXXVIII, p. 254
 TURNER, P. M. 1922
 A Monthly Chronicle: Cotman and Crome in *Burlington*, Vol. XXXX,
 p. 247

	TURNER, J. P.	1920
	John Crome at l'ecole de peintre de Norwich in *Art Ancien et Moderne* Vol. XXXVII p. 236	
	(or in *La Revue de l'Art*, 27, No. 215, April 1920, pp. 223–35)	

Turner,
 Memoir

TURNER, W. Dawson 1838
Etchings of Views in Norfolk by the late John Crome, Founder of the Norwich School of Artists, together with a Biographical Memoir by Dawson Turner, Esq., Norwich

Turner,
 Lithog.

TURNER, W. Dawson 1840
Outlines in Lithography from a Small Collection of Pictures

V. and A. Cat.

VICTORIA and ALBERT MUSEUM. *Catalogue of Water-colour paintings by British Artists and foreigners working in G.B.,* Revised ed.
pp. 148–9 1927
WEDMORE, Frederick 2nd ed. 1876
Studies in English Art

Whitley

WHITLEY, William T. 1928
Artists and Their Friends in England, 1700–1799

Whitley 1800–
 1820

Artists in England, 1800–1820 1928

WILLIAMS, Iolo A.
Early English Water-Colours 1952
WODDERSPOON, John 1858
 2nd ed. 1876

John Crome and His works with Lists of the Pictures Exhibited in Norwich from the Year 1800–1821 inclusive; Some Account of the Norwich Society of Artists; Short Notice of Painters, the local Contemporaries of Crome, etc. etc.
Extracted from the *Norwich Mercury* of November 10th, 17th, 20th and December 1st 1858. The 1876 edition contains a reprint of Dawson Turner's *Biographical Memoir.*
WOODALL, Mary 1939
Gainsborough's Landscape Drawings.

Index